Praise for *The Age of Dise*

"An intriguing narrative of literary ambition and family dysfunction—betrayal, drug addiction, and madness—that begins during the Spanish Civil War and continues into this century."

—Amanda Vaill, *The New York Times Book Review*

"In this sweeping, ambitious debut, journalist Shulman offers a group biography of a family indelibly marked by the Spanish Civil War. . . . Prodigiously researched and beautifully written."

—*Publishers Weekly* (starred review)

"Much has been written about voices of dissent during the Spanish Civil War. This book adds to a smaller body of literature on the intellectuals who chose survival over principles. . . . Examining Panero's output and his relationships, Shulman reconstructs the arc of a man who saw literature as both craft and escape."

—*The New Yorker*

"A brilliant biography of the outlandish Panero family."

—*The National Book Review*

"Well researched and bittersweet, Shulman's book lays out the family story and the aftermath of Franco objectively and with finesse. . . . Shulman does not judge. Thank God. Nothing sours biography like righteousness."

—Spencer Reece, Book Post

"A valuable primer on the ways literature intertwined with politics during Franco's reign."

—Rigoberto González, *Los Angeles Times*

"One of the best Spanish Civil War books of all time."

—BookAuthority

"A deeply researched portrait. . . . Spain's roiling history, beginning in the 1930s, forms the backdrop to the family's turmoil. A richly detailed history."

—*Kirkus Reviews*

"Aaron Shulman has fashioned *The Age of Disenchantments*—part biography, part political history—in which he juxtaposes the Panero clan's literary successes and private unraveling with the fate and fortune of Spain itself. . . . A portrait of an earlier Spain . . . when poets were widely loved and celebrated, and as a young visitor to the Paneros' house put it, 'all the young people were drunk with hope and poetry.'"

—Caroline Moorehead, *The Wall Street Journal*

"Shulman's narrative blends the personal and the political, and raises timely questions—about living and making art when fascism is a boot on your neck; about how our individual stories complicate and inform our collective history; and about the wisdom and cost of letting our families—and nations—define us. *The Age of Disenchantments* has something important to show us about the urgency of history and our agency within it."

—Lauren Hamlin, *Los Angeles Review of Books*

"The book reads as so many squiggling lines of startling connections, a grave revisiting of the horrors of the [Spanish] Civil War, and as genuine wonder and appreciation for a singular family. The way the Paneros moved, changed, decayed, and ended is astonishing."

—Caren Beilin, Full Stop

"The paradox of *The Age of Disenchantments* is that the Paneros, with their fatal and theatrical destiny, serve to give a very balanced telling of the twentieth century in Spain. . . . Those who get irritated with English-language books that paint Spain as if it were a scene from *Carmen* can trust Shulman."

—Luis Alemany, *El Mundo*

"The book reads well, and if it were published in Spanish, it would have a public. Someone might even want to make a TV show."

—Manuel Rodríguez Rivero, *Babelia, El País*

"A fascinating and groundbreaking account of the complex social conditions that were obtained not only under Franco, but also in the brutal early years of the civil war in Spain."

—Charles Donelan, *Santa Barbara Independent*

"Shulman paints a vivid panorama of lives changed by conflicts they couldn't control. . . . Unlike many mythmaking narratives of the Spanish Civil War, *The Age of Disenchantments* makes it clear that moral high ground was hard to find."

—David Luhrssen, *Shepherd Express*

"Part history, part melodrama, and sure to entertain public library patrons attracted to family biographies or Spain."

—*Library Journal*

"Shulman is able to bring to life the Panero family's heartache and the Spanish Civil War's devastation as only a trained journalist can: by mixing history, interviews, and well-honed research to complete a full picture for the reader. The resulting work avoids a dry historical retelling of the war, instead weaving a narrative story that piques even non-historians' interest."

—Haley Lewis, *San Francisco Book Review*

"Aaron Shulman has written a fascinating account of the epic rise and fall of the Paneros, a literary family that lived at the vortex of change during Spain's dramatic past century. In Shulman's hands, the story of the gifted, doomed Paneros becomes an absorbing rumination on loyalty and betrayal, history and myth, literature and pretense, the nature of family, and memory itself. A remarkable book and a compulsive read."

—Jon Lee Anderson, author of *Che: A Revolutionary Life*

"At its heart, this book is about the soul of Spain. The lives of the Paneros—poets, writers, brothers, lovers, and rivals—roiled and rhymed with the revolutions and counterrevolutions of a nation in search of itself. As richly and intimately drawn as the characters might have drawn themselves."

—Joe Hagan, author of *Sticky Fingers:
The Life and Times of Jann Wenner and* Rolling Stone *Magazine*

"Aaron Shulman shifts gears through Spanish poetry, film, biography, and his own autobiography and fits these pieces together like so many Russian dolls that are each independent yet somehow nestle into one harmonious unit. He revives the complex, passionate, and faded Grey

Gardens–like landscape of the Spanish past, and, thanks to his deep love for Spain, readers will be enchanted with the journeys he shares."

—Soledad Fox Maura, professor of Spanish and comparative literature, Williams College, and author of *Exile, Writer, Soldier, Spy: Jorge Semprún*

"Two generations of ambitious poets get swept up in and then magically *become* Spain's warring, momentous, weird, and tempestuous twentieth century. This is a mythic saga of artists passionately believing that they were shaping the world, only to be utterly remade by it. Read *The Age of Disenchantments* now before we are all binge-watching it on Netflix."

—Jack Hitt, author of *Off the Road: A Modern-Day Walk Down the Pilgrim's Route into Spain*

"Betrayal and sacrifice, passion and poetry, the fate of a country if not a continent, epic destruction—all is in play in this sweeping yet intimate account. Yet what makes this book so truly rich and resonant is Shulman's ability to expose the core humanity that underlies the entire saga. That feeling left in the gut is this book's most satisfying, lasting gift."

—Mark Eisner, author of *Neruda: The Poet's Calling*

THE AGE OF DISENCHANTMENTS

The AGE of DISENCHANTMENTS

THE EPIC STORY OF SPAIN'S MOST NOTORIOUS LITERARY FAMILY AND THE LONG SHADOW OF THE SPANISH CIVIL WAR

AARON SHULMAN

An Imprint of HarperCollinsPublishers

Passages of this book originally appeared in *The Believer*, *The American Scholar*, and the *Los Angeles Review of Books*.

THE AGE OF DISENCHANTMENTS. Copyright © 2019 by Aaron Shulman. All rights reserved. Printed in the United States of America. No part of this book may be used or reproduced in any manner whatsoever without written permission except in the case of brief quotations embodied in critical articles and reviews. For information, address HarperCollins Publishers, 195 Broadway, New York, NY 10007.

HarperCollins books may be purchased for educational, business, or sales promotional use. For information, please email the Special Markets Department at SPsales@harpercollins.com.

A hardcover edition of this book was published in 2019 by Ecco, an imprint of HarperCollins Publishers.

FIRST ECCO PAPERBACK EDITION PUBLISHED 2020

Designed by Renata De Oliveira

Library of Congress Cataloging-in-Publication Data has been applied for.

ISBN 978-0-06-248420-8 (pbk.)

20 21 22 23 LSC 10 9 8 7 6 5 4 3 2 1

FOR ELISA,
my home wherever I go

CONTENTS

THE AGE OF DISENCHANTMENTS

PROLOGUE: LORCA'S MOON

Before dawn on August 17, 1936, a man dressed in white pajamas and a blazer stepped out of a car onto the dirt road connecting the towns of Víznar and Alfacar in the foothills outside Granada, Spain. He had thick, arching eyebrows, a widow's peak sharpened by a tar-black receding hairline, and a slight gut that looked good on his thirty-eight-year-old frame. It was a moonless night and he wasn't alone under the dark tent of the Andalusian sky. He was escorted by five soldiers, along with three other prisoners: two anarchist bullfighters and a white-haired schoolteacher with a wooden leg. The headlights from the two cars that had delivered them here illuminated the group as they made their way over an embankment onto a nearby field dotted with olive trees. The soldiers carried Astra 900 semiautomatic pistols and German Mauser rifles. By now the four captives knew that they were going to die. The man in the pajamas was the poet Federico García Lorca.

Exactly a month earlier, Francisco Franco and other Spanish generals had launched a coup d'état against Spain's young, contentious democracy. A brave, ruthless career officer with an incongruously reedy voice and the grandiose custom of riding

a white horse into battle, the forty-three-year-old Franco led forces in Spanish Morocco, where he commanded the colonial army of forty thousand *Africanista* soldiers, including the notoriously brutal Spanish Foreign Legion. Coordinated uprisings in military garrisons across the Spanish peninsula followed the next day, buoyed by the support of right-wing sympathizers, foot soldiers of fascist militia, and members of the Civil Guard—or national police corps—who aligned themselves with the rebellion. The uprising's goal was to remove the Popular Front, a left-wing coalition that had won elections in February, and save their country from what they saw as the excesses of the Second Spanish Republic, the system of governance instituted in 1931 after the military dictator Miguel Primo de Rivera was ousted and his ally King Alfonso XIII left the country. In the five years since the Republic's founding, leftist administrations had carried out a series of ambitious reforms aimed at transforming and modernizing Spain: legislation to increase rights for women, new agrarian laws to reduce the suffering of the landless poor, changes in the educational system to free it from the dominance of the Catholic Church, and restructuring of the armed forces to decrease the influence of the military. Such attacks on the traditional structures of Spanish society earned the reformists, as well as the Republic itself, a committed bloc of enemies, from loyal monarchists to conservative Catholics, from wealthy landowners to the Spanish fascist party, the Falange. Now these groups united under Franco and other generals. They hoped to take back Spain and return it to its former imperial greatness, which in many cases meant eliminating perceived foes, such as Lorca.

Born in 1898 to a well-off family in a village near Granada, Lorca had grown up to be a gifted musician, pathbreaking poet, theater-filling dramatist, and unparalleled party guest. His personality was so contagious that when a young Salvador Dalí first met Lorca in college, the painter would literally run

away from him to battle in private his jealousy of the Granadine's charisma. By the time he was in his midthirties, Lorca was one of the most beloved Spanish-language writers alive. Alongside his literary peers, the Generation of '27, he reinvigorated Spanish poetry, bringing artistic innovations from the rest of Europe into harmony with Spain's folkloric traditions, especially that of his native Andalusia with its rich gypsy influences. The Chilean poet Pablo Neruda wrote of his friend Lorca: "I have never seen grace and genius, a winged heart and a crystalline waterfall, come together in anyone else as they did in him."

Behind that shimmering waterfall, however, Lorca inhabited a fragile, shadowy inner world. As a gay man in a steadfastly homophobic society, he was never able to express his true self in all its complexity, perhaps the worst fate imaginable for someone as torrentially expressive as Lorca. His pain fueled poems of melancholy longing and stage tragedies of disastrously failed love. Yet if the country that created Lorca failed to accept him during his life, this didn't stop him from cherishing Spain all the way down to its darkest impulses.

"Everywhere else, death is an end. Death comes, and they draw the curtains," Lorca wrote in a famous lecture. "Not in Spain. In Spain they open them." He traced the Spanish tradition of bullfighting to the same fatalistic attraction to death. "Spain," Lorca wrote, "is the only country where death is a national spectacle, the only one where death sounds long trumpet blasts at the coming of spring." Now in the hot summer of 1936, death had spilled out of the *plaza de toros*—the bullfighting arena—into the plazas of cities and villages, where the Nationalist uprising left bodies rotting in the streets.

After being airlifted by Nazi Junkers transports across the Strait of Gibraltar, Franco's army beat an unrelenting march northward toward Madrid, with the aid of German and Italian tanks and planes. Taking orders from superiors and incited by

the sinister broadcasts of Lieutenant General Queipo de Llano in Seville, the uprising machine-gunned innocents, raped and branded women, and carried out mass executions of peasants. The soldiers of the Foreign Legion, who called themselves the bridegrooms of death, collected the ears of enemies, just as Franco had once done as a young soldier in Africa. Their battle cry was: "*¡Viva la muerte!*"—Long live death!

In Lorca's hometown of Granada, where he had fled to thinking he would be safer than in his adopted Madrid, long-simmering hatreds and rivalries boiled over. Falangist *Escuadras Negras*—Black Squads—began conducting summary executions, revealing a bloodlust among neighbors that rapidly left ravines threaded with shallow graves. In Granada's municipal cemetery, where firing squads also operated, the caretaker was later rumored to have gone insane from all of the carnage he witnessed during the war. This violence merely mirrored what was occurring all throughout Spain as adherents to the coup battled for control with backers of the government, opening the curtains for death.

Spain's fratricidal free-for-all was at heart a dispute over the identity of the nation in a still-young century that had already produced the First World War and the Bolshevik revolution—and over who would shape that identity. Would the country return to the lost dominion of the Catholic kings, a medieval feudalism in which landowners ruled over disenfranchised peasants and the church defined public and private life? Would it continue on the brash new boulevard of democracy built on Enlightenment ideals of reason and a belief in liberty and equality? Or would it get trampled and torn apart in the crossroads of history, with Stalin's communism bearing down on one side and Hitler's Nazism on the other? For years—arguably for centuries—these tensions had been building in Spain, as if the past and the future had come together to form a crushing vise

on the present. In the past 120 years alone, the country had seen three civil wars, two dictators, six different constitutions, and over fifty coups. Not only the rebels but even some politicians of the Popular Front saw a new eruption of violence as inevitable and necessary. The only solution, as the socialist leader Francisco Largo Caballero put it, was a "bloodbath."

In Granada, it quickly became clear that Lorca's safety was far from guaranteed. On July 20, less than a week after his arrival, his brother-in-law, the recently elected mayor of the city, was arrested. His term in office had lasted a mere ten days. Soon after, a group of Falange thugs showed up at the Lorca family home and knocked the poet down the stairs. Then they tied the Lorcas' groundskeeper to a tree and beat him. Lorca was terrified. As the leader of a government-sponsored theater troupe that performed in the dusty, forgotten pueblos of Spain, he was a vocal supporter of the Republic. Add to this the envy his success inspired, never mind his fondness for insulting the conservative bourgeoisie of Granada, and it seemed certain that sooner or later the soldiers would return for, as some of his detractors called Lorca, "the fag with the bow tie."

The next day he went into hiding at the house of Luis Rosales, a twenty-six-year-old poet who idolized his older friend, even as he himself had joined the uprising. This was the Spain of that tempestuous, uncertain moment: a maze of bonds and vendettas—personal and ideological, local and national—in which people might protect their supposed enemies from their own apparent allies, even at great risk to themselves. It was also a moment in which betrayals proliferated.

The maze swallowed Lorca. While there are different versions of who betrayed him—some would say it was one of Luis Rosales's brothers, others would claim that the poet's whereabouts were an open secret in Granada—the result was the same. Word

made its way to a vengeful would-be small-time politician named Ramón Ruiz Alonso, who hoped that erasing Lorca would raise his profile in the ranks of the Falange.

On the afternoon of August 16, just hours after Lorca learned that his brother-in-law had been executed, Ruiz Alonso led a convoy of over one hundred soldiers to the Rosales home, which they surrounded with their guns aimed as if preparing for the last stand of a legendary bandit. With the men of the house away at the front, Mrs. Rosales resisted the demand that Lorca show himself. Ruiz Alonso refused to be diverted. "He's done more damage with a pen than others have with a pistol," he said. Trembling, Lorca finally appeared. He was taken to a government building, then after nightfall driven up into the scrubby hills of the Sierra Nevada mountains to an ad hoc prison in the white-painted village of Víznar. Before dawn, he and his three fellow prisoners were delivered to a bend in the road to Alfacar, where he stepped out onto the dirt under a sky with no moon, dressed in his blazer and white pajamas.

"Just as being born didn't concern me, neither does dying," Lorca had told a reporter not three months earlier, during what he didn't know would be his last interview. This was a lie. He feared his mortality to the point of morbid obsession; for years he periodically playacted out his death in front of friends as a form of comic therapy. But how could he have properly prepared for this end, with its nightmare logic and unforgiving sudden-ness? Death, the "question of questions," as Lorca called it, the great unknowable void—it was upon him, emptied of all poetic romance.

On the dark field adjacent to the road, the soldiers told the prisoners to stop. The five men weren't professional executioners. They had taken a side and now accepted their duties, some more zealously than others. One of the soldiers, who would later brag in public about having shot Lorca in his "big head," was the first

cousin of a man whom the poet had unflatteringly fictionalized in a new play. One of the other men had paced nervously earlier in the night, exclaiming, "This isn't for me! This isn't for me!" Another, the leader of the firing squad and a former chauffeur for the first prime minister of the Republic, had lost his firstborn ten-month-old son the day before.

The five men lifted their guns, took aim, and fired.

If anyone heard the echoing cracks, they didn't come to see what had happened. Lorca writhed on the ground, bleeding, until one of the soldiers administered a coup de grâce. He stopped moving, and suddenly verses from the sorrowful "Lament" he had written for his friend Ignacio Sánchez Mejías, a famous bullfighter who was fatally gored, spoke of the fate of the man who had written them:

> *But now he sleeps without end.*
> *Now the moss and the grass*
> *open with sure fingers*
> *the flower of his skull.*
> *And now his blood comes out singing.*

Federico García Lorca was dead. The Spanish Civil War was far from over.

THIS BOOK IS NOT ABOUT FEDERICO GARCÍA LORCA OR, SOLELY, ABOUT THE SPANISH Civil War. It is, however, about two facets of human experience inseparable from his death and the war: the braiding of lives and stories and the interplay between memory and myth.

There are many books about Lorca, and nearly all of them mention the fact that the moon wasn't visible on the night he was killed. I mentioned this, too, in my account of his death— twice, to be exact. The moon appeared frequently in Lorca's

poetry, perhaps most iconically in "Romance de la Luna, Luna" or "Ballad of the Moon, Moon," which includes the line, so heartrending in retrospect, *"Huye, luna, luna, luna"*—"Flee, moon, moon, moon." The people who write about Lorca's death highlight the moon's absence because of the poetic irony and tragic aura: a man who constantly called out to the moon for inspiration wouldn't have been able to seek its comfort during his last moments on earth as he looked up at the sky, knowing that he was about to die.

I understand why biographers underline Lorca's abandonment by the moon. It is gorgeously terrible. Yet, objectively, it means absolutely nothing. The moon's absence was incidental, random, trivia that only takes on the meaning we give it. It allows us to add a small daub of beauty, however painful, onto a story that is at heart nothing more than proof of human barbarity. *We can't control history*, our evocations of Lorca's final minutes seem to say, *but we can control the stories we tell about history*. It's true: converting experience into narrative gives an illusion of control, and sometimes even actual control. This is the ultimate tragedy of Lorca—that he lost not just his life but his words, his role as teller of his story. His death was his end as a narrator. The question, then, is: If we can't control our lives, can we ever hope to control our stories?

The story I tell in this book is about five flawed individuals at the mercy of historical forces who, nevertheless, relentlessly, even self-destructively answered this question in the affirmative. Their lives were shaped by the Spanish Civil War and its legacy, yet they insisted on exercising their narrative rights as if their words might rewrite reality, even at their own peril. In doing so, they shaped eras which at the same time shaped them, transforming personal history into national myth. The century-long saga I tell is about a family that turned the stories about their lives *into* their lives. Perhaps fittingly, I didn't go

looking for it. The story pulled me in like a force beyond my control.

NEARLY SEVENTY-SIX YEARS AFTER LORCA'S DEATH, IN THE SUMMER OF 2012, I WAS living in Madrid, where the Spanish Civil War was now a collective memory, albeit still a very touchy one. Four years earlier, when I was twenty-six, I had met a Spanish woman named Elisa while visiting Guatemala. When we tell the story today, our own neatly packaged narrative hewn from memory, it comes off as obnoxiously picturesque. She was volunteering at an orphanage where I had volunteered the year before. When I came back to see the children that summer, there she was, and there I was. We spent eight days together over the next six weeks as I traveled around Guatemala doing research for an article and she taught kindergarten. That was all it took. Three years later we got married in an Andalusian patio full of orange trees, surrounded by Spaniards and Americans, everyone eating from the same humongous paella with our names written in red peppers.

I liked living in Spain. Before moving to Madrid, we spent two years in Elisa's hometown of Córdoba, in the south. There I lucked into a group of friends that made the small provincial city with its labyrinthine alleys feel like home. During the workweek, I mixed freelance assignments with a novel I hoped to finish. On the weekends, Elisa and I got together with her family or our friends for the heavy midday meal, followed by the part of eating in Spain that I found nearly as delicious as the food: *la sobremesa*, the period after eating when you sit and drink coffee and talk for as long as the conversation lasts, sometimes even until you're hungry again. I really didn't have much figured out besides my love for literature and Elisa, but that was enough. Life in Spain was good.

In other respects, life in Spain wasn't so good. The financial

crisis had left the country in free fall. Unemployment nationally was at nearly 30 percent, and it was much higher in Córdoba. After the nonprofit where Elisa worked ran out of money, she spent nine months unemployed. We finally left Córdoba for Madrid, where she found a job.

It was a bleak moment in Madrid, too, with no shortage of images into which to pour our anxiety about our future in Elisa's country, never mind the future of the country itself. Up in the sky, massive skeletal construction cranes hung in stillness above buildings they had failed to complete. On the ground, angry demonstrations snaked through the centuries-old avenues and café-filled plazas. Every time we left our tiny studio in the neighborhood of Lavapiés, we seemed to get swept into one of these daily marches that ran like a river through the city center, each different in the colors of the demonstrators' shirts and the words of their chants, but all issuing from the same headwater of indignation—*la crisis*. The only person who was optimistic at the time was Elisa's grandmother back in Córdoba, who reassured us that things would never get as bad as they were during the Civil War, which she had lived through as a child.

Amid all of this, as Elisa and I were starting to seriously consider leaving Spain, one night in June 2012 my friend Javi invited us over to watch a movie.

Javi is that friend I always seem to seek out wherever I am who ups my degree of cool by association. The difference this time around was that Javi's studied hipness had a European flavor. He smoked cigarettes with gestures that alluded to scenes from French New Wave films, cruised around on a Royal Enfield motorcycle, and read worrisome quantities of Goethe. I'd met him playing basketball in Córdoba and now we'd ended up living a short walk from each other in Madrid. As it turned out, Javi's invitation would be a big bang of sorts in my life, a day that unsuspectingly proliferated into thousands of other days, leading

me back in time and deep into lives distinct from my own but which nonetheless seemed to speak directly to me.

Javi set up the projector in his living room and explained that we were going to watch a Spanish cult documentary from the 1970s called *El Desencanto*. I tried translating in my head: *The Unhappiness?* No, I thought. Too stilted. *The Disenchantment?* Maybe. I would just have to see. Javi didn't want to say much about the film, only that it was about a dead Spanish poet and his strange family.

"*Lo vas a flipar,*" Javi said, hitting play. You're going to love it.

The opening credits rolled over an old-timey, black-and-white family photo: a mother posing in a shadowy sitting room with three young, adorable boys. No one in the photo looked happy in the least. This was the beginning, the moment I met the Paneros.

The person missing from the photo was the father and husband, Leopoldo Panero, a man people often referred to as the "*poeta oficial,*" or "poet laureate," of the Franco dictatorship. The premise of *El Desencanto* is disarmingly simple: mother and sons

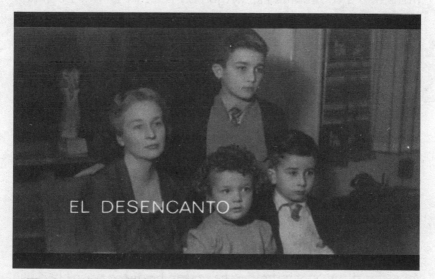

The opening shot of **El Desencanto** *is a family portrait of Felicidad Blanc and her three sons*

convene in 1974, twenty years after that photo was taken, to talk about Dad, who died twelve years earlier, in 1962. As is the case with every family, but especially this one, things in fact aren't simple at all. Leopoldo Panero left behind an embittered, seductively eloquent widow, Felicidad Blanc, who has her own version of the family story to tell. The same goes for her three brilliant and troubled sons, who compete for the title of Panero poetic heir. Juan Luis, the eldest, is a hard-drinking dandy who puts on the airs of a reincarnated F. Scott Fitzgerald, with a bullfighter's swagger. Leopoldo María, the middle son, has been in and out of mental institutions, a doomed genius in the tradition of the French poet Antonin Artaud. Michi, the youngest, is the handsome guide to the Panero universe and its subtle pyrotechnician, lighting the fuse to the family's powder keg of rivalries and resentments, which blow up on camera. Lingering in the background of their story is the pall of the dictatorship, like an illness they've learned to live with. As they throw open the closet where all the dirty laundry has been moldering for decades, the film turns into a communal hatchet job on the memory of Leopoldo Panero, as well as a deconstruction of that most universal and inescapable of human institutions: family.

Two things elevate *El Desencanto* from being a uniquely bizarre onscreen therapy session into a more powerful and lasting artifact. One: the viewer understands that the family is a microcosm of the society that produced it, and what's wrong in one is connected to what's wrong in the other. Family is the primal seat of memory, making private myths out of experiences that are inseparable from public myths. The Paneros can be seen as a metaphor for Spain and its past.

Two: the Paneros are, collectively, Don Quixote. While the great disheveled knight-errant of Spanish literature is most famous for tilting at windmills, the reason he did so wasn't because he was a born man of action. It was because he had ingested too

many books and taken them literally. "His fantasy filled with everything he had read . . . ," wrote Cervantes of his tragicomic hero, "enchantments as well as combats, battles, challenges, wounds, courtings, loves, torments, and other impossible foolishness." This overdose of narrative is what spurred Don Quixote to go on his epic adventures. The Paneros, too, have saturated their minds with books, and the manner in which they talk and act comes off nearly as headlong as the knight from La Mancha. They seem to believe that their collective past, combined with their present lives, is a novel they're in the midst of writing. It becomes clear that the family doesn't know how *not* to frame its existence inside of literature. Storytelling is their vice.

I recalled the famous opening line of *Anna Karenina*, which I would soon learn had already been applied to the Paneros ad nauseam: "All happy families are alike; each unhappy family is unhappy in its own way." In *El Desencanto*, the Paneros up the ante—their shared talent—and infuse their in-its-own-wayness with a prophecy. We learn that none of the sons appears able to produce children, so they may have reached *el fin de raza*—the end of the bloodline. The film, then, is a kind of theatrical last will and testament, which explains why the stakes feel so high. They revel in this atmosphere of refined fatalism, casting themselves as characters in a Wagnerian opera. Of course, the Paneros are just people, like you and me, no matter how poetic or odd. But it is as if they refuse to accept this banal fact, as though simply being one more family buffeted by history and chance, without the gilding of literary myth, would be unbearable. They opt instead to invest their story with a mystique that only art can provide. In doing so, they construct a new legacy.

Yes, I thought, when the film was over. *The Disenchantment*. That's the right translation, because the title was both the truth and a lie. Yes, life in Franco's Spain seemed to have robbed them of an essential wholeness. But the Paneros delighted in

their dissolution, willfully converting it into literature to enchant the viewer. The documentary I had just seen was a work of art, undoubtedly, yet so were the Paneros. They lived under Lorca's moon.

Javi turned on the lights and asked us what we thought. I rhapsodized about the film in overheated Spanish, then Elisa and I said good-night and walked home.

OBSESSIONS START UNASSUMINGLY, LIKE LOVE. MY OBSESSION WITH THE PANEROS started with me poking around on the internet. Who were these people? What had happened to them? Did the prophecy come true? I learned that *The Disenchantment* wasn't a mere cult curio for the Javis of Spain but a national legend that persisted in the memory of older generations. When the film came out in 1976, one year after Franco's death, it became a cultural phenomenon, part scandal and part catharsis. During the beginning of Spain's precarious transition to democracy, just one year before the passage of the 1977 Amnesty Law known as the Pact of Forgetting, along came the Paneros dredging up the past and prosecuting their dead father figure who was associated with the Franco regime—with no interest in amnesties. Their dismantling of traditional myths about family was seen as a symbolic deconstruction of the nation's recently deceased father figure and his legacy. The forces of history swept up *The Disenchantment* and made the Paneros famous, their personal story flowing into Spain's national one. The film changed their lives.

To understand the Paneros, I realized, I had to better understand Spanish history. So like Don Quixote, I read a lot. I read books by the family, from their poetry to their memoirs, and I read books by or about writers or topics that intersected with the family. I read in greater depth about the Spanish Civil War and the writers who had lived through it, or, like Lorca,

not lived through it. I soon learned that Leopoldo Panero was much more complex than the political caricature relegated to the margins of history, just as I learned that his wife and three sons weren't only the characters they had played in the infamous film about their family. Then I started "reading" in a testimonial sense—seeking out scraps of history in the memories of living people. I interviewed the director of the documentary and a few other close-up observers of the Paneros. The more I read and the more I listened, the more I came to see that the family's story held within it Spain's story across the breadth of the twentieth century, and vice versa. After two years, it dawned on me that I had stumbled onto an epic that had never been fully told before: the collective history of the family.

Ironically, by this time Elisa and I no longer lived in Spain. We had started our life in the US. Yet the themes of the Paneros' story spoke to me more strongly than ever: the allure and hazards of nostalgia, the comforts and wounds of family, the ecstasies and limitations of literature, the feeling of smallness in the face of circumstances beyond our control and the struggle to discover the amount of influence we do possess. I flew back to Spain as often as was feasible. I met more people who'd known the Paneros, and listened to their stories in cafés, offices, and apartments. People shared their recollections with me with startling openness, like they had been waiting for this peculiar American to appear and probe their memories, often with very personal questions. I immersed myself in archives and tracked down unpublished manuscripts. The stories I collected transported me from prison cells to nightclubs, from post–World War II London to pre-Castro Cuba, from the battlefields of the Spanish Civil War to the home where a singular family had created itself. Then I would return to my home in the US to sift through the materials I gathered to try to understand the inner lives of these five strangers. I dreamed about the Paneros. Eventually, I came to love them.

"We tell ourselves stories in order to live . . . ," Joan Didion famously wrote. "We live entirely, especially if we are writers, by the imposition of a narrative line upon disparate images, by the 'ideas' with which we have learned to freeze the shifting phantasmagoria which is our actual experience." This book chronicles the lives and words of the Paneros, who told themselves and others a phantasmagoria of stories. It recounts their many disenchantments as well as their fleeting moments of contentment—of being *encantado*, happy. This book also chronicles over a hundred years of history and culture in a country beloved by many, myself included. While monumentally unique, Spain's story is nonetheless a universal story. With both savagery and grace, it has battled the angels and devils that every person, family, and nation must sooner or later confront: hate and love, the past and the future, crime and punishment, and remembering and forgetting. History is both individual and collective. Just as the personal, the political, and the literary combined to create the life and legacy of Federico García Lorca, so did these same forces shape Spain and the Paneros.

Leopoldo, Felicidad, Juan Luis, Leopoldo María, and Michi each imposed a narrative structure on their lives, leaving out as much as they left in. I have pulled their versions together, along with a tapestry of other fragments, corroborating facts, and necessary context. I have sought to filter out myth and imposed my own narrative arc as truthfully as possible. Even though they are all dead now, I can't help but wonder what the family would think of my telling of their lives. Most likely they would bristle at my seizing of their experiences, although I suspect they would be pleased that their legacy is still alive. But of course, I wrote this book for myself, not for them. I have converted the Paneros into my own Lorca moon, a story I tell myself because, with its dramatic layers and complex questions, it forces me to think about my own choices. And this helps me to live.

PART 1

PARADISE LOST
1909–1939

*"Everything is interrupted.
The great flood of Spanish pain submerges us all."*
—LEOPOLDO PANERO

"Our youth is departing. It is the beginning of the war."
—FELICIDAD BLANC

A PREMATURE SKELETON

The Uprising in León, July to November 1936

Two months after the assassination of Federico García Lorca and 750 kilometers north in the province of León, a young poet named Leopoldo Panero Torbado celebrated his birthday in his hometown, the small city of Astorga. He was a self-possessed law school graduate with kind round eyes, an introspectively downturned mouth, and an elongated face reminiscent of an El Greco painting. It was October 19 and he had just turned twenty-seven.

This birthday was marked by circumstances that set it dramatically apart from other years. An aspiring diplomat, Leopoldo had returned home in July from a year of study at Cambridge only to discover a week later that he had come back to a country at war. When he had visited Spanish Morocco as a teen in the 1920s, encountering exotic aromas and bejeweled tapestries, he described it as a "phantasmagoria of the senses." Now the military uprising that erupted there and spread across the rest of Spain sent an altogether different phantasmagoria washing over Leopoldo's senses, filling him with fear.

The Panero family was traditional and well-off, yet progressive, and since the revolt, life for them, as for nearly every family in Spain, had been upset into a state of flux. On the day of the coup, a cousin of Leopoldo's mother who was a prominent liberal politician had been driving back to Madrid after a visit to the north but decided to turn off the main road to wait out the crisis with his relatives in Astorga. With any luck, the government would squash the revolt in a single day as it had a previous one four years earlier. Responding to the rumors of a nationwide plot, a Republican general was already in town keeping watch over the local military garrison for signs of unrest, and with him was a militia of leftist miners. Radio reports from different corners of the country told contradictory stories: the uprising had failed, said one; it had triumphed, said another. Confusion and suspense reigned.

Astorga hung in a precarious limbo for two days, until the general and the miners departed to go arm themselves at a military depot in a nearby city. In the vacuum they left behind, the historically conservative townspeople of Astorga gave themselves over to the rebellion, as did the rest of the southern half of the province. Aided by local supporters of the insurrection, civil guardsmen took to the streets and declared a state of war. In parallel, the military occupied city hall, arresting the Republican authorities gathered there. What was happening in the rest of the country was still a contest of conflicting narratives, but in Astorga the outcome was clear. The uprising had indeed triumphed.

Within hours, civil guards descended on the Panero household. In spite of Leopoldo's father's protestations, the visiting cousin was detained. Very soon after, the killing began. The socialist mayor of Astorga was shot against the town cemetery wall at dawn. A similar fate befell Pepe, the newspaper vendor at the train station, a well-read lefty in his thirties who had talked politics with Leopoldo and his friends since their teenage years.

As the body count mounted, Leopoldo's older brother, Juan, an army reservist and supporter of the Republic since before it even existed, reported for duty to the new authorities in the hope that his adhesion to the coup would retroactively mitigate his past. Back at home, the Paneros threw potentially incriminating books down the family well and buried a Masonic medallion that belonged to Leopoldo's father. A regional daily published the front-page headline: "Long live Spain! The glorious Spanish Army rises up with arms against the bad sons of the Patria." The two Panero sons had to prove to the rebellion that they were good.

Leopoldo was even more vulnerable than his brother, his past less easy to recast. As an undergraduate in Madrid in the early '30s, he had mixed with Lorca and nearly all the other celebrated leftist poets of that time, and he had picked up Marxism along the way. In 1931, he signed an open letter with members

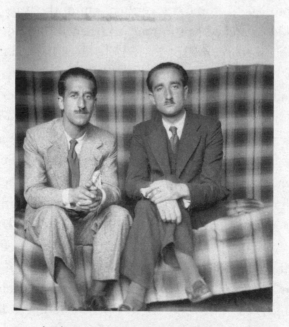

Juan (left) and Leopoldo Panero (right) in the 1930s

of the International Union of Revolutionary Proletariat Writers. That same year he brought the Peruvian poet César Vallejo, an unabashed communist, home to their gossipy provincial town for Christmas. Leopoldo had even published an ode in an Astorga periodical to two Spanish generals executed in 1931 whom democrats considered martyrs for their role in helping bring the Republic into being. On paper, Leopoldo looked much worse than Pepe ever had.

Yet even as his hometown became militarized, no one came for Leopoldo. This might have been due to bribes his father may have paid to the new uniformed lords of Astorga, who set up their headquarters inside the stained-glass prism of the town's Episcopal Palace with the bishop's blessing; or it might have been because there were more pressing matters. The local military barracks became a prison. Trains took cars full of singing soldiers from the town station to the front. And bodies were deposited on the roads outside of town, symbolic threats that forced motorists to stop to move them out of the way.

Leopoldo watched as summer lengthened into fall and what had been planned as a swift takeover of power, like a house passed on to new owners, escalated into an all-consuming civil war.

In Madrid, the capital, the Republican authorities squashed the revolt but struggled to reestablish order. Among a portion of its defenders, a vengeful streak as bloodthirsty as the Nationalists' took hold. Uncontrolled elements, many of whom were anarchist militiamen, executed those they thought supported the rebellion, often with no evidence and even less due process. Meanwhile, the embattled government reorganized and unsuccessfully sought to buy arms from other European democracies, such as France and Great Britain, which refused, preferring to maintain a "nonintervention" policy of self-serving, low-risk appeasement. Democratic France closed its borders to Spanish refugees fleeing the war to the north, as did authoritarian Portugal to the west. Very

soon, the Republic would be forced to turn to an ally with ulterior motives for providing military aid—Joseph Stalin.

Across enemy lines, the military structure of the revolt took a definitive shape. Francisco Franco outflanked other prominent Nationalist generals and soon consolidated his position as *El Generalísimo*, the supreme leader of what he envisioned as a crusade to take back Spain from Bolsheviks, Jews, and Freemasons. At the Battle of Badajoz, his Army of Africa broke through the medieval gates of the city and secured a crucial early victory through the close-quarters bayonet fighting at which his legionnaires and their mercenary counterparts, Moroccan *regulares*, excelled. The days that followed saw the slaughter of Loyalist defenders and innocents on a nightmarish scale. A journalist for the *Chicago Tribune* who reported on the "City of Horrors" found the scenes he encountered shockingly barbaric. In Badajoz's bullfighting ring, where mass executions had taken place, he gazed out at "more blood than you would think in 1,800 bodies." This campaign of terror and extermination would come to define Franco's approach to the war, even supplanting his original goal of expediently substituting one government for another. Instead, his military strategy would embody his millenarian belief in an apocalyptic, Christian revolution that would take its time to pitilessly grind down the enemy. The Generalísimo believed that a purging of the impure, corrupted soul of Spain called for a great blood sacrifice, and it was his duty to see this through.

In Astorga, such orgiastic extremes of savagery as those in Badajoz didn't occur, perhaps only because the zone belonged to Nationalist forces from the start. In lieu of a front or barracks to defend, they focused on excising the enemy within their territory through a witch hunt for "Reds," detaining many people based on *denuncias*, or reports made by informants. In other words, by neighbors, some of whom took advantage of the moment to fabricate stories for personal gain or out of petty vindictiveness.

It was in this manner that the war did in the end return, quite literally, to the Paneros' doorstep.

On October 19, armed civil guards appeared again at the family's home, only on this occasion they had come to arrest closer kin than a cousin. They demanded the surrender of the third of the six Panero children, the youngest son, Leopoldo. Someone had denounced him to the authorities. "It was because of wickedness," said his young niece Odila eighty years later.

Even with the undeniable sampling of leftist activities that the insurgency's growing juggernaut of repression could have leveled at Leopoldo in its kangaroo courts, it was of all things a brazen fiction that led to his detention on the day that he turned twenty-seven. He was accused of working for International Red Aid, a communist charity that he had allegedly raised funds for while studying abroad. It didn't matter that the only petitioning for monies he had engaged in while in Britain was for himself, when he wrote his parents pleading for supplements to his meager living allowance.

Later that night, after the soldiers took Leopoldo away from his house and family, they also detained his friend and the fiancé of his sister Asunción. Ángel Jiménez was a gentle, bespectacled law school graduate, whose only crime, as far as anyone could tell, was to have read the wrong newspaper, the reformist *El Sol*. The next day, the two were transported to the city of León, the nearby capital of the province, where they were admitted as prisoners into the Convent of San Marcos.

A former stop for pilgrims walking the Camino de Santiago in earlier centuries, San Marcos was an imposing, fortresslike island of gray stone designed to divide the world into two spaces: outside the convent and inside. Constructed in the sixteenth century, San Marcos was the embodiment of Spanish Renaissance architecture, which brought together Italian influences with local Gothic traditions to create the homegrown plateresque style,

with decorative flourishes reminiscent of the work of silver-
smiths (*plateros*). The convent had been used as a prison before,
playing host to at least one previous poet-inmate. During the
Inquisition, Francisco de Quevedo, one of the most famous writ-
ers in the history of Spanish letters, had been imprisoned there
in 1639 after criticizing a powerful nobleman. The dungeon-like
jail quickly broke his spirit. Quevedo did eventually make it out
of San Marcos alive, only to die two years later. From the rumors
circulating about what was happening inside the convent since
the outbreak of the war, Leopoldo and Ángel didn't know if they
would be so lucky.

Soon after arriving, the two young men had their heads shaved,
their stamp of admittance into the Dantesque netherworld the
convent had become. In the previous century, the church had lost
ownership of San Marcos to the government; until the coup the
military had been using it to house stallions. But once again the
building proved itself responsive to the needs of jailers, only now
on a massive, murderous scale.

Nearly every space in the convent became an instrument of
political violence for the "Glorious National Movement" that
the uprising had unleashed. The chapter house, the cloister, the
stables—these areas all became cells, overcrowded and shiveringly
cold, except for the punitive *carbonera*, or "coal bunker," a small
room where the deliberate pileup of prisoners was so extreme that
many died from the inhuman heat and lack of ventilation. Guards
frequently doled out beatings on the stairs, in the showers, and
in the sewing rooms; other tortures occurred in the church it-
self, often in worshipping areas such as the choir. The fall of 1936
marked only the beginning of its wartime use. San Marcos would
soon hold up to 7,000 men and 300 women, and by 1940 roughly
20,000 members of "anti-Spain" would pass inside its stone walls,
all forcibly converted into pilgrims of a different sort, on a journey
they hoped would not end there.

"You'll see, they're going to kill us," Ángel said to Leopoldo again and again in their communal cell as the days passed in an agony of waiting. The rank smell of bodies mixed with the residual tang of horse urine and the sharp scent of Zotal, a product the guards used to clean the cells when the prisoners were out in the patio during the daily ten minutes they were given to bathe themselves. Ángel wasn't wrong in thinking that they might be selected for a *paseo*, or "stroll," perhaps the most harrowing euphemism of the Spanish Civil War, used by both the Nationalists and the Loyalists to mean being taken out and shot. Prisoners who survived San Marcos would later recall the most terrifying moment of the day as when a guard appeared and read off a list of names. "Gather your things," the guard would say to those called. "You're going to be moved." They would be moved, yes, but only to the county council offices or nearby hillsides, for execution. That is, unless one had the dubious good fortune of being taken on a false *paseo*, part of the psychological terror regimen at San Marcos. Guards would lead a group of inmates outside to the yard and line them up for a waiting firing squad. The soldiers would raise their rifles, take aim—then shoot blanks. After this sadistic prank, the guards would then return the prisoners to their cells, though there was one older man who died right there in the patio from the scare of his own near-death, collapsing never to get back up again as the other men were "resuscitated."

While the squalid conditions in San Marcos were like nothing Leopoldo had ever experienced, he also encountered kindness and companionship. There were people he knew: a guard who snuck them sandwiches; a military doctor who tried to intervene on their behalf; and the principal of the school in Astorga, along with its Republican priest, who shared the same cell as him and Ángel. Leopoldo's sisters Asunción and María Luisa managed to visit him and Ángel after waiting

beneath the convent's elaborate facade decorated with Greek gods, biblical figures, and Spanish monarchs. The two young women were shocked by the shorn insomniac husks who had replaced their loved ones in less than two weeks. During the brief visit, Leopoldo tried to hold on to his role as the worldly older brother and persuade them that the two men were fine. His sisters weren't convinced.

Near the end of October, the principal of Astorga's high school and its priest were taken on a *paseo* to a nearby village, where they were shot and buried in a mass grave, or *fosa común*. Then, a few nights later, the guards came for Ángel and transferred him to another cell. Early the next morning, Leopoldo caught sight of his would-have-been brother-in-law being escorted down the hallway. The two made eye contact for a fleeting instant, for the last time. Ángel's face was undone by fear. Just three years ago, he had gone through a crisis when he had failed his first attempt at the civil servant exams, and Leopoldo had helped him through the setback. Now those innocent days seemed a lifetime ago, that crisis a luxury. Soldiers drove Ángel out of San Marcos and shot him in a forested area on the road from León to Astorga.

Leopoldo was sure that he would be next. Yes, he came from a respectable family with deep roots in Astorga—an "institution" in the town, as one friend put it—but what did that matter? His father was a Mason—one of Franco's public enemies because of their historically antagonistic relationship with the Catholic Church—who had already been subjected to an interrogation and might end up in San Marcos himself. Plus, hadn't Ángel come from a respectable family, too, his father a doctor? And sure, Leopoldo had begun to make a name for himself in the Spanish poetry scene—an evening paper in Madrid had included a mention of him on the front page the year before—but he knew for a fact that this didn't matter. The uprising had dared to kill *Federico García Lorca*. In September, rumors had started

swirling about Lorca having been assassinated, followed by an international outcry. H. G. Wells, president of the PEN Club of London, sent a telegram to Granada asking for information about his whereabouts only to receive a curt, evasive reply. And Lorca himself never appeared, as Franco surely would have demanded had the poet been alive in Nationalist territory, considering the bad press the matter was garnering. As hard as it was to believe, Lorca was clearly dead. So if one of Spain's most celebrated writers hadn't been able to save himself, then what chance did he, Leopoldo Panero, have?

The first week of November passed. The guards' keys clanked in the locks, echoing of death. Leopoldo wasn't dead, yet he was only provisionally among the living. The same might have been said about the Republic, or at least that was the feeling in besieged Madrid. Fearful that the capital might fall any day, the government frantically uprooted to the city of Valencia, on the temperate Mediterranean coast, where they were better protected from warplanes of the German Condor Legion, and farther from the encircling Nationalist troops. Meanwhile, back in León, the damp chill of the Bernesga River, which ran adjacent to the convent, invaded the prison. Waiting in his cold cell, one day Leopoldo saw a soldier he knew from life on the outside, from the time before people he knew started getting murdered. The young man was the ex-boyfriend of his older sister Odila. Having heard that the Nationalist soldiers pocketed articles of value from the bodies of those they took on *paseos*, Leopoldo asked him to deliver the two possessions he still had with him to his mother—his watch and a ring.

Leopoldo was preparing to leave this life, and as he did so, it stirred something that had already begun to awaken inside of him before the war, something profound and mysterious. He had never been particularly religious, just an average Catholic boy from small-town Spain, whose political beliefs had later eclipsed

his religious ones. But in the past few years, his search for a po-
etic voice had led him back into spiritual questions, and now his
experience in San Marcos—this once sacred place turned into
a Spanish hell—was fortifying his faith. As he later wrote in a
poem:

In the prison of lived disillusions
I slept on a hard bed, between wool
and the vegetable heat of the flocks;
it was like lying on human soil
and a holy experience, I swear to you,
to pulse like a fountain when it flows.

What would his death mean, and what had his life meant?
He would never see his beloved natal city of Astorga again, nor
the hearth of his home, nor the family he loved. What would
happen to him and his soul? Would it pulse out of him like the
water of a fountain, joining the eternal flow? Would the God
who had released such ungodly forces in Spain redeem him? He
felt, he wrote, like the "inhabitant of a premature skeleton."

Wrapped in a colorful wool blanket his family had sent him,
Leopoldo Panero stood at the window of his cell staring outside
at the beautiful sunsets, waiting to die.

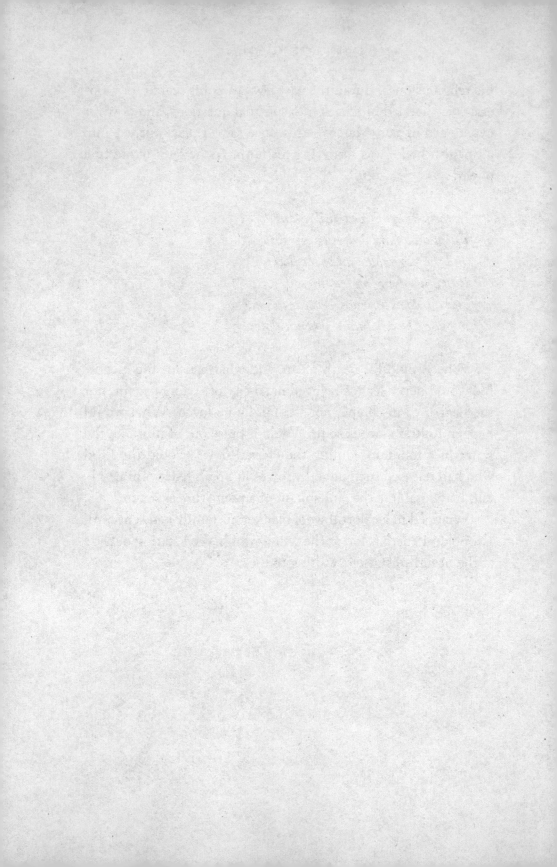

THE *SEÑORITO* FROM ASTORGA

Youth, 1909–1936

Leopoldo Panero was born in the fall of 1909, a quiet year in which his parents never could have imagined that their family's story would come to seem, as their crying newborn son would write in a poem many years later, like "miraculous ruins."

Many families have a mythic place of origin, the beginning of the story that beckons future generations to return. The Paneros' was a small city standing above an austere, dun-colored plain dotted with green meadows in the spring and red poppies in the summer.

Astorga in the first decades of the twentieth century was a quaint provincial town with a population of almost six thousand and a history that went back nearly two millennia. As a convenient connecting point between other settlements in a verdant range of mountains, it was created as a camp for soldiers of Augustus, the first emperor of the Roman Empire. Over the centuries, Asturica Augusta, as the city was originally called, experienced the upheavals that shaped the Iberian Peninsula:

invasions by the barbarians and Visigoths, the Islamic conquest and Christian *Reconquista*, and finally the Napoleonic Wars, which saw the city besieged by French troops who were routed in 1812. By the time Leopoldo came into the world, this long, storied history had produced a strong local identity—the people of the region called their massif La Maragatería—and a picturesque fortress wall surrounding Astorga that had been destroyed and rebuilt several times. Inside its ramparts, a peaceful town life flourished: a local chocolate industry; a bustling Tuesday market in the town plaza; and annual festivals such as the frankincense-scented, Virgin-bearing processions of Holy Week. Beyond this circumscribed universe loomed the snow-quilted El Teleno mountain to the west, like the heaped form of a sleeping god. It was as if history had already occurred in Astorga and now all would be tranquil.

The Panero family was part of a newly prosperous bourgeoisie that had emerged in Astorga in the nineteenth century. Leopoldo's grandfather had opened a confectionary shop that became the unofficial meeting place for the town, and later he cofounded the city's first flour factory. His wife bore him sixteen children, the third of whom was a boy named Moisés, who grew up to be a wiry, well-dressed bank manager known for his cheerful nature. He married Máxima Torbado, a woman with an oval face and a tiny mouth whose full figure contrasted with that of her slender husband. She was the serious, strong-willed only child of a town legend, a man whose heroic exploits as a gambler took him all the way to Switzerland, where his daughter was born.

As though reconciling the size of Moisés's enormous family on the one hand and Máxima's tiny one on the other, the couple had six children, two boys and four girls, in the following order: Odila, Juan, Leopoldo, Asunción, María Luisa, and little Rosario (Charo). After several years in a smaller house, they

moved into one of the nicest homes in Astorga, a mansion sitting against the city's ancient wall. It had an enclosed courtyard with an arched entrance that turned the house into an intimate, protected enclave. Moisés was rumored to have inherited the home from a wealthy uncle who had made his fortune in the Americas. Just down the street from it rose the chiseled reaches of Astorga's Gothic cathedral and the fairy-tale towers of the Episcopal Palace, designed by the Catalan architect Antoni Gaudí.

The Panero home was its own domestic palace. The first floor had six rooms, including servants' quarters and a barnlike space adjacent to the kitchen for chickens and milk cows. Two separate stairwells connected to the second floor, which had twelve rooms, a nesting of parlors and bedrooms in which it was easy for a first-time visitor to get lost. The main stairwell had a stained-glass window with Moisés's initials, while the rest of the house bore the mark of his antiquarian tastes: vitrines and ornamental vases, grandfather clocks and busts of Spanish nobles, religious paintings and formal oil portraits of forebears, finely crafted *bargueño* desks, and an imposing Roman-era headstone embedded in the wall at the end of the entry hallway. Outside, the large courtyard was a riot of plants and flowers that Máxima adored. Ivy climbed up the facade to the glassed-in balcony, and a fountain stood at its center with a gazebo nearby. There was a town rhyme that captured the privileged position of the family and the envy they inspired: *¿Quién es Dios? Panero y otros dos.* Who is God? Panero and two others.

From a very early age, one of the most important people in Leopoldo's life was his brother Juan, who was one year older. A childhood friend of both recalled how they were "united by a link stronger and more voluntary than the identity of blood, as if their having the same parents was owed to a choice they themselves had made." This wasn't to say that they were two versions of the same person. They were very different. Juan had

María Luisa, Máxima, Juan, Asunción, Odila, Leopoldo, and Moisés in the garden of the home they lived in before moving close to the cathedral

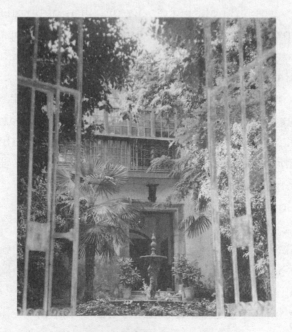

The courtyard of the Panero mansion

inherited the carefree cheer of his father and was a natural at sports and trouble. Leopoldo, in contrast, was his mother's son. He was quiet and guarded, taking in the world around him with a pensive, soulful gaze. As children, the brothers even looked like the parent whose character they had inherited. Juan had a low forehead, inquisitive eyebrows, and a narrow physiognomy. Leopoldo was round-faced, slightly jug-eared, and had a wider, more prominent nose. The boys shared a mutual respect, even if Juan tended to be the leader as they played with their sisters and friends. Many years later, after the war, the same childhood friend of the two brothers would describe this time and place as a "paradise lost."

These halcyon years for the close-knit Panero clan continued as the children grew, though a shift came in 1919, when the local school in Astorga reorganized itself to teach only elementary-age students. There was no choice but for Leopoldo and Juan, ten and eleven respectively, to go off to boarding school in San Sebastián, an elegant, rainy Basque city couched inside mosslike mountains on the Atlantic's Bay of Biscay. Leopoldo and Juan's seasonal returns to Astorga—for Holy Week, Christmas, and summer vacation—reunited them with their friends, and together the gang discovered the Nicaraguan poet Rubén Darío. "Divine treasure of youth / You leave to never again return," Darío wrote, "When I want to cry I do not cry / And often I cry without wanting." For this peculiar group of divine treasure hunters, such ecstatic, tortured expressions of sentiment fired their imaginations. Over generations, their families had risen beyond the peasant way of life that dominated La Maragatería and the rest of Spain in order to give their children learning. Just being able to read was a privilege, but these poetry-drunk adolescents embraced the revelation of literature with a single-mindedness that most other boys their

age reserved only for soccer—that is, save for Juan, who was of two minds, since he was too talented at soccer not to love it as well.

Leopoldo often spent time with his mother's parents in Villa Odila, their Tolstoyan country manor outside of Astorga, in the village of Castrillo de las Piedras. La Casa del Monte, or the House in the Hills, as they called it, was complete with a nearby river, a chapel, vineyards, a dovecote, three wells, chicken coops, and caretakers. Castrillo was a sanctuary for teenage Leopoldo. When he wasn't out hunting with his vigorous grandfather Quirino, the gambler whose beard was as Tolstoyan as his estate, Leopoldo used the rural solitude to read book after book. When he began writing his own verses and prose, his parents built an office-like *torreón*, or "tower," for him atop the Astorga house. Yet life wasn't just poetry for Leopoldo and his group. As their hero Darío himself put it, "Without woman, life is mere words."

Puberty hit. It transformed the boys' bodies, and sure enough, words weren't enough. They wanted to experience firsthand the mysteries of the opposite sex, which had inspired so many famous verses. Juan was the first in the group to have muscles and grow a mustache. The trailblazer in amorous pursuits, he smoked cigarettes and danced the newly imported Charleston. His close friend Luis Alonso Luengo saw Juan's buoyant personality embodied in his characteristic gait: "That walk of his, on tiptoes, pushing his body upward, in a soft sway, as if preparing to fly—his feet on the ground and his head in the sky." A stiff dancer, Leopoldo nevertheless resembled his brother more now than he had in the past, at least physically. By their late teens they had both grown into narrow frames, with slender faces, like their father. Both were sharp dressers and sported finely trimmed mustaches. But they looked only vaguely similar, their features like subtle, knowing allusions to the other's, and Leopoldo had slyer, more understated strengths than Juan. He had

inherited his grandfather's penchant for gambling, transmuting his quiet nature into an unreadable poker face. Love, however, would prove to be a more challenging game. For Leopoldo, the dual magnets of women and poetry would come to embody the complex and often problematic relationship between writing about life and life as actually lived.

In 1927, the two brothers both ended up in college in Madrid. (Juan studied business, Leopoldo law.) They lived in an apartment in the center of the city. Their street ran from Puerta del Sol—Madrid's teeming central plaza aswirl with rattling trams, honking motorcars, rushing pedestrians, and hollering street vendors—north to La Gran Vía, the newly booming Parisian-style boulevard that boasted the city's first skyscraper, the fifteen-story Telefónica Building. The Spanish capital was expanding at a dynamic pace, and by the time Leopoldo moved there, the population of Madrid had soared to nearly one million, creating a bright, noisy metropolis such as the country had never seen. There were movie theaters and casinos, beer halls and dance halls, an underground metro and fashionable shops. Yet Madrid still preserved traditions that spoke of Spain's essentially provincial, small-town heart. There were the professional knife-sharpeners who went from building to building playing a flute down in the street to announce their presence to housewives hanging the wash up on lines outside their windows. Cars weren't allowed to go faster than the horse-drawn carriages they rode beside on the road. In the city's bullfighting arena bedizened toreros battled their horned foes in a dance of ritual sacrifice, while a new, bigger arena was under construction. Madrid was a city of both ancient vitality and heady transformation, with opportunities for anyone hungry enough to grab them.

Leopoldo was hungry. At twenty, he had arrived in Madrid confident that he was a poet and driven to truly become one. Like most aspiring literati his age, he was busy inhaling the avant-garde

work of the Generation of '27, who were revolutionizing Spanish poetry and producing figures such as Lorca, Vicente Aleixandre, and Jorge Guillén, whose *Cántico* Leopoldo read over and over again. Later, when Leopoldo met Guillén in person, he allegedly recited the book to him in person, from memory, all fifty poems, much to the older poet's amazement. Leopoldo and his literary clique in Madrid debated poetry and other matters at salons held by the brilliant young philosopher María Zambrano, where he was, as a friend recalled, "always happy, cordial, full of teasing humor, but uncorrupted by frivolousness."

Leopoldo's lack of frivolity found a new form in late 1929, when he cofounded a literary magazine with friends called *Nueva Revista* (New Magazine). The enterprise brought together new literary voices with already established ones, such as Rafael Alberti and José Bergamín, both of whom would become legendary figures during the Civil War. In the inaugural issue of the magazine, Leopoldo's first published poem appeared, "Ballad of the Swimmer and the Sun." The poem evoked a swimmer who doesn't know "the Purpose that your arms / *want* in their spirals . . . What your arms search for / the birds told me about." Decades later, well after the Nationalist victory had restructured Spanish life and many of Leopoldo's leftist friends from this period condemned him as a turncoat, his politically charged poetry, so different from these early verses, would resemble those same spiraling swimmer's arms: a force whose meaning he seemed not to fully understand. At this time, however, Leopoldo dreamed only of a literature that could penetrate "the ineffable and mysterious mist," in order to unveil things "sheltered behind the hermetic reality of the cosmos."

The internal cosmos of Leopoldo's own body, however, abruptly forced him into a hermetic reality away from Madrid. In early 1930, he came down with tuberculosis.

Tuberculosis was a life-and-death matter in a world that

didn't yet have antibiotics, and two years earlier Leopoldo had lost a friend to the disease. In the hope of averting their own family tragedy, Moisés and Máxima packed their youngest son off to a sanatorium in the Sierra de Guadarrama, a mountain range whose sun-soaked, snaggletooth peaks and steeply cupped valleys meander through the northwest province of Madrid. Its dry, fresh air offered a curative sojourn for tubercular Spaniards who could afford it, reflecting a practice common throughout much of Europe at the time. Snugged into its panoramic, alpine environs, the wide, four-story main building of the Royal Sanatorium built by King Alfonso XIII looked like exactly what it was: the blending of a hotel and a hospital.

In Leopoldo's stay in Guadarrama there was something of Thomas Mann's *The Magic Mountain*, a novel published five years earlier that told the story of Europe's spiritual and societal decay in the years before World War I. Centered on the experiences of a young German named Hans, the story follows him as he gets sucked into the peculiar world of a similar sanatorium for sufferers of the so-called white plague, in the Swiss Alps. Leopoldo luxuriated in the languid days he spent on the patio's chaise lounges overlooking pine-belted slopes. He wrote poems about the shudders of awe that nature aroused in him and got to know the other inhabitants of this fragilely suspended, antiseptic existence. And just like Hans, Leopoldo fell in love.

Joaquina Márquez was a woman "made of wind and of grace," as Leopoldo described her. The daughter of the chief physician at the sanatorium, she had led a lonely life in a convent from an early age, and the dapper, urbane Leopoldo was a revelation for her. Joaquina was sensitive and passionate, with an intensity of personality heightened by her isolation and delicate health. She embodied the poetic aura which had attached itself to tuberculosis during the nineteenth century. The "romantic disease" had

become a fad in upper echelons of European society, spurring women to apply makeup to give their skin the translucent, sickly look of a "poor melancholy angel." Joaquina was just that angel. Her life was a poem of sorts, which Leopoldo captured in verse.

In one poem Leopoldo imagined Joaquina as a fragile bird without wings, which delighted her. The two gushed overwrought sentiment in a feverish correspondence. "Until I met you," she wrote, "my life had been rather ordinary, no one who knows me would have thought that I could end up having love after all my disappointments, beaten down by my disease. I had decided to live alone with my dreams enclosed in my disenchantment, never believing that real love could exist for me." In another letter she told Leopoldo, "I can't believe, and forgive me if I offend you, that I have inspired the passion that has so

Joaquina Márquez

deliciously presented itself. Might it not be a purely poetic hallucination?"

But by December 1930, Leopoldo and Joaquina's time together in Guadarrama had run out. After eight months, he was healthy again. He had survived the white plague. The price of his recovery was his relationship with Joaquina, which didn't survive his return to Madrid. In the spring, Leopoldo's letters tapered off. Wounded yet defiant, Joaquina called back to the dawning of their relationship with a jab she surely hoped would wound him at the heart of his being, where the poet met the man.

"I remove myself from your life completely," she wrote to Leopoldo before leaving for a sanatorium in Switzerland, where she died in 1931, "but not before thanking you for the beautiful pieces of literature you wrote for me in moments of insincere *poetic hallucination.*"

AS SO OFTEN HAPPENED LATER TO LEOPOLDO, CHANGES IN HIS PRIVATE LIFE coincided with bigger changes in Spain's public life, merging into the same irresistible current.

Just as his relationship with Joaquina was dissolving, so was the dictatorship of Miguel Primo de Rivera, the patriotic general who had ruled Spain since overthrowing its parliamentary government in 1923. Much like Mussolini, he had taken power with the backing of the country's king, a circumstance that would have far-reaching consequences. In the intervening years, Primo de Rivera proved himself to be relatively soft as far as strongmen of his ilk went. He was less interested in annihilating his opponents and bending the citizenry to his will than modernizing Spain with the support of the church and Crown, though he was happy to send his critics into exile if needed. He built new roads, strengthened industry, and led a nationalistic war in colonial Morocco that played well back home. (It was this war

that turned Francisco Franco into a national hero.) By crushing the existing political parties, however, he bred enemies on the left and right who attacked the hollowed-out center of politics that the dictator occupied, causing national divisions to deepen. After the Great Depression in the United States rippled across the Atlantic Ocean and sank the economy in Spain, the Spanish people forced Primo de Rivera out of power in early 1930.

A chaotic transition ensued. Leopoldo lived it firsthand, writing home to his parents about the eerily empty streets ringing with gunshots. This tumultuous period eventually produced national elections in April 1931. Republican candidates opposed to the monarchy won the majority of votes, proclaimed a republic, and rerouted the flow of Spanish history. King Alfonso left the country as cheering crowds took to the streets, pooling into plazas to celebrate with red-yellow-and-purple Republican flags. Working-class revelers tore down monarchical statues while other, more reflective celebrants marveled that such a transfer of power had occurred without bloodshed.

Meanwhile, high society trembled. Communists were leaping from the streets into the congress! Would the Spanish aristocracy become the new White Russians, displaced by a native Bolshevik revolution? What would all of this mean?

For Leopoldo and Juan, both die-hard Republicans, it meant a hopeful new future for their country. Now all that remained was for the new government to ink a constitution, and eight months later, the Second Spanish Republic was born.

The following years were a tremendously active time for Leopoldo. As he finished up his law degree, he decided he wanted to become a diplomat, though this in no way diminished his dedication to poetry. In Spain, the people who created art didn't see themselves as separate from politics. The country's poets and writers openly espoused their political views, reacting as public intellectuals to the successes and failures of the turbulent, rap-

idly evolving Republic. The towering philosopher José Ortega y Gasset, for instance, was at first a supporter of the new government as a member of the parliament, only later to fall out with it. This reflected the fluid and often bitterly shifting alliances that characterized politics, as both leaders and everyday citizens saw the challenges of putting lofty principles into practice in a newly minted democratic system. As was perhaps expected, the first Republican government made glaring mistakes. For example, officials were inexcusably soft on violence against the church and its representatives. This alienated huge swaths of the Catholic populace, who were as essential to the consolidation of Spain's future as the landless peasants. Much later, most people would agree that the Republic struggled because it failed to satisfy either the right or the left, and because politicians on both sides questioned the legitimacy of democracy itself.

LEOPOLDO EXPERIENCED A POLITICAL TRANSFORMATION NEAR THE END OF 1931 WHEN the thirty-nine-year-old Peruvian poet César Vallejo arrived in Madrid. Leopoldo and Juan met the impoverished visionary and invited him to spend Christmas with their family in snowy Astorga. As a teenage boy who was present for the visit wrote, Vallejo's Peruvian accent "brought us exotic aromas, ideas that trembled inside of us, like windowpanes shaken by the breeze." With combed black hair and a promontory-like brow, the devoutly Catholic Vallejo was also a devout communist. It appeared to be his love for the meek inheritors of the earth that tugged Leopoldo left of Juan's Republicanism, toward Marxism. As the teenager who had felt himself shake like a windowpane put it, "All the young people were drunk with hope and poetry." Vallejo channeled both of these forces, and not long after, Leopoldo could be seen walking the streets of Madrid sporting a silver pin with the hammer and sickle

in his buttonhole. With his three-piece suits and downtown apartment, Leopoldo was a product of the zeitgeist and the personification of a cultural phenomenon: the commie *señorito*, a term which meant either "young gentleman" or "rich kid," depending on the tone accompanying it.

Leopoldo spent the next year and a half between France and Great Britain studying French and English, then the Panero brothers reunited in Madrid in 1934. Juan was now twenty-six, Leopoldo twenty-five. They moved into a boardinghouse where they became best friends with a young poet from Granada named Luis Rosales—the very same young poet whose family would try and fail to shelter Federico García Lorca from the uprising in Granada two years later at the outbreak of the war. But all that was still to come, a tragedy too colossal to foresee. Even as communists and fascists brawled in the streets, these were innocent days in the lives of Leopoldo, Juan, and Luis. They were simply three eager young men fortunate enough to have come together in a time of literary brotherhood, living in a city full of the best Spanish-language poets in the world.

Tall and confident, with an avid smile and round glasses, Rosales was a handsome owl oozing conversation. He could turn a short walk into an hours-long odyssey of talk, shot through with poetic theories and arguments for the sake of argument. Sometimes he even broke into song. Rosales's conservative background didn't impede his friendship with the two Paneros; in fact, it seemed to provide a constructive friction to the endless hours they spent together. He argued with Leopoldo—"Leopordo" in his Andalusian accent—in discussions that were as much intellectual debates for their own edification as theatrical performances for others. His influence on Juan, who had lost direction, was stronger. Rosales believed in Juan's talents as a writer and helped him to rediscover himself. "This is the year of my salvation," he wrote to

Rosales during a vacation the friends spent apart. "This is the year in which I've felt more deeply anguished, and thus the one which I've been able to perceive that serene tremble of spring which ignites that firm, radical conviction, to be in, and be a part of life . . . it was you, your friendship." Juan finished on a note of collective optimism: "Behind pain there is a soul, that is what is in us: a soul, by way of pain. And with all of our pain we must do that which those who came before us haven't: lift up Spain, and lift up Spain by lifting up ourselves."

The timing of Juan's return to poetry was fortuitous, as a man who would become one of the century's most famous practitioners of the word had just arrived in Madrid.

Pablo Neruda.

THE NEW CHILEAN CONSUL TO MADRID, NERUDA ARRIVED IN THE SPANISH CAPITAL IN June 1934 intent on securing his reputation as a poet to be reckoned with. Like his good friend Lorca, Neruda was an ecstatic collision of traits: childlike and serious, vain and generous, petty and spiritual, romantic and adulterous. At a gathering that year, Lorca described his Chilean friend as "closer to death than to philosophy, closer to pain than to intelligence." Yet this didn't capture the magnetic vitality with which Neruda conquered Madrid. He and his wife—whose marriage, incidentally, was in the process of disintegrating—moved into a fifth-floor apartment with a view of the Sierra de Guadarrama. They filled it with flowers and it became an open-door social hub for the literati of Madrid. Neruda hosted get-togethers that spilled in from bars, then back out into the streets, then back into the apartment again, where people slept on the floor. Since Lorca often stopped to visit with Rosales and the Panero boys at their hangout, the Café Lyon, the three young men fell naturally into the poetic

road show that accompanied Neruda. The Panero brothers quickly came to idolize the Chilean, to the extent that twenty years later, under very different circumstances and in a world far removed from the 1930s, Leopoldo would write an angry poem addressed to Neruda, a poem which would alter his career and legacy, in which he lamented, "I loved you."

Leopoldo had the opportunity to come to Neruda's aid at the start of 1935, after another Chilean poet claimed that he had plagiarized verses in his book *Twenty Love Poems and a Song of Despair*. A born self-promoter with friends who were happy to defend him, Neruda arranged a celebration in his own honor and a corresponding publication. *Homage to Pablo*

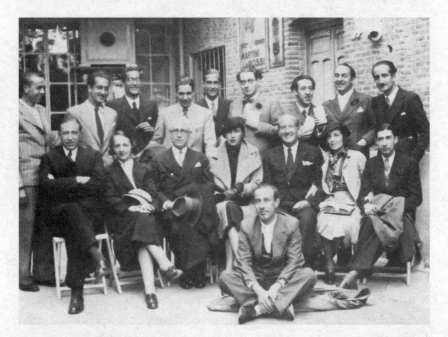

A 1935 gathering held in honor of Vicente Aleixandre (third from the right, seated): Miguel Hernández (far left) stands next to Juan Panero, who stands next to Luis Rosales. Pablo Neruda (second to far right) stands next to Leopoldo Panero. María Zambrano (second to far left) is seated, along with José Bergamín (far right), and Gerardo Diego (ground). The Civil War would divide, scatter, and kill this pantheon of Spanish writers.

Neruda and Three Material Songs combined recent poems with a florid letter of support from sixteen Spanish poets. Among the signers of the letter were Luis Rosales, and Juan and Leopoldo Panero.

With his reputation burnished and now the owner of his own star in the literary firmament, Neruda was offered the editorship of a new literary journal, which he named *Caballo Verde Para la Poesía* (Green Horse for Poetry). After poems by Vicente Aleixandre, who would go on to win the Nobel Prize in Literature, and Lorca, who excerpted verses from his then-unpublished book *Poet in New York*, appeared a poem by Leopoldo Panero. It contained the prophetic line, "To lose you would be like crushing a nightingale in my hands." Leopoldo and Neruda would later do just that—crush the nightingale of the past they had shared in Madrid before the war.

Through hard work, passion, and an eagerness to be a part of the moment, Leopoldo was finally poised to join the most select circle of Spanish-language poets. His poetry was solidifying into an aesthetic that discarded the linguistic gamesmanship of the Generation of '27 in favor of a more naturalistic, earnest engagement with daily life, under which stirred spiritual searching. The only problem was that Leopoldo still didn't have a book completed. Luis Rosales and Juan, on the other hand, both did. Later in the year, Luis published *Abril* (April), and after Leopoldo decided to resume his studies at Cambridge, Juan came out with *Cantos del Ofrecimiento* (Songs of Offering). The poems revolved around Juan's lasting obsessions, women and love, which happened to be the same two things that sent Leopoldo into a lacerating spiral of anguish during his twenty-sixth year, in 1936. He had fallen hard for a young woman named Laura de Los Ríos, the daughter of a Republican cabinet member. She failed to reciprocate his feelings, plunging him into a crisis of despair. Why wasn't love as malleable as words *about* love?

When Leopoldo returned home from Cambridge during the hot summer of 1936, however, an even more profound crisis awaited him and the rest of Spain, one that would test his faith, his ideals, his poetry, and much else. He had worked hard to create a future for himself. The Civil War would unravel it, launching him into a radically different, unimagined life.

TO WIN AND TO CONVINCE

Máxima and the Missus, November 1936

While Leopoldo waited in his cold cell in the San Marcos Convent amid his flock of fellow prisoners, the war outside intensified.

The first real engagement between Loyalist (the Popular army) and Nationalist troops had taken place in the Sierra de Guadarrama, filling the valleys Leopoldo had looked out on in 1930 from the Royal Sanatorium with clouds of smoke and the echoing booms of mortars. The Republican infantry and cavalry held off the rebels up in the mountains, but the forces of the insurrection regrouped to converge on Madrid, setting up a showdown which had the potential to decide the war. The city was the symbolic and industrial stronghold of Spain, and if it fell, so might the Republic.

The fighting began in early November. Foreign legionnaires and Moroccan mercenaries attacked Madrid through the Casa de Campo, the hilly hunting grounds that had belonged to the royal family. They were aided by Italian soldiers and German tanks that met the fierce if disorganized resistance of the

International Brigades, a mix of German, French, and Polish volunteers for "The Last Great Cause," as some would later call the Spanish Civil War. The barely trained Brigades made their way down the Gran Vía amid cheers from citizens who had thought the defense of the city a lost cause after the government had uprooted to Valencia. They inflicted severe causalities on the rebel forces during three attempted crossings of the Manzanares River, but the Nationalists broke through on the fourth. Both sides dug in for a bloody battle in University City, turning the buildings where Leopoldo had attended classes as an undergraduate into blown-out husks full of cold, hungry soldiers. Soon after, as the Battle of Madrid lengthened into an epic siege that would last the entirety of the war, one of the most notorious massacres of the conflict occurred. In a mass *saca*, the extrajudicial removal of captured inmates, Loyalists executed over one thousand prisoners in the small town of Paracuellos de Jarama. The moral high ground of the Republic trembled, threatening to collapse completely. Both sides of the war had thrown off the yoke of restraint, surrendering to a thirst for blood.

With death rising like a flood all throughout Spain, and Ángel already dead, Leopoldo's family knew just as well as he did that he likely had little time left before it was his turn to be taken on a *paseo* from San Marcos. But the people they might have called on for help in other times were themselves in precarious situations. The Paneros' decades of good fortune had abandoned them, and their worst fear became real in November when a friendly doctor at the prison informed the family that Leopoldo's name was on the kill list. Leopoldo's mother sprang into action.

If anyone in the family was capable of resisting this national conflict suddenly made horribly personal, it was Máxima. Her husband Moisés was the winsome one, the charming exterior of the house of their marriage. She was the discipline and rigor,

the stones that kept the structure in place, like those holding the roof of their home over their children's heads. A dignified matriarch with a dark nest of hair, a ball of keys jangling in her authoritative apron, and a gaze that kept things hidden the way her imprisoned son's gaze did, she wasn't a character like her bicep-flexing father. But she *had* character.

After Leopoldo was arrested and hauled away to San Marcos, Máxima had combed the city of León for anyone who might be able to intervene on his behalf, to no avail. When she went to the prison to visit her son and bring him food, the guards at the front gate wouldn't let her pass. She bided her time on the outside, her freedom like a mother's prison while Leopoldo was locked away inside, but now the hands on the clock of fate were spinning rapidly. There was one gambit left for Leopoldo's salvation. She had held off on playing this card, but she was a gambler's daughter, after all, and now was the moment, though Máxima herself didn't know if she was bluffing or not.

Francisco Franco's wife, Carmen Polo, was her distant cousin.

Panero family lore has it that before setting out on her pilgrimage two hundred kilometers south to Salamanca, the olden city that had become Franco's seat of power, Máxima first stocked up on *mantecadas*—Astorga's specialty, a sweet, crumbly cake known throughout Spain. One of her as yet unborn grandsons would later compare the *mantecadas* Máxima carried with her on the train to Salamanca to the madeleine from Proust's *Remembrance of Things Past*, a cake whose taste opened up a door to memories that came swelling into the mind. It would come to seem as if as much nostalgia and literature were baked into Máxima's *mantecadas* as sugar and flour. The mythical halo the cakes acquired reflected the weight of this moment in the family's history: an act of courage which, with a cascading impact, allowed many, many other acts to follow, precipitating the family into further mythmaking. Máxima was going to beg for the life

of her son, and in Spain, where regional delicacies are their own geography, she would use every resource at her disposal.

The tricky aspect of her mission was that Máxima's relationship with Carmen Polo was tenuous to the point that she thought an intermediary might be beneficial. Her cousin came from an extended branch of the family north in Oviedo that boasted greater wealth and higher standing than the merely provincially well-off Torbados and Paneros. Indeed, Carmen's father had initially disapproved of her courtship two decades earlier with the untitled military officer she had fallen for. But after Franco became a national hero she had married him with the approval of King Alfonso himself. Now that her husband had opportunistically maneuvered himself into the role of the leader of the rebellion (even up until the week before the coup, Franco wasn't sure if he would participate), Carmen Polo was no longer just his wife. She had become *La Señora*—The Missus—a figure to be treated with reverence.

Máxima had only known her cousin in superficial settings when they were girls, so she sought to engineer a reintroduction. She appealed to one of the most respected minds in Spain, the writer and philosopher Miguel de Unamuno. Leopoldo had served as his interpreter in Cambridge the previous year when the bespectacled, white-bearded don had received an honorary doctorate. When Unamuno welcomed Máxima into his home, however, he explained that he couldn't help. He had fallen into disgrace with the new military authorities and was under house arrest.

In one of the bravest public gestures of defiance during the Civil War, a month earlier Unamuno had spoken out against the rebellion at an event celebrating just that—the rebellion. In the assembly hall of the University of Salamanca, the old professor and rector interrupted a performance of fascist pageantry taking place onstage after General Millán Astray, who wore an

eyepatch that made him look like a movie caricature of a villain, led a call of "Long live death!" Overwhelmed by the moral obligation to denounce Spain's descent into "uncivil war," Unamuno stood up and addressed the crowd with a sonorous phrase that soon became legendary: "*Venceréis, pero no convenceréis.*" You will win, but you will not convince.

Deprived of Unamuno's assistance, Máxima went on her own to the Episcopal Palace, which the Bishop of Salamanca had happily ceded to the rebels as the city became the "Capital of the Crusade." The old cathedral was now the military headquarters of the Nationalist army and General Franco's new residence. From his office there he was in the process of expertly bringing the different factions of the heterogeneous power structure of the coup under his control. (He would complete this consolidation in April 1937 with the Decree of Unification.) This group was made up of clergy and aristocrats, "old shirt" and "new shirt" Falangists, monarchists and Carlists (supporters of a competing branch of the royal family), and the military officer corps. Each had their own agenda. The monarchists wanted the return of the king above all else, for example, while the fascists wanted a Spanish form of National Socialism, and the landowners simply wanted to go back to a time before land reform and workers' rights. As yet to be fused into a single entity, the different armed factions still dressed in distinct uniforms, creating a carnival that Máxima would have noticed as she navigated the busy streets of Salamanca amid food lines and military vehicles: the blue red-tasseled caps of the Falangists; the red berets of the Carlist *Requeté* militiamen; the Moorish cloaks of the Moroccan mercenaries; the black shirts of Italian *squadristi*; and even the Nazi regalia of visiting German pilots and advisers. Yet their diverse interests had converged in one shared goal—to eliminate the Republican government, which they saw as a puppet of the Soviet Union.

Meanwhile, Carmen Polo, with her shellacked-looking

coiffure and love of pearls, played her role as the impeccable
first lady of the crusade. Not just Máxima Torbado but hun-
dreds of desperate Spanish mothers showed up on the steps of
the Episcopal Palace hoping to win pardons for condemned
sons. Most didn't get past the door. Not so for Máxima. After
her request was delivered to *La Señora*, she was permitted to
enter Franco's citadel.

Carmen Polo cordially received Máxima into the humming
nervous system of Nationalist operations. In turn Máxima gave
her the *mantecadas* she had brought from Astorga and explained
the mother's nightmare she was living. Máxima showed her
cousin the letters Leopoldo had sent from Cambridge asking
his parents for money, along with receipts of money transfers. If
he was the agent of an international communist organization,
then why would he be writing home like a penniless student?
After Máxima had finished making her case, Polo explained
that Paco—her husband, *Paco* being the nickname for men
named Francisco—was in a meeting.

"I'll explain your situation to him when he is out," she said.

Máxima thanked her cousin, left the palace, and took the
train home to Astorga. Now all she, Leopoldo, and the rest of
the family could do was hope and wait.

LIKE AN ALMOND TREE

From Communist to Fascist, November 1936 to January 1938

On November 18, the same day that Hitler and Mussolini officially recognized Franco's government, Leopoldo was released from the San Marcos Convent. His young niece Odila saw him appear on a staircase in the house. He looked relieved but sad and exhausted. He still had with him the wool blanket he had used in prison. Leopoldo would later tell one of his nephews that his mother had brought him into the world twice. This was the day of his rebirth. He was free, yet this didn't mean he was out of danger.

For Leopoldo and so many other Spaniards, geography was turning out to be destiny. The happenstance of where you were when the insurgency rose up determined the often severely limited options you had for improving your chances of survival. The language employed to tell stories about the beginning of the war would reflect this in the recurrent words and syntax that suggested individuals were acted upon by external circumstances, rather than being actors themselves: *La guerra le sorprendió en el norte* (The war surprised him in the north) . . . *Me tocó en León*

(It caught me in León). Lives were being turned into passive grammar.

Leopoldo had to take a hard look at his own limited options. He had barely survived getting *caught* by the coup in Astorga, so should he attempt to clandestinely cross into Republican territory? This would be nearly suicidally difficult, but if he did make it through, what would happen then? He could be taken for a fascist double agent and executed. Or if he did manage to join the Popular army, how might his family be punished for his treason? The Paneros had already had to pay fines to the new authorities for their politics, and the hostility of their fellow Astorgans and even some of the local priests had forced them to stop attending church. Every time a car passed the house at night, Leopoldo's sisters listened in terror, fearing that it was coming to take their father away. But say the family went unharmed, would Leopoldo take up arms against his brother Juan, who had joined the revolt after it *surprised him in Astorga*? There were no good options.

After Leopoldo was back on his feet, civil guards came to the house looking for him. He escaped out the back and ran down the street behind the house to a pharmacy owned by a cousin, who hid him in the supply room. Soon after, he returned home. It seemed there was only one realistic option left for Leopoldo.

To become a fascist.

DURING THE WINTER OF 1936–37, THE ZONES CONTROLLED BY THE NATIONALISTS, IN northwest and southern Spain, saw the beginning of a cultural renaissance of conservative values. Risqué clothing, such as skirts and short sleeves for women, were banned, and dishes and places with foreign-inflected names were "re-Hispanicized." The popular *Russian salad*, for example, became *National salad*.

The church rendered null divorces and civil marriages issued by the Republic. These top-down changes imposed greater unity among Nationalist troops and supporters, while internecine political divisions roiled the Republican zone as it came to rely on the Soviet Union for war materiel. In exchange for his support, Stalin sent agents to exert influence on the Republic, especially its internal security forces. Fueled by violent Soviet manipulations, over the next two years the tensions between Leninists and Trotskyists, anarchists and social democrats, regional causes and national concerns, as well as all other manner of political interests and affiliations, gradually ate away at what was supposed to be a Popular Front united against fascism. This ideological infighting would lead to bloody conflicts in which the defenders of the Republic squandered crucial resources to kill and imprison one another, rather than single-mindedly concentrate on their common foe.

The plight of soldiers on both sides was exhausting and traumatic. Up on hilltops and down in trenches, in besieged buildings and bombed-out houses, life was chaotic and disorganized, unsanitary and poorly provisioned, especially in the undersupplied Popular army. Long stretches of inactivity were broken by sudden engagements that left mountain slopes, olive groves, and roadsides littered with the bodies of young men, many still teenagers. While over the course of the war unchecked Popular Front militias would be responsible for destroying churches and killing defenseless clergy—some seven thousand in total—the Republic eventually managed to curtail the vigilante "justice" that erupted, even as homicidal turf wars fractured it from within. The Nationalists, on the other hand, increased often ghoulishly their mistreatment of the civilian populace. Franco's commanders led their soldiers into conquered towns where they staged mass autos-da-fé and systematically

raped women. Another favored tactic of the rebellion, which occurred in Gaudí's Episcopal Palace just a block from the Paneros' house, was to shave the heads of women accused of leftist sympathies and force them to drink castor oil, thus leaving behind victims robbed of their female identity, who soiled themselves uncontrollably to boot. The expressions of hate were tribal and savage.

Fighting calmed briefly over the cold Christmas and New Year's, only to resume with three vicious engagements in the early months of 1937. In January, on the southern Mediterranean coast at Málaga, motorized Italian Blackshirts rolled into the poorly defended port, sending Republican refugees fleeing with their possessions along barren roads that were bombed by warplanes and shelled by warships. Back in the city, nearly four thousand people who didn't escape were shot, many dying on the beach with the dead end of the sea stretching into the distance. Then in February, along the Jarama River outside Madrid, Franco's forces attempted to gain the road to Valencia, an essential transport line inside Republican territory. Soviet planes and tanks blasted them back, balancing out the devastating losses of International Brigadiers on a rise nicknamed "Suicide Hill." In March, in the city of Guadalajara, north of Madrid, Franco's unwillingness to communicate better with his Italian collaborators allowed the Loyalists to secure a bracing victory, overrunning their enemy with tanks and hand-to-hand fighting. On both sides of the conflict, some of the men left behind by these engagements died for what they believed in. Others who had been forced to pick a side died for the beliefs of the men commanding them.

Tucked away from the front in Astorga, Leopoldo remained pinned down by his geography and his past, caught between his beliefs and his reality as reports about these battles filtered in through the Nationalist propaganda apparatus. He was alone,

his brotherhood of poetry shattered. The poets he looked up to were in the Republican zone, while his closest friends— his brother, Juan, and Luis Rosales—were in the Nationalist zone. (Rosales had nearly been shot by his own compatriots in Granada back in August after protesting Lorca's detention. His family had had to pay a large fine to absolve themselves of the crime of sheltering the poet, and Luis was reincorporated in the Navarrese north. He was put to use as a propagandist, editing a fascist literary magazine called *Hierarchy*.) It seemed only a matter of time before Leopoldo's paralysis would land him in San Marcos again, or worse, so he and his family decided that he must wear a disguise to ensure his safety, as Juan had done. Leopoldo would leave Astorga and join another brotherhood: the Falange, the Spanish fascist party.

If the key to winning a war is giving young men a cause worthy of dying for, the impassioned one-party ideology of the Falange did just that. It had a revolutionary workers' spirit and stylized mystique that seduced an enormous swath of young Spaniards, men and women alike. Membership had swelled from just seventy-five thousand members before the war to nearly one million, turning it into the spiritual backbone of the Nationalist zone. Franco himself, however, wasn't a fascist in the pure sense of the Falange. At bottom he was simply a soldier in service of a romantic vision of Spain's traditional values and imperial grandeur. But with his shrewd, power-hungry nature, he understood the importance of appearing to be fascist in order to win the war, both to retain Hitler and Mussolini's support, and to control the mass of blue-shirted foot soldiers of the Falange.

For entirely different reasons Leopoldo also understood the importance of appearing to be fascist. So on July 19, 1937, he walked into the Falange headquarters in Salamanca, the city where his mother had secured his second birth, and joined up. He became one more member in *El Movimiento*, as his

stamped credential read, "For God, for Spain, and for its New Revolution."

THE TIMING OF LEOPOLDO'S DECISION TO JOIN THE FALANGE WAS UNCOMFORTABLY symbolic. During the first half of July, the Second International Congress of Writers for the Defense of Culture had met in Valencia, Madrid, and Barcelona. A gathering of anti-fascist poets, novelists, and thinkers from around the world, the congress brought together Leopoldo's prewar social world, as well as the English writer Stephen Spender, the photographers Robert Capa and Gerda Taro, the French intellectuals André Malraux and André Gide, and the young Mexican poet Octavio Paz and the writer Elena Garro. The congress became a legendary event— from which Leopoldo Panero was absent.

The wartime summit boiling with larger-than-life personalities consisted of nonstop speeches and ceremonies, roundtables and debates, and even bountiful fetes in poor pueblos, which made some of the visiting dignitaries uneasy. There they were, intellectuals on the side of the workingman, yet wining and dining in destroyed, starving towns. The congress was marked by a controversy surrounding a book Gide had published criticizing the Soviet Union, but it nevertheless galvanized the writers to search for new strategies to stir the conscience of the world to come to the defense of the Republic. Art had proved it could do such things. Right then, Pablo Picasso's *Guernica*, the Spanish painter's cubist masterpiece depicting the horror of German and Italian carpet-bombing of a Basque town, was moving hearts and minds at the International Exposition in Paris. It was crucial to attempt to replicate this success, since all the Republican government's political maneuvering to try to gain the support of its democratic neighbors had achieved very little. "The cause

of republican Spain is the cause of the world," declared the Peruvian César Vallejo, who would never visit Astorga again, in a speech he gave at the congress. "We're the ones responsible for what happens in the world, because we have the most formidable weapon—the word."

This was a rousing sentiment. Even if it was wishful thinking, it reflected how the war in Spain had come to be *the* cause célèbre of its time. As the historian Stanley Weintraub later wrote, "Never since has a cause so captured the moral and physical influence of so many makers and molders of the language." Many saw the Spanish Civil War, quite correctly, as a rehearsal of a much greater conflict of democracy versus fascism that would soon consume the rest of Europe. The British activist Nancy Cunard published a survey of prominent writers which asked them to declare where they stood on the conflict. Of the 148 who responded, 127 supported the Loyalists, while 16 came out neutral, and 5 supported the Nationalists. Spain became a fashionable destination for engagé writers, like W. H. Auden, who popped into the country for brief, inspired visits, then popped out and went home to write about the experience. George Orwell—who actually fought in the trenches for the Republic and was shot in the throat—considered some of these "war tourists" who employed only the pen and not the sword "fashionable pansies."

Yet there was no denying the uniquely important role that poetry was playing in the war. As Pablo Neruda wrote in his memoirs, "In the history of the intellect there has not been a subject as fertile for poets as the Spanish war." Perhaps this was because no conflict had ever been so bloody and so literary *simultaneously*. Most remarkable of all, this was visible in real time. Ernest Hemingway sent grandiose battle dispatches to American newspapers, Auden published *Spain* in Britain, and Malraux wrote the novel *Man's Fate* for the French between missions he

flew as a pilot for the Republic. What many of these writers missed, however noble their intentions, was that, internally, the war was more than just a microcosm of the building tensions between world powers. It was a family affair, a uniquely Spanish quandary, riddled with uniquely Spanish problems. On the ground, the conflict wasn't as black-and-white or good-versus-evil as the international press often presented it, especially after both sides instituted conscriptions in the fall of 1936. How else to explain the fact that the Republican Juan Panero was now fighting for Franco and the communist Leopoldo was now technically a fascist? Meanwhile, similarly lacking in nuance, writers on the other side of the ideological divide reductively attacked those who spun literary gold out of the plight of the Republic. Ezra Pound called them "a gang of sap-headed dilettantes."

While they might be short on war materiel, the Loyalists were indisputably—and indelibly—winning the war of words, not just abroad, but inside Spain as well. Poetry was essential to morale, mythmaking, and a lyric sense of togetherness, and the Republic's literature was simply better than that of the Nationalists. While men and women from abroad did produce powerful, enduring books, it was the Spanish writers themselves who were the true literary heroes of the war. A select and brave few of them fought with both pen *and* sword, such as the young poet Miguel Hernández, who read his ferocious, earthy verses to crowds of fellow soldiers on the front lines before joining them in battle. "Here I am come to love you," Hernández wrote, "and here I am to defend you / with my blood and with my mouth / like two faithful firearms."

Leopoldo had known Hernández in Madrid, back when he was just another young poet on the scene, albeit with a humble background as a shepherd from Valencia. Along with Juan and Luis, the two had both been present in May 1935 at a gather-

ing in Madrid held in honor of Vicente Aleixandre. Now everywhere in Republican territory Hernández's verses appeared in books and periodicals; his voice resounded on the radio; and his handsome, tanned face looked out from newspapers. As Hernández himself put it, "The great tragedy that is occurring in Spain needs poets that contain it, express it, orient it, and carry it through to victory and truth." In rebel-controlled territory, with his signed Falange credential in hand, Leopoldo was destined not to be one of these poets.

He could at least take solace in the fact that his whole family was still alive, something fewer and fewer Spaniards could claim as the war progressed. The Paneros celebrated their good fortune when Juan came home to Astorga for a brief visit in August 1937. He and Leopoldo were able to catch up with each other and the rest of the family at Villa Odila, Máxima's parents' rural estate. Juan and Leopoldo's legendary grandfather Quirino had passed away in 1929, but the property he had left behind was still the Panero clan's sanctuary away from town. Juan brought news of their sister Asunción, who he had recently visited in San Sebastián, and also news of his own: he had been given a star and promoted to second lieutenant. In the evening, Juan bid farewell to the family and set off in a military vehicle with other soldiers headed for León, where he was stationed. This was the last time Leopoldo would see his brother alive. On the dark curving road, the driver of the vehicle lost control and crashed into a guardrail. The vehicle flipped.

Back at Villa Odila, a messenger arrived telling the family of the accident. They rushed to Astorga, where Juan had been taken. When they got there, he already was dead. His skull had been crushed. His corpse was brought to the house, with gauze still bandaging his head. In the Panero home, with the silent garden of their childhood outside, Leopoldo approached the body of his brother. *Juan*. Juan who had been his playmate,

best friend, and literary comrade, the person with whom he had lived "the first hopes, the first verses, the purest and most noble thrills of the soul." Juan, who smoked, joked, danced, and laughed. Looking down at Juan's lifeless body, Leopoldo reached out and touched the bandages on his head. The blow that had killed him had left nothing, only a terrible soft emptiness. His brother was gone.

Juan's death made the front page of Astorga's newspaper. "He died for God and for Country," the article declared. Two days after the accident, the family attended Mass, then accompanied Juan's remains to the Panero family crypt in the Astorga municipal cemetery, on the outskirts of town. Inside its stone walls, Máxima and Moisés laid their firstborn son to rest. Leopoldo left no account of that day, though the magnitude of his silence was more powerful than any words would have been. Juan's death was so "overwhelming and direct," he later said, that he lost the most fundamental part of who he was—his poetry. Leopoldo stopped being able to write.

"All at once," he wrote, "everything sank and disappeared."

"FOR ME, HIS LOSS IS PERSONALLY INCOMPARABLE, I'M LIVING THESE HOURS OF HIS death completely alone," Luis Rosales wrote to Leopoldo in a shattered letter a few weeks later, after learning of Juan's accident. "I'm writing to you and don't know what to say after such a long time—years—of separation. . . . When liberated Spain arrived, I feared for all of you and I don't know why because of a presentiment above all I feared for Juan. Then the good news started. And now, Leopoldo, your telegram came just when it looked possible that we could all be together again, remembering our spiritual communion. Isn't it true, Leopoldo, that we all belong to the same spiritual and moral principles? Isn't it true that our lives and our souls have the same

meaning? . . . When can we be together and talk about him? . . . He was flesh of my flesh, spirit of my spirit, voice of my voice." Now Juan was just a soul's memory: *by way of pain.*

Shortly after, Luis Rosales, always the literary locomotor, swooped in with a plan for how to properly mourn Juan. "It is absolutely necessary that we see each other," he and another friend, Luis Felipe Vivanco, wrote to Leopoldo in October 1937. "You should come to Pamplona as soon as possible. We need your help and your presence. We are preparing a tribute to Juan in *Hierarchy.* Collect the entirety of his work and bring it with you." Leopoldo liked this idea. In a letter to his parents, he discussed which verses of Juan's to publish alongside poems by friends eulogizing him: "Naturally the verse that says, 'An early death like an almond tree,' I wouldn't take out, also the first, 'Oh how lovely it is to die, if in love. . . .'" The family may have lost Juan, but they still had his words.

Leopoldo, however, couldn't go to Pamplona to see Luis just yet. After losing one son, Moisés and Máxima didn't want to lose the other. Rumors of Leopoldo's past had followed him to Salamanca and they worried that his membership in the Falange wasn't enough to guarantee his safety. Making a stronger commitment to the Nationalist cause was necessary and nearly a failsafe option. As a recruitment tool, the authorities were choosing to forgive left-wing sins of the past and protect enlistees from prison and execution in exchange for military service.

Leopoldo joined Franco's army.

He was assigned to the 82nd Infantry Division, and in November 1937, he reported for duty.

LITTLE IS KNOWN OF LEOPOLDO'S EXPERIENCES WITH THE 82ND INFANTRY DIVISION. It is a mystery he left in the narrative of his life, a silence in

a life of words. Unlike love, he didn't poeticize war. What is known is that his primary duty as a soldier was to serve as the driver for Colonel Miguel Arredondo, a distant relative. Years later, Leopoldo would drift though the memories of friends in the rear guard who remembered him as a half-present presence always coming and going. He left only lyrical clues in his poetry: trainloads of soldiers, a sweat-stained uniform, sleeping under the sky. In the 1950s, more than a decade deep into Franco's dictatorship, he would claim that he was a combatant in Asturias, in Catalonia, and, at the end of the war, on the Toledo front. On the front lines or not, he did face the privations of war. As his niece Odila would always remember, Leopoldo once told a story about a long, unbearably hot day during the war in which he and fellow soldiers came across a puddle with a dead soldier lying in it. They were without water and dangerously dehydrated. Leopoldo kneeled down and drank from the puddle.

As a Nationalist soldier, Leopoldo now found himself in a strange new reality: a bombed-out wasteland where priests led masses in front of tanks and even occasionally fought beside the soldiers they prayed for; and where soldiers sang the Falange anthem "Cara al Sol" (Face to the Sun) while holding their arms up in the fascist salute, often in view of buildings draped with banners of Hitler and Mussolini's faces. With his colonel-cousin in the passenger seat, a man who had a laugh "like a fountain," Leopoldo maneuvered military vehicles through the green mountains of the north, wearing his uniform as a disguise, a mask with which to protect himself—at least at first.

While on leave in the winter of 1938, Leopoldo returned to Astorga and made a visit to the cathedral. There one of the priests welcomed him in spite of his family's pariah status. The priest wore his cassock, Leopoldo his uniform. It was January, five months since Juan's death, and one of the harshest winters in Spain in decades. At that very moment a brutal battle was being

waged for control of the small mountain town of Teruel, in the eastern region of Aragon. Leopoldo was far from the action, yet he carried the pain of the war inside him and needed comfort. He had always felt a sense of peace in the cathedral. "On opening your doors all is calm. . . ." he would write in a poem about returning there. "My heart worn down by time, / like your steps by feet." Leopoldo's friend Luis Alonso Luengo, who was also present that day, recalled rays of sunlight streaming in through the windows of the rectory. The three men talked, and when Leopoldo said goodbye, Luengo felt he saw a change in his friend, with whom he had spent his adolescence arguing about faith: "Was it an authentic conversion Leopoldo was going through then? It would be better to call it a definitive encounter with God."

If Leopoldo had returned to his Catholic roots once and for all, he had to decide what this meant in devastated, fratricidal Spain, in which he had lost his links with a past so different from the future he now found himself fighting for. He had nearly ended up as one of the "Spaniards sacrificed by a dark religion which almost no one understands," as Lorca had once written, and he might still become one, like Juan already had. But had Rosales overstepped in suggesting that he and Leopoldo shared the same spiritual essence? Could they really have the same morals if Leopoldo had been a communist who believed in the Republic, while Luis had joined the rebellion from the very start? Perhaps so. Political and spiritual principles weren't necessarily the same thing. San Marcos had taught Leopoldo that "behind the nullity and void of the earthly existence, the consoling necessity and presence of God fatally appears." Might this be all that really mattered?

That winter, Leopoldo wrote to a friend who worked at the office of the Secretary General of the Falange in Salamanca to tell him that he was going to change his life.

How difficult the choice was or what anguish attended it

(or didn't) is impossible to know, but Leopoldo made a decision. Maybe it was because of his spiritual awakening, maybe it was because he needed brothers after losing his own, maybe it was because the contagious unity of the Nationalist zone had infected him, or maybe it was because he was a talented card player, like his grandfather, who knew when he was up and when he was down, when to raise the ante and when to fold. Leopoldo had been living two lives, existing as two people, and playing two sides of one game. He couldn't keep this up, so he folded on one hand and went all in with the other.

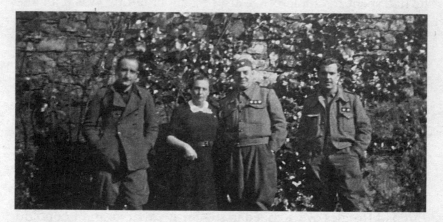

The only known image of Leopoldo (left) from the war. The man to the right of the woman was an Italian solider, sent by Mussolini to fight for the Nationalists.

VERSES OF A COMBATANT

The Nationalist Path to Victory, January 1938 to April 1939

In 1937, Pablo Neruda had published a short book of poems titled *Spain in the Heart: Hymn to the Glories of the People at War*. The verses were lyrical and blunt, personal and communal, heart-wrenching and wrathful. Neruda addressed his dead friend Lorca: "remember my house with the balconies where / the June light drowned the flowers in your mouth?" He described how "through the streets the blood of children / simply flowed." He imprecated against Franco, writing: "may you be alone and awake among all the dead, / and may blood fall on you like rain." And he urged on the defenders of the Republic: "onward across the ploughed lands, / onward through the dry, sleepless, delirious and frayed night." Like the best poetry of the Spanish Civil War, it succeeded as both propaganda and art, and its literary value would outlast its political usefulness. The poems came from the heart—Neruda's and that of the Popular Front.

Neruda's book first appeared in Chile, but in 1938, the

prestigious printer Manuel Altolaguirre managed to print *Spain in the Heart* in the Monastery of Montserrat in Catalonia as battles raged nearby. Its publication was later mythologized to the point that it is hard to distinguish between truth and legend, but Altolaguirre claimed that it was printed by active-duty soldiers. "Not only did they use raw materials (cotton and pieces of cloth) supplied by the commissariat," he wrote, "but the soldiers added to the mixture clothes, bandages, war trophies, an enemy flag and the shirt of a Moorish prisoner." Along with Miguel Hernández's 1937 *Viento del Pueblo* (Wind of the People), Neruda's book rallied the spirits of Spanish militiamen, while also inspiring solidarity abroad.

The Nationalist cause, in contrast, had no such equivalents, no blazing voices or totemic verses that embodied and bolstered its struggle. Propagandists tried to elevate Ramiro de Maeztu, a writer who was killed on a *paseo* in Madrid in the fall of 1936, into the Nationalist Lorca, but his work didn't hold up under the weight of martyrdom. And much of the poetry written in praise of Franco was so hermetic and chest-poundingly manly that it failed to resonate beyond a narrow, sometimes homoerotic cult of personality, like Ernest Giménez Caballero's evocation of Franco's military baton: "His truncheon, his incomparable phallus." Rehashing old myths—from the Bible, Spanish history, and European anti-Semitism—instead of creating new ones, the narrative of Franco's army was inferior to that of the Republic. It lacked the alchemy of defiance, pain, and underdog's courage. So the Nationalist command decided that if they didn't have their own poet-visionary of the war, they would just have to invent one.

In December 1938, one month after Neruda's book was printed in Montserrat, the Nationalist press Ediciones Arriba published *Los Versos del Combatiente* (Verses of the Combatant)

by Mortar Sergeant José R. Camacho. The poems glorified sacrifice, lamented fallen comrades, and called for an unstinting fight to the end. "Until we conquer you Spain," intoned one, "Our heart is / split in half like the Patria." But Sergeant Camacho wasn't the real author of the book, although he was a real person—Luis Rosales's brother. The poems were a team effort masterminded by Rosales, who was now posted in the city of Burgos, Franco's newly relocated base of operations. As Rosales explained fifty years later, "The book was created for the soldiers. It was a form of poetic indoctrination." One of the indoctrinators was Leopoldo. He was writing again.

Burgos was the beating heart of the Nationalist zone, a bastion of Castilian values and natural hub for the rebellion. Many people who had escaped Madrid made their way there and waited anxiously for the fall of the capital, which refused to fall. Burgos's streets were full of soldiers coming and going from the front, and some of the city's crowded cafés stayed open all night long for the ones who couldn't find beds to sleep in. Every once in a while, when he could get away from his unit, Leopoldo was one of these visiting soldiers.

Thin, hair combed back, wearing a thick jacket and high boots, he was a castaway drifting across the roiling surface of history, unmoored from the shore of his past. Yet among the literati of the uprising, a close-knit group of mostly young writers who gathered in a buzzing office, he found an anchor of brotherhood. Between propaganda assignments and discussions of the war, they held intellectual salons and read one another their poetry. When Rosales asked Leopoldo to contribute to *Verses of the Combatant*, he composed a poem about a soldier who had died in the Battle of Teruel. "In the Alfambra Valley," he wrote in soft verses that read like a coded whisper to Máxima about Juan, "next to the river, / my friend fell, mother, / my friend fell."

Hiding behind the mask of the ghostwriter, Leopoldo reclaimed his voice, as though finally beginning to uncover the words for the grief of losing his brother. In the process, he fused his private universe of poetry with the public theater of war and prepared to jettison his past. The eight-line poem presaged an irreversible shift in Leopoldo's life.

Leopoldo made his periodic trips to Burgos from his posting in Mieres, a small mining town in the northern province of Asturias. In the fall of 1934, Mieres had been a bubbling saucepan of communist fervor, providing the backdrop for what turned out to be an inverted dry run for the war to come two years later—a leftist rebellion against the rightist government in power. Responding to exploitative working conditions and tremendous poverty, thousands of dynamite-wielding miners rose up against mine owners and the regional infrastructure that supported them. The government brought in none other than General Francisco Franco to crush the uprising. His troops killed at least 1,200 of the rebellious miners and arrested thousands more, while also punishing the community through rape, torture, and looting. These memories were still fresh in Mieres.

In the fall of 1937, forces under Franco's command had returned to coal-rich Asturias and once again pacified the populace, this time with the aid of the German Condor Legion. In 1938, Leopoldo was in Mieres driving Colonel Arredondo. He drank a lot and dated a local girl whom he promised to write an "acrostic sonnet" for but never did. Yet he was writing new poems, only of a political rather than amorous nature—and no longer hiding behind a mask.

In 1939, Rosales's press published another book, *Crown of Sonnets in Honor of José Antonio Primo de Rivera*. It was a short collection of poems paying tribute to the martyred leader of Spanish fascism, José Antonio Primo de Rivera, the son of ousted dictator Miguel Primo de Rivera. José Antonio, as he

was commonly called, was an alluring and complex figure. A lawyer and politician, he was macho and intellectual, sensitive and incendiary. A hater of democracy, he constructed a mystique that alienated establishment conservatives and liberals alike. He buoyed himself aloft upon a zeppelin of romantic bombast, Nietzschean charisma, and a belief in purifying violence. "In a poetic movement, we shall raise this fervent zeal for Spain, we shall sacrifice, we shall renounce, and ours will be the triumph," he proclaimed in a famous speech. "I am a candidate, but I am one without faith or respect for the system. . . . We do not intend to go quarrel with the habitués over the rotting remains of a sordid banquet. Our place is outside, although sometimes we may have to go within. Our place is in the fresh air, under the clear night, weapon on our shoulder, with the stars above." Cherrypicking elements of German and Italian fascism, José Antonio shaped himself into a Spanish creation entirely his own. Likely he would have challenged Franco as the leader of the Nationalist cause if he hadn't been jailed by the Republic before the outbreak of the war. With his characteristically tactical shrewdness, Franco didn't make an earnest effort to negotiate his release, instead using the Falange leader's absence as a wedge to divide and conquer Spanish fascists and bring them under his control. As a result, José Antonio was executed in November 1936, two days after Leopoldo was released from San Marcos.

Whether he was seduced by the revolutionary aura of José Antonio, the collective zeal of his friends, or the fatalism of his own predicament, Leopoldo welcomed the romance of Spanish fascism into his poetic world. He wrote a sonnet for the book Rosales published, imagining that José Antonio "watches over from the crystalline sky / of Spain, and in the wakeful night . . . speaks without speaking, sees without seeing." The young idealist who had once worn a hammer and sickle in his buttonhole, who had believed in the Republic, and who had nearly been

murdered for these beliefs—now writing verses in praise of one of the men who had helped to overturn all of that.

Was Leopoldo really out in the fresh air and under the clear night with other Spanish fascists? Deep inside, in his most private depths of thought and feeling, was he truly willing to believe that Juan's call for their generation to "lift up Spain by lifting up ourselves" meant this war? It is impossible to say, though Ernest Hemingway could have been describing Leopoldo in the novel about the Spanish Civil War he would soon publish, *For Whom the Bell Tolls*. In the book, the narrator, an American volunteer, thinks to himself: "There are many who do not know they are fascists but will find it out when the time comes."

Whatever betrayals of the past Leopoldo's political conversion entailed, his newfound coherence—between his actions and his poetry, between his politics and his spirit, between life and death—seemed to heal him. It was as if his lyrical performance of mourning for the Nationalist cause allowed him to at last mourn Juan.

"The first verses escaped from my pen since 1936," Leopoldo wrote of a poem he began composing about Juan around this time, titled "Adolescent in Shadow." (This lie suggests he didn't consider the pieces for the two Rosales books his own voice.) It was both an ode to and an elegy for "my brother, / my partner and much more." Writing it proved cathartic. "These poor and misted nine-syllable lines, lacerated by sadness, watered by the soul, [were] the key, spiritual and intimate, to a large portion of my future work. I remembered through their stanzas and sang through their words our childhood and adolescence, first in the country fields, rolling with black poplars and shaded by the oaks that encircled Astorga. . . . The wing of the war and its destruction passed tremulously through their damp syllables." Soon after, he wrote a poem for his sisters evoking the pain left by

Juan's and Ángel's deaths. Its first line read like a scar on his heart: "We are always alone."

Paradise was lost, yes, but Leopoldo had found a new voice.

IN MARCH 1938, NATIONALIST SOLDIERS REACHED THE MEDITERRANEAN, SLICING Republican territory in two. A month later, while the Abraham Lincoln Brigade of American volunteers was under attack in Tarragona, Leopoldo's idol César Vallejo fell ill from an intestinal infection while doing work on behalf of the Republic in Paris. On April 15, he succumbed to hallucinations and shouted from his hospital bed, "I am in Spain!" He died that same day, leaving behind a pained wail of a book about the war, *Spain, Take This Cup from Me*. It crescendoed with the verses: "if mother / Spain falls . . . go out, children of the world, go and look for her! . . . Beware, Spain, of your own Spain! . . . Beware of those who love you! / Beware of your heroes! / Beware of your dead!"

When 1939 arrived, two and a half long years since the July uprising of 1936, mother Spain was indeed falling. After months of fighting along the Ebro River, with mortar blasts sending up geysers of earth and bodies on both banks as warplanes strafed and bombed from above, the Nationalist troops crossed to the other side. At last they would close in on Barcelona, where the Republican government was located. German and Italian bombers launched a devastating offensive on the city, the incendiary explosions filling the once grandiose boulevards with a storm of wreckage. The Catalan capital that had briefly become a socialist utopia at the start of the war was now a gutted tableau of defeat. Corpses blighted the streets in front of buckled buildings that sheltered the thousands of refugees who poured into Barcelona from other parts of Republican Spain, fleeing the reprisals that Franco's unforgiving philosophy of victory promised.

As what had once been *his* Republic was definitively falling at

the end of March, Leopoldo rode into Barcelona. The Nationalist vanguard had already invaded the city and executed thousands. Nationalist supporters in Barcelona mobbed the cars of the triumphant officers as church bells rang. Soldiers danced into the night with prostitutes. Meanwhile, France finally opened its borders to let the ragged and hungry exodus of four hundred thousand Spanish refugees wash in like the survivors of a nation-size shipwreck. Arriving after the celebrations, Leopoldo scoured Barcelona for socks but found none.

With the war in its final phase, like the last breath of air escaping from a body, he began a southerly journey through his "extraordinarily ruined" country. Pulled along by the Republic's imminent surrender, he passed through Toledo, from which Franco's army made its final conquering descent on Madrid, the seemingly unbreakable city that now broke. The front dissolved as Popular army units abandoned their positions. Across the rest of Spain the Nationalists marched through towns and villages, showered with flowers thrown by the mainly middle- and upper-class sympathizers who had been waiting for this moment for nearly three years.

On April 1, the Spanish Civil War ended. Close to 200,000 people had been summarily executed. The forces inside the Republic authored roughly a quarter of these deaths, the Nationalists the rest. Approximately the same number of people had died in combat, along with 35,000 civilians in Republican territory dying in bombardments or from the privations and sicknesses of the war. During the subsequent decade, another 20,000 Spaniards would be executed as a result of Franco's policies of repression, and many thousands more would die or languish in labor camps and prisons.

Leopoldo had survived one of the most catastrophic events of the twentieth century. It had changed him, his family, and everyone he knew. It had demolished the past and rewritten the future. But, somehow, he had made it through. Many years later,

he would write two poems capturing his feeling of having just barely been saved from the "horseman" of death. In the poems he invoked two other miraculous survivors whose stories he braided into his own: Fyodor Dostoyevsky, the Russian novelist who was also condemned to be shot by a firing squad, only to be spared at the last minute, which brought on a religious conversion; and Lazarus, the biblical figure that Jesus resurrected. The war had reshaped Leopoldo, in own words, into "the *señorito* that rises from his tomb." Now that the war was over, who would he become?

The answer to this question would come in the form of the great "poetic hallucination" of Leopoldo's life—the woman he would marry.

THE GIRL WHO CRIED

A Madrid Childhood, 1913–1926

Felicidad Blanc y Bergnes de Las Casas's first memories were of the clip-clop of horse-drawn carriages dashing along Madrid's Gran Vía, which ran perpendicular to Victor Hugo Street, where her family lived in an apartment with fourteen balconies. It was only fitting that her childhood street should be named after a romantic French novelist from the nineteenth century since she would spend her adult life in elusive pursuit of the novelistic fantasies of the era she had just missed. Born on February 3, 1913, she was named after her mother—*felicidad* means "happiness"—though as she wrote late in life, "That name was like a challenge to destiny, since neither my mother nor I were ever too happy."

Felicidad's father, José Blanc Fortacín, was a dapper, mustached surgeon who at twenty had fallen in love with an entrancing, dark-haired actress he saw play Desdemona in a performance of *Othello* in Barcelona, the longtime enclave of his family. Unlike the Venetian belle in Shakespeare's play who defies her father to marry an older man, for this Desdemona it was the other

way around. Her besotted suitor was seven years her junior, and he was the one who spurned his family by marrying an older woman. Not only that, he uprooted from his native city and relocated to his new wife's home of Madrid, where he moved into an apartment crowded with her extended family: her mother, her sister, an aunt, her brother, and a niece. Having fallen out with his parents, the young doctor had to carve out his career with no outside support in the fin de siècle Spanish capital whose vermouth-drinking sociability and late-night vitality grated on his austere, workaholic nerves. For this sacrifice, his wife gave up her acting career to devote herself entirely to him, ensuring that he could relax after long days attending patients. They both came from well-off families of French lineage, but in Madrid the young couple had few advantages.

At first, José and Felicidad only barely scraped by. He worked tirelessly at his clinic and they had two daughters, Margot and Eloísa, then six years later a son, Luis. By the time blue-eyed Fe-

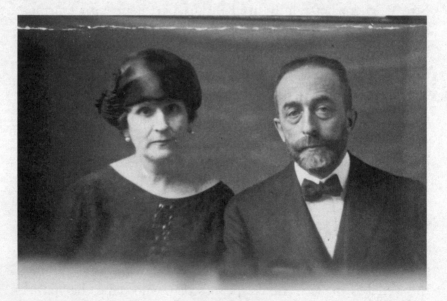

Felicidad Blanc y Bergnes de Las Casas and José Blanc Fortacín

licidad, the last and youngest child, came along, José was making a name for himself in his field and in society, and even in the imagination. In 1912, at the age of thirty-four, he became the chief of surgery at the Hospital de la Princesa; the following year he received tenure as a professor at Madrid's medical school; and in the subsequent decade he left a mark in the young memory of Camilo José Cela, a future Nobel Prize–winning author who would give the good doctor a cameo in a novel. Lifted by this success, José and Felicidad's family joined the ranks of Madrid's growing middle class, and their upward mobility continued to soar. When little Felicidad was three years old, they moved into the light-filled apartment on Victor Hugo, one of whose balconies looked out onto Calle de Alcalá, the avenue where Leopoldo Panero and his friends would sell their literary magazine at the end of the 1920s.

Outside on the Gran Vía, Madrid was expanding by the day. The outskirts of the city still retained vestiges of Spain's rural character—wheat fields, grazing grounds for livestock—but the center was like a throbbing construction site. Tiny Felicidad had a box seat to observe the modernizing capital rise from the ground. She watched oxen haul in cart after cart of bricks, while below the latticework of scaffoldings men in suits bustled to and fro wearing bowlers, fedoras, and straw boater hats that bobbed along like so many distant floating vessels. East of the clamor on the Gran Vía, washerwomen did laundry in the Manzanares River, hanging sheets up to dry on the banks, where they stretched like a fleet of white sails without ships. But the city at large, its rich and its poor, was of little concern to Felicidad; her world was the island of her neighborhood and the life of her home. At night, down on the street, an old man played songs on a violin and a scoliotic woman hollered a sales pitch to passersby, "Matches and tobacco!"

The constant companion of Felicidad's childhood was her grandmother Isabel. She was a melancholy dreamer who had

been widowed very young, then went on to commit the social sin of bearing an illegitimate child (as it happened, with a prominent liberal politician). The ensuing years had bent her into a spine-bowed woman herself, although she hadn't given up on elegance and often donned a velvet bonnet. In her old age she had become deeply superstitious, while nonetheless holding on to the progressive political convictions of her youth. Isabel took her granddaughter on lengthy walks around the city. They often strolled along the hedged paths of nearby Retiro Park, though Felicidad didn't like playing with other children. She preferred observing the bullfighters taking walks and the women wearing traditional lace shawls. Isabel told her stories of the family's misfortunes, like that of her unstable son, Felicidad's Uncle Antonio, who married a woman who died from tuberculosis, only to later commit suicide. From a very early age, Felicidad was captivated by the seductive power of family myths, especially when they were wedded with tragedy.

As Felicidad grew, she faced a personal tragedy of sorts: her mother descended into depression. She often spent whole days alone in her bedroom with the lights off, as if playing the part of their mother was beyond her abilities after already playing the perfect wife. Her namesake youngest child would come to her in the dark room, sit at the foot of her skirts, and ask her to turn on the lights. She would smile and lift up small, lonely-eyed Felicidad in a hug, then return to her shadowy solitude.

With the four Blanc children's mother effectively in absentia from child-rearing, Great Aunt Eloísa, Grandmother Isabel's sister, filled the household power vacuum. (The uncle and his daughter who had once lived with the family had both died.) Severe and domineering, Eloísa was a dark-haired despot for whom relationships inside the family were a map of preferential, nation-like alliances demanding aggressive policies of intervention. Jealous of Felicidad's love for her grandmother—who still

exuded an air of the black sheep
from her long-ago scandal—
Great-aunt Eloísa shone her
more tender side only on blond-
haired Margot, who was already
a teenager, and bratty Luis, who
was favored for being the only
boy. Yet in the apartment on
Victor Hugo Street, all care was
ultimately organized around
the needs of the brilliant sur-
geon and man of the house, who
came home tired from demand-
ing operations during which he
incorporated new medical inno-

Felicidad as a child

vations. (He was one of the first physicians in Spain to conduct
blood transfusions.) In the evenings, the doctor's only indul-
gences were listening to opera and eating dessert.

To his children, José Blanc was a "mythical figure." With
such a demanding work life, he was within reach of his chil-
dren for just a few minutes each day. Felicidad did whatever she
could to win his approval. One year, when it was time for shots
at home, Luis ran off and hid while she sought her father out in
his office, inspired by how he had once operated on himself for
a gangrenous infection, biting a handkerchief to stifle the pain.
"I'm not afraid, Papá," little "Feli," as she was called, told him.
"Give me a handkerchief and I'll put it between my teeth to not
scream."

José Blanc looked down at his youngest daughter, pleased.

When Felicidad began her schooling, the daughter of the
diligent doctor turned out to be a congenitally poor student. Her
first teacher was Fraulein Karl, a German woman who gave les-
sons at the house. She made Great-aunt Eloísa seem kittenish.

On one occasion, after Felicidad spilled some ink, Fraulein Karl gave her a resounding slap across the face. A few years later, her parents enrolled her in an all-girls school run by French nuns, and there she became known as "the girl who cried." Like her grandmother, she was a daydreamer. She was the only student in her class who didn't learn her multiplication tables, which she kept a secret until she couldn't bear it anymore and confessed her ignorance to the mother superior. She did so "with that mixture of shyness and daring that has always characterized me in critical moments," Felicidad later wrote. The nun was impressed by the bravery of the anguished girl. Over fifty years later, seeing something important in her bite-the-kerchief fearlessness of going to the mother superior, Felicidad would reflect, "I consider that feat of mine one of the most courageous acts of my life." She underestimated herself. In adulthood, she would display great courage on several occasions. Yet just as often she would surrender to circumstance and pity herself.

Instead of studying, Felicidad preferred to spend her time with toy figurines, small animals, and dolls, the last of which obsessed her until the late age of fifteen. While Felicidad failed to bring home good grades, she learned French quickly, and this was how she discovered her first love, the pastime that would shape her identity and life: reading.

The spell literature cast on her began with the Jules Verne novels she read for class, but the first book that truly hypnotized her was a collection by Hans Christian Andersen. Beneath the fairy tales she felt the coursing of real emotions. She read Charles Dickens's *David Copperfield*, which taught her about the passage of time, then stumbled upon French romance novels, which she read over and over. These steamy stories of elegant ladies and gallant suitors, and all that could go right and wrong between them, sunk their narratives roots into her mind. The characters of the books she read became her inner

family—"dead companions . . ." she wrote, "who brought us so many things, those who gave us so much, and didn't expect anything in return."

Literature fed Felicidad's imagination during all the time that she spent at home by herself as her mother chaperoned her two older sisters to society gatherings and dances. Meanwhile, Luis only wanted to play boy games or make fun of Feli and call her ugly. So when not reading, in her solitude she became an actress, like her mother had been, except she performed only for herself. Her favorite "game" was to do imitations of the ill-fated people who came to their home or whom she saw out in the street: the wife of the stonemason who had suffered an injury, the upper-class lady who had lost all of her money. Her family found her role-playing odd. They couldn't understand why a child would be so captivated by hardship. "What fixation is there in me with misery and misfortune?" she wondered.

Felicidad's own miseries would come to dwarf those of the people who animated her lonely hours, though these misfortunes were years away. For now, she still had plenty of time to read, to be young, and to fall in love with falling in love.

CHAPTER 7

LONG LIVE SPAIN

A Niña Bien, *1920–1936*

The 1920s saw two significant changes in the lives of the Blanc-Bergnes household. Felicidad's oldest sister, Margot, married and moved to Argentina with her new husband, and her grandmother Isabel moved back to Barcelona to spend her final years. Felicidad felt more alone than ever.

Her parents enrolled her in a school specializing in business education, where she continued to receive the bad grades that came naturally to her. Few women in Spain had careers and it didn't look like she would be an exception. Not that this was especially troubling for teenage Felicidad. She was immersed in the transition from girlhood to womanhood and all the new-found attention this brought. One summer on a family vacation on the coast of the Basque Country she fell for a boy her age named Manuel, who was shy like her. They held hands, danced together in costumes during the noisy town fair, and kissed. It was like a scene out of a novel. "The first joining of two people, the awakening of a vague desire that marks us for the rest of our

life," Felicidad would recall. "When I was back in Madrid I was no longer the withdrawn girl I had been."

Felicidad's transformation coincided with yet another change for her family: a new home. Her father wanted to celebrate his decades of hard work by moving his family into a house, so he bought a *palacete*—a small palace, translated literally, but more accurately, a mansion. It stood on the street Manuel Silvela, in Madrid's upper-crust neighborhood of Salamanca, rising from the ground like a castle to loom over the small trees on the street below. The house had three spacious floors; an interior courtyard and a terrace full of lilacs, rosebushes, and sweet-smelling honeysuckle; and a central hallway that Felicidad walked down one day together with Luis and her sister Eloísa before the family had moved in, the electricity still yet to be turned on.

"You know what I feel?" Luis said, holding a candle, the only light illuminating them. Felicidad's older brother had become a moody sixteen-year-old with a hard edge guarding his own version of the melancholy that was coming to seem like a hereditary disorder in the family. "That in this house more misfortunes will find us."

Felicidad took in Luis's ominous words, beholding the spooky, shadowy cavern of the hallway. She felt as if the house were threatening them. What if he were right?

Indeed, it was in this house, as Felicidad's first son would one day write of his mother, that she "learned the eternal walk of sadness." Yet although her life wasn't perfect, it was still innocent. Like Leopoldo Panero, she too had a paradise to lose.

FELICIDAD'S SISTER ELOÍSA, NOW TWENTY-TWO, HAD ALWAYS BEEN THE MOST eccentric of the Blanc children. She couldn't have been more dissimilar to the stern great-aunt she was named after. She was

The palacete *at Manuel Silvela 8*

vivacious and innocent, stormy and rebellious. When Eloísa was a teen, she had played kid games with Felicidad that seemed slightly off for a girl her age. Her black hair and huge green eyes won her a legion of male admirers, leading her conservative parents to prohibit her from having boyfriends. In the summer of 1926, likely at their behest, she and thirteen-year-old Felicidad attended a reception in which women's groups met with Spain's dictator, Primo de Rivera, to celebrate his successful military campaign in Morocco. Such stuffy affairs weren't for Eloísa. At night she snuck out of the house on a succession of clandestine rendezvous, taking Felicidad along as her sidekick. Soon, however, too many suitors would have been a problem their parents welcomed after Eloísa's eccentricities began taking on a darker shade.

Eloísa and Felicidad shared a bedroom. This arrangement

had been fine at first, until Eloísa developed a series of delusions. She started waking Felicidad in the middle of the night to make her watch a neighborhood man who often stood out in the street, sure that he was going to come up to their room. Even more unsettling, Eloísa became convinced that she was possessed by the devil and prayed for hours on end to save herself. Little by little, her affection for Feli turned into paranoid jealousy; next, she became obsessed with a newspaper columnist she thought was sending her hidden messages in his articles. Then she got in a car accident with a young man she was out carousing with. After being grounded, she thought that she was going to die and asked to make her final confession. The Blanc parents were at a loss for what to do, yet as 1930 rolled in, they had another problem child: Luis.

Like other young men in Madrid—in fact, like Juan Panero, who at this time was protesting against the dictatorship at the university—Luis threw himself into dangerous student demonstrations against Primo de Rivera. This infuriated conservative José Blanc. After father and son clashed, Luis kept his life a secret from the rest of the family. The rooms of the *palacete* on Manuel Silvela filled with silence.

Luis's prophecy had come true—or had *begun* to come true.

AT HOME, FELICIDAD RETREATED INTO HER ROMANCE NOVELS, WHILE OUTSIDE THE house her life came to resemble these very same melodramatic stories. At seventeen, she had grown into a lithe, slender figure and bloomed with looks that people compared to Greta Garbo's, earning her a certain fame among her social set. A girl who knew her at the time described Felicidad as "the prettiest girl in Madrid and she lived in a beautiful house among those boulevards surrounded by gardens and a certain mystery." She had a beauty that was almost shocking in its artistry: a perfection of a narrow

chin, high cheekbones, and a doll-like nose. These features combined to have a force much greater than her personality, her looks taking on a life of their own. Boy after boy fell for her, but she always fell harder, her emotions perfumed by years of dreamy reading. "I fall in repeatedly and with a surprising ease," she remembered, "the smallest detail, a more or less complementary phrase about me, something that shows that someone notices me, it thrills me. I tirelessly seek love." It appeared in the form of Julio, Antonio, and others. There were group outings to the country, gossip, dances, and kisses. But Felicidad was governed by hot-cold emotions that swung from one extreme to the other. Infatuations appeared then vanished. Inevitable drama always followed, precipitating a breakup.

Felicidad's existence halved itself into two worlds: out in the city, where life was bright and alive as she paraded with friends down the Castellana, the tree-lined avenue where moneyed, primped Madrid displayed itself, the women donning flapper-style cloche hats from America, the men grinning under the shine of pomaded hair; and at home, where the mood was shadowy and troubled as Eloísa's delusions worsened and there was no surgical technique José Blanc could call on to cure his daughter. Finally, he and his wife committed her to a mental hospital. Locked in a room administered by a nun who strolled the hallways with a jangling nest of keys, Eloísa's condition didn't improve. Her

Felicidad on vacation in San Sebastian, in the Basque Country

face became deranged-looking, reminding Felicidad of crazy women from movies.

When Eloísa came home after a few months, their parents put her back in the same room with Felicidad, who feared not just the outbursts of her sister's insanity but also being infected by it: "The terror that I could go crazy myself, that I could be like her, and the ease with which I think one can pass from normality to insanity." Time would reveal that Felicidad was justified in her worries of contagion, except she wouldn't be the one to lose her mind like her older sister. The heir to Eloísa's illness would be one of Felicidad's sons.

AT THE START OF 1930, THE PROTEST MOVEMENT THAT HAD ATTRACTED LUIS came together with other currents of dissatisfaction in Spain to force Primo de Rivera out of power. Very likely Felicidad heard the same gunshots out in the streets that Leopoldo wrote home about. After the collapse of the dictatorship, an uncertain interregnum followed. Another general stepped in to escort the country toward a constitutional monarchy, only to incite a failed military uprising aimed at instituting a republic. In April 1931, Spaniards took to the ballot boxes for municipal elections and elected a majority of Republican candidates to office. Having lost the support of the military, King Alfonso XIII left the country for Italy without abdicating. "Sunday's elections," he said with prideful defeat, "have shown me that I no longer enjoy the love of my people. I could very easily find minds to support my royal powers against all comers, but I am determined to have nothing to do with setting one of my countrymen against another in a fratricidal civil war."

The war King Alfonso foresaw was averted—for now.

In the Blanc household, unlike that of the progressive Paneros, the founding of the Republic was not welcome news. The

esteemed surgeon would no longer be invited to dinners at the Royal Palace, though that wasn't the real issue. Most wealthy families in Spain feared that the new government's proposed reforms would hurt the church, erode Spanish traditions, and clear a path for the scourge of communism. Additionally, even if they had supported the ouster of Primo de Rivera, most conservatives were upset at having lost their king. This was true for Luis, who had wanted the dictator out but not the royal family along with him. King Alfonso's exile prompted him to join the Monarchist Youth. Felicidad shared her brother's feeling of "romantic kinship" with lost causes, with those benighted actors cast as the losers of history. Together they marched down the Castellana with a banner that read: LONG LIVE SPAIN, LONG LIVE THE KING.

In spite of resistance from several sectors of society, Spain was undeniably and inexorably transforming. In the hub of Madrid, intellectual riches gradually superseded material ones as the most precious social capital, creating the cultural ferment that Leopoldo became part of in cafés and salons. Four years younger than him, Felicidad watched the layers of teenage prestige reorganize themselves as popularity took measure with a new yardstick. The children of the aristocracy lost their proprietary glamour as social royalty, their positions usurped by the sons and daughters of Spain's writers and thinkers.

This shakeup of the social order, however, didn't downgrade Felicidad. As an antidote to her solitary life at home, she had become vivacious and talkative, even a leader. She captained her field hockey team, and while she wasn't a very good player and her team hardly ever won, it gained her notice outside her customary circle in 1932, when she was nineteen. The monarchist *ABC* newspaper incorrectly reported that her team had lost one of the few games it had actually won, spurring Felicidad to write an outraged letter to the editors, who were smitten. They put a

photo of her posing with her hockey stick on the cover of their sports magazine. The following year, an *ABC* cartoonist published an affectionate caricature of her. She was quite literally the picture-perfect *niña bien*, a well-to-do young woman who did what was expected of her. Her parents had long since pulled her out of her school, so her primary responsibilities were simply to dress well, charm her peers, and avoid having any opinions on topics reserved for men, such as politics. Yet this was a period in Spain in which it was hard not to have opinions, or at the very least not to take notice of the violent tensions boiling beneath the surface of daily life.

In August 1931, the monarchist General José Sanjurjo launched a coup from Seville against the Republican government. It failed and he was imprisoned, but the incident reflected a growing lack of control and civility throughout Spain. On the right, wealthy landowners viciously resisted peasants' attempts to farm uncultivated fields that would soften their abject poverty. On the left, anarchists sacked churches and attacked clergy. Needing to mete out justice against both sides, the government managed to both further infuriate its enemies while alienating its allies. In October 1933, José Antonio Primo de Rivera founded the Spanish fascist movement, galvanizing young men to join the Falange in a heroic endeavor to save Spain. The following month, a conservative coalition won the national elections, ushering in what was to be called the *Bienio Negro* or the *Bienio Rectificador*—the "Black Two Years" or the "Rectifying Two Years"—depending on one's political standpoint. Crises ensued. The government squashed the miners' revolt in Asturias. Telephone workers in Madrid went on strike and street fighting broke out. Both the Falange and the Communist Party gained members. Society was polarizing.

Felicidad floated above these turbulent times as though

looking down at a remote drama, unaware that she would soon be rudely pulled back to earth. "In that climate of tension and fervor that the Republic created," she wrote, "for me it continued being a time of spring, of love." It was only fitting that when Felicidad finally did have a political awakening, it wasn't by way of a book or rally, but a young man she fell for.

RAFAEL DIDN'T COME FROM A MONEYED FAMILY LIKE FELICIDAD'S. HE DIDN'T GO on ski trips to the mountains with friends like she did. But he had the new cachet of the intellectual class. A psychiatrist and the nephew of an important Republican minister, he lent her books by Tolstoy and Turgenev, and introduced her to progressive ideas about education and economic equality. Soon she had to keep a secret from her family: she believed in the Republic.

In February 1936, just two weeks after Felicidad's twenty-third birthday, a leftist coalition called the Popular Front took power in general elections, ending the conservative biennium. In a move aimed at breaking up the network of potential enemies within the military, the new government demoted Francisco Franco to a post in the distant Canary Islands, and in March it outlawed the Falange and detained José Antonio Primo de Rivera. A paroxysm of political violence followed, as well as provocatively preferential treatment the government lavished on their ideological allies, such as releasing left-wing criminals from jail. Foolishly, the Popular Front shored up their power base while undermining constitutional rights all Spaniards were entitled to.

In April, on the fifth anniversary of the Republic, leftist youth and fascist youth clashed in the streets of Madrid, and a battle broke out between government Assault Guards (paramilitary police) and armed Falange demonstrators. They traded

gunfire in plazas as both sides dodged behind trees and by-standers dove for cover. In May, workers held a general strike across the country, while a cohort of generals conspired. Everyone in Madrid could feel danger in the air, from housewives to the maids who cleaned their homes, from politicians to the men who shined their shoes. Toughs from different political factions carried guns with them in the street. Something was going to happen. The tension needed a release. Spain was barreling toward catastrophe.

That summer, like always, a gelatinous heat settled over Madrid. Felicidad let herself be lulled into a stupor that was as much a result of the scorching temperatures as the fantasy that normal life for her and the rest of Spain could continue uninterrupted. Her sister Margot and her husband had moved back to Madrid from Buenos Aires and were living near Retiro Park. Luis was deep in his studies, aloof and moody as ever. Eloísa was at home in relative calm. Felicidad and Rafael met at a café in the afternoons to talk about how many kids they would have after they married, then he would walk her home. Despite her private political about-face, Felicidad still wrapped herself in the blinding, voluptuous vanity of love, consumed by a story that was more palatable than reality and even seemed more real than it—until reality overpowered it.

On the night of Sunday, July 12, the Blancs were preparing to return to the Basque Country for another lazy summer at the beach when Rafael called with alarming news. Falange Blueshirts had gunned down José Castillo, a prominent Republican lieutenant. Not to be outdone, a Civil Guard captain used the widespread call for retribution as an opportunity to erase another José—Calvo Sotelo, the firebrand leader of the right-wing opposition. Assault Guards went to his home in the late hours of the same night and took him away in a car. They shot him in the head and dumped his body. Both men's funerals were held at different times in the

same cemetery. Some people celebrated the escalation of violence, others feared it. "The city has a baleful, alarming look," one writer recalled. Riots erupted across Spain.

Tension ran high in the *palacete* at Manuel Silvela 8 during the uncertain days that followed. "This must not be tolerated!" Felicidad's father roared, enraged by Calvo Sotelo's murder. Right-wing party leaders boycotted the parliament and several left Madrid. Rumors of an impending mutiny swirled. The government sent military authorities to garrisons in different parts of the country, like the general they sent to Astorga. Freshly back from the United Kingdom, Leopoldo Panero reunited with his family in his home while the Blancs sat together in theirs. Luis eyed Felicidad, knowing she was secretly pro-Republic, while Eloísa defused the tension by clownishly parroting leftist jeers. "You're all a bunch of right-wingers!" she crowed. The family laughed, until Felicidad's mother hushed her, already sensing that they could no longer trust anyone. Their working-class cook— what might she think and whom might she tell?

July 16 was an eerily calm day in Madrid. Hot and sunny.

The following evening the Army of Africa rose up in Spanish Morocco.

Revolts in military garrisons and police stations throughout Spain rocked villages and cities alike for the next two days. Leftist militiamen and Loyalist officers battled for control with fascist insurgents and rebel soldiers. But the coup had yet to materialize in Madrid. State radio reports first lied that no uprising was taking place anywhere in Spain, then claimed that there had indeed been a coup that the government had handily put down. In reality, the government was in free fall. Republican officials were placing calls one after another to regional authorities and receiving the same enthusiastic Nationalist greeting from the rebel officers now in control: "*¡Arriba España!*"—"Up with Spain!"

Near Felicidad's house, thousands of trade unionists gathered in the streets to defend the Republic, waiting to be armed by the government. Elsewhere in the city other unionists and leftist youth already had eight thousand rifles between them. Their enemies need only show their faces. The suspense in Madrid felt like an achingly long fuse that kept on burning. Then on July 20, the explosion came. Felicidad woke up to shouts out in the street.

General Joaquín Fanjul and rebel soldiers had risen up in the Montaña Barracks overlooking the Manzanares River. An armed crowd had been waiting outside and the people forced the soldiers back into the fortresslike building, setting up a showdown that could only end in bloodshed. The government had freed anarchists from local prisons to aid in the defense of the capital and the city was rapidly descending into chaos.

Luis rushed into Felicidad's bedroom and opened the window.

"Get up!" he said. The fragrance of honeysuckle flooded in from the garden, soon to be replaced by three years of dust and grit. "Can't you hear the blasts?"

The two siblings stood at the window together and listened. Booms echoed across the city, some close, others distant. Once again, Felicidad's world was being divided in two, only this time it wasn't the life of her family. It was Spain itself—everyone's lives, everyone's families. The two siblings looked at each other in silence.

We're saying goodbye to something, Felicidad thought.

The greatest misfortune of all had arrived.

A FEW DAYS

The Uprising in Madrid, July to August 1936

The standoff at the Montaña Barracks lasted only until noon of the day it began. After waving a white flag of surrender to induce the angry crowd to rush the building, the rebels sprayed them with machine-gun fire. Men and women crumpled to the ground, sending the Assault Guards, militiamen, and civilians reeling back. This happened twice more, serving only to harden the resolve of the crowd, which finally broke through the gates and stormed the barracks. They threw the rebel soldiers off the upper floors, shot those who resisted, and arrested the few who managed to surrender in earnest. When the fighting was over, hundreds of bodies littered the ground as blood dried in the hot sun.

Later that day, the bell rang at Manuel Silvela 8. It was a resident from the hospital. He had come to tell José Blanc that he was needed. He was one of the country's foremost experts in blood transfusions and today the people of Madrid were losing copious amounts of blood. Soon all of Spain would rely on the techniques he had pioneered alongside a handful of

other Spanish doctors. Transfusions would save thousands of lives during the war. Yet the prospect of their patriarch leaving the house terrified the family. Felicidad's mother got down on her knees and begged her husband not to go. The blasts had stopped but the hollow clatter of gunfire persisted.

"It's my duty," José said.

He left for the hospital on foot, stepping into a ghost city. The normally busy streets were deserted, the windows of apartments shut. He called later to tell the family that he wouldn't make it home that day. There were too many wounded in need of operations.

The family waited, paralyzed, listening to conflicting reports on the radio, except for indomitable Great-aunt Eloísa, who refused to be cowed. Rafael had counseled them not to leave the house, but she pooh-poohed his warning. "This will only last a few days," she said, leaving the house to go buy food as though it were any other afternoon.

Great-aunt Eloísa returned just minutes later after nearly getting picked off by crossfire while crossing the Gran Vía. Shots and shouts rang out through the rest of the day and night.

As law and order broke down further over the coming days, the Blanc family was less frightened by stray bullets than by the fury of their fellow *madrileños*, whom the coup had unchained. Decades, even centuries, of economic resentment came gushing out. Many of the armed and empowered working-class militias occupied mansions of the aristocracy, looting their artwork and extravagant antiques and seizing their opulent collections of silver and chinaware. All of a sudden the class meant to serve the rich had taken power. Metaphorically, upstairs became downstairs and servants became masters, although many butlers and cooks and maids remained faithful to their employers.

In the city at large, military necessity quickly mixed with opportunities for revenge. Trade unions set up checkpoints and

street patrols, examining papers in search of rebel combatants and sympathizers. They sent enemies both real and imagined to *checas*, makeshift holding prisons. There was the notorious and dissonantly nicknamed Checa of Fine Arts in the basement of the building that housed a cultural organization. From here and other locations across the city, a cross section of rebel fighters, the wealthy, the politically conservative, and the innocent yet unlucky were taken out on *paseos* and shot. Bodies piled up in the royal family's former hunting grounds, and many of the executioners talked about their victims as if they were animals. Margot and her husband appeared at the house after a group of women accosted them in the street with threats. The terror in Madrid was the political inverse of the terror in Nationalist strongholds like Astorga, yet just as impulsive and violent.

The family feared above all for Luis, who withdrew into silence. Belonging to the Monarchist Youth was more than enough to land him in front of a firing squad during this lawless, panicked limbo. And he was of prime fighting age, so if the coup failed in the capital, he would have to join a Republican militia; not having done so already was a liability. At that moment young men from all corners of the city were speeding down the streets in packed cars to the emerging fronts of battle. Even young women were grabbing rifles and heading up into the hillsides of the Guadarrama to defend the Republic. Yet Luis refused to seek refuge in a foreign embassy, as a neighbor woman did a few days later when militiamen took over her chalet, tossing a painted portrait of her into a tree. At home, the climate of fear caused him to open up to Felicidad in ways he never had before, telling her about a girl he was in love with and reading her a poem he had written with the line, "To die young, so that no one may remember me . . ."

In reality, it was their father who was the most vulnerable. At the hospital, Dr. Blanc refused to operate on a rebel soldier who

had been shot in the throat during the battle at the Montaña Barracks because he was sure the young man would just be executed once he was stable. At a meeting, his colleagues accused him of having right-wing loyalties. He didn't deny that this was true but argued that he had been tending to the wounded since the very first day of the uprising and that his first obligation was to his oath as a doctor. This earned him a special dispensation, but he didn't leave the hospital to go see his family for fear of being detained at one of the checkpoints, as had occurred with one of his staff, who was killed. At home, the family didn't answer when militiamen pounded on the door, even though Rafael had managed to procure two Communist Party membership cards, one for Luis and the other for Margot's husband. Just like the Panero brothers, all across Spain people were attempting to rewrite, forge, or nullify their pasts. The Blanc family destroyed objects marked with the Las Casas seal. They lived in a mansion, owned a Hispano-Suiza luxury car, and employed a chauffeur and servants, so anything they could do to minimize their display of privilege was necessary.

After days of relentless noise and uncertainty, a fragile calm settled on the city. The uprising had been contained in Madrid. Newspapers under the command of the Republican government claimed the country was back under its control. In truth, Franco's Army of Africa was charging north toward Madrid, leaving fields of death in its wake.

During these quiet days, Felicidad and Margot dared to take a walk. They passed friends without greeting them, no one wanting to betray confidences in public that might mark them as well-to-do. Bullet holes pitted the facades of buildings they had passed countless times, and competing political graffiti emblazoned walls. Sandbags piled on corners. A half a million refugees poured in from other parts of Spain with the few possessions they'd been able to carry. The fancy crowds on

the Castellana had vanished, replaced by *milicianos*, or leftist militiamen, wearing blue coveralls and red-and-black kerchiefs with rifles on their shoulders. The Las Ventas bullfighting stadium became a mustering station for new recruits, as did movie theaters across the city. Everywhere people threw up clenched fists in the salute of the Popular Front. Back home at night, as darkness cloaked the transformed city, Felicidad and her family listened to the call and answer of rebel *pacos*—the onomatopoeic nickname for snipers—eliciting return fire from the militias.

It was a time of sweat and fear. As in Astorga, paranoia and denunciations proliferated. Nationalist radio transmissions bragged of a "fifth column" of conspirators working clandestinely in Madrid. "Every neighbor, every friend," wrote Leopoldo's friend Ricardo Gullón, who was in Madrid, "could be an informer or friend capable of dying at our side." The breakdown of the rule of law turned the city into a cradle of both heroism and cowardice as the government attempted to regroup. New leadership was needed. Communist leaders were organized and articulate, while Republican officials were discombobulated. What was happening? Spain's long tradition of *pronuciamientos*—coups producing a rapid transfer of power—was devolving into something else.

As the conflict between the two Spains stretched from July into August, José Blanc and his wife decided that it was best to move their daughter Eloísa to a hospital in a town south of Madrid. Rafael worked there and he arranged for an ambulance to come to their home to get her. It arrived at night, and as the family said goodbye to Eloísa, the most heartbroken of them all was Luis. He fell to pieces as the ambulance pulled away, holding on to his mother as if he would never see his sister again.

During the predawn hours of August 27, the Nationalist aerial attack on Madrid commenced. It was the first bombing of a civilian population in human history. German warplanes on

loan from Hitler buzzed in ominously over rooftops, unloading bombs onto the Spanish capital. Quaking explosions shattered windows, cratered streets, and sheared off the sides of buildings. The hot, deafening flashes were terrifying. At home with her family, Felicidad cowered on the floor, waiting for the attack to end. A bomb fell just three blocks away as she squeezed her sister Margot's hand. The enormous house shuddered as though it had merged with their trembling bodies. This was all-out war.

A new life had begun for Felicidad and her family that would last for the next three years: the air-raid sirens screaming out over the city; the jolting rattle of antiaircraft guns; the warplanes' sinister hum getting closer; the booming flashes of bombs as the explosions shook life itself, scattering shrapnel and setting buildings aflame; the bodies of dead men, women, and children bent and maimed in the streets; and at the night in the sky above Madrid, mortar traces scribbling patterns of light across the darkness, a show that would have been magical had it not foretold a siege that was only just beginning.

While the city's displaced inhabitants and newly arrived refugees fled into Madrid's subway tunnels and other makeshift shelters, the Blanc family moved down into the basement of their home, where they would live for the remainder of the war.

¡NO PASARÁN!

The Siege of Madrid, September 1936 to January 1939

As the autumn rains came and soaked Madrid, the front moved inside the city itself. The Nationalist troops crossed the Manzanares River into University City, where Loyalist soldiers fought classroom by classroom to hold back the advance, in some cases using stacked books as barricades, offering an alternative meaning to "the literature of war." In street fighting, militiamen took aim at the invaders across bulwarks of felled horses. Meanwhile, the citizens of Madrid fought by refusing to be afraid. The city's fierce spirit of resistance soon became the stuff of legend. People ambled past bombed-out storefronts as if they still held the products that were becoming increasingly scarce. Beneath apartment windows X-ed with tape to prevent shattering, they drank coffee on café terraces, ducking inside when the air-raid sirens wailed. Kids played games with pieces of shrapnel and learned to decipher the different whistles of incoming shells. Families made do with onions and few other vegetables. After the executions tapered off, Felicidad told an interviewer some forty years later, Madrid seemed to her almost

like a village, with silent, tranquil streets, albeit ones that might
be laid to waste by explosions at any moment. Yet at night, with
blacked-out streetlamps clothing the avenues in a shadowy blue
haze, people drank in the bars that still served alcohol. Even
after the government itself uprooted from the city in the fall, the
people who stayed were indomitable. Between buildings hung
banners with the slogan that became the city's defiant battle cry:
"*¡NO PASARÁN!*"—THEY WILL NOT PASS! MADRID WILL BE THE
TOMB OF FASCISM.

As German and Italian fighter planes battled with Soviet
ones over Madrid like crazed mosquitoes, foreign journalists
chased action all over the country, turning the war into the
first conflict in history to be broadcast "live." It wasn't just
a poetic conflict but a tragically photogenic one. Day after
day, images of death burned themselves into the memories of
readers all over the world. Just a mile away from the Blanc
home, the Hotel Florida housed Ernest Hemingway and John
Dos Passos, Dorothy Parker and Martha Gellhorn, as well as
numerous other writers who woke to mortars shaking their
rooms as smoke filled the Gran Vía from the shelling of the
nearby Telefónica Building. Everyone knew that if Madrid fell
the rest of the country would follow, or as the dramatic pro-
paganda posters plastering the city spun it: SAVE MADRID AND
WE WILL SAVE SPAIN!

During this punishing autumn as the city resisted the offen-
sive, one night Felicidad woke up with a sudden, intense pain. It
had nothing to do with the bombardments, though her insides
were twisting as if she'd been hit with shrapnel.

Her appendix had burst. She was rushed to the hospital.

José Blanc claimed to never fear performing surgery. His only
fear came before the operating theater, when deciding if surgery
was the best course of action or not. But he had never operated on
his own daughter, who now waited for him, and he was nervous.

The nurses put Felicidad under with chloroform and during the procedure she had a dream in which people shouted: *We killed her!* She was sure that she was dead, only to wake up in a quiet, sunny room. The operation had been a success.

That night her father sat by her bedside and tenderly fluffed her pillow. She had never seen this soft side of the stern demigod of a man from whom she had always futilely longed for affection. She felt euphorically uninhibited by the morphine.

"Why are you so cold with us?" she asked her father.

José Blanc grazed his daughter's face with his hand.

She felt that she had finally found her father.

And as it turned out, after she had recovered, her father had found his new nurse.

WITH THE THUNDEROUS TERROR BOMBING OF THE CONDOR LEGION CONTINUING, making the Gran Vía look like the construction site Felicidad had gazed out upon as a child, the military command decreed that all adults in the city must participate in the war effort or be evacuated. Her father suggested she work with him at the hospital. Felicidad couldn't bear the sight of blood, but she had no choice if she didn't want to be separated from her family, like Margot, who had left the city with her husband and fled to Paris.

On her first day at the hospital, the gentleness she had briefly glimpsed in her father disappeared, replaced by professional severity. As they stood on the threshold of the operating room together, Felicidad dressed head-to-toe in a white medical gown, José Blanc took her aside and said, "Don't make me look stupid by saying you feel dizzy."

During the operation, her legs trembled as her father glanced at her. But she breathed her way through it—and that was that. From then on she was fine. Eventually Felicidad even

disconcerted José Blanc by nibbling on bread while observing operations.

DURING THE LONG, HARD YEAR OF 1937, THE NATIONALISTS GAINED TERRITORY, while the Republic fought desperately to survive. The battles of Jarama, Guadalajara, Teruel, and Brunete resulted in tremendous losses of life on both sides. The Vatican recognized Franco's government and Germany invaded Austria. The official news that made it into Madrid passed through the Republican propaganda filter, which reshaped facts into a malleable plastic with only one purpose: maintaining morale. The day after the city of Málaga fell to Italian Blackshirts, for example, Madrid papers reported that nothing abnormal was occurring on any of the fronts. Felicidad's daily news was only what she saw and heard around her. The lions at the zoo roared with hunger, and a man with a rugged beard and a renegade look moved into the requisitioned house across from theirs. He seemed familiar, as if she'd seen him in the press, which it turned out she had. He was *El Campesino*—The Peasant—a mythical communist military leader (who wasn't actually a peasant). Felicidad's parents were terrified of him, especially after the day he blew her a kiss. Their fears were unfounded. He was too busy with his comings and goings from the front to pay much mind to the well-to-do family next door, save for when he had his men shovel the snow from their doorstep.

The war transformed Felicidad. Like thousands of other Spanish women, the virtuous necessities of the war effort liberated her from constraining social conventions that limited women. It allowed her to discover a new self. After her baptism by blood as a nurse at her father's hospital, she ceased being the *niña bien* of the past and developed new ideas about what she was capable of and what a woman could contribute to society. Even

if she still received amorous attention, like the ballads one of El Campesino's men sang to her from the roof, she was no longer a lovesick teenager. She was a twenty-four-year-old woman in a war zone and people needed her.

The doctors and other nurses at the hospital came to respect Felicidad, and this made her father proud. It was a civil hospital, so they didn't exclusively treat wounded soldiers. They also tended to the noncombatants who had stayed in the city, most of whom came in sick from hunger and poor living conditions; many arrived with nutrient-depleted bones that had snapped during ordinary tasks. Felicidad's bedside manner was comforting to the people whose hands she held before they went into the operating room. Once, a young man who had been shot near his heart asked her if he was going to die. She lied and told him he would be fine. Later she saw him wheeled out of the operating room under a white sheet. On another occasion, she cared for a young girl whose legs had been blown off.

Such experiences were difficult knowing that her brother Luis could end up in a similar state in a hospital in some other part of the country. In the spring of 1937, men in the city with his year of birth were officially conscripted, and this had made him happy. He told Felicidad he was tired of hiding out in their house while others died. Whether or not Luis had truly come around to the cause of the Republic when he boarded the truck that took him up into the mountains outside Madrid, when he returned home on his first leave he was committed to fighting the Nationalists. At the start, it hadn't been easy. Several of his fellow soldiers had done work as plumbers and carpenters at the Blanc mansion and recognized him. "How much work did you have done?" Luis teased his parents. It was only a joking matter because the other men had ended up accepting him as one of their own, unlike other fellow soldiers who were shot as traitors. He taught those of his new comrades who were illiterate how to

read, just as Felicidad was doing with neighborhood kids during her off-hours. When his leave ended, Luis was furious to learn that his father had arranged for him to be sent to a different unit, a safer one away from the front. His political conversion, a mask that became his real face, resembled that of the man his younger sister would meet after the war, only in reverse, from right to left.

After Luis departed again, the rest of the people in Felicidad's life began abandoning her one by one. She received a letter from Rafael saying that everything had changed and it was over between them. She strolled alone, crying, through the empty streets of her once elegant, now ruined neighborhood. Her past, like love itself, was the crumbling masonry of destroyed apartment buildings. Everyone she had known before the war seemed to be either dead, missing, or in the "other zone" like her sister Eloísa, whom the family wouldn't see again until after the war, since her asylum had fallen under Nationalist control. Even Great-aunt Eloísa, that flinty rock of a woman Felicidad's sister was named after, drifted away like gunsmoke, yet without actually going anywhere.

The war had worn Great-aunt Eloísa down. She had lost an alarming amount of weight and she no longer appeared to care if she lived or died. While the rest of the family slept in the cold but secure basement, Great-aunt Eloísa slept in her room as German and Italian planes droned overhead, her last act of willfulness, or simply fatalistic surrender. A child of the nineteenth century, the ingenious brutality of the twentieth was showing her to the door before worse horrors could come. Her health rapidly failed. One day she became delirious. Felicidad and her mother and father took Great-aunt Eloísa down to a bed in the basement. The family dog began barking in the garden.

"He senses death," José Blanc said.

Early in the morning, Great-aunt Eloísa died. Felicidad was no longer a stranger to such things. She and her father wrapped

her great-aunt in a sheet. The next day, they took her to the cemetery, where coffin after coffin arrived. The shortage of wood in Madrid was so severe, and the death toll so high, that most families rented coffins instead of buying them.

MORE ALONE NOW THAN EVER AT THE HOUSE, FELICIDAD SLIPPED BACK INTO HER world of books. While the war had reinforced the joints of her being into a structure that was tougher and more durable, literature was still her foundation. No matter the carnage she witnessed, she didn't lose her infatuation with infatuation, her romance with romance. If anything, so much tragedy underscored the need for beauty in life, the sense that misfortune was inevitable, so all one could hope to do was give it aesthetic meaning, to reshape life with words, to turn pain into poetry. Books were her instruction manual.

Felicidad sat in the garden and read as mortars exploded in the distance. She read *Madame Bovary* and became Flaubert's heroine, just as she read *War and Peace* and became Natasha. But where was Emma Bovary's passion in her life, where was her Prince Andrei? If the war had turned her into one of the helpless dolls that she had played with as a child, why couldn't she control the drama? During this time, amid her family's hardships, she became obsessed with another family—the House of Wittelsbach.

The Wittelsbachs were a royal Bavarian dynasty whose main line went extinct in 1918. Felicidad found the decadent decline of the family captivating, most of all that of Ludwig II, the legendary "Swan King" who withdrew from his imperial responsibilities to dedicate himself to building extravagant palaces. He was a patron of the German composer Richard Wagner, whom Hitler was busy championing as a Nazi idol at the same time that Felicidad was reading about him. Ludwig II ended up going mad and drowning

under mysterious circumstances. During the lonely hours away from the hospital while she read, the fall of the House of Wittelsbach sifted down deep into Felicidad's psyche. She lost herself in reveries about the characters of the story, trying to forget the artillery shells that fell nearby. She would pass her fascination with the Wittelsbach myth on to her own male heirs, who would in turn use it to reinvent the myths of their family.

LUIS WAS BACK AT THE FRONT, HAVING MANEUVERED HIS WAY OUT OF THE REAR-GUARD unit his father had pulled strings to get him assigned to. He visited the family after the bloody subzero Battle of Teruel, which he had fought in, concluded in February 1938. While home, he told Felicidad that if he didn't make it back again, he wanted her to have all of his books. His fatalism unnerved her.

"Why do you say that?" she asked.

"Because I sense that I won't return, and that is what I most want." Luis had witnessed the romance of death and now yearned for it. "The other day I saw a column advance singing 'Red Flag,'" he said. "They killed nearly all of them, and know what I thought? That it was a beautiful way to die, it was to die for something. If I die like that, like an unknown soldier, I'd like if the family didn't know what my death was like."

Fortunately, Luis was reassigned to relatively tranquil Valencia, where restaurants still operated with normality, people could buy fruit, and the city wasn't an apocalyptic tableau of bitter hunger, expanding debris, and mounting corpses.

The Blanc family continued their wartime vigil in the basement. Now that Great-aunt Eloísa was gone, Felicidad's mother transformed, taking charge of the house in a way she never had before. The family ate watery soups with stale bread and read to one another by candlelight, like many other families. As the conservative novelist Agustín de Foxá would satirically comment,

"A part of the Spanish bourgeoisie needed 30,000 executions in order to dedicate themselves to reading." The Blancs also read the letters Luis sent them, but as the year wore on, the letters stopped coming. The Battle of the Ebro began, lasting from July to November, until the Popular army, no longer able to withstand the material superiority of the Nationalists, retreated back across the flooded river, losing ground it had bitterly won. Luis was in this area of the country and the family didn't know what his involvement in the fighting might be. Franco was tightening the noose around Valencia and Barcelona, and after the Munich Agreement in September, which allowed Hitler's annexation of Czechoslovakia, it looked like fascism would soon overtake all of Europe.

After the new year, Madrid began to regain some of its former shape as its inhabitants prepared for the inevitable end of the war. The city had put up a heroic fight, but if the last remaining pockets of the Republic fell, so would the capital. Felicidad reconnected with old friends—everyone looked older—and also made new ones. She felt halfway good again just knowing all the suffering would soon wind down, until one day she returned home to find her mother crying. She held a letter with the letterhead of Luis's unit: he had been taken prisoner at the Ebro. The family wrote to Margot, in Paris, who visited the headquarters of the Nationalist diplomats there. They informed her that the letter from Luis's officers was incorrect. Euphemistically, they explained what had really happened: *No prisoners were taken that day.*

Once again, Luis, the prophet, had foretold the family's misfortune, and he had died exactly how he had wanted, shrouded in the unknown. Like a character from a novel—the novel of life—Luis was now one of Felicidad's "dead companions."

WE WON'T BE THE SAME

The Fall of the Republic, January 1939 to May 1939

I n early 1939, the Civil War began its final phase while the rest of Europe moved on from the drama in Spain, readying itself for its own cataclysm. On February 1, the Republican parliament met for the last time. Two weeks later, Franco signed the Law of Political Responsibilities, the legal framework he would use after the war to punish the people who had supported the Republic. At the end of February, Britain and France officially recognized Franco's government. Now it was just a matter of how he would conduct the choreography of victory and defeat, and how many people would still have to die.

In early March, shots rang out near the Blanc home. Shouts of street fighting followed. Soldiers rushed inside their *palacete* and traded fire with troops in the building across the street, which held the Republican radio headquarters. Felicidad thought it was the beginning of the last stand against the Nationalists. She was ready to take part—but the enemy soldiers were also from the Popular army. A war within a war had broken out.

A Popular Front colonel, Segismundo Casado, had rebelled

against his own superiors, who wanted to continue fighting Franco in the hope that the outbreak of the looming world war would finally spur the European democracies to aid the Republic. Colonel Casado and others, however, believed it was time for unconditional surrender, which they hoped might soften Franco's thirst for reprisals. His coup toppled the government, bringing a close to the epic siege and legendary defense of Madrid. As the Popular army dissolved and the city waited for Franco's forces to converge, the Nationalist sympathizers and fifth columnists who had been living under fake identities, hiding in friends' and relatives' homes, and taking refuge in foreign embassies, emerged, pale and victorious, stepping into the spring sunshine. And like partners in a dance, losers of the war now sought asylum in those same embassies.

Felicidad's mother took down the Republican flag at their home. Her parents had supported the Republican struggle because they had to, because the war had *caught* them in Madrid. But now were they really to pretend that they welcomed the forces that had bombarded them for three years and killed their son? Likewise, Leopoldo Panero, who was in Barcelona looking for socks, would have to evaluate where his loyalties would lie in the bewildering, brave new world of peace.

At the end of March, Felicidad was out with a friend amid the abandoned trenches and uprooted trees that had become her cityscape, when the first trucks filled with victors waving the bicolor monarchist Spanish flag rolled into Madrid. "Up with Spain!" they shouted, throwing the fascist salute. People were coming in from all over the country to celebrate. "[It was] the same carnivalesque mood of the 14th of April, upon the proclamation of the Republic," wrote a Chilean diplomat in his diary. Of course, this jubilation was actually the definitive end of the Republic. The people looked like aliens from another race to Felicidad. She held back tears, feeling that same old melancholy

identification with lost causes that she and Luis had always felt, only this time the lost cause was her own and Luis wasn't alive to share it with her. She remembered something he had said to her on his last visit home, when he talked about what life would be like after the war. *We won't be the same*, he said. It was true. She wasn't the same. Neither was her family. And neither was the rest of Spain, conquerors and conquered alike.

On April 1, Felicidad listened on the radio to the reading of Franco's last wartime message: "The Nationalist troops have achieved their final military objectives. The war is over."

The plazas of Madrid filled with ecstatic crowds who sang victory songs to the soldiers marching through the streets. "*¡Han pasado!*" people chanted—"They have passed!" To Felicidad it felt like an occupation. Indeed, Nationalist soldiers all over Spain were searching offices and warehouses to collect incriminating documents on people from the losing side. Felicidad's membership card for the Republican Left political party would end up in the massive archive the government amassed. She didn't know this and, anyway, wasn't ready to contemplate what the future might hold. She was sinking into the past, seduced by its nostalgic siren song. *Now we must retrace those three years*, she thought. *Go back in time, remake what was lost*. But that was impossible.

In May, Francisco Franco rode into Madrid in a grandiose procession announcing the arrival of the country's new warrior-king and ruler. His regime had already started renaming the streets. The Avenida de la Castellana was now the Avenida of Generalísimo Franco. Down it paraded the victors in an orgy of martial glory that lasted five hours: Falangists and army officers, Italian Blackshirts and Moors, *Requetés* and legionnaires. The crowd cheered at the pageant of tanks, crucifixes, and horses. For the victors the day marked a modern-day reconquest of Spain. In the rainy sky above, biplanes wrote a message that undulated over the festivities: *VIVA FRANCO*—LONG LIVE FRANCO.

As Franco inaugurated his dominion over Spain, Felicidad began rebuilding her life in much the same way masons were rebuilding Madrid—lifting a new structure out of the rubble. One day an old flame, who was now married, showed up at the house to visit her. A piece of writing she later published suggested they shared an illicit kiss. Nothing would come of this fleeting dalliance, but it allowed her to recall "our youth that once made us think that everything was possible." That innocent Madrid was gone, but in this lost past she glimpsed a hope for the future. She thought that maybe she could be happy again. Perhaps she might finally live up to her name.

PART 2

LA FAMILIA
1940–1962

"Where was my mistake? Perhaps in confusing literature with life. Books are made to be read, not to live them out next to those who write them."
—FELICIDAD BLANC

"Make your thoughts and your words hold up against your life."
—LEOPOLDO PANERO

LIGHT ENTERS THE HEART

A Blind Date, Winter 1940

Late in the cold, snowy winter of 1940, Felicidad stood inside the entrance of the Prado Museum, waiting for her blind date. She gazed at *La Gioconda*, the oldest known copy of the *Mona Lisa*, painted by an apprentice in Leonardo da Vinci's studio. The mysterious woman in the portrait gazed back. The sixteenth-century painting had recently returned to the Prado along with works by Goya, El Greco, and Velázquez, as well as much of the rest of the enormous collection the Republic had crated out of Madrid for safekeeping during the war. The new regime had made a propaganda show of having rescued Spain's artistic patrimony from the "Reds," and in the fall the museum had reopened. Felicidad was the one who had chosen this meeting place for the date. *La Gioconda*'s presence reflected her sense that life benefited from the touch of art, and as a regular at the Prado since she was a child, she hoped to use her knowledge of art history to impress the man friends had set her up with. His name was Leopoldo Panero.

She was pessimistic about the date. She only felt at ease with

people like her who had lived through the siege of Madrid, and this Leopoldo had spent the war in the Nationalist zone. Even if he was a poet, which attracted her, he surely wrote gratingly patriotic verses about the "new Spain." But her friends had told her that he, too, had suffered; apparently, he'd nearly been executed. They were certain the two would connect.

Felicidad noticed a handsome man dressed in dark clothing enter the gallery. He was alone. She realized she preferred it this way, without their friends as chaperones.

Their gazes met and Felicidad felt an unmistakable passion quiver between them as another set of eyes—La Gioconda's—observed them enigmatically. After her initial elation at the war ending, the abyss of her brother Luis's absence had swallowed her. But what if this was the love that could cure her loneliness?

Except the man wasn't Leopoldo Panero.

Escaping Felicidad's notice, her friends María Teresa and José Antonio had walked into the museum with someone else—the real Leopoldo Panero. He had a beak of a nose, a hairline in retreat, and bony shoulders. She greeted her friends, who introduced her to her date. She noted his large, rough hands. Not the hands of a poet.

I hate him, Felicidad thought.

The foursome moved on into the interlocking galleries. There on the wall hung *Las Meninas*, Velázquez's depiction of himself painting the Infanta amid her retinue; and there the hallucinatory triptych of Bosch's *Garden of Earthly Delights*, newly arrived from the king's former residence at El Escorial. As they took in the works that the war had buffeted but failed to destroy, like Felicidad and Leopoldo themselves, a chill grew between them, as though the harsh winter that had blanketed the city in snow was gusting into the museum. He didn't seem any more interested in her than she was in him. At the end of

the date, the two said a cool goodbye and went their separate ways.

LIKE TWENTY-SEVEN-YEAR-OLD FELICIDAD, THIRTY-YEAR-OLD LEOPOLDO, TOO, WAS struggling to find where he belonged in a changed Spain that was only just beginning to reconstruct itself. He had recently moved into an apartment that he shared with three of his sisters north of Retiro Park. His mother insisted on keeping her four unwed children in Madrid, out of reach of the vindictive intrigues of Astorga. Denunciations against neighbors for alleged left-wing crimes were now an institutionalized part of Spain's vengeful new judicial system. Just as during the war, memory was a weapon. If associations with "anti-Spain" stained your past, then you might lose your property, go to jail, or be disallowed to practice your profession. The fear of reprisals was so intense it drove some people to extremes. The former Republican mayor of a town in Málaga, for example, would spend thirty years hiding in a bunker beneath his home. Máxima came down for extended stays in the Madrid apartment, where she doted on her youngest daughter, Charito, Leopoldo's vivacious little sister who had recently turned twenty.

Like nearly every other family in Spain, the Paneros bore the heavy weight of the past in a present that demanded great forti-tude. "The war left a deep mark on the family," a cousin wrote. "The deaths of Juan and Ángel, the persecution of Leopoldo and his father, shook that house of happiness, which never returned to how it was before." An air of sorrow clung to Máxima like a shadow, and the same went for her remaining son, who hoped to remake his life in the city where he had come of age. But it wasn't the same city. The pulsing dynamo of prewar Madrid was a Spanish Atlantis, vanished into the sea of history. It had been replaced by a shattered metropolis beginning what would be called *los años de hambre*—the years of hunger. Nowhere was this

more visible than in the outskirts of the city, where impoverished political undesirables lived in subhuman conditions.

By comparison, the Paneros were fortunate. Even so, the future offered little cause for optimism and no guarantees. Uncertainty stretched in all directions. With Leopoldo's stint in San Marcos blemishing his past, it was unlikely that he had any chance at the diplomatic career he'd spent so many years studying for, in spite of having served in Franco's army as a solider and poet. His literary prospects in Spain looked only slightly better. Poetry, Leopoldo's abiding raison d'être, was itself like a destroyed city.

Lorca wasn't the only important Spanish writer who hadn't survived the war. The indomitable Miguel de Unamuno was gone, too. The bearded university rector who had spoken out against the rebellion in front of Franco's most rabid supporters had passed away in his home the month after Máxima had sought out his help in Salamanca. Another of Leopoldo's idols, Antonio Machado, hadn't been so lucky to die in his own bed, expiring in a hotel in France while fleeing Franco's forces during the refugee exodus at the end of the war. Meanwhile, the still-living members of the Spanish literary establishment that opposed the Nationalists—nearly every poet Leopoldo had looked up to as a young man—were largely marooned in exile. Many floated stateless through the cities of Europe, where states themselves were dissolving as the Nazi army spilled across the continent. Those who had fought for the Republic and chose not to leave Spain—or weren't able to—faced Franco's Law of Political Responsibilities. Such was the case for the poet-soldier Miguel Hernández, whom Leopoldo and Juan had known in their heady Madrid years. He was at that very moment wasting away in a jail near the Gran Vía, and in March, soon after Leopoldo's blind date with Felicidad, he was sentenced to death. In the new Spain, however, this was an unremarkable outcome.

Since the war, executions were taking place at such a ferocious

pace that Franco, who at first signed all the orders himself, was finally forced to delegate the ever-growing pile on his desk. The regime's draconian legal doctrine effectively turned the past into a fence with which to entrap (and kill) its already defeated enemies, in tandem with actual fences that imprisoned over 270,000 people in the dictatorship's squalid concentration and work camps, where they suffered from typhus and dysentery, lived with fleas and poor sanitation, and had to sing Falangist anthems while holding their arms up in the fascist salute. Women's prisons in Madrid filled and some twelve thousand infants and children would be taken from incarcerated mothers and placed in orphanages or with regime-approved families. Soon prisoners would even be forced to donate blood for transfusions for the Nazi army. The Law of Political Responsibilities criminalized and fined not only people who had opposed, or just failed to support, the uprising in 1936. It reached back to 1934 and punished those who had supported progressive parties back when Spain was democratic. This, of course, included Leopoldo. In fact, the regime's security apparatus had a special designation for people like him with left-wing records who had joined the Falange: Category B.

In spite of this climate of fear, by the winter of 1940 the literary culture that remained in Madrid had begun piecing itself back together at the Café Lyon, the same café where Leopoldo, Luis Rosales, and Juan used to gather. Writers and members of Leopoldo's generation—the Generation of '36, as they would be called, marking the year that slashed so many lives into a before and after—gathered to smoke cigarettes, drink coffee and alcohol, and argue not only about literature but about the news filtering in from the rest of the world.

Since Hitler had invaded Poland in September 1939, unleashing the global conflict the Civil War had been a rehearsal for, Nazism had become a fad in Spain. It meshed seamlessly with Franco's self-serving performance of fascism. The regime hung

the yoke and arrows of the Falange insignia from the Telefónica Building and celebrated the third anniversary of José Antonio Primo de Rivera's execution with a ten-day, torchlit procession that carried his remains five hundred kilometers from Alicante to Madrid. On the radio, meanwhile, newscasters championed Nazi battlefield victories, and Heinrich Himmler visited Spain that fall. (The chief of the SS found bullfighting too barbarous for his tastes.) Against the convulsive backdrop of the war in Europe, Madrid was conspicuously quiet as Franco weighed his imperial ambitions and admiration for Hitler against Spain's empty war chest. Despite his newfound *falangista* leanings, Leopoldo retained many of his old affinities, including his Anglophilia, and he openly rooted for the Allies.

Along with literary cafés, other prewar cultural institutions were beginning to reanimate themselves in Madrid. A month after his misfire of a blind date, Leopoldo went to a Sunday concert with Luis Rosales at a theater near the Prado. As they entered, he ran into none other than languid, blue-eyed Felicidad. Although their first encounter had been far from electric, the standoffish distance Felicidad had felt between them dissolved. After the performance, Leopoldo offered to walk her home.

"Since I met you I have this strange feeling," he said as they strolled north toward her house on Manuel Silvela. "When I look at you I don't see you as young. I see you already as older, with wrinkles, walking along the wall of Astorga, at the end of life."

The wall of defects Felicidad had first seen in Leopoldo crumbled, revealing a different person. His words were better than any of her French romance novels.

I'm in love with him, Felicidad thought.

SOON AFTER, SHE AND LEOPOLDO SPENT AN AFTERNOON TOGETHER. THIS SECOND date went better than their first. They talked easily. Felicidad

discovered that she really did like the poet with the hands of a peasant, especially how cultured he was. She was also attracted to the sadness they shared, to their twin misfortunes. "Maybe it was that postwar atmosphere with the memories so close, the wounds still open," she wrote. "What united us both was the pain of having lost a brother. Or maybe it was owed to our disorientation, to our loneliness." Whatever the source of attraction, they had a connection more real than the one she had fleetingly projected onto the darkly dressed man at the Prado.

Leopoldo and Felicidad began meeting at the Café de las Salesas, an old-time Madrid haunt with bow-tied waiters, plush red couches, and mirrored walls that seemed to double the size of the establishment. She related fragments of her life during the war and told him about her brother Luis. Leopoldo understood her stories and related his own with an absence of anger that astonished her. When he talked about waiting to die in San Marcos, his gaze would drift off as he described the sunsets outside his cell window. She grasped the contradictions of his wartime life, the arc of his political apostasy. Luis had crossed the same divide that had split Spain in two, just in the other direction. But neither of the two wanted to talk excessively about the past they had been lucky enough to survive, as if pooling their memories together might release a deluge that would drown them.

As spring arrived, sunshine nibbled at the snow, and the layer of ice covering the paddle-boat pond at the Retiro thawed. This was a welcome change in a city where gas to sufficiently heat homes was nearly as hard to come by as the money to pay for it. The war had left Spain's economy like the country's infrastructure—in ruins. Jobs were scarce and it wasn't uncommon to hear people say that half of Spain was in prison while the other half was going hungry. The government had instituted a strict rationing policy the month after the war ended

that would last for twelve years. Ragged lines curled outside of dispensaries. Supplies often ran short and fights broke out. These straitened conditions gave rise to a booming black market known as *el estraperlo*. Food and other basic goods that had previously been accessible to most Spaniards now went for stratospheric prices. Fortunes would be made by speculators, often with ties to the regime, who exploited shortages to gouge prices. Leopoldo queued up in the rationing lines like everyone else and sent a portion of his allotted tobacco ration—two packs a week—to his father Moisés in Astorga. Yet in spite of these hard times, this was an idyllic period for Leopoldo and Felicidad, though not without its bumps.

When Felicidad met Leopoldo's sisters, she discovered that the *niña bien* of her past hadn't been entirely ground down by the war. The Paneros were upper class, yes, but they were *provincial*. The family wasn't of the same urban caste as hers. She thought the Panero girls were lacking in taste, their manners unrefined. Neither was she charmed by Luis Rosales, whose joined-at-the-hip friendship with her new boyfriend would prompt her to call him Leopoldo's "other me." When they all went out dancing one night, she felt Luis's teasing eyes pressing on her from behind his glasses. Perhaps none of this would have bothered her if Leopoldo didn't frustrate her sometimes. He had a tendency to withdraw into opacity and his unreadability wasn't something she imagined. A friend of Leopoldo's called him "the man of the secret." He was guarded about what went on in his head even when Felicidad asked, like the day they attended a talk at the French Institute. She noticed him scribbling in a notebook.

"What are you writing?" Felicidad said.

Leopoldo brushed her off. "Nothing. Just some notes."

This upset her. It seemed to confirm her feeling that he didn't see them as equals, that he had more control over their

interactions than she did. The war had showed her that she was capable of much more than she had ever thought, and that being a woman in Spain could encompass more than just submissively keeping house, caring for children, and offering decorous conversation. The new culture that was taking shape under Franco, however, sought to erase those gains. Women who had stepped out from the shadows of domestic life had to return to the diminished roles from which they had briefly emerged. Soon enough, the regime would make male superiority an article of state, legislating that "the national community is founded on the man, as the bearer of eternal values." Her past might not bear the stamp of Category B like Leopoldo's, but her life was stamped with the category of Woman. Was he willing to see past that and actually appreciate her?

A few days after the talk at the French Institute, they got into a fight. She was convinced that her relationship with Leopoldo was over until a letter from him arrived at her house containing a poem he had written for her titled "Cántico." It turned out he had been jotting down notes for it at the talk, which is why he had chosen not to share it with her. Now here was the secret from the man of the secret, and it was just for her:

> *Your beauty is true. It is true. How such light*
> *enters the heart! How the soul that finds you*
> *breathes in your aroma of earth in spring!*
> *It is true. Your skin has the penumbra of a dove.*

Sixteen more stanzas followed, flowing with song and sentiment. Leopoldo elevated Felicidad into a metaphor that contained life and death, nature and humanity. He seemed to reach out through his verses and touch "the joyful wheat of her hair." He captured the paradox of how love both connected two souls

while failing to fuse them into one. "Naked and alone," he wrote, "my heart watches you." And he imagined assuaging Felicidad's isolation, describing her as "a sad, unknown island."

"You," Leopoldo wrote, "are the presence of God."

There was nothing in the world Felicidad adored more than words on a page, and these words were for her and about her. It was as if poetry could reconstruct anything and repair all that was broken. Leopoldo had transformed her into literature.

She needed to be with him.

IF WE KNOW HOW TO DESERVE OUR HAPPINESS

Love and Poetry in Postwar Spain, January to October 1940

Leopoldo's poem mended things between him and Felicidad, while also serving a greater purpose. It became the balm she applied to the subsequent stings of disappointment she experienced as she got to know him better that spring: how Leopoldo often drifted off into distraction; how he suggested she get rid of books from her collection because he had them; how his less than dashing looks remained just that. All of this Felicidad remedied by rereading "Cántico" again and again. It fed her vanity, soothed her sadness, and transformed her loneliness. It was as if Leopoldo's poetry could right all the imperfections of the man who had written them. Did it matter that the reality from which the poem sprung wasn't ever as perfect as the verses it inspired? She told herself it didn't. She yearned for life and literature to be one.

Leopoldo also blurred romantic and literary attraction, as was his custom. In Felicidad he had discovered a new muse, a shield with which to protect himself against the writer's block

that had plagued him after Juan's death. And thanks to her, he found inspiration with which to feed another hungry muse— Academia Musa Musae.

Through the stewardship of senior members of the remaining literary community in Madrid, Luis Rosales pushed for the informal gatherings at the Café Lyon to take on a more official character, as a literary *peña*, or "club." The Academia—whose name in Latin meant Place of the Muses—had celebrated its first meeting in the National Library, where statues of Miguel de Cervantes and Lope de Vega guarded the grand neoclassical entrance. Excluding women from participation, the club brought together over a hundred writers who would shape postwar Spanish letters—or so its regime boosters hoped. The reality was much more complex. The few true artists among Nationalist writers needed time to rediscover their craft outside the dysmorphia of ideologies; those who wished to, that is. At the same time, exiled writers were starting to publish significant works abroad, while at home in Spain an *exilio interior*, or "internal exile," would emerge, neither allying itself with the dictatorship nor openly challenging it. This assemblage of tensions reflected the literary problem, which was also a political problem, built into the fundamental mandate of Francoism and all authoritarian regimes: the subordination of the individual to the state. Yet at Musa Musae, (male) individuals of all stripes were welcome: fascists, monarchists, politically ambiguous opportunists, and even leftists looking to reinvent themselves (one Republican member had changed his name). Leopoldo was a complicated, even baffling amalgam of all of these types.

Sporting a suit and tie with a pocket kerchief, with slicked-back hair and a pencil mustache considered a Francoist aesthetic, Leopoldo attended Musa Musae from its inception. In the audience he sat among the newly appointed gatekeepers of the arts and the fascist visionaries tasked with refashioning

Spanish culture. At the club's third meeting, held in early April in the Museum of Modern Art, Leopoldo read his poetry. He had a formidable baritone with a cello-like gravity, and his voice made an impression on the audience. He read a poem about Joaquina Márquez, followed by the poem he'd written at the end of the war about Juan. He concluded, however, with his poem about the person who was most alive for him at that moment—Felicidad. He read "Cántico," whose last lines merged his new love with old Spanish tradition.

"You are the word that the Angel declared to Mary," Leopoldo read, "announcing to death the unity of all beings!"

Afterward, the literati gathered outside the museum. One man commented that Leopoldo's reading had been like a brilliant performance by a bullfighter. The next day, a newspaper published an article praising his poetry. One friend who was present that night wrote, "No one questioned that a poet with a very personal voice had appeared." But would this be enough to secure a place for him in the new Spain?

THAT SUMMER FRANCO OFFICIALLY DECLARED SPAIN'S NONBELLIGERENCE IN THE rapidly intensifying world war. This wasn't the same thing as neutrality. To the Allies, Franco's position looked like a hedge as he rebuilt his country's military in order to join the fight alongside Germany and Italy, whose support had been so decisive in his victory over the Republic. In reality, Franco was more than willing to make a pact with Hitler and Mussolini, but only if they offered Spain colonial territories in his beloved North Africa. Franco boldly made this demand at the same time that he refused Germany's request to occupy one of the Canary Islands. The führer bristled at this, especially since Spain had yet to pay back its Civil War debt. The negotiations between the two countries were contentious. As the Third Reich's ambassador in

Madrid put it, "Spain cannot expect us to provide her with a new colonial empire through our victories and get nothing for it."

Meanwhile, the unforgiving Spanish sun beat down on the whitewashed villages of the south, the tawny hide of the Castilian plains, and the thawing slopes of the Pyrenees. Historically, life in Spain slowed during the summer, even in busy cities like Madrid, where the air seemed to thicken into a wax. Those who could sought refuge from the heat at the beach, in country homes, or wherever shade was found. The war had interrupted the sacred institution of vacation, but this year it was breathing back to life, at least for privileged Spaniards like Leopoldo and Felicidad, whose families demanded their presence. This meant that the couple would have to spend nearly three months apart.

Felicidad would be heading north with her family to a town on the Atlantic coast, where she had first fallen in love with the sea as child. There she would reunite with her sister Margot, who had returned to Spain. Leopoldo went home to landlocked Astorga. But before saying goodbye, he and Felicidad came to a decision: they were going to get married—if they could get their parents' approval.

THE SUMMER REPRESENTED AN IMPORTANT HOMECOMING FOR LEOPOLDO. THE LOVE of his family had been the one constant he could depend on while everything else in his life seemed fated to change. Not only was Juan no longer with them, and Astorga no longer a safe haven for the Paneros, but their prosperity was fading. The family's businesses weren't doing well. Leopoldo's mother, whom he idolized, increasingly questioned her husband's handling of the family's finances, but this wasn't the only stress Moisés had to deal with. The regime's newly formed Special Jurisdiction for the Repression of Freemasonry and Communism, a judicial inquisition against Franco's enemies, had opened a file on him.

In the nest of his aggrieved yet still close family Felicidad nonetheless dominated Leopoldo's thoughts as he sat with his sisters out in the garden or took walks at Villa Odila. "I didn't know I loved you so much," he wrote her in a letter, "that it would be so difficult to be alone, that I would feel so much pain being away from you. You are the best thing in my life; you are at once the memory and hope of my heart. Returning home to my old things, my teenage bedroom, the places where I dreamed so much, I'm allowing my hopes to descend on them; I'm including them again in the currents of my inner time and connecting them sweetly to my future life. I owe you lots of things, and among them, not the smallest of these is, you are the only person who has been able to make me contemplate with whole and bare joy this world that for me had been tinged with sadness. . . . We will be truly fortunate if we know how to deserve our happiness."

Felicidad received this letter in Madrid just before heading north to the beach. "The hours have become so long since you left that these three days without hearing from you seem like a century," she wrote back. "When you were here I never thought the pain at not having you would be so great, but the more days that pass the larger the emptiness and loneliness I feel."

After Felicidad made her way to the north, she and Leopoldo volleyed more letters back and forth with a feverish intensity. The two seemed as besotted with each other as with the literary drama of their separation. As the weeks wore on, Felicidad's tenacious melancholy perplexed Leopoldo. He was full of nostalgia and desire, he told her, but he wasn't depressed. She strove to be more upbeat. In August they nearly broke up when her train back to Madrid made a stop in León and he failed to make it there in time to see her, as promised. In their letters they occasionally made passing references to events outside of Spain, but Leopoldo couldn't mention even the war that was consuming Europe without repurposing it as the medium through which to express his

longing for Felicidad. "To hear the whistle of the mailman has a meaning deeper than learning of the fall of Paris," he wrote her with a starry-eyed vastness that would have seemed comical if it weren't so earnest. "To receive a photo of you would only be matched, for example, by the United States declaring war on Germany."

Their correspondence had the love-drunk breathlessness of two dreamy adolescents, but how truly *real* was this love? Were Leopoldo's letters another poetic fantasy? Did Felicidad love him or just his poetry that she inspired? Were their desires for the relationship the true literary work, a myth eclipsing the reality of the other person?

This much is clear: damaged by loss, engulfed by uncertainty, and seduced by literature, Leopoldo and Felicidad seemed cosmically suited to fall for each other in such a way that would make disillusionment inevitable.

WHEN LEOPOLDO RETURNED TO MADRID IN OCTOBER, HE BROUGHT FELICIDAD TWO NEW poems he'd written for her, as well as news of a conversation he'd had with his parents: they approved of their marriage.

TRIUMPH OF LOVE

Wedding and War, October 1940 to May 1941

On the afternoon of October 23, 1940, a train carried Francisco Franco into the railway station in the French town of Hendaye, just across the border from Spain. Waiting for him was Adolf Hitler. The two dictators were at last to meet in person to discuss their common ground in the escalating global war. On the train platform, the *Caudillo* greeted the führer with an enthusiastic handshake and jolly grin seemingly more suited to an exhibition golf match than the meeting of two murderous dictators. Together they marched past a formation of the SS honor guard, giving the soldiers the fascist salute. After these formalities, they convened in a car of Hitler's private train, each with their entourage of advisers, for what turned out to be a long and fruitless meeting.

While hagiographers of Franco would claim that he valiantly held off threats by Hitler to force Spain into the war, in reality the Generalísimo exasperated Hitler with his gentle, rambling self-regard and untenable demands. Germany was neither eager to have Spain enter the war, nor willing to concede it conquered territories, so the conversation went nowhere. At the end of the

meeting, Franco agreed to a secret protocol between the two countries that served as a loose commitment from Spain to back the Nazis if Germany ever truly needed help.

Back in Madrid, people were more concerned with securing food than with the World War. That fall a grain crisis further punished an already underfed populace. In spite of the Francoist slogan, *Not one home without heat, not one Spaniard without bread,* the cherished Spanish staple of a fresh-baked loaf of bread cost about the average daily wage, making it unavailable to most homes, and less appetizing when it was made with substitute flour. In many a household, iconic dishes like the *tortilla española* lost their identity by way of losing their ingredients, not to mention their nourishment. This Spanish omelet, a juicy golden disk of egg and potatoes, often became a sad parody of tradition—made without eggs or potatoes. For millions of Spaniards, however, things were much worse. It was common to see adults and children in rags on the streets picking food out of slop pails. Disease abounded and large numbers of women turned to prostitution to survive. These and other realities of Spanish life didn't appear in newspapers, which peddled propaganda. A policy of omission told the real story of the times, as did the writer Camilo José Cela, a friend of Leopoldo's who captured the honeycomb of desperation of Madrid apartment buildings in his censored novel *The Hive.* Populating the book were pious mothers and adulterous fathers, persecuted sons and deflowered daughters, scheming bosses and exploited workers, war orphans and night watchmen. The city buzzed with secrets and toil, anxiety and gossip.

Leopoldo later described postwar Spaniards as "millionaires of crumbs," and amid such a state of affairs, José Blanc and Felicidad Bergnes de Las Casas were reluctant to give their daughter away. While Máxima and Moisés's only condition had been a sentimental one—that Leopoldo and Felicidad marry on the

same day they had, May 29—Felicidad's father disapproved of her suitor's dismal financial prospects and her mother doubted that Leopoldo was the right man for her daughter to wager her marital happiness on. She had observed Felicidad's anguish during the couple's fights, and under Franco, the stakes for entering into marriage were higher than ever. Divorce had been abolished and men had in effect become the legal guardians of their wives. If Felicidad wanted to get a job, travel alone, or open her own bank account, she would need Leopoldo's consent.

But she was determined to marry him, and the sooner the better. Her parents were planning to bring her sister Eloísa back from the mental hospital to live with the family again and Felicidad didn't think she could bear the daily onslaught of her delusions taking over the house again. "I'm coming to Madrid determined to find a solution for our life and a home however and wherever," Leopoldo had written Felicidad in his last letter of the summer. Yet how and where to do this was still a mystery.

He did have new prospects. Through Musa Musae Leopoldo had strengthened his friendship with Dionisio Ridruejo, a fascist oratorical wunderkind who had risen at an astonishing speed through the uprising's ranks to become director of press and propaganda. That fall Ridruejo secured the patronage to start a new literary magazine. His patron was Ramón Serrano Suñer, Franco's brother-in-law. Known as *El Cuñadísimo*—the brother-in-law-in-chief—he was a trusted adviser to Franco during the war and now a powerful minister. With his backing, Ridruejo and Pedro Laín Entralgo, the young editor in chief of the government's publishing house, the National Publisher, founded *Escorial*. Its editorial agenda mirrored the regime's economic policy of autarky, which aimed to achieve self-sufficiency for Spain through isolation from the global economy. In the literary economy, the magazine sealed itself

off from all poetic influences that looked beyond the navel of Spanish tradition. In the first issue Ridruejo praised the Civil War's "true, upright, and clean national violence."

Luis Rosales was appointed the executive editor of *Escorial* and Leopoldo spent many mornings with him in the magazine's office. Felicidad often accompanied him and got to know, as she put it, "all of those that remained of that brilliant generation that had disappeared." The first issue of *Escorial* appeared in November and included poems by the person who was missing for Leopoldo and Luis—Juan. Soon after, Leopoldo was offered a contract as a contributing writer. It didn't pay much, but it was a start.

Winter came, and Leopoldo and Felicidad spent Christmas apart, each with their own families. Once again, they shot letters back and forth like flaming arrows. When they returned to Madrid and the spring arrived, the gong of good fortune finally rang. Pedro Laín hired Leopoldo to edit four anthologies of poetry for the National Publisher. His payment was respectable, if meager, but it suggested that in spite of his past he would, eventually, have a career with which to take care of his future wife. Felicidad, for her part, knew what she was getting into marrying a poet. She was eager to leave her opulent home and experience the joys of romantic poverty that she had read about.

José Blanc reluctantly gave the young couple his blessing.

THE DAY OF THE WEDDING WAS UNSEASONABLY CHILLY AND THE MORNING WAS A circus of stress. Máxima felt ill, requiring an irritated José Blanc to examine her, only to determine that it was just indigestion. Felicidad made her last confession as an unwed woman, and when she got home the phone wouldn't stop ringing and her mother wouldn't stop crying. Leopoldo came over in a bad mood

because his shoes were too tight. They argued, then he left for the chapel. Alone, Felicidad gazed at herself in the mirror wearing her wedding dress, then peeked in at Luis's untouched bedroom. She was going to become a married woman and this house, where so much had happened, would cease to be her home.

In the afternoon, Felicidad arrived with her parents at the chapel. As they approached the doorway, she felt a tremor of doubt. *If we just kept walking,* she asked herself, *if we didn't stop at the door and nothing changed?* Instead, she went inside.

Sun filled the high windows of the chapel as Felicidad walked down the aisle toward the flower-covered altar where Leopoldo stood waiting for her, surrounded by candles and clergy. He was

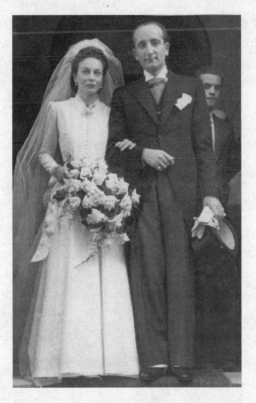

Felicidad and Leopoldo on their wedding day

clean-shaven and wore a tuxedo. Máxima occupied the space beside him dressed all in black, a mantilla shawl hooped over her head. An organ played. They watched as Felicidad approached, petite and angelic, her white veil hanging over her face and her father at her side. She was so nervous she thought that she might trip, but she made it to the altar, where the priest led those gathered in prayer. When it came to time to answer the priest's sacred question, she and Leopoldo both said yes.

"Triumph of love," read a verse the poet Gerardo Diego wrote that day for the occasion. He, Luis Rosales, and two other writers were the official witnesses to the ceremony—four poet-signatories consecrating the love of another poet and his muse.

When the ceremony concluded, Felicidad threaded her arm into Leopoldo's and they walked out of the chapel. They had survived Spain's war separately. Now, together, they would navigate its peace.

CHAPTER 14

THE SURVIVOR

Marriage and Career, Summer of 1941 to July 1942

After savoring a lazy, sunbaked honeymoon in a beach town on the Mediterranean coast, Leopoldo and Felicidad traveled on to Astorga to spend the rest of the summer.

Although she immediately fell in love with the Paneros' grand old house and country estate in Castrillo, she was crestfallen to watch the newfound intimacy with Leopoldo dissolve amid his rowdily affectionate family. She felt that she had to compete with Máxima, and even more so with Luis Rosales and other friends who came to visit. She also realized that there was still much to discover about the man she had married. Moody and jokey, sociable and distant, urbane and earthy, Leopoldo contained confounding multitudes. He likely experienced something similar with her. When the newlyweds took walks by themselves, sometimes they fell silent. *Like two strangers*, Felicidad thought.

Back in Madrid, they moved into the apartment Leopoldo had shared with his sisters. Their routine swiftly turned drab

and conventional. Just as summer vacation wasn't life, courtship wasn't marriage. During the day, Leopoldo worked on the anthologies he was editing. At night, he stayed out late drinking with friends. Receding into a cocoon of isolation, Felicidad reread Leopoldo's poems about her. Sometimes she woke to the sound of his key clinking into the lock and the door to the apartment opening, followed by unsteady footsteps. This sonic ritual would take on an iconic power in her memories. He stopped writing her poems and they had no cause to write each other letters. It turned out that being a poet's wife lacked poetry. Normally literature was the compensation life offered her in exchange for its tedium and sorrows, but what if *this* literary life failed her?

THESE EARLY DAYS OF LEOPOLDO AND FELICIDAD'S MARRIAGE IN SPAIN, WHERE people were still striving to figure out what life after war meant, coincided with the escalation of war in the rest of the world.

That June the Nazi army had invaded the Soviet Union, forcing Stalin to join the Allies against Hitler. In a piece of patriotic theater that doubled as a toe-dipping gambit into the global conflict, Franco sent eighteen thousand Spanish volunteers, known as the Blue Division, to fight alongside the Nazis on the Eastern Front. Then fall came and with it the Japanese bombing of Pearl Harbor on December 7, which prompted the Franco regime to wire a congratulatory telegram to Japan. Four days later, the thing Leopoldo had fantasized about in one of his lovesick letters to Felicidad came true: the United States declared war on Germany. In spite of broad public support for the Blue Division, the vast majority of Spaniards were against further involvement in the war. They were just beginning to construct a new future out of the one they had lost. Leopoldo

and Felicidad themselves particularly needed to think about the future.

By Christmas, she was pregnant.

THE QUESTION OF HOW THEY WOULD AFFORD TO HAVE A CHILD WAS ANSWERED EARLY the next year when Leopoldo had another stroke of luck. He landed a new, steadier job—as a censor for the regime.

Every authoritarian regime is built on fictions, and one of Franco's was that books weren't just books. They were potential threats to Spain.

In Madrid, the country's nerve center, police raided booksellers and street stalls, cutting off the free flow of ideas. Among other works, they confiscated *White Fang* by Jack London and the Charlie Chan novels by Earl Derr Biggers; these books ended up in warehouses alongside works by Stendhal, Victor Hugo, Charlotte Brontë, and Alexander Dumas. (Movies, naturally, were also interdicted.) Yet in a doublespeak equal parts elitist and suppressive, the government claimed that not all of the confiscated books were actually banned. The reading of them was simply restricted to a special class of learned Spaniards that would not be corrupted by their content. These men fell into a category known as *los eruditos*—the erudite ones—of whom Leopoldo became a card-carrying member, complete with the seal of the Bishop of Madrid. But the curation of culture under Franco required not only the tight control of already published works. It also demanded the careful control of which new books would be permitted to exist, which is where Leopoldo came in.

He was hired as *técnico*—a technician or specialist—in the National Delegation of Propaganda. At the ministerial offices of the vice-secretary of education, located on José Antonio Primo de Rivera Avenue, his job was to judge books submitted for approval

for publication. The measure of what was appropriate—or not—was a function of three questions that all censors had to answer in their reports on the books they were assigned: *Does it attack Dogma or Morals? Institutions or the Regime? Does it have literary or factual value?* In short, Leopoldo's job was to enforce an editorial vision molded in Franco's very own pious, anti-communist, father-of-the-nation image. Indeed, the *Caudillo* himself provided an aesthetic blueprint for his ideal work of literature in January 1941 when a film titled *Raza* premiered in Madrid, written by Jaime de Andrade—Franco's pseudonym. It was a convoluted Civil War epic, a vanity propaganda project peopled by Nationalist characters resembling the dictator's own family. In the spring, a novelized version of the screenplay went on sale. The book was fiction, but it wasn't literature. It was a national family story, political mythology.

Leopoldo's new job allowed him and Felicidad to step back onto the social ladder they had fallen from as adults. They moved into a modest middle-class apartment on the third floor of Calle Ibiza 35, near Felicidad's parents. Wheat fields swayed in empty lots out the window, giving the street a small-town feel inside the big city. It was more Astorga than Madrid, with remnants of an older, quainter way of life from the past close at hand. Farmers came in from the country to sell melons on the corners in the summer and turkeys in the winter; gypsies collected the garbage in horse-drawn carts. But the apartment made room for the future. With four bedrooms, a large foyer, balcony and patio, office and living room, their new dwelling would comfortably accommodate a family. Much later, in a different era, the apartment would also house the singular mythos that came to envelop the Panero lair on Calle Ibiza and all its strange happenings.

Leopoldo's social life intensified. The new apartment made them neighbors with Dionisio Ridruejo—just back from soldiering with the Blue Division, though now with a jaded outlook on

the drift of Spanish life under Franco—and Agustín de Foxá. In contrast to Ridruejo's earnest, poetic fascism, Foxá was an aristocratic bon vivant. He worked as a diplomat for the regime, enjoying his parallel role as the mordant wit of his generation. As he famously quipped, "I'm a count, I'm fat, I smoke cigars, how am I not going to be a right-winger?" Along with Luis Rosales, whose characteristic cough always announced his arrival, literati frequently came to Ibiza 35 for the midday meal. As Felicidad played hostess, her thoughts revolved around her growing belly, though during the long lunches that seamlessly became cocktail hours she was seduced by the chorus of charisma that reverberated inside their living room. She listened as the men argued about current events. For example, King Alfonso XIII had died the previous year in Rome, leaving his son Don Juan as the heir to his empty throne back in Spain. They also argued about the direction of Spanish literature. As Leopoldo saw it, with the pain of the Civil War "the poetry of the survivors would be made." But what did it mean that so much of that pain was exiled across the world, a type of contraband prohibited in Spain?

Far from the noisy living room, people abroad also wondered what would happen to the rich literary tradition of Spain. As the British consul Geoffrey Firmin in Malcolm Lowry's 1947 novel *Under the Volcano*, set in 1938, argued, "*when* the fascists win there'll only be a sort of 'freezing' of culture." Three years into Franco's rule, Leopoldo was himself worried that Spain was on the precipice of a cultural ice age, and at work he took an approach to his job that set him apart from more hard-line censors. He rarely if ever recommended that a book's publication be blocked. When he did, it wasn't for ideological reasons but literary ones—because the book was simply bad, as was the case with a romance novel he rejected. He had a reputation as a friend to writers, advocating for the dark novels of Camilo José Cela, for instance. If working as a censor made him a toady of

Franco in the eyes of exiles, to writers in Spain he looked more like an editorial double agent. Ethical guilt and innocence could be as elastic as Franco's rule was rigid.

Yet in spite of whatever heat Leopoldo hoped to stoke inside of a Spain that was freezing both literally and literarily, he took home his paycheck from a suppressive bureaucracy whose purpose, as his contract put it, was to protect "God, Spain, and its National-Syndicalism Revolution." He was learning to maneuver inside the new Spain to advance his career, but at what cost? As an *erudito*, he lived above the censorship he enforced; as a poet whose meaning in life came from expressing himself, he was legislating the free expression of others; and as a person, his values were becoming strained and smudgy, Faustian even. He had opened the door of his self still wider to contradictions, like an invasion of houseguests who fill the home of the host who invited them, threatening to displace him. These conflicts, though, were secondary to survival, and Leopoldo had long since become a perennial survivor. Again, a line from Hemingway's *For Whom the Bell Tolls* applied: "It was easier to live under a regime than to fight it."

WORD OF MY SILENT DEPTH

The First Son, September 1942

That August Leopoldo and Felicidad forwent vacation away from the city and waited for the baby to arrive in "the sad, dusty Madrid of summer," as he described it. In the shuttered chiaroscuro of their apartment Leopoldo wrote while Felicidad sewed diapers. Finally, in early September, her contractions started. She and Leopoldo rushed to the hospital, where her father awaited them.

It was a long, crushing night of labor. "I'm nothing more than this very pain," Felicidad wrote. "The desire to die, to finish, that the whole thing be over, this is the only thing that fills my thoughts." But the finish wouldn't come. Leopoldo watched from a chair in the delivery room, powerless. José Blanc paced. As the hours passed, the doctors became concerned not just about the baby's chances of survival but Felicidad's. The nurse administered chloroform, the scene recalling her appendicitis during the war, except now her father wasn't the presiding physician. She asked Leopoldo and her father to leave, then at dawn, the baby was born. It was a boy. Leopoldo returned to the room and was

given the tiny crying creature. Overjoyed, he cradled the baby in his arms and showed him to Felicidad, who was still coming back from the anesthesia and pain.

"I don't care about anything," was all she could say.

BACK HOME AT IBIZA 35, FELICIDAD BEGAN A SLOW, ARDUOUS RECOVERY WHILE Leopoldo lavished his affections on their healthy, chubby-cheeked little boy. They named him Juan Luis, after their brothers who had died in the war—Juan Panero and Luis Blanc.

As was only natural for him, Leopoldo composed a poem for his heir. He had shaped his courtship through words and now sought to do the same with fatherhood. For him the creation of a family was inseparable from the creation of literature. In the short,

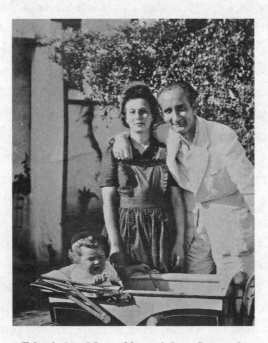

Felicidad and Leopoldo with Juan Luis in his stroller in Castrillo de las Piedras

tender poem he folded himself into the purifying innocence of his baby, whom he described as the "drowsy frenzy / of my flesh, word of my silent depth." He imagined his first child leading him by the hand away from "my dark shore." As he penned these verses, elsewhere in the apartment Felicidad felt melancholy, struggling to reconcile the current story line of her life with the one that she had imagined when she met Leopoldo. Which choices had been hers and which hadn't? Leopoldo felt similarly helpless, if for different reasons. He seemed to think that, having not yet lived and knowing so little, his newborn son was the only one who possessed the secret to a good life.

"In your ignorance," Leopoldo wrote, "I put my faith."

HOUSE AND TRADITION

Family Life and the End of World War II, Fall 1943 to Fall 1945

Madrid is a city of more than one million cadavers," Leopoldo's voice boomed.

It was the fall of 1943 and he was at a bar with friends. After throwing back a few whiskeys at the nearby British Institute, they had ended up here, where Leopoldo began reciting verses from *Children of Wrath*, an as yet unpublished book of poems by Dámaso Alonso. Eleven years Leopoldo's senior, Alonso had been the unofficial literary critic of the Generation of '27. With an egg-bald head, blocky glasses, and bulldog cheeks, Alonso gave the impression of a university don prone to cartoonish trouble, which in fact was often the case. Yet *Children of Wrath* was an existential wail of a book. Leopoldo was at that moment shepherding it through the regime's publishing apparatus, though not without having to battle his fellow censors on words that made them squeamish. The voice of the poems was that of an insomniac raging against a world hollowed out by death who hoped against hope to rediscover God. Leopoldo knew the poems by heart, and with a few drinks in him he recited them flawlessly, while Alonso approvingly looked on.

"Oh yes, I know her," Leopoldo intoned, moving on to a different poem, which followed a wandering woman who was like Spain itself, adrift and downtrodden. Alonso would dedicate this poem to him in the published book. "This woman, I know her: she came by train, a very long train; she traveled for many days, and for many nights."

The poem moved Leopoldo deeply. In July, his little sister, Charito, the youngest of the Panero siblings, had died in Astorga of tubercular meningitis. *Children of Wrath* transmitted the spiritual pain that he and everyone in Spain seemed to feel.

Lately, Leopoldo was drinking more.

"And this woman woke in the night," he continued as the poem neared its climax, "and she was alone, and she looked around her, and she began running down the hallways of the train, from one car to another, and she was alone, she looked for the ticket-taker, the train men, an employee, a hobo traveling hidden under a seat, and she was alone, and she cried out in the darkness, and she was alone, and she asked the darkness, and she was alone, and she asked whom the conductor was, who was moving that horrible train. And no one answered her, because she was alone, because she was alone."

FELICIDAD FELT ALONE. WHEN LEOPOLDO WASN'T AT WORK, OUT WITH HIS FRIENDS, or writing in his study, he doted on one-year-old Juan Luis, which left little time for her. While she adored her baby boy, she felt neglected, unseen. Leopoldo never told her what it had been like for him when she'd come near death during her delirious night of labor, which hurt her. In their new family life, she experienced neither the highs nor the lows to which she was long accustomed and yearned for; she was like a pendulum brought to rest, denied of its purpose. She rarely even read anymore, except for Leopoldo's poems about her. *You'll always be*

in those poems, she told herself. *Isn't that what you wanted? Don't ask for more.*

The same whiskey-soaked fall, feeling adrift in his own way, Leopoldo began work on an important new poem. He described it as "the biography of my soul." Unlike Alonso, for him life wasn't a spiritual wasteland where the living were worse off than the dead. It was a palace of memory. "I wanted to proceed from childhood itself, from its first babblings, through the circumstances, realities, and hopes that weave the quotidian plot of our existence as men," Leopoldo wrote of the new poem. "I had just established my own household and separated myself, as a result, from that which was original and paternal, abandoning forever *la estancia*"—the room or sojourn—"where I had spent 30 years of my life." The question he asked himself as he diligently worked on the new verses, watching them balloon in length, was if he would be truly able to create a new home, a new *estancia*.

Leopoldo turned as usual to Astorga and his family to answer this question. Even so, the poem throbbed with solitude. Echoing Alonso, "I'm alone" became one of the poem's refrains. He anchored the theme of death to the loved ones he had lost: "all of you, delicate ones, impalpable, remote in my blood, made every day of my substance, zeal of a dream of eternity." He felt that "the serene marvel" of his childhood had left behind only a "house of smoke." But there was also a savoring in his words, nearly a sublimity in the way his verses held the amber of his lost paradise up to examine it beneath the lonely lamp of adulthood.

"It is sweet to remember," Leopoldo wrote.

His work in progress reflected all of Spain's tormented relationship with memory. Like every man and woman who had survived the Civil War, he had lost things that he would never get back. Recalling them revived the ache, and yet the ache was all that was left. Present pain and past joy were one. Which was worse, the solitude of remembering or not remembering? And

yet indulging in memory wasn't a neutral act. It was a politically charged one. Under Franco, revisiting certain ideas, people, and events from the past was dangerous. Some types of mourning—for the Republic, for a different version of Spanish life—were a liability. The dictatorship censored public memory, teaching only one version of history: the one the Nationalist victors wrote.

These issues Leopoldo didn't probe in his new poem. His life was shaped by politics that he now seemed to want to ignore. His poetic world was one of private memory. He resurrected his departed ones by infusing them with the myth-dusted matter of literature, which he had more control over. Nostalgia wasn't the same thing as life, but it was his only means of reconciling Spain's and his own dueling desires to remember and to forget.

By the time Leopoldo completed his new work—"La Estancia Vacía" (The Empty Room)—the first chapter of the biography of his soul had grown to over a thousand lines. While death, aloneness, and the destruction of an innocent past still formed the bedrock of the poem, redemption had revealed itself. Throughout the sonorous downpour of verses, like rain falling on Astorga, Leopoldo had called out to his *Señor*—the Lord—in whom he hoped to find a path out of loneliness. The reversal came in the moment when the repetition of the phrase "I'm alone" gave way to: "I'm not alone." Seeming to reference his time in San Marcos, he understood that God had been beside him all along, no matter what befell him and the people he loved. This recognition of his need for God, rather than underscoring Leopoldo's own helplessness, lifted him phoenix-like out of the ashes of the past. It was as though, in accepting that one room of his life was empty, he had the chance to fill a new one for the future.

"Lord," he wrote, "this is my house and my tradition."

The reality, however, was that he and Felicidad were having trouble filling their house. She had given birth to a stillborn boy the previous year, followed by another pregnancy and another

boy, only to have him die the day he was born prematurely. Felicidad sunk into despair, as did Leopoldo. He was thirty-four and finding it impossible to replicate in his own household the robust family life whose memories gave him strength. She was thirty-one, with two children she'd lost, like one of the sad figures of misfortune that had captivated her as a child. These hardships further distanced Felicidad and Leopoldo from each other.

Late in 1944, "The Empty Room" was published, first in *Escorial*, then as a slim offprint. It was both a triumph and defeat for Leopoldo. As a single poem, if a lengthy one, it failed to cement his standing like a book would have, though it stoked the high expectations that continued to build around him. The poet Gerardo Diego would call it "the masterpiece of Panero's generation, and perhaps of all the poetry of those years."

ON JUNE 6, 1944, THE ALLIES LAUNCHED THE INVASION OF NORMANDY, MARKING THE beginning of the end of the war.

Nearby yet a world away, D-Day forced Franco to reevaluate his strategy. While he hoped that Hitler might still rally Germany to victory, he finally accepted that his nostalgic fantasy of regaining territory in Africa was just that—fantasy. Now his priority was to ensure Spanish sovereignty should the Allies win, and even finesse his way into their favor. To do so, he sought to recast Spain as an embattled bastion of neutrality in a war-tossed continent, rather than as an opportunist little brother to the Axis trying to switch families. But more urgently, he had to defend Spain itself from invasion. Since the fall of Paris in 1940, Republican exiles had been active in the French Resistance, and they hoped that the shift in power, which had flooded the beaches of Normandy, would spill over the Pyrenees and wash away Franco.

In late April of the following year, Mussolini was hanged in Rome. Two days later, Hitler committed suicide in his bunker

in Berlin. On May 8, Germany surrendered unconditionally to the Allies. That same day Franco officially ended his relationship with the Third Reich. The war in Europe was finally over.

Leopoldo and Felicidad celebrated with friends in Madrid, Leopoldo throwing back copious amounts of wine. With a mix of wily caution and providential ineptitude, their dictator had shepherded Spain through the war unscathed. In doing so, he had set the country up for international ostracism, though for the time being the Allies let Spain be, an irreversible blow for Spanish exiles. The *Caudillo* had permitted the deaths of some ten thousand Spanish Republicans in Nazi camps, but the *maquisards*—or *maquis*, as Spanish guerrillas were called—who made incursions through the Pyrenees and carried out attacks elsewhere in Spain received no support from Britain or France. The dictatorship's forces easily dispatched them. Franco also warded off another foe: Don Juan. The heir to the Spanish throne had attempted to overthrow him in the spring when he issued a manifesto calling for a constitutional monarchy. The military, however, failed to respond to the monarch's call. Spain was alone but Franco had managed to maintain his house and his tradition.

Like a sign that things would finally get better not just for the world but for Leopoldo and his struggling family, the postwar era sent him an unexpected opportunity. After observing his work as a recent associate of the Institute of Political Studies, a Francoist think tank, the regime offered him a diplomatic posting in London. The position was at the Institute of Spain, a cultural mission opening soon that was aimed at countering the influence of its Republican rival in the British capital, the Spanish Institute. Of course, the posting would mean aligning himself more publicly with the forces that had taken the lives of friends, sent others into exile, and nearly ended his own life. He would also be a representative of a government that most of the world despised.

Leopoldo took the job.

BATTERSEA PARK

Diplomacy and Secrets in London, February 1946 to July 1947

Leopoldo gazed out the window of his plane, high above the Cantabrian Sea. As he left behind the arid tablelands of Spain, sunlight fell on pillowy clouds. Green slices of ocean slid in and out of view. It was February 1946 and he was on his way to London.

To house the Institute of Spain, the Spanish government had rented an impressive five-story, thirty-five-room building with offices and living quarters at 102 Eaton Square, near Buckingham Palace. Leopoldo had come without his family in order to set up their new life before Felicidad and Juan Luis joined him in April. After he arrived and settled in his room, a gray snow fell, powdering the steeples and parks of the city.

London was less ruined than Leopoldo had expected. The Nazi blitzkrieg raids at the start of the war had left the city cratered and silted in ash, then came the buzzing V-1 missiles, known as "doodlebugs," and later the mythically silent V-2s. More than one hundred thousand houses were destroyed and some thirty thousand people died. In seemingly apocalyptic

foreshadowing, flowers and wildlife that had largely disappeared from the city returned, as if human civilization itself were disappearing. But the British were defiant, and less than one year after its six-year war had ended, England was better off than Spain was seven years after its three-year war. While rationing was in effect, the bread Leopoldo ate was better than any he had tasted since 1936. He felt good about his decision to come there.

As elated as he was to be back in the UK, Leopoldo's arrival in London wasn't without unpleasantness. In his new capacity as literary attaché for a regime that had aided the Nazis and still executed innocents, he was snubbed by parts of the British literary community, including old friends. Nonetheless, among Spanish exiles, for whom relations were more familial and tinctured with history, divisions weren't so starkly drawn.

Leopoldo reconnected with Luis Cernuda, a poet seven years his senior from Seville. Their friendship went back to the late 1920s, and the two had worked together for the Republic's Pedagogical Missions in the '30s bringing educational instruction to the forgotten, dusty pueblos of Spain. Exile had flung the often misanthropic Cernuda into an impoverished purgatory in England, where he scraped by teaching. Like Lorca, he had grown up gay in an intolerant society, an experience that infused his poetry with a quiet ferocity. Two of his poems especially upset some readers, each with a perfectly explosive phrase. In one he declared that Spain had died and was now only a name; in the other, he wrote that God was just a dream and didn't exist. In a sense, these sentiments were interchangeable, since Cernuda's Spain was now a nonexistent dream of the past.

While Leopoldo and Cernuda had vastly different sensibilities and experiences, their mutual respect remained intact. During Leopoldo's first month in London, the two spent a Sunday together. Cernuda looked the same as always, if a notch older:

slicked-back hair, a trim mustache poised on his upper lip, and a slightly upturned nose and solemn eyes that projected an impression of refined boredom. Leopoldo, meanwhile, had morphed from a fresh-faced *señorito* into a balding father three years shy of forty. Over dinner, they read each other new work and Leopoldo bragged in a letter to Felicidad, who was eager to meet Cernuda, that his poems had impressed him. Soon after, however, a less poetic matter pulled Leopoldo's mind back to Spain.

The day before Felicidad and Juan Luis arrived in London, Leopoldo's sister Odila sent him a letter with news that landed like his own personalized V-2: His parents had gotten into a colossal fight over shares the two owned in an electric utility, opening already-present fissures in their marriage. Years of tension had culminated in Máxima threatening to leave Moisés and join a convent. Leopoldo's family, his kingdom of nostalgia, was on the brink of collapse. He would help as much as he could by mediating from afar, but his own family, their new life in London, and their collective future required his full attention. He still didn't have a book, which made him very insecure, and he had a new job at which he couldn't afford to fail.

Leopoldo met Felicidad and Juan Luis at the airport on the day they arrived, and the three took a taxi to the institute. The snow had melted and April flowers were in bloom. To Felicidad her arrival in London felt like a new beginning. The past six years had been cold and dark, and she had become someone she didn't recognize. She felt invisible even to herself. England seemed to promise a return to visibility and light.

What struck three-year-old Juan Luis during the cab ride were the remnants of destruction standing out of the cityscape. In his fifties, he would recall his fascination at "a half-razed home, with shredded bits of painted paper and what was left of the rooms, a ghostly scene of a private life made visible to all."

Much later, this description would apply to the Paneros themselves.

THE INSTITUTE OF SPAIN IN LONDON HAD COME INTO BEING DURING AN EPOCHAL pivot in global affairs. On March 5, 1946, just days after Leopoldo arrived in London, Winston Churchill gave his famous Iron Curtain speech, marking the beginning of the Cold War. At the endless diplomatic functions Leopoldo attended that summer, he spoke with Brits who, much like Churchill, felt apprehensive about Stalin's designs on postwar Europe. This boded well for Spain, since Franco's rabid anti-communism now made him a natural ally, even if the British and American governments weren't quite ready to treat him collegially, and their citizens were even less generous. Leopoldo faced this awkward, transitional state of affairs head-on after political intrigues suddenly forced his boss at the institute out, leaving him as interim director. One of his first duties as director was to stand by as a British group organized a protest against the institute. Leopoldo waited behind the locked entrance while the surprisingly pacific demonstrators knocked on the door. He didn't open it for them and the crowd soon dispersed.

Eager to make his new position permanent, Leopoldo began strengthening Spain's literary ties in London and making, as Felicidad put it, his "approach" toward prominent Spanish exiles. Some, like Cernuda, he tried to woo not by claiming that Francoism deserved to be treated with less opprobrium and more nuance, but by trying to convince them to support the restoration of the monarchy.

Like numerous members of the Franco regime at this time, Leopoldo was playing a double game. He hoped Franco would hand power over to Don Juan the Pretender and was preparing for this contingency. The West still didn't know what to do with

the dictator and in spite of setbacks, Don Juan persisted in his campaign against Franco. The king's advisers were busy making alliances with exiles across the political spectrum, including Republicans happy to return to a constitutional monarchy over the dictator. London was a hotbed for this monarchist plotting. Yet playing both sides also meant planning for the likelihood that Franco would hold his grip on power, as he had done before. So in parallel to his private monarchist maneuvering, Leopoldo issued himself a shrewd insurance policy in public, playing two sides again. Under the auspices of the institute, for example, he feted the hard-drinking South African poet Roy Campbell, who fancied himself as a kind of Hemingway of the right and gladiator for Franco's Catholic Spain.

Meanwhile, as Leopoldo engaged in political poker, Felicidad was about to launch a cloak-and-dagger game of her own.

ONE MORNING IN THE FALL, FELICIDAD FINALLY MET LUIS CERNUDA WHILE TAKING A stroll through Hyde Park with Juan Luis. He had politely declined recent invitations from Leopoldo to dine at their home at the institute, but now here he was, debonair and friendly. The encounter was brief but Felicidad felt an instant connection.

Not long after, Cernuda's roommate, the painter Gregorio Prieto, had a show of his work, and Felicidad took special care to dress sharply for the opening. She and Cernuda had a chance to speak alone and she made him laugh. The sense of confidence his attention gave her was intoxicating. She yearned for more, and later that autumn he consented to a visit to their apartment for a meal. Cernuda showed an immediate fondness for Juan Luis, whom he talked to and dandled on his knee. After he left, Cernuda stayed in Felicidad's thoughts. She looked forward to the next time she would be near him again. To her dismay, after she, Leopoldo, and Juan Luis returned from Christmas in Spain

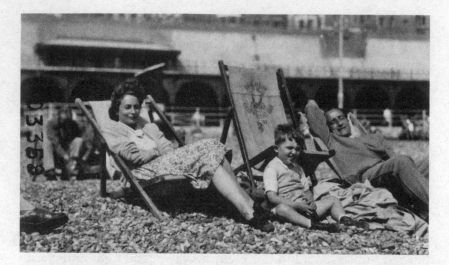

Felicidad, Juan Luis, and Leopoldo at the beach in Brighton. They often
spent weekends in the country home of a relative of Leopoldo's, Pablo Azcárate,
who was the head of the Republican Spanish Institute—in other words,
Leopoldo's rival. In spite of being in seeming conflict, they got along just fine.
They were still family.

with family, Cernuda drifted away. It wasn't clear if the friend-
ship had run its course. Neither was it clear if her and Leopoldo's
time in London had, too.

The new permanent director of the institute had been named
and it wasn't Leopoldo. A backroom political game had played
out inside the Ministry of Foreign Affairs back in Madrid and he
had lost. Leopoldo's bet on Don Juan hadn't fared much better.
Franco continued winning his long-distance fencing match with
the exiled monarch. Spaniards weren't restive for change and the
Caudillo would soon go on a streak of symbolic victories: lavishly
welcoming Eva Perón from Argentina, wooing a group of vis-
iting American politicians, and touring different parts of Spain
to further reinforce his cult of personality. Franco wasn't going
anywhere.

Now that Leopoldo had fallen out of favor with the ministry
and his diplomatic career had precipitously swerved off course,

he was trying to determine what if anything was still left for him to gain in London. Felicidad, meanwhile, saw that her new beginning might be over no sooner than it had started. If that was the case, then she would have to take some vestige of the romance of England home with her to Madrid.

She compensated for Cernuda's absence by striking up a flirtation with one of Don Juan's advisers. He attended many of the same gatherings as Felicidad and Leopoldo, and also loved Tolstoy. Talking about *War and Peace* became her method of coquetry, even as she thought about another of her favorite books, *Madame Bovary*, whose heroine, like her, had read romance novels as a girl and felt oppressed by the dullness of married life.

At the same time, Leopoldo embarked on a new friendship of his own—with T. S. Eliot. The fifty-eight-year-old author of *The Wasteland*, who would win the Nobel Prize in Literature the following year, had been one of the few English-speaking writers to refuse to take a side on the Spanish Civil War. He had no qualms about visiting the institute, so he joined Leopoldo in his office, where they lounged in mustard-colored leather armchairs and drank Spanish sherry, a rare commodity in postwar London. Felicidad would welcome Eliot at the door, awed by the way he seemed to fade into the half light. Juan Luis remembered him as "that polite scarecrow." It is likely that he and Leopoldo discussed Cernuda, since that spring Eliot was considering publishing his work. Eliot passed on the poems, a blow to Cernuda, stuck as he was in London, which he called "a conglomerate of horrors, half monster, half nightmare."

It was around this time that Cernuda reappeared in Panero's life and came over for a long lunch with other Spanish friends who were visiting. Afterward, Felicidad walked Cernuda back to his building, just the two of them. She talked about her brother and as they conversed, she felt listened to, *acknowledged*, in a way

that was both thrilling and foreign. Once again, she felt *seen* by a poet.

It was here where things turned strange.

According to Felicidad, before saying goodbye, she and Cernuda linked hands and stared searchingly into one another's eyes. She experienced a sensation of inevitability. She and Cernuda, she felt, were "like two who since long ago knew that we would find each other." When she got home, she was transformed.

I'm another person, Felicidad thought, spinning inside. *I've rediscovered that which has always been the point of my life, love.*

She fell deeply in love with Cernuda.

Or rather, Felicidad fell in love with her fantasy of him. She felt this way despite the fact that Cernuda was gay, or perhaps because of it. Such a love had a literary impossibility built in, making it dramatically star-crossed. Also, he was the opposite of Leopoldo, the man who had seduced her through poetry into

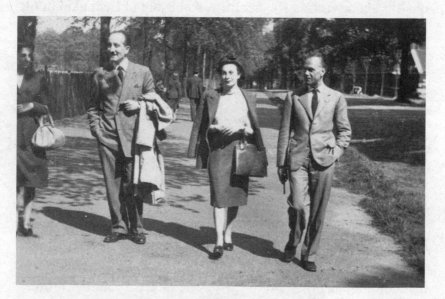

Leopoldo, Felicidad, and Luis Cernuda in London

the painfully unpoetic institution of Spanish marriage. Where Leopoldo was coarse, Cernuda was refined; where Leopoldo worked for the regime, Cernuda lived in exile from it; where Leopoldo had expectations of her, Cernuda had none. Gregorio Prieto described Felicidad during this time as a woman who "didn't have her feet on the ground." This might have been an apt assessment long before her sojourn in London, since she had always been prone to floating away on stories. Perhaps her feelings were real, or perhaps they were colored by a desire for vengeance. In the Cold War of marriage, might Cernuda provide a victorious proxy war?

Above all else, Felicidad needed a true friend, which her marriage had left her bereft of. Whatever the explanation for her infatuation, Cernuda's relationship with the Paneros was about to get more complicated.

LATER THAT SPRING, AN EXILED SPANISH JOURNALIST NAMED RAFAEL MARTÍNEZ NADAL invited Leopoldo and Felicidad over for dessert with his family. Cernuda was there and as they all sat together, a bottle of Courvoisier materialized. Leopoldo generously helped himself. "The cognac loosened Leopoldo's tongue and his phrases," Martínez Nadal recalled. "Panero talked about the intellectual poverty and vulgarity that breathed in Spain, what the prolonged absence of figures like Luis Cernuda would mean for the future of Spanish poetry." Leopoldo asked Cernuda to recite a poem. He chose a new one titled "La Familia" (The Family).

The poem opened with a family together sharing a meal, only to have the speaker painstakingly dismantle the traditional image of happiness. "At the head of the table the austere father," Cernuda read. "Impulsive mother at the other end, with the impossible and unhappy elder sister, and the younger, sweeter one, perhaps no happier, the household rounded out by you, the family home, the

human nest." The *you* might have been Cernuda himself, but it could have been anyone. He went on, "It wasn't your fault you had been created in an ordinary moment of forgetting, by parents merely going through the motion inherited from others, with no passion, whose purpose and implications they never thought of. Nor was it your fault you couldn't understand them: At least you had the courage to be honest both with them and with yourself."

As the poem progressed, Leopoldo slugged down more cognac, becoming visibly agitated. It contrasted cuttingly with his vision of the family home as a sacred tradition. Máxima and Moisés appeared to have gotten through the tempest of their standoff the previous year, but having seen his own parents' marriage nearly shatter, did these lines especially sting him?

Cernuda kept reading to the group. "Time went by, undoing them like bubbles on the surface of a stream, dismantling the poor tyranny they'd built, and leaving you free at last, alone with your life, like all the others with neither home nor kin, masters of their own oblivion. Then when you had rapturously discovered the way their customs are imposed on others and how whoever breaks the rules is excommunicated, you agreed with them, smiling through your pain."

Leopoldo stood up and slammed his hand down on the table. "Enough!" he shouted. "I won't accept this. Family is sacred and you're denigrating it. How could you write this garbage?"

The moment that followed, Martínez Nadal recalled, was "A pandemonium of silence."

Cernuda went to another room overcome with rage. Martínez Nadal talked him down, while Felicidad and Martínez Nadal's wife did the same with Leopoldo. The gathering was clearly over. They all walked to the bus stop, where Leopoldo, Felicidad, and Cernuda had no choice but to board the same bus. During the savagely awkward ride, Felicidad felt Cernuda

looking at her as if in search of sympathy. She remained silent and impassive.

MIRACULOUSLY, LEOPOLDO'S OUTBURST DIDN'T RUIN HIS FRIENDSHIP WITH CERNUDA. As Spaniards living in a country that wasn't home after their own had been rent in two, it was if they themselves werc family. You might slip and break the rules, as Leopoldo had, but you wouldn't be excommunicated. Or perhaps it was because they knew their overlapping sojourns in London were ticking toward their ends and they might as well part on good terms. Cernuda had secured a teaching job at Mount Holyoke College in Massachusetts and Leopoldo accepted that there was no point in his continuing at the institute. Cernuda came to Eaton Square for lunch one day, and Juan Luis's antics helped to ease the tension. During the meal, Leopoldo told Cernuda that he would be accompanying a Spanish dance troupe to Wales and he hoped that Cernuda would visit his wife one day while he was gone to keep her company. Felicidad suspected that Leopoldo had designs on a girl in the troupe; adultery for a Spanish husband of this era was common, though the banality of the accepted hypocrisy of Francoist family valucs didn't make it any easier on wives. Felicidad thrilled at the idea of more time alone with Cernuda, to have her own secret from Leopoldo. "It wasn't one day," she recounted with a flicker of spite, "it was every afternoon."

On long walks while Leopoldo was away, she and Cernuda talked about many things: Spain, the war, Franco, memories—everything, that is, except "never about our love," Felicidad wrote, "as if the presence of Juan Luis made it impossible to do so." Of course, more likely it was impossible because of a lack of romantic feelings on Cernuda's part. As Juan Luis later wrote of his mother's infatuation, "It is likely that she magnified the

memory of what must have been just a nice friendship, but if she did so it was only because she and my father didn't understand each other." Felicidad seemed to be writing a fiction based on her life at the same time that she lived it, yet to her it was real.

One afternoon shortly before she and Leopold were set to fly home to Spain, Cernuda asked Felicidad if she could leave Juan Luis at home and meet him. The next day the two spent the morning in Battersea Park, a rundown strip of green on the Thames with blooming daffodils and a pond. It was Felicidad's favorite refuge in the city. After Cernuda read her a poem, it was clear that their goodbye was upon them. She summoned parting words that were worthy of a character in a romance novel.

"We will never be apart," Felicidad told Cernuda. "Not even death will separate us."

He gazed back at her in silence.

She later recalled this moment as pregnant with the unsaid: "We didn't even have to tell each other we loved each other."

Even if their love was a fiction, Felicidad had found what she so badly needed: the perfect love that could never exist in her life. After five crushing years of marriage and loss in postwar Spain, she had escaped—into her own poetic hallucination. She had become Señora Bovary, Madame Panero.

THE WRITER AND THE WOMAN, THE POET AND THE MAN

The Second Son, Summer 1948 to Spring 1950

In the early hours of June 16, 1948, Felicidad gave birth to her and Leopoldo's second child—a healthy, round-faced baby boy who scooted out into the world butt-first. At last, their family was growing again. They named him Leopoldo María.

The smiley, rosy-cheeked new addition to the family arrived at an inauspicious moment. A vapor trail of failure seemed to have followed them home from London, hovering over their return to Madrid. Leopoldo couldn't find steady work, they were short on money, and the outlook in Spain didn't look much rosier. The economy was suffocating on itself and a food crisis loomed.

In spite of their worries, Leopoldo and Felicidad kept up their social life. That winter they went to a cocktail party where she noticed a woman who was subtly out of place. She had dressed to fit in with the crowd, but tiny déclassé details of her clothing betrayed humbler origins. Felicidad came from the elegant lost world of prewar high society back when it didn't consist of fascist black marketeers and parvenu military officers. She knew when

someone didn't belong. The predicament of this woman snagged on something in her imagination, like a cocktail dress catching on a nail. Afterward, she found herself jotting down ideas and wrote a piece of fiction about her. She opened the story with the woman's husband coming home from work, excitedly telling her that his boss had invited them to his house for a cocktail party. The woman scrambles to put together a worthy outfit but when the night arrives, she feels judged by the other wives and the man's boss rebuffs him. The couple return home deflated, knowing that they have failed at their one chance at upward mobility.

Like an echo of her one-sided emotional affair with Cernuda in London, writing the story gave Felicidad a delicious sense of freedom. It allowed her to reflect on her and Leopoldo's situation through characters whose lives she could control more than her own. For the first time, the erstwhile muse to a poet, and the woman who idolized literature to the point of confusing it with reality, had herself begun to write. Not solely in her mind, as she had done in Battersea Park, but on the page, like Leopoldo.

AFTER FELICIDAD FINISHED "THE COCKTAIL PARTY," WHICH SHE KEPT SECRET FROM Leopoldo, she wrote another story, working on it while rocking her new baby in his cradle. Titled "Sunday," it was about a woman on a weekend outing to the country with her family. The character, whom Felicidad clearly identified with, reflects on the domestic malaise that has overtaken her life: "the stuffy atmosphere of the house, the oppression of the walls and the deafening noise of the children." She recalls a passionate love from her youth, then thinks of her husband: "She married him without love, like a resource for her loneliness. Why did she sometimes twist inside because he wasn't what she dreamed of? What fault did he have in any of it?" Considering the blame she would later

heap on Leopoldo, this might be Felicidad's most honest remark about her own complacency in their marriage.

One day, she finally gathered the courage to read her stories to Leopoldo. He was taken aback yet impressed. Soon after, a reading for her was organized at Luis Rosales's home. As she read the three stories, she looked into Luis's thick-lensed gaze as if no one else were there. Here he was, her rival, the man who stole her husband away day after day to drink and talk till late, yet the same one who often paid attention to her with small, touching gestures that Leopoldo lacked. Now she was giving him the power to judge her inner world. The compact miniatures she had written, like stones polished brilliant by wear, were about women with unlived lives and doomed longings. They were her.

As Felicidad read, Rosales looked like he might be drowsing off. But when she finished reading, he said, "These need to be published."

And they were. The stories soon appeared in literary magazines, in some of the same publications where Leopoldo himself placed work. If not quite his competition, his "Feli" was nevertheless abruptly a colleague of sorts. His own success, however, soon overshadowed hers when his long-awaited first book at last came out that summer.

ESCRITO A CADA INSTANTE—WRITTEN AT EVERY INSTANT—REPRESENTED LEOPOLDO'S mature poetic vision. The book was a summation of his life just months away from turning forty. Like Felicidad's stories, the poems *were* him, his inner life transformed into a shimmering mirror of verse. The language was sonorous and straightforward, the poems by turns earthy and spiritual, aggrieved and exultant. Nostalgia battled with pain, and loneliness twined with communion. In the book's final poem, "The Vocation," he offered his conception of *la familia*, as though in response to

Cernuda's: "The exact good sense of the father and mother, / discussing aloud the vocation of a son. . . . I understand that nothing belongs to you / more purely and deeply than I do."

Notably absent from *Written at Every Instant* was Spain's political reality. There were no conflicts except interior ones. The few references to the Civil War weren't specific; few hints of Leopoldo's experiences seeped in, on the one hand, nor shadings of propaganda on the other. He did dare to eulogize Lorca, whose assassination was still an embarrassing blemish on the regime's visage. Leopoldo evoked him as a victim of Spain's arena thrill at death—"your intimacy with blood like a bull." Spanish poetry had suffered a great loss, but it was Lorca himself who had suffered most. "Dead," Leopoldo wrote, "you cry."

Escrito a Cada Instante was universally acclaimed in Spain. Leopoldo was awarded the National Poetry Prize, as well as another prize from the Royal Spanish Academy. The book also had admirers among exiles and old acquaintances. The poet Juan Gil-Albert, one of the central figures of the anti-fascist International Congress of Writers in 1937, sent him a letter of praise, as did a remarkably conciliatory Luis Cernuda. "After reading your book I understand the sad, and even outraged, surprise you had on reading those verses of 'La Familia,'" he wrote from the United States. "I am sure, however, that with mutual sympathy and friendship we can put up with and accept each other."

At middle age, after ten trying years in postwar Spain, Leopoldo had finally delivered the work he and others had hoped he had in him. He had harvested memory in service of verses balancing individual experience with universal concerns. Yet he continued to struggle to find a balance between life and literary creation. Leopoldo believed, as he put it, in "the equality between the poet and the man." Yet at this culminating moment

in his life, had he found equality—which is to say, coherence—between his words and his deeds? His family life wasn't the haloed institution he sang of in his poems, and his work for the regime didn't square with his grief over the blood spilled during and after the Civil War. Life in Franco's Spain had reshaped him but even after his time in London he seemed not to know what he looked like to people outside of Spain. He would soon find out.

THAT FALL, RIDING HIS HIGH TIDE OF SUCCESS, LEOPOLDO ACCEPTED AN INVITATION to tour Latin America as a poetic emissary for the regime. With Luis Rosales, Agustín de Foxá, and another poet, he toured several countries giving readings. In some, like Nicaragua (which had its own dictator), they were treated like dignitaries. In others, where anti-Franco sentiment was strong, they were treated like criminals. At a reading in Cuba, university students hurled eggs at them; in Venezuela, demonstrators cut the electricity and fired gunshots. Rosales was repeatedly jeered and accused of killing Lorca, which pained him and the rest of the group. Right before they left for Mexico, the Spanish envoy there who was arranging their itinerary was assassinated on a crowded street in broad daylight by an exiled Spanish anarchist who had fought for the Republic. The rest of the trip was canceled and the poets were called home. The Civil War had ended over a decade ago, but its embers still traveled on the wind, flaming up far from Spain. Leopoldo was shocked by the hate he and his friends had aroused. With seemingly willful obtuseness, he claimed he couldn't grasp why people saw him as a representative of the Franco regime. He returned to Spain feeling miserably, unjustly misunderstood.

"How glad I am to have done that trip, precisely that one and not another," Leopoldo wrote back in Madrid. "By way of

pain, everything so difficult, so Spanishly difficult, so face-to-face with the truth!" Deep down, however, like a character from one of Felicidad's stories, he ached with disappointment. His inner and outer experiences refused to align. No matter how much he wrote about the past, he wasn't able to fix it.

EXTRAPOETIC CHOICES

The Third Son, and Loyalty and Betrayal, 1950–1951

Although Felicidad experienced a renewed sense of hope for her marriage after Leopoldo's return from Latin America, her feelings of optimism were short-lived. She gave up writing short stories, as if her fictions hadn't produced the effects on reality she had intended. This gave her more time to ruminate on her dissatisfactions.

More disillusioning than ever was the contrast between Felicidad and Leopoldo's lived relationship and the one of his poetry. With the success of *Escrito a Cada Instante*, their love that had been deflated by quotidian complacency and the pain of losing two babies now belonged to thousands of new readers. They would imagine her as the worshipped muse of a poet—a real-life *Gioconda*, like the painting they had met in front of a decade before—and not an unhappy homemaker. "Those poems that I listen to from his lips and read so many times, the ones that talk about me, to whom do they refer?" she wondered. "To that solitary, abandoned woman, the one to whom he doesn't pay attention, the one that he makes wait long hours at night. . . . I

start to see them as if they were written about another woman. Another woman that doesn't live with him, who is far, who I barely know."

Such marital malaise, of course, was familiar territory by now for Leopoldo and Felicidad, so their continued tensions didn't presage a crisis of any sort, until one night, shortly after his return from the Americas, when he asked her an unexpected question.

"Tell me," Leopoldo said. "You've never cheated on me, have you?"

BY THE SPRING OF 1950, THE INTERPLAY BETWEEN LOYALTY AND BETRAYAL HAD become an inescapable theme in Leopoldo's life. Ever since the day he turned twenty-seven and was hauled away to San Marcos, he had been forced to make many hard choices. Some people considered his decisions betrayals—betrayals of people he had known, but above all, betrayals of his history and his ideals. He had become a man he likely wouldn't have recognized back when he and Juan and their friends were dreaming of lifting up Spain together. Even so, if his evolution was egregious in its outward contradictions, Leopoldo wasn't the only member of his generation to choose the present over the past, survival over principles. Spain was still in the grip of a dictator who demanded loyalty from the institutions he depended on but promised none himself. Few if any people who had soldiered in the war for Franco, like Luis Rosales, had thought they were fighting for his indefinite rule. Leopoldo and others had found ways to make lives and bided their time, hoping the monarchy would edge the *Caudillo* out of power even as he outmaneuvered every opponent. With the outbreak of the Korean War that summer, the United States warmed to Franco as a bulwark against the spread of communism, and the two countries would make a watershed military alliance official in 1953 with the Pact of Madrid.

After his return from the Americas, something shifted in Leopoldo. He was done playing a double game, tired of masks. Spain was what it was, he was who he was, and he was done angling and apologizing. Although his country was far from perfect, he was proud to call it home, Francoist warts and all. It outraged him to listen to strangers from abroad attack his house and his tradition when they didn't— couldn't—understand it. If he had any last hesitations about declaring his loyalty to the regime, two job offers dispelled his doubts: a permanent position as the director of a new government-sponsored literary magazine; and a temporary one as secretary general of the upcoming Hispano-American Congress of Intellectual Cooperation, which Spain was hosting. With a relaxing of the international community's ostracism of Spain, cultured men like Leopoldo were needed to burnish the country's reputation—and to defend it, a cause he assiduously took up. In a letter that summer to the Ecuadorian poet Alejandro Carrión, who had publicly turned down an invitation to the congress, Leopoldo responded with a tone of courtesy that evoked an image of him gritting his teeth in a smile of suppressed rage:

> *From the outset I won't bother to convince you my friend Carrión; precisely to convince you I had invited you, well aware of your extrapoetic position, to visit Spain. To visit freely, directly, without any other obligation than that which, as an intellectual, is incumbent upon you: respect for the truth. What do you want me to answer and explain to you through a few words? It would hurt me very much if such words, so modestly mine, sounded like propaganda, like an extrapoetic refrain. And surely I forgive you, forgive your deceived Hispanic good faith, your gallant polemic and ardor. The propaganda against Spain—whose good sides and bad sides I understand, you must recognize, better*

than any absent person and down to their very roots—the
propaganda, I mean, unleashed in America against Spain,
has falsified, exaggerated, and debased the truth to such an
extent, that only with your own eyes, your absolutely free
presence, would it have been possible and feasible for you
to make a fair judgment, bitter or not, of our freedom and
our life. Everything else, and unfortunately your words in-
cluded, is pure and abstract ideology; it's about time that
every person faces up personally, authentically, to the world
that they care about and take the pulse of life with their own
hand.

Extrapoetic. This is a word that surely almost anyone other than Leopoldo would have forgone for the more obvious choice: *political.* Extrapoetically speaking, Leopoldo's loyalties were clearer now than ever. As far as his long, strange evolution from communist poet to defender of Franco's Spain was concerned, there was little left for him to betray, save for the one entity in his life he always had been unfailingly loyal to: his family. Except marriage was more complicated than being a son or brother. Even if it was the ordinary bad behavior of men of his time and place, he had betrayed Felicidad, both in London and while on the trip to Latin America. But what would happen if she had betrayed him?

LEOPOLDO'S QUESTION HUNG IN THE AIR BETWEEN THEM.

Felicidad recalled, "He tells me that with our confession we would set off on a new way of living, we would fill the emptiness of these years." At last, they stood on the threshold of the true house of their marriage, about to abandon the facade.

Leopoldo went first, answering his own question. He confessed to a few trivial affairs, including the girl from the dance

troupe in the UK whom Felicidad had suspected. And what about her? Leopoldo asked. What had gone on between her and the flirtatious adviser to the king?

Emboldened by this mood of abrupt, naked honesty and good-faith amnesty—or perhaps sensing an opportunity to wound in a way she'd never before dared—Felicidad told Leopoldo about Luis Cernuda. Of course, there was nothing to tell beyond her own feelings and interpretation of events. But why would he question her account? If Leopoldo had been looking for forgiveness by making his confession, he hadn't actually been prepared to return the favor. Her revelation sent him into a rage.

"I don't want to remember that night," Felicidad later wrote, "nor the following nights: his vengeance, his fury, his injured pride." According to her, Leopoldo decided to kick her out of the house and forced her to sign a document admitting her guilt and giving up custody of their two sons. Although divorce was illegal, it wasn't unheard-of for married couples to quietly separate, keeping it as an open secret in lieu of a legal split. Such an arrangement would be much closer to Cernuda's cynical idea of *familia* than Leopoldo's own supposedly sacrosanct one. The poet was banishing his muse. He could no longer shield the imperfection of his personal life with the perfectibility of poetry. And Felicidad was living her very own marriage plot ripped from a nineteenth-century novel, yet with none of the romance. That they had arrived at this point was the fault of both. Since they had met ten years earlier, their flaws had conspired to produce this moment.

While Felicidad packed her belongings, Leopoldo tore up Cernuda's books.

On the verge of leaving Ibiza 35 to go to her parents' house, Felicidad decided to beg Leopoldo for forgiveness. The prospect of not being able to take her two sons with her was too much to bear. With zero legal rights, she had everything to lose.

At the end of a long, excruciating night, Leopoldo forgave Felicidad and decided to let her stay on one condition: that Juan Luis and Leopoldo María no longer see her parents, her only source of independent emotional support. She agreed, although by the end of the year Leopoldo relented. José Blanc was dying of cancer. He allowed Juan Luis and Leopoldo María to visit their grandfather, and Leopoldo visited José Blanc himself for the administering of last rites. In January, at age seventy-two, the great surgeon who still missed his native Barcelona passed away in Madrid. The youngest daughter he'd left behind no longer had a father. She had only the father of her children, and the same month of José Blanc's death she became pregnant again.

As it happened, the baby was due the month before Leopoldo's biggest professional opportunity yet, which had appeared like a reward for his newfound vocal loyalty to the regime. As the newly appointed Secretary General of the Office of Intellectual Cooperation, he was tapped to organize the first ever Biennial of Hispano-American Art, in Madrid.

THE MONTHS OF PREPARATION LEADING UP TO THE BIENNIAL WERE A TIME OF CHAOS. Not only did Leopoldo have to secure works of art from some two dozen countries, he had to oversee their transport and mounting, and also handle the demands of the artists. On top of all this, he had to ensure that the works he selected did the impossible: satisfy the Francoist aesthetic sensibility "for the good of the Patria," as the artist Antoni Tàpies sarcastically put it, while still being relevant to contemporary art. The biennial was an international event, and Leopoldo was charged with putting the makeup on Spain's scarred face for the rest of the world.

On September 14, with the biennial just a month away, Felicidad was at home when she felt a contraction. She called to Leopoldo. He was in his study working on a poem about

St. James—Santiago in Spanish—Jesus's apostle who lent his name to the famous pilgrim's trail of Compostela that passed through Leopoldo's home province of León. Doubtful that she was really entering labor, he told Felicidad to wait. He returned to his typing. She listened to the clatter of the keys, feeling the pain intensify. By the time Leopoldo finally emerged from his study, it was too late to go to the hospital.

There in the apartment, Felicidad gave birth to the baby. Thankfully, there were no complications. It was yet another boy. Leopoldo never finished his poem, but he and Felicidad gave their third son an extra name in honor of the saint: José Moisés Santiago.

THE LARGE CROWD APPLAUDED. DRESSED IN HIS CAPTAIN GENERAL'S GALA UNIFORM, with the Laureate Cross of Saint Ferdinand on his chest, His Excellency the Head of State Francisco Franco stepped out of a chauffeured car in front of the National Library in Madrid. It was half past noon on October 12, 1951, and he had arrived for the opening ceremonies of the biennial. As he reviewed a battalion of soldiers waiting at attention, a military band played the national anthem. The flags of the twenty-five countries represented in the exposition halls rippled in the wind, including the United States'. Nearly sixty years old, Franco largely shied away from public life, but this event called for due pageantry. It allowed him to reinforce his identification with the mythical history of Spain. The inauguration of the biennial coincided not only with the national holiday commemorating Columbus's discovery of the Americas but also with another anniversary of empire: the five hundredth year since the birth of Queen Isabel of Castile, who with her husband, King Ferdinand, took back the Iberian Peninsula from the Moors, initiated the Spanish Inquisition, and launched the conquest of the New World. It was

also critical for Franco and his government to try to wrest back control of the unfolding political narrative from Pablo Picasso, who a month earlier had published a manifesto denouncing the biennial.

A herd of government officials, including a tuxedoed Leopoldo, waited for the dictator at the top of the marble steps to the library, which had been covered in a red carpet. They conducted him inside to the vestibule, where the minister of education read remarks. Spain, he said, supported freedom of artistic expression as long as the works were "authentic" to their time and place, and came from the soul, since "the soul is God." The retinue then followed Franco on to the galleries, Leopoldo acting as guide.

He was proud of what he and his staff had accomplished. The biennial team had brought together nearly 2,500 works of art, not just in the Museum of Modern Art, but several other venues as well. Over the coming months, prizes of all sorts would be awarded. In a newspaper interview, Leopoldo claimed that Picasso's attack on the biennial was proof of its importance not just at home in Spain but abroad. With spins like these in the press, he was defending his earnest hard work to put art at the center of Spanish life again. At the same time, he was peddling apologias for the regime on a larger stage.

Leopoldo's writing is silent on what would appear to be a profoundly symbolic, meet-your-maker moment at the biennial. Here he was, face-to-face with the man who had remade both his life and the life of his country. Looking at Leopoldo, though, no one would have imagined these aftershocks of history quaking beneath the day's calm surface. He looked like one more loyal servant to Franco. He *was* one more loyal servant. With his long-tailed tux, there was something of a butler to his appearance. He was doing his job.

After the dictator's tour of the exhibition halls concluded,

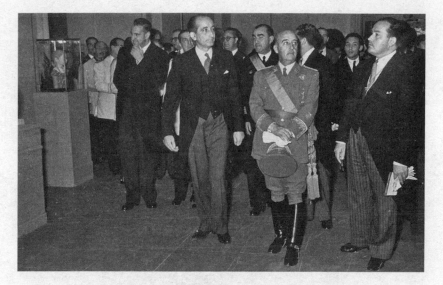

Leopoldo leading Franco through a gallery of the biennial

Leopoldo accompanied Franco outside and bowed to him as he left. The *Caudillo*'s visit had been a success.

The next day, the biennial opened to the public. Long lines formed, reflecting a pent-up hunger for new visions and forms. By choosing to display abstract works from abroad Leopoldo had let in an invigorating gust of wind that the stuffy air of Spain and its people badly needed. Yet there was still one last big event that Leopoldo had to pull off—a theatrical mixture of propaganda and art involving none other than Salvador Dalí.

AFTER NEARLY A DECADE LIVING IN THE UNITED STATES, DALÍ WAS BACK IN SPAIN. One of the most famous artists in the world, as much for his eccentric personality and pomaded mustache—a shape-shifting work of art itself—as for his surrealist masterpieces, Lorca's old friend claimed to have undergone a spiritual transformation. Dalí swore off the surrealism he had pioneered as a young man, as well as modern art altogether, and called for a return to the

Felicidad and Leopoldo taking in Dalí's Christ of Saint John of the Cross

Renaissance through religious ecstasy. This new posture seemed as much performance art as art theory, but Dalí claimed that he was a genuine Catholic. The Franco regime was all too happy to promote this reinvention of the Catalan painter's aesthetic vision, no matter how flamboyant; and Dalí was all too happy to be used as an instrument by the dictatorship. He lent his new painting *Christ of Saint John of the Cross* to the biennial, and sent a telegram denouncing Picasso, which Leopoldo and others distributed to Spanish newspapers. But Dalí's crusade against Picasso didn't end there.

On November 11, the María Guerrero Theater of Madrid filled with the city's intelligentsia, aristocrats, politicians, and university students. Dalí was set to give a "self-promotional set piece," as his biographer Ian Gibson later described it, sure to be as entertaining as it was unpredictable. Felicidad sat with her

sons in a box seat, while Leopoldo managed the chaos behind the scenes. Dalí had always been a divisive figure and the chaos in the crowded theater was so uncontrollable that it caused a forty-five-minute delay. Then Dalí appeared on stage in a pin-striped suit, imperious and defiant, looking like an otter dressed up as a gangster, his mustache waxed upward.

"Picasso is Spanish," Dalí said into microphones of the eager press corps, setting up his famed though nonetheless complimentary jibe at the sincerity of Picasso's politics. "So am I. Picasso is a genius. So am I. Picasso is about seventy-four. I'm about forty-eight. Picasso is known in every country in the world. So am I. Picasso is a communist. Nor am I."

The event was a feat of perfect propaganda for the government, a work of craftsmanship on par with anything on display in the numerous galleries. Leopoldo's hand was on the pulse of Spanish life and he celebrated the success over a meal with Dalí and other regime officials. He had made a definitive extrapoetic choice and now he would be loyal to it.

FRIENDS AND ENEMIES

Canto General *versus* Canto Personal, *1950–1953*

During the nearly fifteen years since the beginning of the Civil War, Leopoldo wasn't the only person who had transformed. The same was true for many of the people he'd known in his youth. Among these erstwhile friends from the past was Pablo Neruda.

While the outbreak of the war had surprised Leopoldo and Juan Panero in Astorga, it had caught Neruda in Madrid. After the Nationalists' aerial bombardments on the city commenced that summer, he had fled north to Barcelona, where he wrote his battle hymn of a book, *Spain in the Heart*. Before the year ended, Neruda abandoned Spain and his post as Chilean consul to work for the Republic in Paris. Like Leopoldo, the Civil War recalibrated the arc of the rest of his life, though in a markedly different direction. As Leopoldo made his gradual political right-hand turn beginning as a soldier in Franco's army, the previously uncommitted Neruda had whipped to the left.

Neruda's words and deeds converged. He moved past the moody solipsism and alienation that had characterized his earlier

poetry, beautiful though it was, and came to believe that his work had to have meaning for "the people, the people whose sword, whose handkerchief my humble poetry wants to be, to dry the sweat of its vast sorrows and give it a weapon in its struggle for bread." Yet he also fought for these people in his actions. In the spring of 1939, for example, as refugees from Spain poured into France, most of whom were funneled into squalid holding camps, Neruda undertook to bring a ship's worth of this stateless exodus across the Atlantic to Chile. This was a laborious, diplomatically byzantine task he had to struggle to complete, but in the end he succeeded. Two thousand Spanish refugees arrived in Chile the same day that Britain and France declared war on Germany. For Neruda, this victory was better than any poem he'd ever written. It was the poetry of social justice.

What began for Neruda as visceral anti-fascism born in the blood-soaked streets of Madrid hardened into a conscientious sense of duty. His devotion to "the people" led him to a new ideology and a career in politics. In the spring of 1945, he was elected to a senate seat in Chile, and that summer joined the Communist Party, becoming a staunch supporter of Stalin. (Like many leftist intellectuals, he would later regret this, but only after failing to denounce the purges.) After his political transformation found its professional expression, his poetic one followed.

"Can poetry serve our fellow men?" Neruda wrote. "Can it find a place in man's struggles?" To answer this question, he began work on an ambitious new book in which he aimed to resolve the tensions at the core of his being and the world: between art and politics, justice and oppression, history and the present, man and nature, life and death, and hate and love. On his return home to South America from Europe in 1943, he had visited the ruins of Machu Picchu in Peru, and this encounter with the ancient grandeur of his continent proved to be a pow-

erful, mystical experience that contained a political promise. He would title this work in progress *Canto General*, or *General Song*.

In spite of his political transformation, Neruda inevitably continued being Neruda. No matter where he went, he took with him his charm, ego, and vanity. By 1947, he was one of the most famous writers in the world, with ten books to his name and an ever-lengthening list of accolades. Events held in his honor drew thousands; his prominent nozzle of a nose became iconic, poking out from beneath either his famous bald dome or a bohemian beret. As always, Neruda threw extravagant bashes and carried on affairs. He retailed his own mythos and alienated the occasional friend, like Octavio Paz, whom Neruda drunkenly insulted because of the younger writer's break from Marxism. The Chilean poet whom Leopoldo had met at the very beginning of his seemingly endless rise was as large-living as the reputation that preceded him. Yet when put to the test, Neruda's principles were the real thing: On January 6, 1948, Neruda took the podium in the Chilean senate and denounced the country's repressive president, Gabriel González Videla. He voiced a litany of other complaints and read off the names of some six hundred unjustly imprisoned Chileans. A week later, there was a price on his head.

Neruda and his wife spent the next year on the run in Chile. He grew a beard and traveled under a fake name. "I moved from house to house, every day. . . ." he wrote. "I passed through fields, ports, cities, camps, and was in the homes of peasants, engineers, lawyers, seamen, doctors, miners." Neruda wrote every chance he could, clacking away on his typewriter as his *Canto* grew and grew. The book was becoming an exhaustive recasting of Latin America from the perspective of its native peoples and landscapes. Neruda's verses celebrated its flora and fauna, revisited its heroes and villains, and retold the history of the so-called New World to set down a more just narrative of the Americas, of which Europeans weren't the owners. The book also included

alchemies in which he mixed his personal battles with those of his continent, swirling in his enemies from the present fight in Chile and the past one in Spain.

In March 1949, Neruda crossed the Andes on horseback along a smuggler's trail and arrived in Argentina. He had made it out of Chile, free and alive. He escaped to France, where Pablo Picasso and other friends welcomed him. A year later, he published a limited first edition of *Canto General* in Mexico. A month later it appeared in Chile. The book wasn't published in Spain, but his verses inevitably made their way to Madrid.

AS AN ESTEEMED POET, FORMER CENSOR, AND ANTHOLOGIST WITH NUMEROUS CON-tacts in Latin America, it is likely that Leopoldo was one of the first people in Spain to read *Canto General*. He thought that the poem "The Heights of Macchu Picchu" was the best Neruda had ever written. In a quintessentially Castilian phrase conjuring both olive oil and Catholicism, Leopoldo called it "gorgeously virgin." But while the book was staggering in its heroic scope and fevered musicality, it wounded him. In the section retelling the Spanish Conquest, Neruda attacked not just Spain, but two of Leopoldo's poet friends: Gerardo Diego, who had been close to his brother, Juan, and a witness at his wedding; and Dámaso Alonso, his drinking buddy and author of *Children of Wrath*.

Neruda's friend Miguel Hernández, the poet-warrior of the Popular Front, had died in one of Franco's prisons in 1942 despite Neruda's interventions on his behalf from Paris. He still hadn't recovered from this loss and near the end of *Canto General* he included a poem about Hernández. "May those who killed you know that they will pay with blood," Neruda seethed. "May those who tormented you know that they will see me one day. / May the bastards that today include your name / in their books, the Dámasos, the Gerardos, the sons / of bitches, silent accomplices of

the executioner, / know that your martyrdom will not be erased, and your death / will fall upon their moon of cowards."

Sitting at home in his study, Leopoldo said he "almost forgave the ferocious insults." They were a form of betrayal. But he didn't do anything—not yet. He was consumed by his new professional responsibilities, and also his personal gains and losses. His family had happily expanded with the birth of his third son, only to then cruelly contract with the death of both of his parents within one month of each other in 1952. *The definitive agony*—that was how Leopoldo described the death of Máxima, the mother who had twice given him the gift of life. In spite of the struggles of their long marriage, Moisés had promptly followed his wife as though he literally couldn't live without her.

At the very end of "La Estancia Vacía," Leopoldo had imagined an ax hitting the silent trunk of a tree "blow by blow." For him, this was the sound of death as God worked, filling man's heart with questions. His parents, the trunk of his life, had fallen. The rooms he had grown up in really were empty now. The only salvation left was what Leopoldo had already done: build a family of his own. It may not have been the life he had imagined, but it was his. He had become the trunk shooting out new branches.

IN EARLY 1953, LEOPOLDO WAS TOYING WITH A NEW BOOK THAT HE ENVISIONED CALLING *Moral Epistles to My Best Friends and Enemies*. His poetic tour of the Americas had unlocked an us-versus-them mentality that he had resisted his whole adult life, during which Spain was almost always divided into an us and them. That spring, a recent issue of a literary magazine published by Spanish exiles in Mexico ended up in his reading pile. It contained "The Lost Shepherd," a new poem of still more grief-stricken verses by Pablo Neruda about Miguel Hernández. The poem wasn't very different from the previous one, except in one verse he leveled a new accusation. He wrote

that Jóse María de Cossío, one of the pillars of the conservative literary establishment in Spain and a friend of Leopoldo's, had dined out with Hernández's jailers. In fact, Cossío had lobbied the authorities on his behalf. Neruda's calumny infuriated Leopoldo. He halted work on his epistles and began a new poem. It was a letter to just one enemy—Pablo Neruda.

For the next two months, Leopoldo wrote in a frenzied trance. During Holy Week, which he celebrated in Astorga, he spent eight heady days churning out the bulk of a book-length poem. As always, he dipped his verses in the inkwell of the place that had created him, invoking its ivy and cathedral. But in the rhyming triplets he employed he addressed Neruda directly, spraying him with wrath over the course of 1,500 lines. "Your insults of a bitch are your ring / of Judas," Leopoldo wrote. He called him a coward and accused him of defiling the memory of Hernández and Lorca. "Your naked lying is an outrage . . . you don't care about innocence, / only crime . . . your voice is stained with revenge." Yet Leopoldo recognized the love—and the shared, lost past—that fueled his hate. He wrote that he had once loved Neruda. He recalled signing the letter of homage for him in 1934. "How distant!" Leopoldo raged. "Today you are a dagger in the back."

However self-righteous, there was real pain in Leopoldo's verses. There was also a blindness to Neruda's own pain and the justified sense of betrayal he felt toward Leopoldo and other Spanish poets who had either supported, benefited from, or failed to stand up to the Franco regime. But bridging understanding with Neruda—"stump of a friend, ulcer of the heart"—wasn't on Leopoldo's poetic or extrapoetic agenda. Being put on the defensive had precipitated him into absolutist zeal. The poem transformed his voice, sharpening it into a knife that cut history with an ideological blade. "All of Spain is new (and more beautiful)," he wrote to his old friend, "since you left." He sang the praises of José Antonio Primo de Rivera and his "Falangist rivers." Yet the poem

was also perforated with remorse and laments for the wrongdoings of Francoism and its cold-blooded murders. The work was riddled with contradictions, just like Leopoldo. He called his new book *Canto Personal: Carta Perdida a Pablo Neruda* (Personal Song: Lost Letter to Pablo Neruda).

Not two weeks after Leopoldo finished it, copies of the book were waiting at the printer. It came with a jingoistic prologue by Dionisio Ridruejo, who lauded Leopoldo as "the most complete, essential, and truest of all the poets of that generation that matured after Spain's war." Privately, however, Ridruejo and other friends, especially Luis Rosales, warned Leopoldo that he was stepping into the mud of political sloganeering. Their literary generation had wised up over the years, accepting that both fascism and authoritarian traditionalism had been momentous mistakes. Democracy was the best option, even though the dictator they had helped to power didn't agree. Rosales tried to convince Leopoldo not to publish his counter-*Canto*. Leopoldo ignored him.

Rosales's worries about the book's reception were unfounded— or so it seemed at first. Leopoldo's book was breathlessly embraced by the Spanish political establishment, who trumpeted his work along with many writers. Like Dalí at the biennial, Leopoldo was happy to be used as an instrument by the regime. As for Felicidad, she was flummoxed by her husband's book. She judged it as a bewildering love letter to Spain.

Curiously, the acclaim *Canto Personal* received wasn't limited to Spain, or even to the Spanish language. Of all people, Gerald Brenan, the prominent British Hispanist who was temporarily banned from Spain for his anti-Franco views, praised the book in public and private. In a letter to Leopoldo after attending the Madrid Book Fair, he wrote that he thought Leopoldo's poetry was bringing back the excellence of the *Siglo de Oro*, the "Golden Century" of arts and literature in Spain, from the early 1500s to the mid-1600s, when El Greco and Diego Velázquez painted,

El Escorial was built, and Cervantes wrote *Don Quixote*. In October, Brenan published a piece in the *New York Times*, in which he wrote of *Canto Personal*, "If political prejudice can be avoided, [it] will quickly take its place as one of the great poems of Spanish literature. . . . It is the first great book I have read which expresses adequately the mental suffering caused to all Spaniards by the Civil War."

An ocean away in Chile, Neruda wasn't amused. "The intention of Panero's book is obvious," he told a reporter. "I have two implacable adversaries: on the one hand fascism which attacks me from the outside . . . and individuals who attack me from the inside. The first I have combated with my actions for peace and fraternity. The others with my work. Good poets don't concern themselves with other poets, and when they do, it is to praise them. As for the bad ones, they have to write against good poets so they'll be known." Despite Neruda's claim that he never responded to detractors, the literary boxing match between him and Leopoldo wasn't over. Neruda would have the last jab.

That year Leopoldo was awarded the National Literature Prize for *Canto Personal*. "I was a fairly pure and typical poet, foreign to external things," he said in an interview, "but this time I have tried to enter wholly into Spanish life." He had united Spain's official narrative with his own poetry, the biography of his soul.

Leopoldo was at the height of his career, but not for long. He was right: he didn't understand "external things" as well as he understood poetry—and this would have consequences. He had confused national emotions with personal ones, patriotism with propaganda. "My heart beats at every instant," Leopoldo wrote in a poem he published soon after completing *Canto Personal*, "and Spain, Spain, and Spain is its sound." If a Spanish poet living in exile wrote verses like these they meant one thing. If Leopoldo Panero wrote them they meant something altogether different.

CHAPTER 21

GOOD BREAD AND BAD WINE

The Sons and Their Father, 1954–1958

Soon after Leopoldo María was born in the summer of 1948, Leopoldo had written a poem for his newborn second son, just as he'd done for Juan Luis. Titled "Introduction to Ignorance," it was a lullaby of sorts in which he celebrated his second son's innocence: "intensely happy without knowing it, / intensely alone without knowing it." Again, Leopoldo imagined his child as the redeemer of his parents, reversing the customary role of the singer of the lullaby. "You sing to us," he wrote, "not us to you."

As time passed, however, Leopoldo María's parents discovered that he was anything but a soothing lullaby of a child. He was more fragile than Juan Luis, yet more defiant. During his first visit to Astorga during the summer that he was beginning to walk, he had refused to let his father dress him in a pair of blue overalls. When Leopoldo refastened one of his straps, he pulled it right back off. This obstinacy was nothing if not innocent, just not the kind of innocence a parent appreciated. Frustrated, Leopoldo slapped his son in the face, one of many slaps he would

give him. But Leopoldo María didn't cry. He coldly stared down his father, who could only gaze back, perplexed and defeated.

Juan Luis was a different sort of child. Where Leopoldo María was growing ever more social, he became more withdrawn. In photos from his childhood and adolescence Juan Luis hardly ever smiled, and his best friend as a teenager, Rafael Ormaechea, would later recall that he almost never laughed. His grades were bad, just as Felicidad's had been. He enjoyed going to bullfights and American Westerns with his father.

In 1954, Juan Luis, who often butted heads with Leopoldo, turned twelve; indomitable Leopoldo María, who bore a resemblance to Felicidad's dead brother, Luis, turned six; and flagrantly cute, curly-haired José Moisés Santiago, who saw his name transformed by family wordplay into "Michi," turned three. Meanwhile, Leopoldo and Felicidad themselves were aging. He turned forty-five in the fall, his gut filling out as his jowls began to slacken; she forty-one, her face, having become nobly aquiline, was still attractive and sensual—a word men would use to describe her well into her sixties—but fatigued-looking. In the eyes of many of their peers, the Paneros were the ideal portrait of a family. On Sundays, friends often came over to their apartment, among them the painter Álvaro Delgado, who thought Felicidad and the three boys gave "the impression of being a family very united around a father who was extremely affectionate with them."

During the weekend gatherings at the apartment, the main event was frequently performances by little Leopoldo María. The second Panero son was turning out to be more than just defiant. He was brilliant and imaginative, unnervingly so. At age five, he startled his parents by beginning to spontaneously recite poems of his own invention, speaking with a grown-up air as he improvised verses that were incongruously dark for a child. One day, he riffed a particularly strange poem: "So I said, he is my father and people

The Paneros in the mid-1950s

passed by and the drunks passed by. I found myself in a grave covered in stones, I said, pull me out of this grave, but there they left me with the inhabitants of destroyed things which were no more than 4,000 skeletons and my heart trembled but it was a dream that my heart was dreaming."

At first, Leopoldo and Felicidad kept their son's precocity a secret. They worried such outlandish behavior might attract negative attention. Conformity, after all, constituted the top-down value system of the society in which they lived. Gradually, however, they relaxed and soon Leopoldo María was giving impromptu one-man shows that delighted guests. To the people gathered he would say, "I'm inspired," then launch into verses. It was astonishing. Two years later, after reading one of his poems, a writer and family friend noted in his diary, "I wonder if many older poets today would be capable of writing a poem as lovely as this one." In spite of these extraordinary gifts, a fear persisted in Felicidad's mind. Something about Leopoldo

María's luminosity—his prodigious imagination, his nervous joyfulness—reminded her of her sister Eloísa.

Leopoldo, meanwhile, had anxieties of his own beyond the family nest. After the official zeal with which *Canto Personal* had been met, an unmistakable chill had settled around him and his poetry. This cooling was a mix of the personal, the political, and the literary. Dámaso Alonso felt that Leopoldo had been out of line in defending him when he was fully capable of defending himself; and Luis Rosales was right that the increasingly liberal literary establishment would punish the increasingly reactionary Leopoldo.

Leopoldo's *Canto* had emerged out of dying notions from yesterday, while Neruda's work fed into the new poetry of today—*poesía social*, or "social poetry." This movement which overtook Spanish poetry in the 1950s was embodied by Gabriel Celaya's iconic poem "Poetry Is a Weapon Loaded with the Future." A manifesto of sorts, it championed, "Poetry for the poor, necessary poetry / like daily bread." Celaya wrote, "I curse poetry conceived as a cultural / luxury by the neutral ones / who, washing their hands, avoid and evade. / I curse the poetry that doesn't take a side and get dirty." In the 1940s, Leopoldo's poetry had indeed appeared neutral, leaving politics out of a cruelly politicized time and place, though when he got dirty with *Canto Personal*, his poetry turned out to be a weapon that jammed on the past. By falling into step with the politics of the Spanish regime, Leopoldo had fallen out of step with Spanish poetry.

MUCH LIKE LEOPOLDO'S LITERARY CAREER AT THIS TIME, THE 1950S WERE SHAPING up to be a decade of twisty intrigue. Franco withdrew ever further from the day-to-day goings-on of government, preferring instead his two favorite pastimes, hunting and fishing.

Mistakenly thinking that the *Caudillo* was nearing a decision to divest power, or that he might die soon, different competing factions inside the regime—mainly monarchists who wanted the restoration of the throne and die-hard Falangists who wanted a more totalitarian system—angled for positioning. Yet hardly anyone but fascists supported the perpetuation of the dictatorship. Franco had proved himself to be loyal to the church only insofar as it didn't challenge him, loyal to José Antonio's philosophy only in speeches, and loyal to Spain's monarchy only in dangling the possibility of Don Juan's son, Juan Carlos, one day taking the throne in some indeterminate, hypothetical future. A master of self-preservation, Franco was loyal only to himself, which left many feeling betrayed. And now Leopoldo felt betrayed by his literary fortunes.

Having made a tone-deaf aesthetic choice by writing *Canto Personal* in the wrong decade, he felt alone. He drank heavily. He already had a temper, but it got worse with his *mal vino*— "bad wine," an expression meaning he was an angry drunk. One day, fed up with the late-night jangle of his keys in the door to an apartment with children sleeping, Felicidad changed the locks. When Leopoldo came home he raised hell out on the landing.

It was during this period that Leopoldo's three sons formed countless lasting memories of him, and in light of what they would later say about their father alongside Felicidad, it is worth asking a question that lies at the heart of the story of the Paneros: Was Leopoldo a bad father and husband? Or more pointedly, was he any worse of a father and husband than nearly all men of his generation in Franco's Spain? He drank, raged, and cheated, but who didn't? Of course, this wouldn't have mattered to his kids and it didn't excuse his betrayals and egoism; the banality of such behavior didn't make it any less upsetting to his family. Yet there is also a question of if Leopoldo's *mal vino* was truly as bad as Felicidad and her boys later claimed. Numerous accounts testify

to Leopoldo's fierce mood swings, yet fifty years later, a nanny and maid who worked for the family for eleven years, Angelines Baltasar, couldn't recall him ever raising his voice at Felicidad or their children. Or was he the perfect reflection of the regime he worked for, determined to appear one way in public, but different in the shadows?

What is undeniable is that Leopoldo was a cryptic, complicated, and often difficult man, and his personality and the power he wielded over his family left a profound mark on his wife and children. Leopoldo's friend José María Souvirón compared him to fresh-baked bread—hard on the outside but warm on the inside. As Souvirón wrote, "It is necessary to forgive (and one must do so, because he deserves it) a coarse, almost prickly crust, with which, when it seems he's attacking, he's defending his intimate tenderness."

Yes, Leopoldo was full of pain, but he also caused pain. It is unlikely that Felicidad and her sons vastly exaggerated Leopoldo's behavior. A quite different question is if they ever forgave it.

Leopoldo María, Juan Luis, and Michi

THE KILLER OF NIGHTINGALES

A Happy Family, 1959–1962

The fountain in the Piazza de Ferrari shot up water in white arcs. The Cathedral of San Lorenzo rang its bells. It was the spring of 1959 and Leopoldo, Felicidad, and their three boys were in Genoa, Italy.

They weren't alone. Far from it. The trip had been organized by the Institute of Hispanic Culture, where Leopoldo now worked. Packed into the chartered tour bus that had brought them across France from Spain were Luis Rosales and his wife and son; three other writers with assorted family members; and two of Leopoldo's sisters and their husbands, who had come to fill out the remaining seats. Also along for the three-week jaunt around the country was a crew from *No-Do*, the propaganda newsreels of the state-run media, filming a ten-minute segment to be aired later. "Genoa, Milan, Roma, Venice, Florence," Felicidad wrote with deliciousness. "The beauty of Italy in front of us."

Over the past five years, much had happened to the Paneros in one sense, and very little in another. In 1954, Leopoldo was

called on to organize a second biennial, this time in Latin America, which took him abroad for nine months. In Venezuela his excessive drinking and friendly mixing with Spanish exiles led to a complaint about him landing on the desk of the minister of foreign relations back in Spain. Now here was an odd, ironic fix: A former communist who had recently published a celebrated fascist book that alienated him from the more liberal literary Spanish establishment *now* was accused of being a communist? Rosales gave a presentation on his friend's behalf to the minister and Leopoldo endured an investigation into his loyalties. The absurd logic of the situation was less important than resolving it, and he came out of the crisis still employed.

Soon after, the family spent four months living in a country house near Barcelona as he organized a third biennial there. When they returned to Madrid, they rented an old stone home in a town outside of the city. Michi later described this episode as a failed attempt at living *The Swiss Family Robinson*. The cold and the isolation were too much, sending the Paneros back to the Calle Ibiza, where new apartment buildings were going up, obscuring memories of wheat fields waving outside the windows. Leopoldo María and Michi began their education at the Liceo Italiano—the Italian School—while Leopoldo sent Juan Luis off to boarding school at the monastery at El Escorial, the king's former residence northwest of the city. Leopoldo thought his eldest son needed discipline. Juan Luis called his new home a "dark tomb." There he smoked cigarettes, drank alcohol, got bad grades, and angered priests who admired his father's poetry.

The family's economic situation was precarious again, even as they appeared better off than they were, driving around in the Seat 1400 Leopoldo had bought with part of his inheritance. Considering the plight of most Spaniards, the only remarkable thing about the Paneros' plight was perhaps how their privileged

backgrounds before the war hadn't led to more or even just the same privilege after the war. They were figures of genteel poverty. And Leopoldo and Felicidad weren't any richer in love than in money. She felt like they had become like roommates. As Leopoldo told a younger writer who often joined him and Luis Rosales for after-work drinks, "At twenty years old one can fall in love with fantasy, but at forty one must go to bed with the truth."

Yet something unexpected occurred during their travels in Italy. Without warning, Leopoldo behaved more like the husband Felicidad had always hoped he would be. On the long bus rides, he was attentive to her and the kids, and stayed close to them, rather than to Rosales and his other friends, who he complained wouldn't stop talking about life back in Madrid. Italy was enjoying a vibrant economic boom that contrasted starkly with Spain's stagnancy, making for a cheerful vacation mood as the group checked off must-see destinations: Venice's many-pigeoned Piazza San Marco bathed in moonlight; Florence's Botticelli Rooms in the Uffizi, Venus's hair billowing dreamily; Rome's Catacombs, and the Vatican; and Pompeii, where doom had delicately preserved antiquity.

The Panero kids loved the trip, but not as much as their parents. "I wished time would stop," Felicidad wrote, "that we might continue eternally on that bus, looking out at the landscapes of Italy." In a long-ago poem, Leopoldo had written about a "forgetful unforgettable love." It now seemed he had suddenly begun to remember.

For Juan Luis, the trip was special for an entirely different reason. He was nearly seventeen and matters beyond just sightseeing were on his mind. Along with all his other sins at El Escorial—from which he had been expelled before the trip—he had discovered masturbation. At the all-boys school,

however, there wasn't even the possibility of finding a girl to sin with him. The closest he came, along with every other boy at the monastery, was when Cary Grant, Frank Sinatra, and Sophia Loren came to El Escorial to make *Pride and Passion*, a film about the Napoleonic invasion of Spain. One day the stars suddenly appeared during recess. There was the gorgeous and busty Loren, low neckline and all. The horde of boys rushed after her as the priests blew their whistles. Cary Grant ushered Loren into a trailer, but not before she gave the pubescent marauders an indulgent wave. That night, the priests made Juan Luis and the other boys kneel until three in the morning with their arms stretched out in imitation of Christ.

In Italy, Juan Luis felt free. He had little to say to his two brothers—Leopoldo María was six years younger than him, Michi nine—and he engaged with the adults on the trip with a newfound maturity, so his parents gave him the latitude to go off on his own. Sure enough, he met a prostitute in a bar and paid her with money from his grandmother Bergnes. She was gentle, having realized he was a virgin. Discovering sex, Juan Luis wrote later, was like the creation of a new wordless language.

The only unpleasant moment of the trip occurred on the night bus ride back through France, in Marseille, when the group came upon an accident blocking the road. A truck had crashed into a car of gypsies. The sight would stay with seven-year-old Michi for the rest of his life as a harbinger of mortality. "The road full of blood, the police sirens, the blinding lights," he wrote. "It was the first glimpse of what death would later come to represent for me. Death, which always comes to disrupt order."

WHEN THE FAMILY RETURNED FROM ITALY, THEY BROUGHT THEIR SENSE OF RENEWAL back home to Madrid. Leopoldo continued to be more present, even recognizing that he had neglected their sons and given too

much of his time to friends instead of to Felicidad and the boys. He still would never be the truly close husband who intimately understood his wife and opened up to her; he would never be the man of his poetry. And she would never be the woman who intuitively understood his mysteries or separated her love of the literary from love itself. But they finally became a relatively cohesive, stable family, and this was no small achievement. Felicidad decided that love was a work of art that sometimes required the sacrifice of pleasure in order to keep it intact. And during this time love reemerged in Leopoldo's poetry. At this late stage in their marriage he wrote several new poems about his wife. "Felicidad:" he wrote, "your name accompanies me / like nothing else."

As if this improvement for the family had the power to conjure others, a professional one followed for Leopoldo. In 1960, he became editorial director of the Spanish *Reader's Digest*, ending his tenure as a functionary for the dictatorship. The job resolved the family's struggles with money, granting them novel luxuries: a television, record player, and refrigerator. They were no longer millionaires of crumbs.

THESE CHANGES FOR THE PANEROS COINCIDED WITH LARGER SHIFTS IN SPAIN. AS Franco delegated more governing responsibilities to a new generation of skilled, modern-minded technocrats who believed in the forces of the free market, the country's economy cracked its door open to the rest of the world. In order for new trade relationships to be forged, however, Spain had to show other European nations a more liberal approach to governance. While Franco still believed that democracy was a decadent system run by Freemason conspirators that would usher in communist domination, he held back the hard-line Falangists in his cabinet and ceded to less repressive judicial procedures. He also made symbolic gestures, like the hug he gave to Dwight Eisenhower

when the American president came to Spain for a brief visit in 1959. Nevertheless, Franco refused to consider stepping down. He worried that handing power back to the monarchy after his death would destroy his legacy. He continued to see the world through his vanquisher's mind-set of the Civil War, and at last completed his monument to that victory. While the Paneros were in Italy, the dictator inaugurated the Valley of the Fallen, his grandiose, cruciform war memorial and future resting place in the Sierra de Guadarrama. The imposing basilica and soaring cross honoring the Nationalist dead had been under construction for twenty years, built by twenty thousand Republican prisoners drafted into "labor battalions." Thousands of these prisoners had themselves "fallen" during the building of the monument, a memorial to the dead built upon more dead.

Leopoldo and Felicidad did have one ongoing concern during this charmed period for the family amid Spain's changes: Juan Luis. After getting kicked out of El Escorial, he had decided to live with Felicidad's mother. (She had rented out the *palacete* on Manuel Silvela after José Blanc died and moved into an apartment.) Juan Luis and Leopoldo clashed constantly, and he had no interest in returning to the place where he had witnessed his father's drunken outbursts. Plus, he adored his grandmother. He read Shakespeare's plays aloud to her and she took him to the theater. His best friend would come over to talk about girls with Juan Luis, and Felicidad Bergnes de Las Casas would exclaim with exasperation, "You talk of nothing but carnalities!" As much as he did indeed talk about the flesh, Juan Luis also had loftier matters on his mind. He, too, had poetry in his blood, but when he entered the university, in 1961, literature mixed with politics—and with the politics of his father.

"I became a conscious anti-Francoist," Juan Luis wrote, "and, while I was at it, an anti–Leopoldo Panerist. Unfortunately,

these two things were always mixed." The remaining leftists in Spain were mainly workers or middle-class youth like him eager to rebel against the world of their parents. On the bus to the university, members from Opus Dei, a Catholic organization, competed with clandestine communist operatives to recruit students. For Juan Luis the choice was easy and one day at Retiro Park he was sworn in to the Spanish Communist Party. From then on, when he wasn't talking books over gin at the student bar, he was agitating against the regime. In the spring of 1962, he participated in the taking of the Department of Economics in support of a miners' strike in Asturias. While the dean managed to keep the activists out of serious trouble, Juan Luis wasn't always so lucky. On one occasion he was detained and beaten.

Just like Leopoldo in his youth, his eldest son was a young man seduced by poetry and dreaming of change. This desire for a different world pressed against powerful forces that didn't exist in prewar Madrid, and in spite of his new job his father was still a symbol of those forces. Not only did Neruda's *Canto General* remain popular among students, but in 1960 the Chilean published a poem that attacked Leopoldo and converted him into a Francoist executioner. "Miguel Hernández dead in his prisons," Neruda wrote, "and poor Federico killed by the medieval criminals, / by the disloyal pack of the Paneros: the killers of nightingales." The Panero name, Juan Luis saw, was a very specific, public burden, especially now that he had started trying his hand at poetry. He refused to show his incipient verses to his father, which stung Leopoldo.

Leopoldo never responded to this last punch from Neruda, but in a feat of either political growth or staggering hypocrisy, in December 1960 he signed an open letter to the government titled "The Problem of Censorship." It decried the "system of intolerance" that was suffocating artistic expression in Spain

and producing an inferior culture. During this period, Leopoldo also wrote a poem titled "It Would Seem," in which (it would seem) he forgot that he had published openly Falangist poetry. "It turns out that now I'm fascist when I smoothly conduct the spring," he wrote. "It turns out that my bones, / my royal and very real bones / (the poor things), / have changed the marrow of their politics." This willful naïveté, alongside an unwillingness to see how his career might be perceived, was by now familiar. It was a governing melody of his life's song.

One night in 1962—the same year that Prince Juan Carlos of Spain married Princess Sofía of Greece in Athens, and the anti-Franco opposition from inside and outside of Spain held an open congress in Munich—Juan Luis visited the Calle Ibiza apartment. Leopoldo had reformed himself as a family man, but he still had a temper and was still a drinker, and in spite of the latest turn in his muddy, switchbacking political odyssey, he didn't approve of Juan Luis's activities. He and Juan Luis got into an argument over politics. Little did he know that at this time his son was engaged in light espionage for communist Cuba; his handler for the Spanish Communist Party, the writer Fernando Sánchez Dragó, had assigned Juan Luis the task of gathering intelligence on the failed CIA-sponsored Bay of Pigs invasion from an exiled Cuban intellectual in Madrid, whom Juan Luis knew through his father's literary network. Even though Leopoldo was unaware of this dangerous activity, his and Juan Luis's conversation escalated into a shouting match that ended with Leopoldo telling his son to leave the house and never come back.

"Have I ever lived here?" Juan Luis said. "I was always just a guest."

JUAN LUIS'S BLOWUP WITH HIS FATHER DIDN'T STOP HIM FROM ACCOMPANYING THE family that August to Villa Odila, the family's rural estate.

Leopoldo María and Michi, now fourteen and ten respectively, rode their bicycles around the countryside the way their father and his brother once had, enchanted by the river and oak trees. For city kids who had grown up in noisy Madrid, Castrillo was like a storybook escape into nature and imagination. They put on performances of plays by Shakespeare with the help of Juan Luis, though otherwise their older brother, now nineteen, kept to himself, studying for classes he had failed during the school year. On Sundays Leopoldo and Felicidad took the boys to morning Mass in Astorga, and on Tuesdays they returned for the market in the town square. Leopoldo worked on a poem he'd been asked to write for the ceremony of a local poetry prize, for which he was one of the judges. When he finished his poem, a paean to the peasant villages scattered around Astorga, he read it to the family as he recorded himself with a reel-to-reel recorder, then had Luis do the same. When they listened back to it, Leopoldo was moved by the same cavernous voice the two shared.

Leopoldo had once said that the calling of the poet was "to sound out the truth, to take us by the hand toward it, to make us feel its abundance in the most intimate part of the heart." Now, after years of distance, he was finally allowing himself to be taken into the heart of his family. Until the Italy trip, he had connected more deeply with Felicidad and their sons through the looking glass of his poetry than with the actual people he hoped to channel in verse. This practice meshed with a credo he inserted into *Canto Personal*: "Only poetry makes reality possible." For most people it would be the other way around—poetry couldn't exist without reality—but it seemed Leopoldo was changing. When it came to love, true experiences had to come before the poetic ones. "We started to intuit that this would be . . ." Felicidad said, "the best stage of our life."

Two days later, Leopoldo had to go to Astorga for the banquet to decide whom the poetry prize should go to. Before

leaving, he sat at his desk and finished another new poem. He wasn't feeling well and wasn't in the mood to attend the event, but once there, he ate and drank plentifully, two pastimes he excelled at. When it was time to choose the winner, he stood up and read the one he liked aloud in the same deep voice he had passed on to Juan Luis. While Leopoldo had lost prestige in Madrid, in Astorga he was still a hometown hero with stature; everyone in town seemed to know when he was visiting. He easily brought the rest of the committee into agreement with him. The winning poet was Antonio Gamoneda, a young man from León who would go on to write movingly about Spain's violent past and become one of its most admired poets. More than fifty years later, Gamoneda would still vividly recall the other big event of the day of his win.

Later that afternoon, back at the house in Castrillo, Michi was out in the heat killing wasps in a laundry shed. He saw his father's car fishtailing down the drive. During this moment of inattention a wasp stung him on the foot. Crying, he went to meet his father to tell him what had happened. Inside the car, Leopoldo was also in pain—a pain in his chest so intense that his crushing grip on the gearshift twisted the metal stick. When he got out of the car and encountered a crying Michi, Leopoldo pushed him out of the way.

"My chest hurts," he said as he went past his son into the house.

Up in the bedroom, Felicidad helped Leopoldo undress and get into bed. He said he thought something he'd eaten had sat badly with him; he asked for tea. His face was a dark red. Felicidad felt something was off that wasn't from food or the punishing heat. Twice that week she'd had the same nightmare: she was running through a crowded street crying with Leopoldo María at her side. It had seemed portentous and

now she ran through the wind-whispering forest to the nearby house of a young doctor, who came immediately. He examined Leopoldo, yet said he would be fine and left. When the pain in his chest persisted, the doctor from Castrillo came. He also dismissed Leopoldo's symptoms—just drinker's indigestion, the doctor said. He gave him a sleeping pill and left.

"Go out on the terrace," Leopoldo told Felicidad from the bed. "Wait for me there. If I need you I'll call you." She did as he said and went outside on the balcony and watched the children play in the yard as the sun plunged out of sight and evening fell.

"It's night now," she wrote later. "I think that the silence of the bedroom, its stillness, isn't normal. I go in then and turn on the light: his face is placid, calm, as if he was asleep. I take his hand: it's frozen, I can't find the pulse, I let it fall. I go down the stairs barely knowing what I'm doing. Maybe it's necessary to give him some sort of injection, maybe what I think is peaceful sleep is something worse. Afterward someone will remind me what I said when I came down: 'He's frozen as if he's dead.'"

Felicidad was right. She called the doctor's intern who came over and put his ear to Leopoldo's chest and confirmed it. He was dead. Then everything took on an unreal shimmer: Michi running off into the fields with Leopoldo María; a priest appearing and praying; Juan Luis returning from the train station where he had gone to call for an ambulance; Leopoldo's sisters arriving from town screaming; peasants waiting to pay their respects—and Leopoldo's body being carried down the stairs under a blanket, one of his hands knocking on each step, those same large coarse hands Felicidad had noticed the first time she met him twenty-two years earlier. When they finally found Michi, he kept repeating: "We were so happy."

The poet Leopoldo Panero Torbado had died at the age of

fifty-two. Sitting on his desk was the poem he had finished that morning, his last. It ended with these final words:

> *Because what matters is what is real*
> *written with the mist of the real*
> *and the aerial traces*
> *of the heart that beats when called upon by its owner,*
> *softly,*
> *very softly,*
> *oh poem.*

Leopoldo Panero near the end
of his life

PART 3

THE TRANSITION
1962–1978

"I looked upon the literature of my sons with a certain dread."
—FELICIDAD BLANC

"All enjoyment begins with self-destruction."
—LEOPOLDO MARÍA PANERO

THERE I WANT TO SLEEP

Funeral, August 1962

The coffin floated down the streets of Astorga in a sea of mourners. At the head of the procession, elder townspeople carried candles whose flames shuddered against the air, followed by priests in starched collars and whispering robes. Villagers from Castrillo de las Piedras acted as pallbearers, shouldering the coffin in the late-afternoon heat. The citizens of Astorga mixed with peasants from nearby pueblos and together they enveloped a sprinkling of black-suited writers who had come from different parts of Spain. The sky was an ashy gray that seemed to hang just above the heads of the mourners. The silence of the procession was cavernous while in the city's homes the local radio station played Mozart's *Requiem*. As the crowd poured through the gates of the municipal cemetery, Astorga prepared to lay one of its finest sons, Leopoldo Panero, to rest.

Felicidad took her place beside the Panero family tomb with Juan Luis, Leopoldo María, and Michi. Leopoldo's death, not even twenty-four hours behind them, had destroyed one of the fundamental pillars of their lives, plunging each into a confused

state of shock. One day they had had a father and a husband—the next day they didn't.

The three boys looked around them at their shell-shocked mother, at their aunts and uncles and cousins, at country folk with sun-hardened faces they knew from summers at Villa Odila, at the official who had come as a representative of the Ministry of Information—and at Luis Rosales. After receiving an anguished phone call from Felicidad the day before while holidaying with his family on the southern coast, he'd paid a cabbie to drive him and his wife and son in a straight shot, one thousand kilometers north, to Astorga, nearly the entire length of Spain. "Leopordo," Rosales's closest friend in drink and talk, his comrade in poetry and the past, was gone. There were no more Panero brothers left for him to lose.

Crucifixes rose from the cemetery's tombs like a marina of stone masts, but only the marble vault belonging to the Panero family lay open. "I was born in Astorga . . ." Leopoldo had written long ago in a poem, "and there I want to sleep, in my familial refuge." His wish was coming true.

As a priest prayed and the throng of mourners filling the cemetery looked on, Leopoldo's coffin was lowered into the crypt where the loved ones he had lost in life now awaited him in death: his grandparents, Quirino and Odila; his parents, Máxima and Moisés; and his siblings, Juan and Charito. Now his own name would be engraved beneath theirs on the smooth marble headstone. As if to add painterly intensity to the already dramatic scene, precisely at the moment that the coffin disappeared into the depths of the tomb, the sun broke through a hole in the clouds. It plunged down onto the cemetery wall, seeming to set everything afire. As Antonio Gamoneda, the young poet for whom Leopoldo had advocated to the prize committee during what turned out to be his last meal, would describe it, "The

most beautiful, convincing, and sadly moving aesthetic act that Leopoldo Panero created was, in my eyes, his own burial."

Soaked in the orange glow, Felicidad felt herself transforming, just as her sons, too, would soon have to remake themselves. All across Spain, newspapers were running headlines announcing the death of the poet Leopoldo Panero, which in turn announced her altered category in life. She was becoming—had already become—that tragic figure who had abounded after the war: a widow. Felicidad didn't yet know what this would mean, nor how her family would survive without Leopoldo, but she did know that life for her and her three boys would never be the same.

EVERYTHING OR NOTHING

Life after Leopoldo, Fall 1962 to Summer 1963

Back in Madrid, a river of visitors flowed into the apartment on Calle Ibiza to offer their condolences. Between tearful kisses and murmured words, Felicidad worried about that thing she'd never had to give a thought to in her youth, and which had been excluded from her responsibilities as a wife and mother: *money.* The family had very little of it.

This was how one autumn day Felicidad found herself standing in front of the Viana Palace, the former residence of a marquis that now housed the Ministry of Foreign Affairs. She had an appointment with the minister, Leopoldo's former boss at the Institute of Political Studies, from whom she was going to request a state pension. It didn't feel good having to beg, but she didn't see another option. "I begin to belong to that sisterhood of classic widows," she wrote, "who traverse waiting rooms of offices with their black dresses and pale faces asking with fear, with still undefeated pride, for favors." She was living the second great break in her life: first the Civil War, and now the death of Leopoldo. Both required her to face the vertigo of sudden change.

Felicidad was so nervous that she took a tranquilizer before the meeting, but as was her talent, she told a compelling story. The minister offered her a monthly pension. It wasn't enough for the family to hold on to their previous lifestyle, but it was something—a sign that she might just have the wherewithal to keep her family afloat.

FOR JUAN LUIS, WHO TURNED TWENTY AFTER THE FUNERAL, THE LOSS OF LEOPOLDO was a "personal cataclysm." As much as he had clashed with his father over the years, effectively exiling himself from the family nest to avoid him, he had still loved Leopoldo. Part of the problem had been that they were too alike: quiet until explosive, alternately accessible and remote, both owners of an armored exterior protecting a roiling interior. Now, with Leopoldo resting for eternity in the Astorga Cemetery, the distance that had always separated them seemed to dissolve. The tender side of his father came back to Juan Luis, the warmth beneath his contradictions. But those memories were just that—memories, "broken gestures, unreachable afternoons," as he wrote. In Juan Luis's imagination, Leopoldo's voice, that deep cello note he had inherited, had been swallowed by the deeper voice of death.

Retreating once again to his grandmother's apartment, Juan Luis sought solace in the other kind of voice that ran in the family—poetry. With a fancy English Parker pen his father had given him, he fiddled with verses about his loss. He wrote a poem wondering how he would answer when his two younger brothers asked about their father. But Juan Luis quickly lost heart. Poetry felt like a theater stage that he was being forced onto by a ghost. It was too uncomfortable, too fraught with legacy, and he doubted he had the talent. Soon enough, he stopped writing altogether, much like Leopoldo had done after Juan's death during the war. This would be the first in a sequence of

echoes from his father's life that would reverberate through his own. Some resonances he would seek out intentionally, others would come unbidden; some would be good for him, others not. As Michi later remarked about Juan Luis's plight, "Being the eldest son must not be fun."

The first echo was practical yet not without symbolism. Juan Luis got himself hired as an editor at *Reader's Digest*, Leopoldo's last employer, working under Luis Rosales.

The job paid fairly well, which meant he didn't have to ask his mother for money, a rare feat of independence for a young man in Spain, where sons usually lived with their families until marriage, and often after, too. Even with Juan Luis taking care of himself, though, Felicidad was having trouble making ends meet. As a supplement to her widow's pension, she had sold their car, and also began selling some of the family's paintings, as well as some of Leopoldo's first-edition books inscribed by authors he had known. She had always lived in relation to literature. Now she was living off of it.

On the one hand, Juan Luis's plunge into adult life was painful. It marked the end of his youth. Aimless days on campus talking poetry over drinks, lazy afternoons in his grandmother's living room, fiery evenings at the meetings of radical student groups—all that came to an end. He dropped out of college, as much by choice as out of necessity, and became a working stiff like his father. Indeed, on paper, he nearly was his father.

On the other hand, adulthood was a liberation. This was in part because Leopoldo's death, tragic as it was, freed him. Juan Luis realized that his flirtation with communism had been mostly a rebellion against a father who had written fascist poetry and worked for the regime. Juan Luis's true nature had been distorted, like Spain's under its tyrant. "I was free of my personal symbol of Franco and, as such, lighter in baggage," he wrote. No longer a fellow traveler, Juan Luis turned to actual travel.

He was dying to get free of Franco's stuffy monastery of an empire and see other parts of Europe. He wasn't able to get the government to issue him a passport, though, so he resigned himself to places he could visit. He struck up an affair with an older woman who became his traveling companion. On the weekends, they took trips all over Spain. Premature adulthood, it turned out, wasn't so bad after all. Juan Luis was a handsome, unmarried young man gaining a fondness for whiskey and a sexual education in a chain of hotel rooms, no small achievement in a land where the Virgin Mary was still a more prominent image than any movie starlet. He had begun what he later called "my repeated navigation from bed to bed." Yet he knew sex and travel weren't real freedom.

For Juan Luis's little brothers, the impact of Leopoldo's death was different. For Michi, who turned eleven that September, life as he knew it had come crashing down in a magnificent demolition. Like the dead gypsies he had seen on the roadside in Marseille, tragedy had singled him out, and so did his schoolteacher back in Madrid. On the first day of school that fall, she made his whole class stand up and pray for him. Michi was mortified. Before the summer he had just been one more kid. Now he felt alone and forsaken, like an orphan. This feeling of abandonment would stay with him like a scar.

While Michi felt like he was shrinking without a father, Leopoldo María took up more space. Later he claimed he couldn't remember the year of any events from his life save for that of his father's death. It was the year that he truly unleashed himself on his world, that it became undeniable how radioactively distinct he was from other kids. Years earlier, Leopoldo had told Felicidad that he shuddered at the thought of what their second son's adolescence would be like. Now that age had arrived, only Leopoldo wasn't there to witness it or curb the extravagances of

his fourteen-year-old namesake, whose behavior reshaped itself around the absence of a father.

At school, Leopoldo María was already the class clown, but now he became the chief mutineer—a gangly, grinning shaman of mischief. One day in Religion, he masterminded a plot with his classmates in which they took turns touching their teacher-priest in such a way that it seemed accidental. They grazed by him en route to the pencil sharpener, tapped his shoulder while reaching for something. The priest noticed that something was amiss, except the subtlety of the prank made it impossible for him to level accusations, leaving him in a state of bewildered silence. In politics class, Leopoldo María led entertaining insurgencies so celebrated by his peers that on one occasion he sold tickets to kids from other classes to come watch, prompting the teacher to turn them away at the door. In gym class, the teacher ordered Leopoldo María to the principal's office for refusing to run laps. Instead of going, he jeered at the teacher, then slipped away and ran in circles around the courtyard, the man puffing futilely after him. The infuriated teacher called Felicidad to complain about her son.

"Well, I don't think that is right," she said. The director of the Liceo had waived tuition for her sons that year, and this was how Leopoldo María was thanking him? But she tried to make the teacher see the upside. "It does show that he knows how to run."

Leopoldo María became a legend at school. Each morning at recess, kids chattered about the trouble he was getting up to that week, and his antics won him a girlfriend. Michi tucked himself into the shadow his older brother cast, awed by his outrageous behavior. Each day when school let out, Leopoldo María tossed his book bag out the window and onto the sidewalk below, where Felicidad picked it up. The Liceo was

a liberal institution compared to Spanish schools, but he was wearing the faculty down. He had no respect even for sacred boundaries. One afternoon, Father Palomar called Felicidad after Leopoldo María tried to convince him that God didn't exist. He recognized her son's exceptional intelligence but feared where it might lead him.

"Leopoldo," Father Palomar said, "could be everything or nothing."

WHILE LEOPOLDO MARÍA TESTED THE BOUNDARIES OF WHAT WAS PERMISSIBLE AT school, Spanish society at large did something similar. The opening of the country's economy to the rest of Europe during the previous decade, along with its pacts with the United States, had allowed a steady drip of Western culture to seep into the parched peninsula. As Spain became the fastest-growing economy in the world, the postwar years of hunger faded into memory. Prosperity arrived and with it consumerism and mass media. Like the Paneros, more and more Spanish families had televisions and record players in their living rooms, making way for pop culture from abroad to enter homes. In parallel, Spain's own pop culture evolved, allowing modern icons like the gypsy singer Lola Flores to compete with Spain's historical and religious ones. As a result of all of this change, a new generation grew up with different expectations and less insular ideas of what life could look like, albeit not without resistance from both ends of the political spectrum. Juan Luis, for example, listened to American jazz records, which reactionaries considered seditious, while his communist friends saw them as a bourgeois indulgence.

Outside their homes Spaniards also encountered new sights and sounds. Always a moviegoing people—Francisco Franco himself was the country's most avid film fan—Spaniards could now have new cinematic experiences. They flocked to see James

Dean in *Rebel Without a Cause*, which arrived in Spain eight years after its American release in 1955. Along with cultural consumables from foreign countries, foreigners themselves flowed into Spain, bringing novel fashions and customs. From the actress Ava Gardner who bought a house in Madrid, to the scantily clad tourists from colder European climes who flocked to Spain's beaches in the summer, visions of colorful new lifestyles seduced Spaniards. The government was so disoriented by these shifting mores that it allowed Luis Buñuel's film *Viridiana* to compete at Cannes, where it won the Palme d'Or. Censors failed to discern that it was a scathing indictment of Catholicism, redolent with spiritual decay and sexual innuendo. The regime's fortress of tradition had been breached.

As the future threatened to tug Spain into its inexorable current, Franco nonetheless clung to the past. *Offer someone your hand*, the Spanish saying goes, *and they'll take your whole arm*. This is what seemed to be happening with the *apertura*, or opening, that Franco had allowed. Spain's economic advances had let social and cultural change in the back door, but the dictator was determined to batten down against any political change that might threaten the power he had wielded over the country for nearly twenty-five years. Resisting such change, however, required a finesse that he could no longer muster.

The Falange, Franco's longtime propaganda tool, had lost influence, and former allies had turned into foes. Having left fascism behind, Leopoldo's old friend Dionisio Ridruejo founded a group called Democratic Action and was currently living in Paris as a vocal exile. The Munich Conference in 1962 had demonstrated that former opponents from the Civil War were committed to working together in their shared desire to oust Franco. They were building networks with student groups and trade unions in Spain. Even the Catholic Church was stepping away from the regime. The reconciliatory doctrine of the

Second Vatican Council, which put liberty and human rights at its center, led to Franco losing standing with the pope. The writer Carmen Martín Gaite later described the dictator's devolving relations with the formerly supportive Vatican in a way that also captured many Catholic relationships under Franco, like Leopoldo and Felicidad's: "They could be compared to the deaf conjugal disagreements of so many marriages of that era, condemned to put up with each other mutually and whose relationship, born in the heat of rhetorical and fleeting enthusiasm, are based on the ignorance of one's ally."

Although Franco's power base was fragmenting, he retained leverage over the monarchist bloc, who wanted him to set down the terms for Prince Juan Carlos becoming the King of Spain when the aging dictator could no longer fulfill his duties. But Franco wasn't yet ready to do more than dangle this possibility, much to the chagrin of members of his inner circle who urged him to institute a succession protocol in the event of his death. Instead, in 1962, he doubled down on his time-tested approach to governance with a piece of barbaric public theater.

That fall, Franco's secret police captured the communist leader Julián Grimau in Madrid. One of the most sought-after enemies of the state, Grimau had spent the Civil War in Barcelona, lived in exile for two decades, then returned to Spain as part of a subversive clandestine network. After being detained, he was taken to police headquarters in Puerta del Sol and tortured, then thrown out of a window. He survived the defenestration, only to be tried and sentenced to death for alleged crimes dating back to the war. During the two days between the verdict and his scheduled execution, demonstrators gathered in cities across Europe and the Americas to protest the sentence, while diplomats and world leaders pleaded with the regime for clemency. Franco was unbending. Grimau was executed by a firing squad.

This crisp jab of repression was a palimpsest: a chilling image from the past pushing up onto the surface of the present. It wasn't clear if the future of Spain might hold everything that those weary of Franco's rule hoped for, or nothing at all.

THE FOLLOWING SUMMER, FELICIDAD'S MOTHER FELL ILL. NEARLY BLIND, FELICIDAD Bergnes had been gradually vanishing from the world she could no longer see and now the rest of her body was following.

One evening that June, Felicidad went over to spend the night at the apartment where her mother lived with Juan Luis. Her mother asked them to help her out of bed into her favorite armchair. She sunk into it and smiled at her grown-up daughter alongside whom she had survived the war, now a woman with her own children, grief, and struggle for *felicidad*. As her breathing became weaker, Felicidad Bergnes took Juan Luis's hand and brought it to her lips and kissed it—and died as she did so. The actress who had captivated her young husband as Desdemona, only to stop acting to be the perfect wife, had left life's proscenium. "Even at the hour of death," Juan Luis wrote, "she knew how to have grandeur and a bit of good theater." He was devastated and spent the next day grieving on a long walk through Retiro Park with a friend.

God's ax of mortality that Leopoldo had written about in his poetry had delivered not one but two blows to the trunk of Felicidad's family in the space of a year. Now she had to see to it that she and her three sons didn't all fall to the ground like so many lopped-off branches. She ached to fill the hole Leopoldo had left behind so her family could hold itself together. She wanted to unite them into an unbreakable unit. But she would need help.

After her mother's funeral, Felicidad asked Juan Luis to move back into the apartment on Calle Ibiza. He said yes and returned, unpacking his belongings in the home where he had

felt like an unwanted guest. He was the man of the house now. This stirred a bravado in him, and one day he gathered his two little brothers and Felicidad in Leopoldo's book-lined study for a family meeting. He had an important announcement to make.

"Dad is dead," Juan Luis said with the grandiosity of a twenty-year-old declaring his manhood as he looked at his little brothers. "From now on I'm going to be your father."

As Michi would recall, "Leopoldo and I looked at each other as if saying, *Has a flying saucer just landed?*"

DISCOVERIES

Family Transformations, 1963–1964

I n November 1963, Luis Cernuda died in Mexico City.

For the past fifteen years, he had been living between Mexico, where he had old friends, and the United States, where he taught at universities to make a living. His hair had turned white but otherwise his delicate features had remained unchanged, as if immune to time. Back in Spain, the home that was still dead for him, his stature as a poet had grown, but what did that matter? He had come to feel that he hadn't written poems—they had written him. The loneliness of his poetry defined him more than his reputation ever would. One morning he rose early as usual and put on his bathrobe and slippers. Before he could light his pipe, he collapsed onto the floor from a heart attack.

The next day, Juan Luis was reading the newspaper at the office when he came across a mention of Cernuda's death. He had blurry childhood memories of the kind man in London who had given him a toy boat, and in the past few years he had liked poems by Cernuda that he had come across in anthologies. He called his mother at home to tell her.

Felicidad absorbed the news in stunned silence. She hadn't written to Cernuda in over a decade, but she still thought of him, still idealized him. Now she was transported back to Battersea Park. She recalled their hands touching for the last time, their doomed love still intact in her memory and intensified by time. Even after Leopoldo's death, she still needed this fiction as a salve for the lack of romance she'd found in real life.

Felicidad stammered a response into the phone. At the other end of the line, Juan Luis noted something odd in his mother's voice, but ignored it and said goodbye.

When he came home from work that afternoon, Felicidad decided to open up to her eldest son in a way she never had before. She told Juan Luis the story of her "sentimental history" with Cernuda, as she put it. Juan Luis didn't believe there had been anything beyond friendship, yet like a mysterious scene glimpsed through a cracked doorway, her confession surprised and intrigued him. Here was a side of his mother beyond the meek homemaker he'd always known.

What Juan Luis felt was . . . *interest*. For the very first time, his mother's life interested him.

Like any selfish son—or perhaps simply all sons—his previous indifference to the woman who had brought him into the world and raised him wasn't what shocked him. It was her sudden humanity. She stopped being just his mother and became a *person*. This was the real revelation, not her feelings for Cernuda. He described the change in his perception with naked honesty: "My mother didn't exist for me until my father died."

The same went for Leopoldo María and Michi, though they wouldn't come to know about *l'affaire* Cernuda for a few more years, when Felicidad would end up talking about him more than their own father. In the uncertain new stage the family had entered, it was as if a familiar but new woman appeared out of the mist of their childhood, standing by herself, with a personality

all her own. The two boys were growing up and becoming inter-
ested in adult things like history and literature, and it turned out
that their seemingly unremarkable mother with her inward gaze
in fact had astute opinions and clever ways of expressing them.
Her elegance wasn't just physical, but intellectual too. With their
father gone, she revealed herself as their mother *and* someone
else. This new woman was, as Michi recalled, "a discovery named
Felicidad Blanc."

For Felicidad herself the experience was almost the same.
Her twenty-year performance as the wife of Leopoldo Panero
had dislocated her sense of self, so she, too, observed the woman
emerging from the mist with wonder. "I think of so many
women, like me," she wrote, "who have let their intelligence dim
from repeating like machines the same gestures, their curiosity
for everything gone, annulled in useless resignation." She still
cursed the country doctors whom she believed had let Leopoldo
die, but his passing wasn't exclusively a calamity. It was also an
opportunity. She had been given a fate different from that of
most of her generation of eclipsed, submissive wives. Her res-
ignation was over, her curiosity was anything but gone, and she
refused to let herself repeat the same mistakes from the past.
What new gestures might she have in her?

THERE WERE OTHER DISCOVERIES AS WELL, ALBEIT LESS PLEASANT ONES. UNTIL
recently, Leopoldo María and Michi had known Juan Luis as a dis-
tant, brooding presence who came and went from the apartment,
staying around only for meals or fights with their father. Now their
older brother had become their self-appointed authority figure and
they didn't much like him in this role. The first six months with
Juan Luis at home were passable, but fault lines of tension soon ap-
peared in the family's nuclear reinvention.

String-bean Michi was an easygoing kid. He was shy with

an ironic charm that won over anyone who paid attention to him tiptoeing catlike along the margins of the apartment's life, and he was rarely a direct source of conflict among his brothers. Nonetheless, Michi refused to accept Juan Luis as a replacement father, and he had good reason. Juan Luis didn't project paternal stability and was even flirting with suicide.

The details surrounding Juan Luis's suicide attempt around this time are hazy. He evaded the subject in later interviews. An avid reader of suicidal poets, his self-conscious grandeur, it seems, bled into genuine unhappiness: the losses of his father and grandmother, and the feeling that he now had to defend his family's name. He took a handful of pills as an experiment in misery and literature, with alcohol as the active ingredient. He doesn't appear to have been truly interested in "the Big Out," as one of his literary idols, F. Scott Fitzgerald, called suicide. His attempt was more an assertion of agency when he felt he had none. Suicide, he claimed, was "the only freedom a human being has."

Unlike Michi, Leopoldo María generated constant conflict with Juan Luis, and not just because his natural reaction to authority was to defy it with drama and high jinks. Leopoldo was, as one friend put it, "insultingly precocious," which put him at odds with the brother who was now also trying to fill the literary hole in the family their father had left.

Inspired after reading more of Cernuda's work, Juan Luis overcame his self-doubt and started noodling with poems again. Meanwhile, fifteen-year-old Leopoldo María discovered Marxism and inhaled tomes on political and aesthetic theory, as well as psychoanalysis, with staggering comprehension, able to converse like a doctoral student. But he still read poetry and wrote startlingly mature verse. Even with six years separating them, both of the brothers now circled the same hereditary claim to being a writer, and this generated mutual antagonism, as if only one were

allowed to follow their father. Yet beyond their fraternal literary competition, there was just something that fundamentally didn't click between Juan Luis and Leopoldo, an oil-and-water discord that was greater than the sum of their two clashing parts. They were similar in their ostentation and protagonism, but also distinct. Juan Luis was proud, self-serious, and domineering; Leopoldo was anarchic, outrageous, and shameless. This made for theatrical conflicts.

In the living room of the apartment on Calle Ibiza, the two brothers fueled their nascent rivalry by competing over who recited Lorca poems better. These were long, bombastic contests, and anywhere else they would have seemed ridiculous, like parodies of literary pretension. But these were the Paneros, sons of a poet. Felicidad watched with a mixture of helplessness and awe. Such scenes were both strange and all too familiar. How many times had she and her sons listened to Leopoldo and his writer friends bluster in the same fashion in this same room? The new generation was simply filling the vacancy.

Joaquín Araújo witnessed this period in the Panero household firsthand. A book-drunk teenager himself who had slurped down all of Kafka and Sartre by age sixteen, he was in search of kindred spirits and heard about Leopoldo María from friends. They went to different schools, so Araújo sought him out at the Liceo. They became instant buddies and formed a club that eventually brought together over one hundred bookish teenagers from the best schools in Madrid. The group read a new work each week, such as José Ortega y Gasset's *The Revolt of the Masses*, and spent Saturdays debating the assigned reading. The hormonal adolescents crammed into restaurants and living rooms, sparring over the ideas that had shaped the tormented century they had awakened into—elitism and democracy, communism and capitalism, Christianity and existentialism. The fact that they were even having such discussions in Franco's Spain presaged great

shifts to come, though they were too young to understand the rebellion that they would soon personify.

Coming from a conservative military family, Araújo felt more at home in the artistic milieu of the Panero household than in his own. He gradually became a live-in friend of sorts at the apartment. He'd never seen a dwelling that looked like a library or walls in a home hung with canvases by some of the most prominent painters in Spain—gifts Leopoldo received during the biennials—as well as works by dead artists that had belonged to Felicidad's parents. The other draw for Araújo was Felicidad herself.

The Panero boys' mother was an entrancing figure who seemed to have stepped out of one of the nineteenth-century portraits on the walls. "She was the strangest homemaker," Araújo said. "Not the least bit conventional. She didn't stand out for cooking or things like that. She was a great hostess but without doing anything special and this was because at heart she was very seductive." At fifty-two, Felicidad's beauty was still magnetic. Araújo described her delicate features as "fragile and crystalline." But it was also her patrician mystique. She had an upper-class lilt, and every afternoon the family sat down for high tea together as if they were English aristocrats. She retired portions of her frumpy maternal wardrobe and began dressing sharply again, like she was attending diplomatic functions. What did it matter that she didn't seem to be a very good mother at more prosaic things like keeping house and meting out discipline? Araújo loved spending time among these people of "truly spectacular, marvelous intelligence." The Calle Ibiza apartment was like a salon for belletristic teenage boys, and Felicidad was its Gertrude Stein.

While Felicidad found modest companionship at home with her sons and their friends, she was still extremely lonely. She had few friendships of her own; they had all been extensions of

her marriage with Leopoldo, and the two years since his death had proved how tenuous most of those relationships were. Only a few good friends still came to visit and check on the family, and she felt her dead husband's legacy likewise being neglected. The previous summer she and the boys had gone to Astorga for a gathering to commemorate the anniversary of Leopoldo's death. The lovely ceremony with recitations of poetry and children in folkloric dress had moved her, but now she sensed that Leopoldo would be forgotten, and she would be, too. There had been a flurry of tributes to him in magazines and a collective idealization of him by his peers, but younger poets weren't interested in his work. He was unfashionable, politically stained. And his friends were too busy with their own careers to act as the permanent caretakers of his posthumous one. Over twenty years of self-sacrifice and now it might turn out that she had played the muse and helpmeet to a poet with no lasting legacy.

Juan Luis saw the state of desertion in which his mother found herself. He also saw that she was still young. Closer to her now than he'd ever been, he decided that he would help her embark on a new life. She needed to smile again, to rediscover life, and he would be the one to show her how. He had already stepped in as the surrogate father to her other two sons, so why not be her surrogate husband? If there was something undeniably oedipal in this, Juan Luis didn't see any perversity in it—not yet.

One evening when they were alone, he told her what he thought: that she needed to change her life. "If not," he said, "you'll end up alone, absolutely alone."

Felicidad knew that he was right.

THE ENCHANTING DISASTER

Rebirth for Felicidad, 1965

During 1964, Franco and his government celebrated the quarter-century anniversary of the end of the Civil War, what they honored as "25 Years of Peace." The lack of irony in this slogan was galling to the extreme for people unsympathetic to the regime, never mind those who had been imprisoned by it, suffered police beatings at its hands, or lived in fear of it. Not only had the postwar years been a time of cruel repression, but as Julián Grimau's death demonstrated, so was the present. Worst of all, there was no getting away from the celebrations. Franco's propaganda apparatchiks wallpapered cities with patriotic posters, decorated highways with patriotic billboards, and glutted the country's plazas with patriotic pomp. Cinemas played film reels trumpeting Franco's victory like it had occurred yesterday. Radio programs memorialized the Nationalist army's stand against the "other Spain." This whitewashed narrative seemed to print itself onto the very surface of life, an obligatory myth imposed on memory. The postal service issued a suite of stamps commemorating the anniversary,

imprinting a seal of "peace"—and Franco's face—on personal correspondence. It was an orgy of blood-soaked nostalgia, manufactured euphoria, and smothered pain.

Juan Luis wanted to get the hell out of Spain.

He had recently read *Justine*, the first book in the British novelist Lawrence Durrell's tetralogy The Alexandria Quartet, about expat life in the eponymous Egyptian city in the 1930s. The narrator, a broke Irishman and aspiring writer, limned an exotic labyrinth astir with spirituality and lust. Alexandria was a mirage where East met West and modernity met antiquity, a place glittering with opulence and stinking of poverty, where "days became simply the spaces between dreams, spaces between the shifting floors of time." Like many readers before him, especially young literary men, Juan Luis heard the siren song of Durrell's Alexandria, whose melody sounded like the perfect antidote to Spain, where time seem to have calcified and there was no space to dream.

After the new year, he finally managed to obtain a passport and went to work convincing his mother that the family should take a trip together. He had learned about a line of cargo ships that sold passenger tickets for a monthlong itinerary to different Mediterranean port cities. One of the stops was Alexandria.

Felicidad wasn't sure the trip was a good idea. It wasn't a luxury cruise, but it wasn't cheap either. Her mother's estate had passed into her hands, easing her economic burden, but did this windfall justify a vacation splurge for the entire family? Juan Luis chipped away at her hesitance, pointing out that they were all growing older and it might be the last opportunity for the four of them to travel together. Still retaining vestiges of the docile woman society had trained her to be, who always gave in to the men in her life, and like the *niña bien* she'd once been who had never had any need to trouble herself with money, Felicidad finally said yes. All of her anxiety about Leopoldo's

pension after his death might as well have been a bad dream she was forgetting. Long-term planning wasn't her forte; she addressed herself to the present, resolving urgent matters and burning through money. As Juan Luis later wrote of Felicidad, "The truth is that my mother was always an enchanting disaster."

JUAN LUIS AND FELICIDAD STOOD ON THE DECK OF THE FREIGHTER AS ALEXANDRIA emerged out of the dawn. White, needle-like minarets poked into the sky, bathed in a pink-and-gold glow. Beehives of apartment buildings climbed up out the cityscape, mysterious lives hidden away inside. As the ship navigated into the port, boats with white sails glided across the water. In Juan Luis's mind, the small vessels had skated from Cleopatra's time directly into his own. He felt like he had seen this all before—because he had.

They had fallen into Durrell's novel.

This was the feeling that defined the week in the city for Felicidad and Juan Luis as the family visited museums, walked along the waterfront Corniche esplanade, and peered into smoke-clouded cafés full of swarthy men, steaming tea, and impenetrable languages. For her, as always, literature waved its magic wand and transformed all it touched. Thanks to The Alexandria Quartet, the squalor she and the boys encountered during the hot days wasn't just squalor. The holy beggars in saintly rags covered in flies in the "thousand dust-tormented streets" and the dizzying alleys full of rats and wailing vendors—these were objects of picturesque romance thrown into sharp relief by the perfumed European yacht clubs full of colorful umbrellas, skimpy bikinis, and flavored ices. If Felicidad was a woman who redeemed depressing realities by filtering them through her literary imagination, it was on this trip that Juan Luis truly became his mother's son. Like her, he yearned to elevate experience and be a character in the epic of life.

When the family rode camels to the pyramids of Giza, Juan Luis did so *in* character. He wrapped himself in a turban and told their guides to call him "Orens." This was the Spanish for the Arabic version of the name Lawrence, as in Lawrence of Arabia. Juan Luis had recently seen the historical drama about the legendary adventurer and admired his books. He continued to experiment with personas and this borrowing of mystique back on the ship as they set off for Beirut. Coasting through the Mediterranean, he read poetry on the deck while smoking a pipe like his other totemic Orens, Lawrence Durrell.

Juan Luis's spasms of literary grandiosity, pursued half in jest and half in earnest, puzzled Michi and Leopoldo María, who were having a vastly different experience of the trip than he and their mother. Michi read the Durrell novels and found little in common with the Alexandria he had visited. Not that he had much of an opportunity to take in the scenery. In Egypt, he picked up a virus that laid him out with fevers and vomiting, and in Beirut Felicidad surfaced from her reveries to take him to

Juan Luis at the pyramids of Giza

Felicidad and Juan Luis on the deck of the ship

a big-bellied healer who cured Michi with a homemade elixir. Meanwhile Leopoldo María disappeared into a different book: the complete works of Vladimir Lenin, which he had purchased in Marseille. As the ship steered on from Beirut to Damascus, then to a series of paradisiacal Greek islands, he saw little beyond this thousand-page isle of paper.

When the cargo ship docked in Barcelona a month later, the family carried back a new cargo of myths—each with changing ideas about who they were, the roles they played, and who they might become. Felicidad felt closer to Juan Luis than ever, almost as if he were her new young husband and this had been their honeymoon.

LIKE THE CITY OF ALEXANDRIA, MADRID, TOO, WAS A CHARACTER IN THE LIVES OF its inhabitants, and in spite of its stultifying atmosphere, it was becoming someone else.

Spain continued its inch-by-inch cultural loosening, and

nowhere more so than in the country's capital city after dark. Flecks of the risqué subculture of "Swinging London" floated across the Channel, and with it came the soundtrack of the British Invasion, along with American music that soon reached apotheosis at Woodstock. A distant outpost of these cultural shifts, in Madrid sexual mores relaxed ever so slightly as hemlines rose and clothing tightened. Bar-goers kept up the Spanish tradition of marathon drinking till the wee hours, but now the odd woman drank, too, her unwed status no longer a hindrance if she had the moxie not to care. "The damn place had *life*!" wrote Ava Gardner, recalling the Madrid of this era. "If you knew your way around, the nights went on forever."

Around this time, a hip new bar called El Oliver opened. The spot quickly became Juan Luis's home away from home, along with the jazz club Bourbon Street (where one night he in fact met Ava Gardner, managing to dribble out flattery in English). Soon enough, he brought Felicidad with him. His mother no longer had Leopoldo to take her out, and her few friends only invited her to stuffy old cafés. As her new surrogate husband, Juan Luis took it upon himself to be her date out on the town.

He had recently come to be friends with a group of poets a decade or so older than him, the generation between his father's and his own. Juan Luis admired their work and talked with them late into the night at El Oliver, where the young literati preened like peacocks. With her world-weary sophistication, Felicidad fit like a tailored garment onto this milieu, and her son's friends became her own. She called them "The Group." Thus began what Felicidad would call the "crazy" period of the widow of the poet Leopoldo Panero.

On a typical night out, Felicidad dressed up and went with Juan Luis to a gallery opening or a literary event, then afterward she and her son and the rest of The Group convened at El Oliver. In the dimly lit bar with records playing in the background, the

zing of hard liquor mixed with smoke from American cigarettes. The demimonde of the new Madrid was like nothing Felicidad had ever experienced before. Formality was out, provocation was in. There were gay men, whom she felt at ease with, and artists of all types. She smoked languidly and didn't need alcohol to stay out late. Talking had always been her drug, her balm against melancholy, and now she could talk, uncensored, until well past the city's bedtime. It was Spain's first modern scene and she became a fixture.

One of the poets from The Group, Carlos Bousoño, had expected to meet the perfect dutiful Spanish housewife from Leopoldo Panero's poetry, but she wasn't that at all. She was a seductive, startlingly original person with a sense of humor and an incisive mind. She racked up new friends but wasn't a people pleaser. She could go from liking someone one minute to making cutting remarks about them the next, and vice versa. The poet Vicente Molina Foix described this pattern as Felicidad's stock market, in which shares rose and fell by the day. She chalked this up to her inability to judge character, while some thought this was because she simply had a tendency to be catty at times. She was disdainful of convention; sometimes she brought out fourteen-year-old Michi, who timidly drank his first cocktails, then soon not so timidly. Men showed interest in Felicidad. One of Leopoldo's friends who was separated from his wife fell secretly in love with her, gushing about her in his diary. Felicidad's former social circle heard rumors of her youthful lifestyle and increased its distance. But she didn't care. Or almost didn't.

One night the Catalan poet Jaime Gil de Biedma was in Madrid. He went out with The Group, developing a delightful chemistry with Juan Luis and Felicidad. When they left El Oliver near dawn, Gil de Biedma accompanied them through the sleeping streets of Madrid back to Ibiza 35. Although she enjoyed flouting convention, this was an especially late night for

her, and she was nervous what the *sereno*, her doorman, might think. As they arrived at the entrance to the building and the *sereno* opened the door, Gil de Biedma covered for Felicidad, making a show of bidding her good-night.

"The bad thing about funerals," he said, "is that they end so late."

After unforgettable nights like these, the real funeral that had changed her life might have almost seemed like a good thing. Felicidad was a quiet rebel, a woman who fit in by not fitting in.

DECADES LATER, MANY PEOPLE WHO KNEW THE PANERO FAMILY WOULD CLAIM THAT Felicidad was a terrible mother, the ground zero of all of her sons' afflictions and disgraces. They said she gave them no limits, no work ethic, and no future—that she passed her own inflated yet fragile self-regard on to them along with her literary pathologies. Other people who knew the Paneros would claim that Felicidad did the best she could with the resources at her disposal. She had been trapped in a suffocating marriage characteristic of her time and place and when she escaped it she tried to create a new imagining of family, while courageously forging ahead as a single parent. Some even said she was a good mother. Yet there was one thing that everyone agreed on. Having Felicidad Blanc as their mother largely defined the men her three sons became, just as they would come to define her.

Though she didn't know it yet, her crazy period was about to end. Felicidad would soon have to face down the oppressive force that Spain's emerging counterculture pushed against: the Franco regime's determination to resist the irresistible wave of change that fleetingly gave her a new life.

RIVALRY AND REFERENDUM

A Battle for Inheritance, 1966–1967

J uan Luis knocked on the green metal door of the house at 3 Velintonia Street. It was a chilly November day in Madrid. He held a blue folder in his hand. Ordered inside it was a sheaf of poems he had written for what he hoped would be his first book. He still didn't know if he was truly a poet or just a young man with a last name that made him want to be one. That was why he had come here, to the home of Vicente Aleixandre, to find out.

One of the greatest living poets writing in Spanish, Vicente Aleixandre was more than a man—he was a destination. Back in the 1930s, his family's home had been a gathering place for Lorca, Neruda, Cernuda, Miguel Hernández, and the rest of that vanished and scattered generation from before the war. Aleixandre was a mentor to Leopoldo, who sought him out on his weekends away from the mountains of Guadarrama while recovering from tuberculosis in the late 1920s. Aleixandre had remained in Spain after the war and become a symbol of the "internal exile," a term that he coined. He refused to cozy up

to the regime, though he maintained a cordial relationship with many poets who did, like Leopoldo and Luis Rosales. Aleixandre suffered from fragile health that imposed a shut-in's lifestyle, which only increased the magnetism that the spacious cottage on Velintonia, near the rebuilt University City, seemed to radiate.

Nearly seventy, Aleixandre had become the elder statesman of Spanish poetry not only because of his body of work, which would earn him the Nobel Prize the following decade. He was singularly generous with his time and goodwill. Over the years, his house had become a mecca and visiting it was a rite of passage for aspiring poets. Timid young versifiers telephoned Aleixandre and made an appointment to see him—just as Juan Luis had done after slugging down a brandy to work up the nerve to call—then made the pilgrimage to knock on his door with their poems in hand, hoping to return home confirmed in their calling. Like an infirm monarch confined to his castle, Aleixandre received his subjects, then chose whether or not to knight them with his praise. He was curious about the poetry of the Panero boy, whom he noted had the same voice as his deceased father.

A maid opened the door and led Juan Luis down a hallway. The house was quiet and austere, though not unwelcoming. He was both excited and uneasy. He had shared some of his poems with Felicidad, who had encouraged him to continue writing, but had barely shown his work to anyone else, especially not his father's friends, in spite of their eagerness to read it. He trusted Aleixandre and whatever his assessment might be.

Luis stepped into a book-filled living room where a Calder mobile dangled from the ceiling and a Miró canvas hung on a wall. There was Aleixandre, with his kind smile and Roman nose, reclining on a divan under a blanket, impeccable in a sweater and tie.

They greeted each other and Juan Luis took a seat facing the

maestro. After a bit of small talk, Aleixandre asked to hear his work. Juan Luis removed the poems from the blue folder and began reading. Now he would finally know whether he should keep writing or surrender that part of his inheritance.

Aleixandre's judgments were swift and precise. He told Juan Luis which poems he thought were strong and which weak. He liked that his poetry was distinct from Leopoldo's. Panero's son might have the same voice as his father, but he didn't have the same *voice*. There was none of the spiritual searching and insistent rootedness in everyday life. Juan Luis's poems were nostalgic but sensual. Love evoked not memory but intimations of death.

When the visit came to its end, Aleixandre accompanied Juan Luis out. As they said goodbye in the doorway of the house, he said to him, "You're a poet."

AFTER HIS VISIT WITH ALEIXANDRE, JUAN LUIS REAFFIRMED HIS COMMITMENT TO poetry and concentrated on finishing his first book. At the same time, his rival Leopoldo María went through an inverse change. Books and writing ceased to be his primary occupation.

Now eighteen, Leopoldo was studying in the Department of Philosophy and Letters at Madrid's Complutense University. While he could have effortlessly excelled there, the things that mattered to him weren't happening in the classrooms but elsewhere: in the meetings held by the campus arm of the Spanish Communist Party, and out in the streets.

In 1965, Spain had seen the first significant national confrontations take place between students and the regime. In Barcelona and Madrid, police (known as *los grises*—the grays—for the color of their uniforms) violently squashed demonstrations. But they couldn't squash the growing strength that fueled them, the desire of the youth to reclaim the streets. A new generation of rebels *with* a cause was coming of age and these young people knew,

as Leopoldo María was just coming to understand, that theory meant nothing without practice. All the books one could read about politics meant nothing without action. They were children of the dictatorship they had been born into, which their parents tolerated or worked for, and they knew that the regime wouldn't fall without a push. The Complutense was a hotbed of agitation, and wherever there was trouble to stir up, that was where Leopoldo wanted to be.

The regime saw that it had to offer a gesture to address the growing clamor for change—in order to prevent any lasting change. As the historian Javier Tusell put it, the government was willing to allow "change within the regime" to avoid "a change of regime." The government's aim was to assuage public unrest and signal a nominal opening of civil society—like a 1966 law to loosen censorship and give the press greater latitude—while ensuring its self-preservation. Yet there was little consensus about how to achieve this. Inside Franco's cabinet, old-guard Falangists vied to maintain the strict authoritarian system on which their power bloc depended, while the new-school technocrats wanted to set up more adaptable institutions inside the government. There was, however, one inevitable and lasting change the government knew it would one day have to adapt to, for which all factions of the regime wanted to be prepared: Franco's death.

The aging *Caudillo* had managed to rule Spain for nearly thirty years not because of a doctrine that he stood upon but thanks to his own unique personal style. "The sphinx without a secret," as some called Franco (an Oscar Wilde quote), had an instinct for power, shot through with idiosyncrasies that by their very nature made it difficult to pass leadership on to someone else. It was possible there was no solid infrastructure beyond the dictator himself. So if the regime *was* Franco, what would happen when he died?

In an attempt to answer this question, the government announced that a national referendum would be held in December

1966. Up for passage was a proposed legal framework for reorganizing power inside the government. On the surface, the new law seemed to redistribute some of Franco's authority by creating a new office of Chief of Government, separate from the dictator's role as Head of State. In reality, the referendum was a play for institutionalizing Francoism without Franco, with the blessing of the people. By smoothing out this wrinkle in the regime blanket, government ministers could get to the real business of drawing a road map for succession. It still wasn't clear if Franco would choose Prince Juan Carlos as his successor, or if he would choose a successor at all. The *Caudillo* seemed unwilling to recognize his own mortality. Old-guard cabinet members feared that the prince would let British-style parliamentary democracy sneak into Spain. Others, sure that only a return to the country's imperial past could guarantee a stable future, wanted to trade in a military baton for a royal scepter; they thought that a strong economy and a restoration of the crown would be the only way to maintain conservative Spanish values and peace. But first came the referendum.

For Leopoldo María and his friends, the proposed law was an outrage. Not only was it farcical to act like Spaniards felt free to vote however they wished when police stood at polling stations as unshielded ballot slips dropped into transparent urns, but Franco was selling the referendum publicly as if it were a judgment on his service to the country. The slogan alone for the campaign drove this home: *¡Franco, sí!* In a country sunk in political apathy and fear, how many people would vote against their own tyrant? Here was an opportunity for Leopoldo to turn talk into action, words into deeds.

Four days before the referendum, he and Joaquín Araújo took to the streets with their pockets full of stickers with another two-word slogan: DON'T VOTE.

Police were out in force that day in Madrid and there was a

tension in the air. The two young men took a long walk across the city, furtively gluing the stickers onto lampposts and walls. They did their best to remain incognito, though this wasn't easy. Of late Leopoldo María had adopted a dandy fashion style. He donned flamboyant capes, rakish hats, and garish ties. Fortunately, they didn't run into any trouble, and late in the afternoon Leopoldo said bye to Araújo and turned onto Calle Ibiza to head home. As he walked toward his family's building, he stopped in front of the display window of a shop. The glass was like a flagrantly blank canvas, and he was like a painter whose brush was dripping with paint. He glued one last sticker onto the window.

Unbeknownst to Leopoldo, a doorman from a neighboring building had seen him. He approached and grabbed hold of Leopoldo, shoving him into an adjacent bakery.

While the doorman called the police, Leopoldo María noticed a bowl of dough sitting on the counter. When no one was looking, he stuffed his remaining stickers into the massive ball of flour and kneaded them into its center. Later Michi would jokily claim that the whole neighborhood ate subversive propaganda for weeks. Officers came and hauled Leopoldo off to the General Direction of Security, where they booked him, confiscated his belongings, and led him down a narrow stairwell.

Located in the centermost point of Madrid, in the Puerta del Sol, the General Direction of Security was the regime's headquarters of policing and torture, the place where enemies of the state entered the netherworld of the penal system. It was from this inscrutable building that interrogators had thrown Julián Grimau out of a window. People walking across the plaza sometimes heard hair-raising moans reach them through grates connected to subterranean cells, like hopeless pleas crossing the River Styx. For every mother, the General Direction was where nightmares be-

gan. It was a mouth that swallowed children, digesting them into other prisons and other miseries.

When Leopoldo María didn't come home that evening, Felicidad called his friends, who didn't know anything. After a sleepless night, she phoned hospitals, then finally the police, who told her where he was. To know he was alive brought a swell of relief, followed by a subsequent one of fear. She went to the General Direction to try to see him, only to meet a wall of indifference. The police were gruff and opaque, and no one told her anything, not even why he had been detained. The same thing happened the next day. Leopoldo was likely receiving beatings in a dank interrogation room, perhaps also electric shocks and cigarette burns, as was common practice. The Francoist police weren't interested, as former prisoner Jesús Rodríguez Barrio recalled, in "the search for information but rather humiliation and terror . . . so that, once released, the person would never think again about acting against the dictatorship." In this fashion, the regime aimed to control society by controlling its thoughts. Many detainees who passed through the General Direction said the worst part, along with the torture, was the uncertainty—not knowing when or how their time there would end. Between interrogations, Leopoldo sat under the single light bulb of his basement cell, on the cold cement floor, listening to the footsteps and chatter in the street above as the city went about its business, almost close enough to touch.

On the third day, as Felicidad waited helplessly at home, the door to the apartment opened and in walked Leopoldo. He had made it out but now carried the scarlet letter of a police file. She could tell the experience had done nothing to shake his resolve, just as slaps from his father as a child had failed to subdue his defiant nature. If anything, the arrest had reinforced it.

The next day, Spanish citizens voted overwhelmingly in favor

of the referendum. Eighty-eight percent voted yes. Only 2 percent voted no. The rest abstained or cast null votes. The referendum was a booming win for Franco.

The passage of the new law unleashed a quake of protests. Leopoldo María attended assemblies at the university and marches in the streets, where he stood out as usual. In his outré clothes, he traipsed through the masses of demonstrators, singing the lyrics to an oppressively cheerful, trumpet-drunk pop song titled "Felicidad." As his fellow marchers chanted slogans against Franco, he cut a surreal figure, crooning, "Happiness, ha, ha, ha, ha! To feel love, ho, ho, ho, ho!" Even as a member of the counterculture, he felt the need to run counter to it.

At the end of the month, union organizers in Madrid called for a citywide strike. In the largest syndical action since before the war, thousands of workers gathered in points across the city, including the Atocha Train Station, where they smashed the windows of buses. In solidarity, students at University City threw rocks at campus police then barricaded themselves inside a building, while others descended on a nearby traffic circle as night fell. Leopoldo was among this second group, who were met by baton-wielding police.

Students threw rocks at the *grises*, who chased after the demonstrators. Helicopters flew overhead shining down spotlights. In the midst of the violent, strobing chaos, Leopoldo took off away from the police, waving fellow protesters after him.

"This way!" he shouted. "This way!"

The group followed him down a side street. For a moment it seemed like they had escaped until they realized where Leopoldo had led them—into a dead end.

They were all arrested.

At the station, Leopoldo claimed that he hadn't participated in the demonstration. He said he had stepped off a bus and gotten sucked into the commotion against his will. The police took

his statement and set him loose—for now. They knew where he lived. Bad luck verging on the comical was emerging as a theme in Leopoldo's activism.

DURING LEOPOLDO MARÍA'S PLUNGE INTO PROTEST, JUAN LUIS LEFT SPAIN AGAIN. He convinced *Reader's Digest* to pay for him to study English in London while doing work at the company's British office. He rented a room at a boardinghouse and basked in the solitude, a world away from Madrid. He worked on his book, revisited memories of his time in London as a child, and drank English pints while lusting after the miniskirted women who paraded down Carnaby Street. It felt good to be far from his family.

When he flew home a few months later, Spain felt grayer than ever, and he drank more than ever. He reminded Felicidad more and more of Leopoldo. Like his father, Juan Luis came back at dawn, his keys jangling in the lock before he stumbled down the hallway to his room. Once he got so drunk at the apartment, and with a *mal vino* outstripping even his father's, that he tried to throw a mattress out of a window. Felicidad didn't like this behavior any more than Juan Luis liked being the paternal figure for his brothers, who didn't like it either. He was done playing house. "I was tired of that whole family story that I had never liked and for which I didn't feel the slightest interest," he wrote. But he wasn't able to break free just yet.

That July 1967, after a long night of drinking with The Group, Juan Luis got into the car of Carlos Bousoño. They sped off into the milky light of daybreak, Bousoño at the wheel. As they turned from one street onto another, they collided with another car. The impact catapulted Juan Luis out through the windshield. As he flew through the air on a crest of shattered glass, all he heard was the ferocious bellow of metal ripping. After landing, he lay on the pavement with bones splintered and blood dripping from his face.

At the hospital Juan Luis learned that he had broken his pelvis and a clavicle. His face was bruised like he'd lost a fight. Thankfully, Bousoño had survived, too, but the experience shook Juan Luis. For the first time, death had winked at him without invitation, unlike his flirtation with suicide—and the experience wasn't the least bit literary. When Felicidad suggested he convalesce that summer in Astorga with her and Michi and Leopoldo María, he had no choice but to agree.

The family spent a hot, lazy August in the house where Máxima and Moisés had raised their children beneath the towers of the cathedral. Two of Leopoldo's sisters—the Astorga aunts, as the Panero boys called them—also spent summers in the house with their families, yet everything was different from how it had been when they were kids. The climbing ivy still wrote green calligraphy across the facade of their childhood home, but the feeling of eternal family warmth that had inspired Leopoldo's poetry was dissipating. Once an institution in this small, proud town perched above an austere plain, the Paneros were slipping into the quicksand of Astorga's history. This past had already ingested millennia of human life, from the Holy Roman Empire to the Second Spanish Republic. Juan Panero, dead thirty years ago that very same August in his own car accident, was just one more fading outline in an ever-growing civilization of ghosts. From this world of shadow he waited for the rest of his kin alongside his parents, having already welcomed his baby sister Charito, and his brother Leopoldo, now five years gone.

As if sensing the pulverizing mortar of eternity pressing down, Juan Luis and Leopoldo María spent the summer immersed in that elusive hedge against oblivion, which also happened to be their father's legacy: poetry. What was literature if not an attempt to *not* be annihilated by time, to fix a message on the wall of history, to leave something—anything—behind? Poetry had been the medium through which Leopoldo Panero

had chosen to live his life, and it appeared his two eldest sons were the heirs to this estate of being. The question was if they could *both* be heirs. Or rather, if Juan Luis and Leopoldo María were willing to split the inheritance.

During the sleepy days in the vast, shadowy house, Felicidad tended to bedridden Juan Luis. Meanwhile, Leopoldo María holed himself up in the *torreón*, the tower-garret for writing that Máxima and Moisés had built for Leopoldo, beyond which the roofs of Astorga changed colors as the sun rose and fell. Now Leopoldo María, whose downward swoop of a nose resembled his father's, seemed to be impersonating him in order to become his own man, though this didn't mean he fit into the town that had produced his father. Neither did Juan Luis, and here again the brothers were similar. In isolated, provincial Astorga, the two were like aliens from the distant moon of Madrid, where people spoke and dressed differently. Thanks to the upper-class airs their mother had passed on to them, they didn't mix with the natives any better than they did with each other.

Felicidad was relieved to see Leopoldo María coming back to poetry. It was through verse that he first revealed himself as something of a genius as a child, and his "extrapoetic" pursuits were too dangerous; she thought he had the intellect to have a career as a professor, which might iron out his disorderly nature. He felt things so intensely, as though he were made of exposed nerve endings. As Joaquín Araújo wrote, "He gave himself 100 lashings of emotion every single day." Felicidad hoped writing would provide an outlet for her son's sensitivity, though it also allowed him to dwell on the subject that inspired the first poems he recited to his family as a child: death. Leopoldo was reading the same poet who had captivated Juan Luis with his suicide, the Italian Cesare Pavese, who took his own life in 1950. Pavese had ended his last diary entry by writing simply, brutally: "Not

words. An act. I won't write anymore." That act was an overdose of barbiturates. Such fatalism enthralled Leopoldo María.

His return to writing poetry occurred at a curious moment—right after the Institute of Hispanic Culture decided to publish Juan Luis's first book. Whether or not this was a coincidence, Leopoldo María gave himself to writing again, and as the days passed in Astorga that summer, Felicidad watched what had been an undercurrent of rivalry between the two brothers thicken into a hot sludge, with her caught smack in the middle. She served as the messenger when Leopoldo asked her to show some of his poems to Juan Luis, who took several days to read them and then only did so with indifference. When she took them back to Leopoldo, she couldn't find the right words to mediate the rivalry, which made it, as well as other things, worse. "Leopoldo begins to accuse me of preference for Juan Luis and of a lack of understanding towards him," she wrote. "Much later I will understand to what extent my clumsiness aggravated the distance, moving us away from each other."

Joaquín Araújo was a quiet bystander as the sibling rivalry intensified in Astorga. "You could feel the competition between the brothers," Araújo recalled, "to the point of delirium." It was as if each imagined an inevitable referendum on who deserved to succeed their father.

IN THE FALL, THE PANEROS RETURNED TO MADRID. RECUPERATED FROM THE ACCIDENT, Juan Luis found an apartment and moved out of Calle Ibiza 35. He had led his own life apart from the rest of the family ever since his father had sent him away to boarding school when he was a boy, and it had been a mistake to try to return to the nest. He was twenty-five and nobody's father. He still saw Felicidad, who came over often, but now he conducted his life free from the untenable fiction of *la familia*.

Leopoldo María continued to cultivate himself as poet. But literature didn't dim his attraction to chaos, nor did he abandon his career as a political agitator.

In spite of the police having recently brought him in for three days of Kafkaesque questioning, he attended another demonstration at the same traffic circle where he had led fellow students into the dead end. He was arrested again. At the station, officers beat him and two cellmates as they curled up on the floor to shield themselves from the blows. After taking his statement the next day, the police released him again. Back at the apartment, the cost of Leopoldo's activism was becoming apparent to Felicidad. He was afraid to sleep at home. He shook every time the doorbell rang. His run-ins with the police had lost their comic shadings. He wasn't playing a game. Where would this end?

Before Christmas of 1967, Leopoldo María attended a poetry reading by members of The Group at the gallery of the art dealer Juana Mordó. In attendance was Pedro Gimferrer, a poet from Barcelona in town to receive the National Poetry Prize for his book *Arde el Mar* (The Sea Burns), which he had won at the impressive age of twenty-two. After the ceremony, he had missed his train back to Barcelona that afternoon, so he went to the reading.

Like Leopoldo, Gimferrer was as peculiar as he was brilliant, just in a less flamboyant way. Lonely and awkward, with a nasal voice and chubby schoolboy's face, he was an encyclopedic vacuum that hoovered up every particle of art in sight. He felt his aesthetic experiences were his true life. He read *everything* by *everyone* from *everywhere*. This was uncommon in Spain, and his aesthetic prowess converted him into the tastemaker for an emerging generation of young writers in Barcelona. Decades later, as an editor, Gimferrer would advocate for the work of an obscure Chilean writer living on the Costa Brava named

Roberto Bolaño. During that winter, though, his only concern was to reinvigorate Spanish poetry, which had a long and rich tradition but was badly in need of renovation.

After the reading, Gimferrer joined the poets for drinks at Bourbon Street. He and Leopoldo María had an instant connection. The intensity of their rapport was spooky, almost uterine, like two brothers from the same poetic womb, only without the rivalry. They talked, Gimferrer wrote, "as if in an encoded language that we were making up as we went. Only a few times have I ever established contact so quickly with a person." He was glad to have missed his train.

The two chattered away in their strange code all the way to Gimferrer's hotel, until the sun came up. Gimferrer was struck by the fact that Leopoldo seemed to understand himself as a person marked by fate as a poet. "He was being called on with a singular destiny," Gimferrer said. This was a rare, strange thing. It made him think of Byron and Shelley. He and Leopoldo were so absorbed by each other that Gimferrer almost missed his train back to Catalonia again.

A few days later, Leopoldo told Felicidad that he was going to Barcelona. Meanwhile, Gimferrer told people there about his new friend. Leopoldo María was the only person he had met whom he thought might be the great poet of their generation.

THE GREAT COMPLICATION

Leopoldo María's Unraveling, 1968

Leopoldo María arrived in Barcelona in the winter of 1968 like a country boy come to the big city—in a three-piece suit and tie, with a suitcase full of dreams. Like his father arriving in Madrid in the late 1920s, he hoped to make his name as a poet.

Gimferrer welcomed Leopoldo into his clique of young literary zealots. The group gathered at El Oro del Rhin, a German-style café frequented by artist types since the 1920s, on the corner of the La Rambla, where office men bustled about in hats and greatcoats, like ready-made symbols of the status quo Leopoldo and his generation were determined to reject. At the café Leopoldo met a young woman named Ana María Moix.

La Nena Moix—The Moix Girl, as her friends called her—was a student in the Department of Philosophy and Letters at the University of Barcelona. A writer as talented as she was shy, she had a high pageboy haircut, out-of-place Mongolian cheekbones, and a cigarette perpetually dangling from her fingers. Her sleepy, koala-bear gaze suggested a person for whom

the external world would never eclipse her internal one. She was suffering from deep depression at the time Leopoldo appeared in Barcelona. In front of his new friends he played his customary role of provocateur clown with philosophical pronouncements and an unsettlingly loud laugh, the smokescreen for his social awkwardness. Ana María saw beyond this posturing and wanted to get to know the real person.

Leopoldo stayed in the apartment of a poet who had to go away for military duty. He did little more than sleep there. He spent nearly all of his time with La Moix, often with Gimferrer present dropping tiny clods of hash in cups of tea while reading them Spanish baroque poets. They hung out in Ana María's family apartment, where cats, conversation, and cigarette smoke enveloped them, as Frank Sinatra and Juliette Gréco played in the background; or they went out to cafés in the busy Eixample district, home to two of Antoni Gaudí's most famous buildings, the dragon-esque Casa Batlló and quarry-like Casa Milà, undulations of stone that stood out like architectural hallucinations along Barcelona's Parisian-style boulevards. There was something equally fantastical about the Panero boy's connection with the Moix Girl. They both had a fascination with *Peter Pan*, and like Wendy Darling, the protagonist of J. M. Barrie's work, each sensed the looming menace of adulthood. Only, their Tinker Bell was books and her fairy dust was the literary allusions they sprinkled their conversations with to overcome their mutual shyness. They talked about poetry and psychoanalysis, which was making a late mark in Spain. Leopoldo and Ana María saw the same thing in the other person: a lost child of literature. Except he also saw something beyond this. Love.

Leopoldo had never had trouble attracting female attention. In high school, he'd had admirers, and in college he'd already had more than one girlfriend. But these short-lived relationships were puppy love, nothing serious and nothing sexual. Now with

Ana María he felt something different: consuming infatuation. But the connection that she felt with Leopoldo was purely platonic, if still intense. Like Luis Cernuda, she was gay.

Her rejection sent Leopoldo spiraling. He had managed to escape the political tar pit of Madrid and glimpse a different life in Barcelona, only to now see his most fervent desire immediately frustrated. In a poem titled "First Love," which he wrote soon after, he evoked the death of his romantic hopes as the "cadaver that still holds the warmth of our kisses." His dreams were "pale birds in gold cages." On top of his hard luck in love, the university refused to accept his transfer enrollment. He went to the airport and flew back, devastated, to his cage in Madrid.

Back at the apartment on Calle Ibiza, Leopoldo shouted at Felicidad, slammed doors, and vomited from drinking. Something seemed to be coming unstuck in his mind. This transformation disturbed Michi, who was now sixteen. "My playmate becomes a strange being," he later said, recalling the shift in his brother. Leopoldo's good friend Joaquín Araújo also found the changes disquieting. Marijuana and hashish was making its way inside Franco's Spain, and Leopoldo was an early experimenter. The drugs seemed to send him off into space and bring back a strange impersonator, albeit a prolific one. "Sometimes we would write together," Araújo said, "and you could see the spectacular velocity of his thoughts and it was lightning bolts." The Doors's "Break on Through (To the Other Side)" played at parties and as Leopoldo sucked down tobacco-laced joints he seemed to be trying to live the song to its letter, with no heed for what the other side might hold.

With Barcelona still on his mind, Leopoldo sent poems for a projected book to the fastidious Gimferrer, deciding that he would use his full name, *Leopoldo María Panero*, to distinguish himself from his father, and also to evoke the poet Rainer Maria Rilke. Gimferrer responded to the poems with a ladle of praise.

"This is what no poet of my generation had given me until now," he wrote. Gimferrer had the contacts to help him find a publisher and he suggested that it was a good time for Leopoldo to submit to the rite of passage of visiting Vicente Aleixandre, although the manners of the second son of Leopoldo Panero—who seemed to have left behind a litter of aspiring poets—didn't impress the maestro. Leopoldo addressed Aleixandre with the informal pronoun *tú* instead of the more respectful *usted*. Fortunately, his poetry did impress him. Yet this failed to lift Leopoldo's spirits.

Leopoldo exchanged letters with La Moix, who worried about him and tried to coax him back to an anchor of self. "I value you for what you are," she wrote, "for what is truly there beneath that Leopoldo who gesticulates, laughs, and pretends so much. Underneath I have glimpsed, almost felt foreshadowed, that other Leopoldo who one day you will be able to show without timidity, that other Leopoldo who is worth so much." This message didn't call him back from the edge he was sleepwalking toward. Unlike Peter Pan, life was forcing him to grow up, but becoming an adult seemed to only bring despair. As Leopoldo wrote in a poem, "Peter Pan is nothing more than a name, a name to utter alone, with a gentle voice, in a dark room."

Leopoldo wrote to Gimferrer to tell him that he no longer wanted to publish. Then one night in February, alone in his bedroom, he swallowed a box of sleeping pills. He did the same with a second box. Then he lay down on his bed.

In the morning, Felicidad rose as usual and began her day. It was raining outside. A few hours later Leopoldo still hadn't gotten up, so she went into his room. His breathing was a strained rumble. She noticed a piece of paper with a short message—a suicide note. Under the bed she found the empty pill boxes. Frightened, she called the family doctor.

Paramedics arrived and loaded Leopoldo into an ambulance.

The doctor went with them and Felicidad, and the doctor's wife hurried behind in another car. At the hospital, the staff wheeled Leopoldo away to the OR to pump his stomach. Felicidad waited. Juan Luis wasn't there. It isn't clear where he was. In his memoirs he wouldn't mention this dramatic incident. Michi notoriously suggested that the rivalry between Juan Luis and Leopoldo extended even to their suicide attempts, as if they were dueling literary works, like the poems their father and Pablo Neruda had once hurled back and forth at each other. Juan Luis denied this was the case and Leopoldo claimed that he took the pills not to one-up his brother but to get the attention of his mother, whom he felt neglected by. If this was true, it worked. He had Felicidad's full and complete attention. As he lay in his hospital room in a state of delirium, she listened to him rant and insult her.

The next day, Leopoldo was moved to a psychiatric clinic, while Felicidad went home to rest but couldn't. Dread pooled in her mind. She thought of her schizophrenic sister Eloísa, still living in an asylum in Madrid, still saying the same lunatic things she'd been saying for the past thirty years. Leopoldo María's extraterrestrial brilliance at age five had augured genius but also something else—a too-bright glow, circuits so hot they might burn up. There were other cases of mental collapse in Felicidad's family history too: another schizophrenic, a suicide. Had she passed these evil genes on to her son?

What Felicidad didn't appear to ask herself was if she had passed her freighted relationship with literature, the way she framed life inside of it, on to her three sons. Leopoldo María and Juan Luis both seemed to be inheritors of this trait, just as they seemed to have inherited poetry from their father. Both read authors who wrote about suicide, both used it as a literary trope in their own writing, and both tried it out themselves. Their attempts may have been acts of their own invention, adolescent melodrama expressed in fatalistically overstated gestures. Or they may have

been doing what came naturally to the sons of Felicidad Blanc: taking literature literally.

Leopoldo María's suicide attempt would mark the end of the second youth Felicidad had briefly enjoyed. As she would later say on camera to Michi about his troubled brother, "Leopoldo, as you know, was the great complication of my life."

Joaquín Araújo was the first person to visit Leopoldo at the clinic. The two friends spent the afternoon strolling around the courtyard. Leopoldo's mind was an angry cyclone, yet it still crackled and he said something that Araújo would never forget:

"We're all crazy. The thing is for them not to find out, like with me."

LEOPOLDO HAD WANTED FELICIDAD TO TAKE CARE OF HIM, YET TO HIS DISMAY HIS mother had now been replaced by psychiatrists. This episode, the day he crossed the threshold into a mental asylum, would arguably be the hinge that swung the rest of his life open, the decisive stroke that sliced his story into two parts. In a figurative but eventually also very real sense, Leopoldo would never leave the parallel universe of psychiatric institutions. It was on the day that he talked in the courtyard with Joaquín Araújo—Thursday, February 22, 1968—that Leopoldo María Panero was born a second time, just like his father. Only he wasn't reborn as a person. He was reborn as a legend that would fuse with the poet, a myth that would devour the man.

LA LOCURA

Institutions and Incarceration, 1968–1969

After being discharged from the clinic in March, Leopoldo yo-yoed back up to Barcelona. He wasn't mentally stable, but he looked so happy at the airport that Felicidad felt good about sending him off. In the end, he had decided to publish his chapbook, and a reputable small press in Málaga printed two hundred copies. It contained only five poems, teasing an in-crowd of readers with the promise of more work to come.

Later that same month, Juan Luis published his first book, *Across Time*. Critics received it warmly. It was nostalgic, sensual, and wistful, and confident in its elegant, straightforward realism. Juan Luis dedicated the book to his mother and to the memory of his father. In a poem composed on the fourth anniversary of Leopoldo's death, Juan Luis confessed how hard it had been to lose him, while the saddest part was to feel his grief fading with time. In another poem, he described Leopoldo's tender side, although he would eliminate this poem from future editions, as he would also do with the book's dedication,

perhaps so as not to undermine the unsentimental loner persona he soon began to cultivate. This would dovetail with his analogous loner status as poet.

In spite of the good reviews and the professional boosterism his father's friends gave him—perhaps even because of it—*Across Time* didn't vault Juan Luis onto the literary stage. He wasn't part of a larger aesthetic current that might invest his work with collective meaning. He floated between literary generations the same way he floated at a distance from his younger brothers. His work had commonalities with the metaphysical preoccupations and colloquial language of the poets of The Group, from the Generation of '50, but he had come after them. Yet he didn't share the esoteric iconoclasm that was gathering force in Barcelona, whereas his brother Leopoldo was a natural fit.

BACK IN THE CATALAN CAPITAL, LEOPOLDO SOWED MORE CHAOS. HE STAYED IN THE same apartment as before, his friend still away, until he outraged the residents of the building with a loud party that ended with a naked person in the stairwell. When the friend learned of the bash and the scandal it had caused, he kicked Leopoldo out. This would turn out to be one of his great talents alongside his poetry, a rhythmic genre of behavior that he perfected: winning over new friends in order to then push them to a breaking point. For Leopoldo, boundaries seemed to matter only insofar as he could transgress them.

During this visit to Barcelona, however, he was still mostly making new friends, and there were plenty to have. Beneath its restrained facade, the city housed an emergent artistic revival, like a teapot about to boil. It crawled with writers and editors who were revitalizing literary life. Thanks in part to the agent Carmen Balcells, it was becoming a key node in the global Spanish-speaking world of publishing. Gimferrer drank with

Gabriel García Márquez, who had just published *One Hundred Years of Solitude*, and Mario Vargas Llosa was finishing *Conversation in the Cathedral*. Barcelona was a hub of ambition and gossip, conversations and manuscripts, long dinners and big plans. The influential editor Beatriz de Moura recalled it as a time of "cultural effervescence." By comparison, Madrid felt like the dusty office of an old-fashioned literary journal.

Leopoldo met fellow poets he shared his work with and editors who gave him copyediting and translating gigs. And he kept writing, working on his first full-length book. He later said this was the happiest time of his life. He was out in the world on his own, with people who lived and breathed literature like he did, and who bucked the rules like he did. He smoked marijuana constantly and his heroic drinking (double whiskeys) earned him fame, as did his off-color antics. In a taxi with friends once he tenaciously tried to convince the cabbie that a garment bag contained a dead body. One just didn't behave this way in Franco's Spain, especially if the police already had a file on you.

As peculiar as they were, Leopoldo's wild impulses embodied the greater zeitgeist. Not just in Spain but across Europe young people were clamoring for change, for liberty, for progress. By acting out they might break out of political strictures, and holders of power across Europe were discovering that a whole generation was rejecting the status quo. The Prague Spring was blooming in Czechoslovakia and the upheavals of "May '68" in Paris erupted the next month. Helplessly himself, Leopoldo was nevertheless a product of his era, as was his poetry. Ana María Moix captured this in a letter to Leopoldo after his suicide attempt. "Our art," she wrote, "is a desperate defense of life, to survive."

But even if Leopoldo felt happy, something inside him remained deeply off. That "other Leopoldo" La Moix had urged him to release refused to emerge, if he was there at all. He was still hopelessly fixated on her; she still wanted him only as a

friend. Alone one afternoon in the room of the pension where he was staying, he descended again into the lightless marine depths of depression, yearning to drown. Outside, a gentle rain fell, drops of water tapping softly on the city. Leopoldo lined up a handful of Valiums and began popping them into his mouth. As he did so, an Andalusian maid appeared.

"But are you going to do the same thing as Marilyn Monroe?!" she said in her southern accent.

At this interruption Leopoldo bolted out of his room, then the hotel. Before he got anywhere, he fainted in the wet street.

He woke up in a dreary light, lying on a cot. All around him other people lay on identical cots. He had been committed again.

Gimferrer called Felicidad, who hurried to Barcelona. She wanted to get Leopoldo transferred to a nicer hospital, but her son wanted only one thing: marijuana. He demanded Felicidad get him some as though it were the only medicine that might save him.

Illicit drugs were new mothering territory for Felicidad. A cousin had told her that using marijuana was worse even than attempting suicide. She didn't know what to think. Sharper than ever she felt the generational chasm dividing her and her sons, even if she felt drawn more to their worlds than her own. "I realize that the old language no longer works," she wrote, "and I don't find the words to substitute, confused between the person I am and the one I still feel obligated to represent." With a heavy heart she had recently sold her parents' *palacete*, her grandiose childhood home, but thankfully she had the money to ensure that Leopoldo was well taken care of. His use of marijuana was a horrible business, she decided, and so she needed to deal with it. She had him moved to a pricey private clinic and after a week in Barcelona she left to spend the summer in France and then Astorga with Michi. She was out of her depth and hoped the doctors would cure her son. Leopoldo, meanwhile, wondered why his mother didn't talk to him about his depression.

The doctor at the new clinic diagnosed Leopoldo as a "non-demencial psychotic." In other words, he was psychotic but functional. Friends came to visit him, including La Moix. Leopoldo spoke in a lucid poetry about his pain, which did little to assuage it. He felt that he had fled the trap of death only to become trapped in insanity. Soon after, Felicidad decided her son needed another, more radical type of treatment.

In June 1968, just days before Leopoldo's twentieth birthday, Felicidad consented to his transfer to a mental hospital in the nearby coastal city of Tarragona for insulin shock treatment.

The new clinic was more like a resort for misfits from well-heeled families than a psychiatric hospital. There was an attractive young woman who compulsively bathed herself; another woman periodically broke out into operettas. The clinic had a wing exclusively for the families of patients, where Felicidad and Michi spent a month. (Juan Luis came for one day but stayed at a hotel.) They all ate together in the same dining room and the families and patients went on outings to the nearby beach. Leopoldo had his own room where he listened to records and ate liqueur-filled candies that Michi snuck him. He made friends with a young man named Ramón whose family hoped to cure him of homosexuality. When Leopoldo acted up, Ramón would yell at him, "Enough with your craziness!"

But Leopoldo's stay in Tarragona wasn't just an upscale Spanish parody of *One Flew Over the Cuckoo's Nest*. It had its dark side: the insulin shock. The treatment had been shown to reduce psychosis in some patients, though it was dubiously effective and by the late sixties had gone out of fashion in most hospitals outside of Spain. The medical staff injected Leopoldo with the insulin, which caused a severe blood-sugar drop. He fell into a light coma during which he would sweat and convulse. Then they would bring him back by administering glucose. A fleeting serenity would settle on him afterward. But

his condition didn't improve. Insanity—*la locura*, in Spanish—continued to hold him in its trap.

Yet he didn't resist. He welcomed it into his poetry and his life.

"INSANITY EXISTS, JUST NOT ITS CURE. . . ." LEOPOLDO TOLD A JOURNALIST THIRTY years later as he chain-smoked in the visitation room of a mental hospital in the Canary Islands. "Insane asylums, prisons, and barracks are places for the deprivation of life. Insane asylums are the Rule of No-Law, that's why for me to leave here every day is like descending from the cross. At night they nail me back up again." Leopoldo left the Tarragona clinic and its insulin shock treatments in fall, but if this felt like a liberation from his own crucifixion, his escape was brief. Once back in Madrid that fall, Franco's rule of law would nail him right back up.

His new doctors prescribed routine, so Felicidad finagled Leopoldo a job at a literary journal published by the Institute of Hispanic Culture, and he began attending classes at the university again. (Although Felicidad felt abandoned by Leopoldo's circle, several people continued to come to her aid, most of all Luis Rosales.) This new routine didn't last even a month. In December, Leopoldo went over to a friend's house where a group had gotten together to get high. He met a young man at the gathering named Eduardo Haro Ibars. Also a writer, Haro Ibars seemed ripped from Allen Ginsberg's *Howl*, one of the "angel-headed hipsters," only Spanish, with the air of a hard-living rebel destined to die young. He'd heard about Leopoldo's talent as a poet, but before they had time to talk much, police invaded the apartment. Drugs went out the window, but not the joint of hash Leopoldo had on him, which the officers found. They arrested everyone there. Newspapers would report the bust as the dismantling of a drug ring.

The police took the delinquents to the General Direction, then on to another lockup for people in violation of the Law of Idlers and Miscreants. Haro Ibars and Leopoldo joked that they were miscreants, certainly, but not idlers: "We've converted the art of living into a job!" At Felicidad's pleading, Vicente Aleixandre came out of his seclusion on Velintonia to testify on her son's behalf in court, which turned into a surreal comedy. The judge was an enormous fan of Aleixandre and forwent the trial to invite the "Maestro" into his chamber to discuss poetry. As for Leopoldo, the judge had no such sympathy. He was transferred along with Haro Ibars to Carabanchel Prison, in a southern district of Madrid. There the two waited to hear the length of their sentence.

Built after the Civil War by prison laborers who moved into the structure they had built, Carabanchel was a panopticon with a massive central dome from which spoke-like radial cell blocks shot out. From above, it gave the impression of a starfish that had been stepped on, its sinews flattened into hard straight lines of brick. The overcrowded prison was divided by category into different galleries. The prisoners were a ragged menagerie of criminals, alleged political agitators, and homosexuals and transvestites.

On Christmas Eve morning, Felicidad waited outside in the cold to see Leopoldo. During this and other bleak waits she endured, Felicidad got to know fellow Spanish women whom she would otherwise never have met: poor gypsies and others with sons and brothers and husbands in jail. Nothing leveled social divisions like shared helplessness. Despair dissolved difference. The first time Felicidad saw Leopoldo behind bars she could barely muster words. She resembled the mother-in-law she had always found so overbearing: Máxima Torbado waiting to see her son outside the San Marcos Convent. But Felicidad had no ace in the hole to get her own Leopoldo out.

Leopoldo was given his sentence: four months. He was moved again, this time north to Zamora, a city along the Douro River. At the start of January, he wrote to Felicidad: "If I hadn't left traces of myself behind, I would believe that I don't exist. Time here is gaseous, and I have the feeling that weeds are growing over me. . . . In the meantime, my case slowly becomes a farce. And in spite of everything, I feel I'm arriving at the center of myself." Indeed, at the provincial prison, Leopoldo discovered a new facet of himself. With Eduardo Haro Ibars, who was bisexual, he had sex with another man for the first time. He had always felt repulsed by homosexuality, but now he discovered that he was strongly drawn to it; remembering his reading of Freud, he started to believe that what most disgusted him was in fact what he most desired. Soon Leopoldo was in love with Haro Ibars, fixating on him as he had done with Ana María Moix, except now he attached therapeutic significance, imagining him as the treatment that his doctors had failed to prescribe. "To find myself in another person," Leopoldo wrote to Felicidad. "Yes that is a good therapy, perhaps the only one, for paranoia."

Freighting his involvement with Haro Ibars with such expectations created unbearable tensions. Leopoldo became violently jealous and drove him away. His mother understood her son all too well. "Your flaw, which is also mine," she wrote to Leopoldo, "is that you put too much on the person that you love and you adorn them with virtues that they generally don't have." Yet Felicidad was elated by the revelation of Leopoldo's sexual desires, which she had suspected. She phoned Joaquín Araújo.

"I'm very happy," she said, "because Leopoldo finally knows he's homosexual."

Araújo was astonished by Felicidad's reaction. She thought being gay would give a meaning to Leopoldo's life that was lacking. Yet she exalted this in a country where practicing homosexuality also fell under the Law of Idlers and Miscreants, a true

measure of how unconventional a Spanish mother she was. But she was also a faithful, resourceful one. Through her friendship with the poet Claudio Rodríguez, who was from Zamora, Leopoldo was appointed prison librarian; and she made the long trip to visit him nearly every weekend. She delivered books he requested, including poetry by Leopoldo Sr., which he admired. And she took home his rank-smelling clothes to wash and bring back.

Prison life was hard on Leopoldo, and not just because of his unrequited love. Enveloped by winter fog from the river, the prison was like a shipwrecked pirate ship, the inmates the doomed crew. It was cold and easy to get sick. There was no solitude, yet at the same time little comforting companionship. To Leopoldo the other prisoners were "like pens without ink." The passage of time was no longer gaseous, which was tolerable. Now it was infinite. "It's like filling one bookcase after another with books with blank pages, or like Sisyphus, only you don't even get to the top." The sense of isolation was chipping new fissures in his already fragile psyche. To soothe his desperation, he sniffed paint thinner. His relationship with Haro Ibars further deteriorated.

After attacking another inmate that he had slept with, Leopoldo landed himself in solitary confinement for three weeks. Unable to bear it, he removed the lining from his jacket, fashioning it into a noose and tying it to his cell window. Then he slipped his neck inside. But the lining couldn't withstand his weight. It broke, dashing him to the floor.

In spite of the daily misery of prison, Leopoldo's brilliant mind showed him the poetry in what he was experiencing. The other prisoners he fought with and befriended, whom he ate and bathed with—they became a tapestry of ideas, a lesson. "In prison the odious dichotomy between the public and the private breaks down. . . ." he said. "The only place, as is often said,

where friendship is possible. . . . Prison is the maternal uterus and outside of it, the I fortifies itself and therefore the most useless and bloody war begins: the war to be me, for which the other must not exist. This is the origin of the exchange of humiliations which, more than mercantile exchange, is what structures current society."

Leopoldo was right. The society into which he had been born was founded on humiliations that divided Spaniards and perpetuated the injustices left by war. Spain was like a prison, and inside an actual prison inside this national one Leopoldo glimpsed strange freedoms and stranger truths. Before being sentenced, was he really so insane in the out-there things he did and said, and in wanting to die? Or was the world he lived in itself insanity incarnate, a place where the sanest people couldn't help but go mad?

Undoubtedly, Leopoldo was sick. He suffered from mental illness and hurt himself and others. But with his luminous perception he rode the finest line of the mind, between sense and nonsense, creating chaos while parsing it, seeing elegance in squalor, making poetry out of pain. It was the inverse of the worst human impulses, which turned peace into war, cities into rubble, and life into death. In short, it was a response to the bloodletting insanity that had given Spain its dictator. The country needed its own shock treatment.

Yet none was coming. The regime held on with stubborn immobility. Franco was determined to make the changing Spain adapt to him rather than the other way around. No matter that the growing unrest was spreading outside of universities and trade unions, finding a voice among Spanish clergy, who advocated for greater freedoms and justice. Franco responded by ordering a special prison just for dissenting priests. In an ironic machination of history, the Generalísimo was committing the same offense that had rallied millions of Spaniards behind him

during the Civil War: persecuting the Catholic Church. The clerical penitentiary happened to be located on the Zamora grounds, nearly within spitting distance of Leopoldo's lockup. There the priests prayed to a God who had met the ultimate indignity up on the Cross, and found strength to face their own persecution. Leopoldo enjoyed no such spiritual succor. Prison was one of the grandest humiliations humans had invented, and inside Zamora's cold walls, amid the smell of filthy bodies and the broken stares of other men, Leopoldo was free only in the torturous snare of his own mind, which was itself a prison.

In April, Leopoldo finished serving his sentence. He walked out of the provincial prison of Zamora, a "free" man.

THE MUTE WITNESS

Michi, 1969–1972

I've always felt like that lonely child who watches the trains pass," wrote Michi in the opening of a memoir he never finished, "and the passengers, looking out their windows, wave to in a fleeting instant, before the train moves off into the silent field."

Throughout his life, from his teenage years during which Leopoldo was incarcerated to his late years in a very different Spain, this image visited Michi at night in dreams. He was always that boy standing on the platform. Ever since his father had boarded the train and the pristine innocence of boyhood had vanished with him, Michi had felt like an "epilogue" to the rest of his family's story. Juan Luis and Leopoldo María led bigger lives, absorbing Felicidad's attention. He was a footnote. Michi resigned himself to being, in his words, "the mute witness."

By 1969, however, he was becoming his own person. In keeping with the family tradition, he was a voracious reader and had ambitions to be a writer. He toyed with poems but was more drawn to short stories, the genre of his mother, whom he

adored. He had an early facility with language and a fascination with death that would have seemed extraordinary had Leopoldo María and Juan Luis not been his older brothers. At age ten, in a story about soldiers in World War II, Michi wrote, "They have a vice: to smoke. To kill is not a vice for them; to die is." He kept writing stories, with odd structural premises, as if incapable of bending to convention. And he revealed what would become an obsession with memory. "Since I myself will become a memory," one character mused, "I have no need to remember." A few years later, he made the pilgrimage to show his stories to Aleixandre, who was encouraging. But Michi, now seventeen, found himself pulled toward another talent he was discovering: wooing the opposite sex.

He had achieved his first necking session a few years earlier with a local girl in Astorga, his heart pounding as the two pawed at each other at dusk beneath the ancient city wall. Although their romance ended there, his sexual awakening had begun.

As Michi grew into noodle-like limbs he wielded with a languid confidence, his face became the perfect alchemy of Felicidad's rounded cheeks and Leopoldo's long bones. His older brothers might overshadow him, but he was better looking. He had a thinker's brow and a sidelong smile, small dark eyes and a roguish flop of curls. He looked like a timid prince. But it wasn't just his looks that would turn him into a legendary playboy. At his school, away from his family, he outgrew his shyness like it was a shirt that no longer fit. He had an ironic wit that was like an irrepressible fizz. His classmates took notice of him, including the person Michi most wanted to catch the eye of: Domitilla Cavalletti.

The daughter of the Italian ambassador to Spain, Domitilla was different from most Spanish girls, with their provincialism and Catholic prudishness. She was intellectually hungry and unapologetically fun. She and Michi kissed for the first time on the

bus ride back from a field trip to the first nuclear power plant in Spain. Sure enough, something radioactive occurred.

Remarkably well-read for someone his age, Michi took on the role of boyfriend and literary tutor, recommending books to Domitilla. But when it came to sex, both were uninitiated. One day over at the Calle Ibiza apartment while Felicidad was out, they ended up on her bed. The moment to lose their virginity had come. Michi and Domitilla were both terrified as they took their clothes off, then did the deed as the family's cat meowed standoffishly nearby and watched. Afterward he convinced himself that their mutual deflowering had been lovely rather than humiliating. Further sex only intensified Michi's strong feelings.

"For the first time," he wrote, "I truly fall in love, plainly and like a madman." He couldn't have sounded more like Felicidad if he had tried. The only problem was Domitilla's father disliked Michi.

Like his mother, Michi had an aristocratic languor, especially when it came to watching—or not watching—how he spent money. He was congenitally lazy and unable to do things he didn't feel like doing. After enrolling at the university in Madrid, he quickly got bored and dropped out of the Department of Philosophy and Letters. He did the same thing the following year with political science. His budding writing career didn't bode any better: he stopped writing stories. Being with Domitilla liberated him to picture a life beyond being a Panero, which seemed to require a literary vocation. But maybe he didn't have to join the family business, he realized. Maybe he didn't have to be a writer. He was fed up with his two brothers' oppressive literariness and self-regard. "My only occupation was to escape the wretched responsibility of being the last Brontë sister," he wrote. Michi decided that his salvation was not in literature but love.

Unlike her husband, Domitilla's mother supported the young couple. At her urging, Domitilla and Michi, both eighteen now,

started discussing marriage. This talk was interrupted, however, when Signore Cavalletti received a new assignment—as the Italian ambassador to France.

Domitilla moved with her family to Paris. Meanwhile Michi switched to study film, which lasted a whole year, and worked part-time at the Institute of Hispanic Culture under Luis Rosales, who treated him like an adopted son. Michi wanted to make movies and helped his friends make theirs, but he had no follow-through. Friends thought he lacked the nerve to face the vulnerability that came with artistic self-exposure.

Michi and Domitilla stayed together, but it wasn't easy. Only the phone connected them, which wasn't enough. "You have to dedicate yourself to something when you hang up the phone," Michi wrote. That something was other girls. Left to his own devices in a Madrid that was more permissive by the month, he discovered his prowess as a lady's man. He was a tractor beam of charm and didn't have the will to resist the young women who couldn't resist him. (He claimed he slept with a psychologist he saw after the first session.) Domitilla caught him with the girl-friend of a friend, which produced a dramatic scene. Still, they stayed together—sort of. Between visits in Paris and Madrid, she also cheated, yet they still discussed marriage. When Michi wasn't telephoning France or out chasing girls, he applied his boundless charisma to making new friends at bars.

One of Michi's closest friends, starting in 1971, was Javier Marías. Like Michi, Javier had to contend with his last name. He was the son of the influential philosopher Julián Marías, a disciple of the even more influential Ortega y Gasset. Neverthe-less, Javier didn't shy away from his inheritance. He had just published his first novel at the age of nineteen. Politically speak-ing, however, his and Michi's last names meant very different things. Michi came from the intellectual milieu of the winners of the Civil War, whereas Marías came from the losers'. Yet both

hailed from the cultural elite in a still largely backward Spain. They understood each other, and, along with books and women, Michi and Marías both loved film. They often watched movies together at the Panero apartment on Calle Ibiza. Marías, like all of Michi's friends, was captivated by Felicidad and her unique household. He and Michi spent almost all of their time together and Marías, like everyone, enjoyed his friend's magnetism, even when Michi took too much pleasure in his wit. "Michi had a childlike side that made you forgive his excessive insolence," said Marías. He got a kick out of the way Michi often narrated his existence in real time: "Now I'm going to the kitchen," he would say to no in particular. "Now I'm grabbing the salt."

Through Marías, Michi acquired a new social circle, a stylish gang of aspiring writers and directors. "Friends with last names," Michi called them (most also hailed from intellectual families with a public cachet). They gathered at a bar called El Dickens. The place had a sophisticated ambience, though during the hot summers cockroaches skittered along the alley adjacent to the terrace where people sat and drank. It was a great place to be young and bohemian, to pretend Spain wasn't what it was. Michi and his close friend Rafael Zarza and others saw their generation as the younger siblings of the upheavals of '68. They didn't want college degrees or full-time jobs or mortgages or children. They wanted only the freedom to do as they pleased, though they tended to pursue this goal through talk rather than direct political action.

Michi's lifestyle reflected a greater pattern among young people in Spain. University life was bifurcating into two channels: students who identified with the political struggle against the Franco regime and those who identified with the cultural loosening transforming Spain. They were the *progres* and the *modernos*, the progressives and the modern ones, the activists and the hipsters. While there was no hard and fast divide, Michi and his friends embodied the spirit of the *modernos*, which was the

growing trend. In contrast to trade union organizing, university activism decreased in the early '70s. But being hip and modern, Michi soon learned, came at a price. "One of my greatest errors committed with Domitilla," he wrote, "was introducing her to the society of my sinister Madrid friends."

During one of Domitilla's visits home, they spent the weekend at a country house with a group of friends. There Michi proposed that he and Domitilla engage in a "round bed"—a threesome or orgy. She was game. "I thought, doubtlessly, that I was very modern," Michi wrote. "The next morning I realized what I had been—simply, a fucking idiot."

His relationship with Domitilla soon unraveled. It all came apart during a visit Michi made to France. Domitilla had fallen for Félix de Azúa, a handsome poet from Barcelona who was living in Paris. Michi's relationship with Domitilla had allowed him to escape the pressure of being a writer, but who she wanted to be with was the writer he hadn't become. Or so Michi interpreted events, ignoring the fact that they were at the start of their twenties, living in different countries, and growing up at the speed of light.

The definitive break came on a rainy afternoon in Paris at the movies as Fred Astaire danced up on the screen. Michi sat beside Domitilla bemoaning the demise of their relationship.

"This sucks," he said. "This sucks . . . this sucks . . ."

"Let me watch the movie," Domitilla said.

Their relationship was over and her harsh words were a slap in the face—so much so that for the rest of his life Michi claimed that Domitilla had actually, physically slapped him. Embroidering this painful moment was the only control he had left.

DURING THE SAME YEAR THAT MICHI WAS TRAVELING TO AND FROM FRANCE TO SEE Domitilla, Leopoldo María was pinballing between Spain and

Morocco, albeit in a very Parisian style: as a *poète maudit*, a doomed outlaw poet.

The label of *poète maudit* appeared in nineteenth-century France to describe the tradition of wild-living, transgressive poets who had changed not only French letters but world literature: Charles Baudelaire, Paul Verlaine, Arthur Rimbaud, Comte de Lautréamont, among others. Living not just outside mainstream norms but against them, they embraced existences overrun with drugs, addiction, insanity, violence, and sexual experimentation. This fatalism frequently led to short lives, but also visionary poetry. The verses of these poets became as beloved as the savage legends they left as their epitaphs, offering readers a peek into a delicious hell that most were too afraid to visit themselves.

Leopoldo wasn't afraid. He seemed to have been born into this tradition as if into a family better suited to him than his own. He was obsessed with *poètes maudits*, both their poetry and their lives. He later claimed to be the reincarnation of Antonin Artaud, another famous French *maudit*, with whom he shared striking similarities. Leopoldo imported this poetic model to Spain and soon became the great *poeta maldito* of his generation.

In April 1970, the editor J. M. Castellet published an anthology that quickly became one of the most talked-about and argued-about books in Spain: *Nueve Novísimos Poetas Españoles* (Nine Very New Spanish Poets). Castellet's specialty was putting a group of writers together between two covers to fashion a conclusive generational statement. (He had included Leopoldo Panero Sr. in a 1960 anthology of postwar Spanish poetry.) The *Novísimos* was his most daring compilation yet, in part because of how daring the poets themselves were. They consisted of members of the Barcelona clique and others, including Gimferrer and Ana María Moix, the only woman in the anthology. The youngest of the nine young poets—the newest of the very new, age

twenty-one when *Novísimos* appeared, with no full-length book yet to his name—was Leopoldo María Panero.

Castellet's crop of youngsters were all born after the Civil War and they all represented a radical break from the traditions of Spanish poetry that preceded them. They weren't interested in the quotidian spirituality of Leopoldo's Generation of '36, nor the existential anguish and social conscience of the poetry that followed. The *novísimos* were upstarts born into the age of mass media, children of movies and television, savvy creatures weaned on camp and capitalism. Disgusted with the repressive nature of social order, they preferred chaos and believed in rational disorder. Seeking escape, they read beyond their own borders. They had a snobbish internationalism, seeking the parentage of poets from other countries and languages. "Young people," Castellet wrote in his prologue, "as irritating as a childhood illness and as provocative and insolent, in poetry, as an adolescent determined to have fun at the expense of the group of his venerable elders."

Leopoldo's poems in the anthology, like his first book that soon followed, captivated readers with their flame-like glow. His verses were unsettling and often beautiful. "Her eyes are dead volcanoes," he wrote. "Her golden hair shipwrecks itself in the wind / So much light deserts her motionless thighs / How much it hurts in the shadows to desire dead bodies." His poems were compulsively allusive, referencing high and low culture, everything from Kafka to Speedy Gonzales, his father's work to *The Wizard of Oz*. As Gimferrer soon wrote of Leopoldo's first book, *Así se Fundó Carnaby Street* (This Was How Carnaby Street Was Founded), the young Panero was no longer "an insinuated promise." His poetry was now a promise fulfilled, giving readers something they had never encountered before.

Leopoldo reveled in the attention. Although critics and poets would debate the merits of the *Novísimos* anthology for years to come, and even Leopoldo himself would criticize it, the book

Leopoldo María around the time of the Novísimos *anthology*

cemented him as a singular new voice in Spanish poetry—and in Panero poetry. He was the heir apparent to his family's poetic legacy. Juan Luis wasn't included in the anthology, and naturally neither was Michi, though like more than a few young writers who were left out, he later claimed near-miss status as the tenth *novísimo.* Again he felt relegated to the role of bystander, and right at the moment that he was coming into his own. He seemed to be stuck as a minor subplot of a much grander story.

Leopoldo's furious *maldito* lifestyle added a dark aura to his work. As his name became a literary watchword, he reveled in self-inflicted bedlam. He got into fights at parties. He stole books from bookstores. He drank ink. While in Tangier, he woke from acid trips sleeping outside and the locals called him Satan. He started losing teeth. Yet he claimed it wasn't the drugs that were leeching away his sanity but the people who didn't love him. He began developing persecution complexes. "I'm starting

to realize," he wrote in a letter, "that those who surround me are too big of sons of bitches for me to permit myself the luxury of being 'crazy.'" He subsisted on coffee, alcohol, and cigarettes.

Back in Madrid, Felicidad placed Leopoldo in a psychiatric clinic to detox, which prompted a failed jailbreak. He tied sheets together from his second-story window, but while climbing down they ripped, botching his escape, and he fell onto the ground. He broke his nose, leaving it permanently twisted. The doctor who treated him described his mental illness as "unclassifiable." He had a heady soup of traits that seemed to mix schizophrenia, depression, and narcissism. But there was an element of performance art to the way Leopoldo lived, of intentional provocation, of astutely crafted myth. Some people thought his sickness and antics were all just a calculated put-on. Others saw it as a narrative he controlled that in turn took control of him. His behavior was a way of rejecting, as someone who knew him put it, "the real putrefaction of the Francoist aristocracy that he came from . . . Leopoldo wanted to inscribe this putrefaction on his body." It often appeared that he used his fragile mental state as a pretext for his destructive behavior, a shield against growing into a responsible adult. Yet at the same time there was a real sickness separate from Leopoldo's embrace of the *maudit* tradition. He seemed to be breaking down a bit more every day, just like the old order of things in Spain.

BY THE EARLY 1970S, FRANCO HAD DEVELOPED PARKINSON'S DISEASE. BETWEEN THE debilitating effects of the disease and the medications he took, he was far from the leader he had been even just a few years earlier. During a visit from Richard Nixon and Henry Kissinger, the dictator fell asleep. (Kissinger did, too.) Convulsions in Spanish society reflected the *Caudillo*'s increasing weakness. Asturian miners launched disruptive strikes. The Basque nationalist group

ETA become an active terrorist organization and assassinated law enforcement officers. In response, neofascist paramilitary groups emerged to aid the police. Despite Franco's famous claim that "Everything is tied down and well tied down," disturbances erupted out in the streets and inside the government.

The dictator had been flashing his red cape of power in Prince Juan Carlos's direction for decades, like a torero playing with a bull, and in 1969 he finally made the protocol for a monarchical restoration official. Even so, this still wasn't an irreversible commitment to placing Juan Carlos on the throne. Political maneuvering might very well rejigger the mechanics of power and alter the course of events. To this end, the different "families" of the regime jockeyed for position, including Franco's wife, who hoped her husband might change his mind and make Juan Carlos's cousin the heir to the dictatorship, since he was married to their granddaughter. In parallel, the Falange looked for ways to stanch their bleeding influence. And all the while the democratic opposition plotted from abroad.

Would tradition hold out against change? Would authoritarian rule defeat democratic reform? Would order withstand the mounting chaos? Spain's destiny was up for grabs.

Michi's, Leopoldo's, and Juan Luis's generations each responded differently to the quivering fulcrum on which their country, and their lives, were poised. Most of Juan Luis's cohort already had families and hoped for stability accompanied by reforms. In Barcelona and Madrid and other cities across the peninsula, Leopoldo and his Spanish "Lost Generation" welcomed convulsion through protest and drug use, long hair and ratty clothes, sexual fluidity and outspoken art—which landed them in prisons and interrogation rooms. "Leopoldo's generation was the most punished one," Michi wrote, "a generation that had to live at a crucial age through the famous death rattle of the regime."

From the sidelines, like that lone child standing on the train platform, Michi and his peers watched this grotesque drama unfold, already living in the future. Sure, he and his buddies self-censored themselves in the film shorts they made, never producing anything so irreverent as to invite the meddling of the authorities. But this didn't oppress them overmuch, didn't compel them to sacrifice themselves to the fight against Franco. There was plenty to enjoy as they waited for the dictator to expire, someday, in El Pardo, his palace outside the city. As he bided his time, Michi was driven by the unshackling of inhibitions and the simple pursuit of fun, which was transgressive in its own right. As Michi's contemporary Jaime Chávarri commented decades later, recalling this period, "The demonstration of frivolity was very important." If there was a sweet spot between the poles of conformity and rebellion under Franco, it was having an outrageously good time, and Michi was the king of frivolous. He proved this on the occasion of his twenty-first birthday in 1972, with a legendary blowout.

The party was held in the apartment of a cousin of Javier Marías, the director Ricardo Franco, and Michi asked people to bring animals instead of books for presents. His friends came, along with Felicidad, and several distinguished older writers. Some guests brought stuffed animals. Others brought real animals—dogs, cats, birds, and even a snake that Michi named Gertrudis. "It looked like the zoo," he wrote. "And it ended with all of the generations vomiting together." That night, at least, all age groups were united in a single gesture.

Michi was succeeding at not being a writer. He was succeeding at not being his father. And he was succeeding at not being either of his brothers. But as much as tried to reject where he came from, he wasn't satisfied with his life. He confessed to thinking of himself as a "fiction that history condemned to

remain as 'Michi.'" He seemed to feel he didn't have ownership of his identity. By abandoning the practice of literature he had chosen to mute himself again, but he knew he had a story to tell—the story of his family.

He just wasn't going to be the one to tell it.

Michi in the mid-1970s

FOUR CHARACTERS IN SEARCH OF AN AUTEUR

An Idea for a Documentary, 1974

Jaime Chávarri should have been thrilled.

It was the summer of 1974 and the tall, wavy-haired thirty-one-year-old director didn't know what to do. At a screening earlier that evening in Madrid, one of Spain's most influential producers, Elías Querejeta, had offered him the opportunity to make a documentary short.

A former professional soccer player, Querejeta had spent the past decade reinvigorating Spanish cinema with a string of masterpieces. He saw film as a tool for political resistance, a means of reflecting Spanish society as it truly was, not as the authorities dictated. He sometimes gave decoy scripts to censors to smuggle taboo content into his productions, then leveraged success abroad to ensure the films appeared in cinemas back home in Spain. His most volcanic controversy to date had erupted the year before with *Cousin Angelica*, a dreamlike exploration of the Civil War, which outraged conservatives, led to reels being robbed, and culminated in the firebombing of a

theater in Barcelona. All of this only further established Que-
rejeta's name as a seal of artistic integrity. He was always on the
lookout for new talent, and if anyone could singlehandedly birth
a director's career, it was Elías Querejeta.

Chávarri should have been thrilled—but he wasn't. The proj-
ect Querejeta had offered him wasn't the one he wanted to di-
rect. A month earlier, Chávarri had pitched the idea of going
into a mental hospital to film the lives of the patients. Querejeta
had looked into it and getting permission was impossible, so he
came back with another idea, the one he had proposed after the
screening: a short documentary about the Panero family.

Querejeta knew Michi Panero—it seemed like everybody
in Madrid did—and the young man had recently regaled him
with a handful of anecdotes about his family. For example, how
they hit rough financial straits after the death of their patriarch,
the poet Leopoldo Panero, and sold off parts of his library. It
was resonant: the family of a literary symbol of the dictatorship
venida a menos—fallen on hard times—reduced to vending the
dead man's books to survive. And there was plenty more mate-
rial to mine.

Or rather, this is one version of the genesis of the film about
the Panero family. There are other versions: Querejeta saying
he didn't bring the idea to Chávarri, but latched on to it when
Chávarri mentioned the Paneros' selling the books in passing
while they drove somewhere together; or Michi saying that it all
began with him back in Paris sketching out notes for a short he
hoped to make about his mother. It seems only fitting that the
precise origin of a film about memory is itself obscured by the very
slipperiness of its subject, as spangled with myth as the Paneros
themselves.

No matter the precise sequence of events, Querejeta's enthu-
siasm about the idea was deflating for Chávarri. He and Michi
Panero were part of the same social circle and he saw him nearly

every day at the bars where he was a fixture, gin and tonic always in hand like an extension of his arm, hosing people with his wit. And while Michi was a friend, he wasn't really a friend. Chávarri felt he had to be guarded around him. Michi had a caustic, scorched-earth sense of humor. He would risk insulting nearly anyone to get a laugh, and if you got burned, well, you were the one who had gotten too close. He was smart and cultured and a good guy to have at a party, but for Chávarri the appeal ended there. How many good stories could Michi's family actually have? Did he really want to make a film about the Paneros, even for Elías Querejeta?

On the other hand, Chávarri didn't know what else to do. The year before, he had finally completed his first professional feature, *School Trips*, a Buñuel-esque story about a troubled young man returning home to his eccentric family. It contained a suicide attempt, premarital sex, and light sadomasochism; getting approval for it from the censors had been a maddening obstacle course. Nonetheless, Chávarri managed to finesse it through the red tape. When it premiered at a festival in Spain, much of the audience hated it, and a few members of the public loudly said so. A journalist had asked him if he planned to continue making movies. Of course he did. What he didn't know was how.

Maybe this documentary was how. There were certain echoes between Chávarri's family and the Paneros. He came from the political class—his great-grandfather Antonio Maura had been the prime minister of Spain five times—and the story of his mother and her sister personified the painful, intimate divisions of the Civil War. Both had been stylish, fiercely independent women in their youth, but with warring politics. Chávarri's aunt became a chief propaganda official for the Republic, while his mother played a similar role for the Nationalists in Burgos. Chávarri knew a thing or two about complex legacies.

He decided that he wouldn't say no to the short—at least not yet. Querejeta had joked that filming the Paneros would be akin to filming patients in a mental hospital. He asked Chávarri to go meet Michi's mother, Felicidad, and only then make up his mind about the project. The strange thing was where Querejeta told him to find her: not at her home, but at her workplace. Unlike nearly all women of her age and background, she had a job.

FELICIDAD HAD STARTED WORKING AT THE PALACE OF CONGRESSES AND EXHIBITIONS in 1971, at the age of fifty-eight, after a new minister revoked her pension. In spite of the inheritance she had received and the subsequent sale of her parents' *palacete,* she'd been unable to keep the family solvent. Leopoldo's recurrent psychiatric care was costly, as were his legal fees and fines, never mind his lifestyle she subsidized. She just wasn't good at saying no. She wanted her sons to be comfortable, which is why she paid for Michi to have his own apartment. She thought he should have a space separate from the chaos Leopoldo created. But Michi didn't work—he was fulfilling his military service, which entailed taking film reels to different barracks for movie nights—so he needed an allowance, too. On top of this, she had to pay the salary of Juani, the woman who cooked and cleaned at the Calle Ibiza apartment. (Angelines, the family's former nanny and maid, had married a man from Astorga and resettled there.) To defray her mounting expenses, Felicidad started hosting American foreign exchange students. One of them was Peter Turnbull, a twenty-year-old from Ohio on a semester abroad from Kalamazoo College in Michigan. Forty-five years after his stay with the Paneros, he still vividly recalled them. "It was as if the family were aristocratic," said Turnbull, who felt like a rube around the sophisti-

cated Paneros, "but as far as I could tell they didn't have much money."

One of her late husband's poet friends had secured Felicidad the job at the Palace of Congresses and Exhibitions, which hosted government-sponsored events. She worked as a combination of hostess and receptionist. She arranged flowers in vases and greeted visitors, on one occasion welcoming Prince Juan Carlos's wife, Sofía. While vanity had always been one of her weaknesses, Felicidad transformed her *niña bien* aloofness into a strength. Instead of feeling ashamed of her fall from comfortable homemaker to lowly civil servant, she was proud of herself for working. It fit the profile of the sly nonconformist she had become since Leopoldo's death better than middle-class mediocrity ever did. She took delight in refusing to be what she was supposed to be, and for a woman of her background she certainly wasn't supposed to weather her disgrace with poise. Entwined in her flaws was an undeniable bravery. It was this intriguing quality that seduced Jaime Chávarri when he went to see her.

The two spoke during Felicidad's break. Although the prospect of appearing on camera frightened her, she was willing to participate in the film. She wanted to support Michi, who had often talked about filming her telling stories from her life. She didn't have the money to finance Michi's pet project, but with Querejeta and Chávarri a version of the idea might come to fruition. Her sister Eloísa had died the year before, the latest reminder that the past was slipping into oblivion. Here was Felicidad's chance to excavate memory and preserve the past. Whether she suspected she had to win Chávarri over or not, he experienced their meeting as if it were a breathtaking audition.

"Her sincerity and almost desperate necessity to express

Jaime Chávarri in 1976, the year his film about the Paneros would be released

herself amaze[d] me," he wrote after their meeting. "Felicidad has a rare desire for a Spanish woman of her class and of her generation: to substitute testimony for gossip."

Chávarri decided he would make the short.

BEFORE BEGINNING PRODUCTION, CHÁVARRI NEEDED TO MEET THE OTHER TWO PANERO sons to secure their commitment to participate. But right away, people who knew Leopoldo began stoking a smoky aura of trouble around him. They told Chávarri that he would either refuse to participate in the film or else be impossible to work with—that is, if he could even be located, which he couldn't. In August, however, Chávarri met with Juan Luis, who signed on. Querejeta had offered the Paneros a fee for their participation, so they would technically be paid actors, and Juan Luis needed the money.

He had just returned from a sojourn in Mexico and was closing an intense chapter in his life. At the start of 1970, he had eloped to New York City with Marina Domecq, the daughter of a wealthy landowning family in Andalusia whose world-famous sherry was advertised on billboards in Madrid. The twenty-one-year-old Domecq, five years his junior, had reminded him of Goya's *Portrait of Doña Isabel de Porcel*, a painting depicting a dark-haired, pink-cheeked aristocrat with an alluring gaze. But it wasn't just this association with art that endowed Marina with a special halo. It was also her real-life associations with Juan Luis's idols. On their estate in Jerez, the Domecq family hosted the legendary bullfighter Antonio Ordóñez, and among his traveling retinue, like aged characters from *The Sun Also Rises*, were often Orson Welles and Ernest Hemingway. And the infatuation ran both ways: Marina loved art and literature, which made the cultured Juan Luis extremely attractive to her. But her father didn't approve of the seasoned bachelor his daughter had shacked up with. One day Juan Luis and Marina got drunk at his apartment and had an ugly fight. She called her father, who sent her brothers to the rescue. They arrived and gave Juan Luis a spirited beating. "They left the mark of the Domecq family ring on my face!" Juan Luis told an unamused Michi afterward.

Now, four years later, like melting effigies of that elopement in wintry New York, Juan Luis and Marina had become "ghosts in the snow," as he wrote. Their first year had been all love, sex, and adventure—a stylish fuck-you to her family, whose ring-bearing punches couldn't reach Juan Luis across the Atlantic. They traveled across the US, then continued south across the border, drinking mescal in Malcolm Lowry's Cuernavaca, then on to Mexico City, where Juan Luis laid violets and his first book of poetry on Luis Cernuda's grave. When the couple returned to Spain, Marina helped Juan Luis compile the first complete edition of his father's poetry for a state-run publishing imprint.

In their free time they traveled to bullfights, Juan Luis selling books and paintings he had inherited in order to afford so much death in the afternoon. During this time, he and Marina's passion faded. They both took lovers. As Juan Luis was quoted in the annulment papers Marina filed with the Catholic Church three years later, "The aureole of love was lost and liberty became licentiousness." Feeling suffocated by the apparent eternal life of Franco and his regime—the fall of the neighboring Salazar dictatorship in Portugal in the spring of 1974 had yielded no ripple effect in Spain, in spite of Franco's wavering health—Juan Luis convinced Marina to return to Mexico, where they had once been happy. Nine months later, the couple flew home to Spain with their relationship in tatters.

The last time Juan Luis and Marina would be together as a couple was for the first day of production of Chávarri's film, on August 28, 1974, during the unveiling ceremony of a statue of Leopoldo Panero in Astorga. The making of the documentary was intended to be simple, quick, and straightforward. It would be everything but that.

GAME OF MASKS

The Making of The Disenchantment *and the Death of Franco,*
August 1974 to November 1975

ere, in Astorga," Luis Rosales said in a sad, melodious voice, pausing as he addressed the multitude filling the square in front of the Episcopal Palace. "Remembering his parents, his siblings. Remembering his house, his yard, and the walls of his living origin. After speaking just a moment ago with the person he loved most in the world, his wife. And with his sons, who were for him the word of his silent depth. I feel that hole of helplessness that his death has left in me grow. I want to say a few words to keep talking about him. To talk again with him and again feel the rough, warm, and wide touch of the hands that on so many occasions opened"—his voice cracked—"the road for me in life. . . ."

Felicidad sat near the small platform where Luis Rosales stood, her face tilted toward him in an expression of mournful observance. To her left sat Michi and to her right Juan Luis, both in tie and jacket, both staring at the ground. To Juan Luis's right sat Marina, and beside her a line of Panero relatives. Hundreds of

attendees occupied several long rows of chairs, while a crowd of hundreds more lined the barricades circumscribing the ceremony. Other people looked on from upper-story windows of apartment buildings facing the square. Schoolchildren in *maragata* dress struck the proper note of tradition, as had a band that played while people took their seats before the proceedings commenced. The large statue, made by a local sculptor, waited to be unveiled beneath a Spanish flag. All of Astorga had come to commemorate the life of its deceased son, the poet Leopoldo Panero, and Felicidad and her two sons dutifully performed their assigned roles.

For now.

Jaime Chávarri and his crew filmed the ceremony. While he had no shooting plan to work from, his idea was to make a film about Leopoldo Panero through the memories of his widow and sons. The presentation of the statue in Astorga seemed like a natural place to begin, though something unnerved him about the massive stone sculpture. He had first encountered it earlier in the day, still wrapped in a plastic tarp. Without really knowing why, he had done a long tracking shot starting from close up and

From left to right: Marina Domecq, Juan Luis, Felicidad, and Michi

The statue of Leopoldo Panero before its unveiling

moving away, so that only after thirty seconds was it possible to make out what the hulking object was, which was when it acquired an irrefutable creepiness. The outline of a human form was clear, especially the head, but with the tarp enveloping it, the statue resembled a bagged cadaver, evoking the image of a dead man about to be thrown into a river. A fold of plastic fell directly over the sculpture's mouth, like a piece of tape silencing a hostage.

"This guy doesn't have the right to talk," Chávarri said forty years later, recalling the impression the image made on him. "He's there, but he's not going to say anything."

AFTER THE INAUGURATION OF THE STATUE, CHÁVARRI SPENT THREE DAYS FILMING Michi, Juan Luis, and Felicidad in the Panero family home in Astorga. With its nineteenth-century décor and furniture, the manse was like a time capsule, providing a mise-en-scène steeped in the past. The plan was for the Paneros to talk about their family history, both individually and together, while the camera rolled. There were, however, two conditions for the production, the first

a stipulation by Chávarri and the second by the Paneros. The first: None of the Paneros would know what the other family members said on camera in private until the film was done. The second: If any one of the Paneros objected to the finished product, each had full power to veto its release. In other words, Chávarri might make a revealing film that would end up languishing unseen in a canister.

Felicidad was the only member of the family who rehearsed what she was going to say before her sessions, and at first she only agreed to appear on camera alone. Having an unscripted conversation with Juan Luis or Michi seemed too unpredictable. Yet this did little to calm her nerves on the first day of the shoot. As Chávarri and the crew readied their equipment, Felicidad felt her heart thudding in her chest, then heard: "Silence, rolling!"

She started talking—nervously at first, then with confidence. As she unearthed memories, she disappeared into the past, soon forgetting the camera altogether.

She told the story of how she met Leopoldo after the war; she recited from memory the poem he wrote about her that occasioned their first fight; then she recalled the day of his death. In a singsong voice oozing with melancholy, carried by her innate talent for structuring life as a novel, Felicidad gave Chávarri the words that would open the film: "He died at seven in the evening in Castrillo de las Piedras one summer afternoon, luminous and clear, like so many others we had lived in other summers. The previous days we had been happy. Once again a rupture interrupted my life."

Juan Luis's sessions were less personal. He steered away from disclosures about himself. He refrained from casting the past as a kind of mythic paradise lost, the way Felicidad was wont to, and resisted his weakness for presenting himself as a character. Instead, he provided context about his father's poetry and career. He talked about Leopoldo's friendly relationship with

the Spanish exile community in London while he was posted there, a fact few people knew about the man now remembered for writing *Canto Personal*. Juan Luis was invested in rescuing his father's standing as a poet, even if their contentious relationship had evaded rescue. What frustrated him about making the film was that he couldn't make remarks critical of the regime under which his father had built and lost his reputation.

Michi, meanwhile, had his own agenda. Although he hung on the margins of the conversation in sessions with Juan Luis and Felicidad, when he was alone in front of Chávarri's lens he was a different person, the guy he was with his friends: voluble and self-assured, only with less wisecracking. Holding either a drink or a cigarette in shadowy nooks of the house, he became a pensive raconteur, a witness no longer willing to remain mute.

Much like his mother, out of the formless clay of the past Michi sculpted story lines, finessing them for heightened drama, except not in the navel-gazing style of Felicidad. He went beyond just his own memories and began assembling the tropes of a legend, the elements of a master narrative of the family for Chávarri, who understood the help that Michi was giving him. As Chávarri later admitted, "Without him the film doesn't function since he was the guiding hand behind it." Michi may have abandoned his writing, a choice that filled him with both relief and despair, but his storytelling instincts hadn't abandoned him. If anything, they had gotten stronger, and talking on camera he seemed to have found his medium. During this first shoot, Michi emerged as a narrator of sorts, and the best kind for telling a true story—a ruthless one, with no reservations. He was willing to smash taboos and make private matters public.

Michi explained how the force of his father's personality— his heavy drinking and geysers of anger—had blotted out the personhood of Felicidad. And he explained and perhaps exaggerated the rivalry that emerged between Juan Luis and

Leopoldo María after the death of Leopoldo Sr., bathing it in literary mythos and Freudian overtones.

Slouching against a wall while seated on a bench, he told of Juan Luis's attempt to take on the role of man of the house in lieu of their father. "It works for six or seven months," Michi said, his voice deep and composed like a dramaturge discussing his characters, "until Leopoldo truly becomes a would-be threat. Later time would show that he was just such a threat against the literary career of Juan Luis. Of course, two things fail in Juan Luis's primitive and perhaps unconscious approach. On the one hand, he's not the father, which is to say, the sons, we don't accept him as our father; the wife, who would be my mother, accepts him at the start. . . . But later, devoured by tremendous jealousy, she starts to distance herself from him, and his literary career . . . is successively frustrated by the performance of Leopoldo. . . . Leopoldo has triumphed as far as one can triumph in this country and Juan Luis, inevitably, not."

Then, as though he hadn't gone far enough, Michi commented on Leopoldo María's constancy in life and in literature as a segue to disparaging Juan Luis's suicide attempts as insincere, like they were a poem lacking in feeling. "They were very literary. I mean, I remember a few that were absolutely literary." Michi paused to lean forward and ash his cigarette dismissively. "Leopoldo, in his two serious suicide attempts, was in a coma for twenty-four hours the first time, and forty-eight the second. And by chance his life was saved."

Michi ashed his cigarette again, looking satisfied with his assessment.

As the shoot in Astorga wound to a close, Chávarri wasn't sure what his film might end up looking like. He knew that the story would have as its backbone the death of Leopoldo Panero and revolve around the hole he had left in the family. But that was all he knew. Nevertheless, he was pleased with the start.

"The Paneros move in front of the camera like fish in water," he wrote.

They were natural performers. Actors at life.

ON HIS RETURN TO MADRID, CHÁVARRI FINALLY MET LEOPOLDO MARÍA, WHO WAS BACK from a stint in London. Now twenty-six, the previous year he had published *Theory*, his second book, an esoteric descent into death and hate and an attempt to fulfill his mission of fighting "the revolution with the weapons of literature." The poems attacked the Enlightenment legacy of rational thought, while also seeming to excoriate Franco and the church. "I saw how murder was carried out in the *name* of God," he wrote, "I saw how villages were exterminated, entire races for not / adoring the image of the Beast, which wears the *name* of God." Leopoldo suggested that the hate that had divided Spain was a glue that involuntarily held people together, almost like familial obligation. "All perfection is in hate," he wrote, "and hate is all that joins me to you." His poetry was becoming a kind of "burned music," to borrow an apt description from one of his own verses, and the pages of *Theory* were—to steal another line—"a splendor of ashes."

Although some critics failed to appreciate the book, it fed Leopoldo's rising renown. When the Mexican poet Octavio Paz passed through Spain on a visit, he organized a dinner and asked to meet a handpicked selection of young Spanish poets, with a special interest in Leopoldo. Paz singled him out by inviting him onto the balcony of the apartment where the gathering was held to speak in private. With his provocateur's irreverence and characteristic fixation on certain phrases, after the dinner ended Leopoldo spent the rest of the night out at bars repeating, "Octavio Paz is stupid all the way from here to Tijuana." Now the Panero *enfant terrible* was back in Madrid,

and Chávarri wanted to lock in his participation in the short about his family.

During several afternoons the two got together at the filmmaker's apartment, where they drank and talked. Leopoldo was immersed in the work of the French psychoanalyst Jacques Lacan as well as Gilles Deleuze and Félix Guattari's *Anti-Oedipus: Capitalism and Schizophrenia*. The book's opening chapter had a line that seemed written just for Leopoldo: "A schizophrenic out for a walk is better a model [for how to maintain one's humanity in society] than a neurotic lying on the analyst's couch." The authors critiqued traditional psychoanalytic thinking and reframed insanity as a pure, revolutionary force. It became a Bible for Leopoldo, who spoke in a sticky patois of poetry and theory that left Chávarri awestruck by his intelligence. Between their conversations, Chávarri tried to read Lacan and *Anti-Oedipus* but couldn't make sense of them. He confessed this to Leopoldo, who let out his rumble of a laugh and pulled out a book he had with him. It was a study aid titled *Understanding Lacan*.

Chávarri may have gotten along with Leopoldo but getting him to participate in the film was another matter. In the end, the most he and Elías Querejeta could get Leopoldo to agree to was a shot of him in an overcoat and bell bottoms walking through the Loeches cemetery in Madrid, offering a searching gaze into the camera. The scene didn't fit with the rest of the footage of the Paneros, but by then Chávarri thought he had more than enough material for a short. In December, he started editing.

THAT SAME FALL OF 1974, SPAIN ENTERED THE LAST STAGE OF WHAT HISTORIANS would call *tardofranquismo*—the late Franco period—as though the dictator were a novelist whose body of work near the end of

his career took on a distinct style. His rule over the country was his life's opus, and as the *Caudillo*'s health continued to decline, one distinguishing characteristic defined his narrative: the inevitability of its dénouement paired with its stubborn refusal to reach the last page. Franco was close to dying but wouldn't actually die, and each shift in his health sent tremors through the country. As a result, a mood of volatile uncertainty hung over national life, and turmoil roiled the streets.

Trade unions across the country continued striking, refusing to be cowed by authorities. The Basque separatist terrorist group ETA intensified its activities and in the next year killed twenty-two military and police officials, along with fourteen civilians. The year before, ETA had bombed the car of Franco's longtime lieutenant, Luis Carrero Blanco, who had been appointed president of the government. The assassination weakened the power bloc determined to preserve Francoism without Franco. Competing plots twisted against one another as different characters tried to read the rising action: the politically ambiguous Prince Juan Carlos and his supporters; the young and old blood of the leftist opposition; the orthodox Francoists and nostalgic fascists; the virtuoso technocrat Manuel Fraga and his regime reformists; and Máxima Torbado's distant cousin Carmen Polo, Franco's wife, whose "bunker" faction didn't want to leave the Palace of El Pardo.

A welter of speculation filled the bars and living rooms of Spain. Would some form of democracy arrive after the *Caudillo*'s death, as much of the business community wanted? Would reactionary elements manage to extend the life of the Falangist *Movimiento*? Or would an entirely unforeseen outcome intervene? One thing was clear: something had to happen. A crescendoing historical tension had to be released. As the historian Javier Tusell wrote, the *apertura* reforms of the 1960s "had

engendered a society in which the regime itself now made no sense at all." The rest of the world watched and waited.

WHILE THE FUTURE HOVERED OVER SPAIN LIKE A PLOT CLIMAX ITS AUTHOR HAD YET to figure out, the Paneros went about their lives.

Michi was living with his current girlfriend, Inés Ortega, the granddaughter of the philosopher Ortega y Gasset. They spent time in Barcelona with the *Gauche Divine*, a group of young artists and intellectuals in Barcelona, while in Madrid they carried on a simulacrum of domestic bliss. In the mornings she made him fresh-squeezed orange juice before heading off to the university; after she left he dumped it out and made himself a gin and tonic, then met up with Javier Marías. During his military service, Michi had begun drinking alone in his apartment, and lately he had less and less control over this habit.

Juan Luis accepted that his marriage was over and finished a new book of poetry.

Felicidad freshened flowers in the lobby of the Palace of Congresses and Exhibitions.

Leopoldo hung out in clandestine gay bars. He would sometimes leave with *chaperos*, male prostitutes, and end up with black eyes and split lips when he couldn't pay them after the act. This violence was likely part of the draw for him. As a young woman who dated Leopoldo the following year explained, "Maneuvers to see his erotic fantasies realized (with a strong ingredient of masochism) determined the majority of his actions." Leopoldo wrote that the closest thing to the act of love was the act of murder, and for him love and hate were inseparable. In a sexually repressed society founded on repressive violence, perhaps it was natural to find release in violent sex—he was able to relive his police beatings, only this time with a dose of pleasure.

All the while, Chávarri worked on his rough cut, which he finished in December.

It was a mess. The film was longer than it was supposed to be, but that wasn't the problem. There was a patchwork of suggestive scenes and interesting testimonies, but glaring holes abounded, as if the edited footage was fragments of a longer film. So that was what Chávarri proposed to Querejeta when he showed him the cut soon after Spaniards ate twelve grapes at midnight, as is the tradition, to ring in the year 1975: that he keep filming the family to make a feature-length documentary.

Querejeta thought it was potentially a disastrous idea. He said yes.

IN MARCH, THE PRODUCTION RETURNED TO ASTORGA. LEOPOLDO HAD VANISHED AGAIN, but the other Paneros committed to spending weekends and free days on the sound stage of memory at the old Panero home, as well as at the family's country estate in Castrillo de las Piedras. Except for Leopoldo—he and Juan Luis refused to appear together—the family now agreed to be filmed talking with one another on camera. Whether they had discussed it between themselves or not in the intervening months, Michi, Juan Luis, and Felicidad had thought more about the film. It was a unique opportunity to reflect on their family in the middle of its story, and to use what they said to influence what was left to unfold. They were prepared to go further than they had during the previous shoot. They had defanged themselves then, but no more. If this was their chance to control their story, they would do so baring their teeth.

Winters in the province of León are long desolations of cold, with an ocean of gray sky rippling above, and that year was no different. While people in southern Spain were enjoying sunny temperatures in the low sixties and the first blossoms of spring, in Astorga the air skinned itself with a knifelike chill. Despite

the cold, one day Chávarri had Michi and Juan Luis sit down at a table out in the garden, where he captured a pivotal scene he would place near the start of the film.

Michi's hair had grown out now that he had completed his military service. Wearing a dark coat with upturned lapels, he was all boyish good looks and floppy curls, sitting straight up, the cockiness of being twenty-three mixed with his air of jaded combativeness. Juan Luis, now thirty-two, was an exercise in contrast. His receding hairline had left a tufted island of hair above a pool of forehead wrinkles, and he slouched back in his chair with a weary, vaguely trollish seniority, reinforced by a coat draped regally over his shoulders. Skeletons of bare trees swayed behind them in a gentle wind. They both had glasses of gin that were nearly empty and held cigarettes trailing smoke.

Michi led the conversation off with a question to Juan Luis about how he thought the documentary they were making would be different had their brother Leopoldo been more involved. When he said Leopoldo's name for the first time, Juan Luis made what is surely one of the strangest facial expressions ever captured on film. It occurred in four seamless stages: a sideways slide of the eyes, raised eyebrows below a laddering of forehead wrinkles, a pained grimace, and a labored inhalation. It seemed a combination of sincere and overdramatized distress, a caricature of horror and rage. It might have been interpreted as a joke if Juan Luis didn't then take Michi's bait with such alacrity.

They proceeded to argue loudly about which Leopoldo, and which events, defined the current state of their family: their father and his premature death or their brother and his tumultuous life. For Michi, it was their brother; for Juan Luis, their father. In essence, they were litigating what was worth forgetting in their family's history and what was worth remembering—and whose remembering won. Juan Luis recognized that their brother's travails had affected Michi more, but the loss of their father had

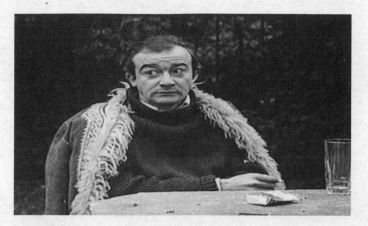

Juan Luis's facial expression in response to Michi mentioning
Leopoldo María

been shattering for him. With a cruel, self-pleasing grin Michi said that losing their father affected him—*financially*, that is, as if his father had never been more to him than a bank account, which was a lie. But this wasn't what Michi actually wanted to talk about. There was a new, deliciously fatalistic trope that he wanted to introduce into the story of the family.

"Listen, what I wanted to suggest to you is the following . . ." Michi said to Juan Luis. "I've participated very little in this whole story until three years ago, as you very well know. Yet, everything that I know about the past, the future, and, above all, the present of the Panero family is that it's the most sordid fucking thing I've ever seen in my life!" He gaveled his hand up and down wildly to stress every word while Juan Luis shed the coat from his shoulders, shaking his head. "It's a family of dolts," Michi went on, "from our aunts all the way back to our famous great-great-grandparents!"

"I don't agree at all," Juan Luis replied, making a swiping *no* gesture with his cigarette. "There has been a sordid part, as in all families, and another part that isn't."

As they argued, speaking almost unintelligibly fast, they became agitated to the point that the film looked like it had been

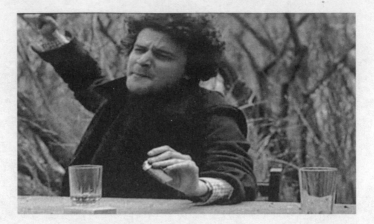

Michi arguing with Juan Luis out in the courtyard

ratcheted up to a higher speed. It was then that Michi unpock-
eted the provocation he'd been saving to drop in between him
and Juan Luis like a grenade: the likelihood that none of the
three Panero sons could have children. He was suggesting that
they were impotent. It seemed to be something that had already
been discussed. But Michi had a mythic coating with which to
layer this revelation. He wondered aloud if they might die out
like the family of Ludwig II, the Swan King of Bavaria from the
House of Wittelsbach, the historical personage and "dead com-
panion" that Felicidad had passed on to her three sons. What
if he repackaged the tale of King Ludwig II for the House of
Panero? Instead of history, it would be a prophecy.

"*Fin de raza*," Michi said. "End of the line. It's an Astorgan
end of the line." He and his two brothers would fail to procreate
and their family's sordid saga would end.

"No, no, no," Juan Luis said, shaking his head with such
fierceness that a Mach-force wind appeared to ripple the skin of
his face.

"We're not the Wittelsbachs outright," Michi rectified.
"That's clear."

"What the hell do I care?" Juan Luis said. "I could give a shit

about the Wittelsbachs! I'm not pretending to be Ludwig II of Bavaria, with these little trees."

"But you act like it!"

"But why the fuck am I going to act like the Wittelsbachs?" Juan Luis exploded.

"You *play* at being *el fin de raza*."

"Fine, sure."

"You play at *fin de raza*."

"Because we are the end of the line, that is clear."

"But why?" Michi said. "Maybe I'll suddenly knock up a girl."

"Well, do it, kid, do it." Juan Luis raised his hands toward heaven. "A miracle. Hell."

"Or you, which would be even more miraculous."

ALTHOUGH JUAN LUIS HAD LET UNFILTERED EMOTION SHOW THROUGH DURING HIS argument with Michi, he didn't let it happen again. For the Paneros, the film they were making was, as Chávarri realized, "a game of masks." Juan Luis had let his mask slip, nearly revealing his true face, so he went to work fixing it back in place. As had been his habit in the past, he constructed a character for himself. From then on, the persona he adopted—part fact, part fiction— was a confection of Iberian cad and literary dandy, pretentious and swaggering, equal parts macho bullfighter and Parisian flaneur.

During one filming session in a dark sitting room, Juan Luis sat at a table and enumerated a series of sentimental objects he said he always took with him when he traveled abroad, which he called his "fetishes." With a boozy pomposity seemingly designed to be unlikeable, he held up a Calatrava Cross, a switchblade he claimed had saved him on two occasions, the Parker pen his father had given him, and a Stetson that might have come from one of the Westerns he saw with Leopoldo as a boy.

"I love the sensation of the movie bad guy which infects it,"

Juan Luis said of the hat, as if instructing Chávarri on how he wanted to be portrayed in the film.

He held up a book by the Greek poet Constantine Cavafy and another by Jorge Luis Borges, which prompted him to slip into a parody of an Argentine accent. Between showing the camera small photos of Albert Camus and Luis Cernuda, he held up one of F. Scott Fitzgerald.

"Alcoholic, *as myself*," Juan Luis said with a ne'er-do-well's unctuous self-satisfaction, these last two words in English. (He meant *like myself*.) "With a horrible wife, *as myself*."

In another scene in the same room, Juan Luis read a poem he had written about his father. It was a searching inquiry into who Leopoldo Panero really was, but with his overwrought facial expressions, the recitation came off as showy self-aggrandizement.

"The issue of your drinking has generated much talk. . . ." Juan Luis read, "Your exploits in bordellos have been talked about and some of your friends tend to retell them adorning them with picturesque details (although it's very possible that it would amuse you to know this). As for the violent outbursts of your temper why mention what we all know. However, for History you are: an example of asceticism, loving father, old Christian, gentleman from Astorga, unforgettable spouse, paladin of the just. And also there's some truth in all of this. Without a doubt you were a strange and very curious guy. Red for some, friend of Vallejo, condemned in San Marcos, and blue for others, friend of Foxá, poet of Francoism, 'The disloyal pack of the Paneros, killers of nightingales,' as Neruda angrily wrote. And your end—fat and skeptical—with your English suits that you liked so much and whiskey in hand, working for an American company. And years later canonized in magazines and books . . . the Leopoldo Panero streets and the Leopoldo Panero plaques and the Leopoldo Panero prize and the Leopoldo Panero school . . . and finally this Leopoldo Panero statue. . . ."

In another solo session, Juan Luis explored his role as heir to Leopoldo Panero in a much less reverential way. While talking about how he and Felicidad began going out together after his father's death, he told the story of a meal the two had at a restaurant once. "The waiter was convinced that I was my mother's gigolo, and this got me very excited. . . ." Juan Luis said, donning a cretinous grin. "It aroused me, even sexually."

Whether this was true or not didn't matter. It was the saying of such a thing in Franco's Spain, as well as his impious comments about his father, that did. Moments like these left Chávarri and his crew astonished.

Juan Luis would claim that his aim was to make cinema while Chávarri, Querejeta, and his own family were intent on conducting psychoanalysis. "They wanted to make a Bergman film and me a John Ford one," he wrote. This tonal incongruence, as it turned out, would produce an intriguing friction in the finished film, a tip-off about the different narratives competing within the family.

Juan Luis's caricatured performance, however, wasn't the only positive, unforeseen development. The environs where Chávarri filmed the Paneros were becoming a character, too, providing striking images and a Gothic mood. The house in Astorga was like "the mansion of gloom" from Edgar Allan Poe's story "The Fall of the House of Usher," also a tale about the extinction of a bloodline with intimations of incest. Shadows filled the interiors like a dark liquid threatening to drown the Paneros, except for one day in the windowed front room on the second floor when sunlight filtered in around Felicidad like sparkling dust, making her look like an angel. At the Castrillo estate, which had fallen into disrepair, Chávarri captured her in an apocalyptic tableau of decay and ruin, walking among abandoned, collapsing structures. And just like Chávarri had intuited when he met Felicidad, she was willing to say things that most women of

her generation would never say aloud, let alone on camera. She might look like an angel, but she wasn't one.

It was one thing for Michi and Juan Luis to make scandalous remarks and slaughter sacred Spanish bulls. It was quite another for Felicidad to do so, even in her slyly subversive way, and she was happy to burn bridges.

Recalling Leopoldo's friendship with Luis Rosales, Felicidad described him as a claustrophobic presence she couldn't escape, just like his calling card of a cough. "Luis Rosales was the inseparable companion of our lives. . . ." she said. "He loved me a lot, I loved him less. . . . I would go to bed, fall asleep, and I would hear the voice of Luis Rosales in the distance. All in all, Luis Rosales was my entire life." And she was nearly as provocative as Juan Luis when talking about the intimate turn their relationship took after Leopoldo's passing.

"Juan Luis was like the substitution of your father," Felicidad said to Michi with a devilishly innocent twinkle. "My new husband . . . Me with that air of a widow that I had to adopt, sometimes sad, sometimes happier."

Although Felicidad would later adopt a posture of naïveté about such comments, she surely knew what she was doing: settling scores. She was full of decades of resentment about the role she had been consigned to as the wife of Leopoldo Panero. She was sick of feeling invisible, and sick of not having a forum to express herself beyond the handful of short stories she'd published. This was her opportunity to rectify that. Moreover, she didn't recognize the image of Leopoldo that his literary groundskeepers had enshrined: a tender Spanish father who *was* his poems about his wife and sons, about God and nature. She wanted to actually see her husband in his legacy. So as the weeks passed in Astorga and Chávarri probed her memories, Felicidad continued her rebellion—by being simply honest. By going from being the object of Leopoldo's poems

Felicidad looking through one of the dilapidated structures at
Castrillo de las Piedras

about her to the subject of her own story. She recalled her frustrations with Leopoldo and talked about the things she didn't like about him: his bad moods, how he ignored her, the way he dominated her life.

Juan Luis was right: Felicidad's performance fit the title of an Ingmar Bergman work—*Scenes from a Marriage.*

IN SPITE OF THE PRODUCTION'S PROGRESS, CHÁVARRI FEARED THAT HE WAS BARRELING toward failure. The ten-minute reels the cameras ran on caused cuts in the middle of interviews and the loss of valuable material, turning unrepeatable moments into useless fragments. On top of this, he questioned his own abilities. For example, he cut a take one day because Felicidad started crying and he felt bad. A truly great director, he thought, would have kept rolling. On another occasion, his nerves were so shot that he had to go to the bathroom to vomit. But it was the Paneros themselves who were the biggest obstacle, since they also thought he was failing.

Even as Michi helped him coax out the emerging narratives, he doubted that Chávarri had the necessary chops as a director,

and Felicidad and Juan Luis had similar doubts. Sometimes it felt like they were all working together as a team—Michi sometimes helped mediate disagreements, and he kept his aunts away from the house so they wouldn't hear what the family was saying on camera—but more often than not Chávarri clashed with the Paneros. At night, he and his crew drank heavily with Michi and Juan Luis, often ending the night insulting one another. Then Chávarri went back to his sorry hotel room, which had no hot water, and tried not to cry. In the morning, they would all be back on set, shivering and hungover, with no choice but to keep working. It was so cold in some of the rooms in the Panero house that their breaths came out as steam. Chávarri imagined holding a match up to these alcoholized clouds and watching them burst into flame.

"Chávarri suffers," Michi wrote, "and Mom enjoys."

Near the end of the shoot, the tensions between the Paneros and Chávarri boiled over. The enjoyment that had defined the family's attitude to the documentary at the start of the project had transformed into a sense of betrayal. They felt they had been pushed to say too much, to betray themselves, that they were being used. They refused to continue.

On the one hand, Chávarri understood how the Paneros felt. They *had* said too much, or at least more than they knew. He'd captured them making telling disclosures, contradicting themselves, and selling out confidences. He saw now that making a film about the Paneros wasn't learning the rules of their game of masks and catching them when the real faces showed. The Paneros *were* their masks. They were being themselves even when they were being actors playing the Paneros, just as they also played themselves off camera. It was a masterful ongoing performance that reflected something universal. Life itself was an unending performance in which every person played roles assigned by different contexts. This was especially true in a dicta-

torship. Leopoldo Panero himself had put on a mask during the Civil War and never managed to take it off again. Public norms remolded private beliefs, but what the other Paneros were doing was breaking down *the odious dichotomy between the public and the private*, as Leopoldo said of his experience in prison. If having to wear these masks was a prison, the family tried to transcend the confines of their cells by cannibalizing their lives into narrative. But even with their caricatures, embellishments, and carefully chosen themes, they were starting to suspect that this might come at a high price. Chávarri understood their discomfort, but they had all already come this far. They had to finish what they had begun.

Querejeta hightailed it to Astorga and convened Chávarri and the Paneros at a café. They argued bitterly, hurling abuse. When they had said all there was to say, each stormed out. Nothing had been resolved. Yet as if by some power beyond their control, the next morning they all showed up ready to shoot.

"It didn't matter what we might say or feel," Chávarri said. "The project moved onward."

Soon after, they concluded the shoot in Astorga. Back in Madrid, Chávarri tried to imagine how he would stitch all of the footage into a film. He had no idea. But if he did somehow manage to turn the many hours of the Paneros into a watchable piece of cinema, he thought he had hit on the title, taken from a song by Chicho Sánchez Ferlosio, with the line: *Oh! What disenchantment if the wind were to erase what I sing!* Chávarri had used the lyrics to spark thoughts in Michi in one of their sessions, and Michi had said, "I think one thing is evident, that to be unhappy"—or disenchanted, *desencantado*—"you have to have once been happy. And I'm quite sure that I don't remember more than four or five very fragile and very fleeting moments in my life of having been, let's say, happy"—*encantado*, enchanted.

That was it—*El Desencanto.*
The Disenchantment.

WHILE THE PANEROS HAD BEEN IMMERSED IN THEIR FAMILY'S PAST THAT SPRING IN Astorga, the future was closing in on the rest of Spain. By the summer of 1975, the Franco regime, which had existed for thirty-six years, was in free fall.

Infighting, ministerial resignations, and a lack of any coherent political mission paralyzed the government. Likewise, the different families of the regime were unable to come together to prepare for a Spain after Franco, who was too enfeebled to intervene in the proliferating problems. His once iron grip had weakened definitively, as had his ability to fully comprehend events. Objectively, Franco's situation was entirely banal: He was simply an old man coming to the end of his life. Except that he was an old man whose death would affect the lives of thirty-five million people—and who could still take lives.

In September, in another defiant gesture of violence, the regime sentenced two members of ETA and three members of a revolutionary Marxist group to death. Ignoring pleas from the pope, Prince Juan Carlos, dozens of nations, and all of his own bishops, Franco refused to grant the men pardons. They were shot at daybreak. In response, protesters gathered outside Spanish embassies around the world. In Portugal, which was in the midst of a transition to democracy, demonstrators sacked a Spanish consulate and burned its contents in the street.

A few days later, Franco appeared for the last time in public, in Madrid's Plaza de Oriente, his longtime arena for pageantry and propaganda. The weather was gusty and cold. Wearing sunglasses and a uniform, he addressed a crowd of thousands, many of whom had been bused in to attend. He had become a withered casing of the triumphant general who'd once stood in

this same place. Yet his message hadn't changed. Surrounded by military men and politicians, with his wife and Prince Carlos by him, he told the sea of admirers that Spain still was under siege by Freemasons and communists, then ended his speech in tears.

The exposure to the cold left Franco ill, and two weeks later he suffered a heart attack. With a soldier's sense of duty, the next week he found the vigor to work in his office and lead a cabinet meeting, but his discipline couldn't save his failing body. He suffered another heart attack, followed by internal hemorrhaging. Franco might die any day and the whole nation knew it. History seemed held in a state of suspended animation, poised on the cusp of change, yet like Franco himself, refusing to submit.

Shortly before Franco's final address at the Oriente Palace, Leopoldo María reappeared in Madrid after a Dexedrine bender in Paris. Chávarri tracked him down, then Querejeta convinced him to let them film two sessions with him. Juan Luis had left for Latin America again, so there would be no pressure for the two brothers to be interviewed together. For the location of the shoots, Leopoldo chose his former school, the Liceo Italiano, to converse with his mother and Michi, and an old-style tavern to hold forth alone. Chávarri had spent his summer organizing the Astorga footage, while two other directors Querejeta worked with, Carlos Saura and Ricardo Franco, were off working on more auspicious productions that would win prizes at Cannes. Chávarri still didn't know whether he was succeeding or failing. If his documentary was a kind of family chorus in which the father had been silenced, he hoped that Leopoldo María was the missing voice.

Leopoldo didn't disappoint. During the session at the tavern, he spoke frankly about his life during the past several years: his arrests and suicide attempts, his time in prisons and mental hospitals, and of course his family. His face had a clammy pallor and there was a haunted pain around his eyes, but he was confident on camera. He told of his misfortunes with a humorous sense of

the absurd, like when he had tried to hang himself in prison but his improvised noose broke, tossing him onto the floor.

"I think I've been the scapegoat of the whole family, no?" Leopoldo said in a gurgly, deep voice, staring at the floor. "They've turned me into the symbol of all that they most detest in themselves. But it *was* inside them. And maybe more than in me."

Whether this was true or not, like Michi's invocation of Ludwig II to prophesize the end of the bloodline, it made for a potent narrative. Like Juan Luis, Leopoldo discussed an attraction to Felicidad, but instead of just flirting with the idea of incest he jumped right into bed with it. Shockingly, as he gave his Oedipal formulation, he nearly had a Freudian slip into an even more incendiary taboo—an attraction to his father.

"Maybe a schizophrenic person lacks an Oedipus complex. . . ." Leopoldo said. "What I would like to do is sleep with my fa—with my mother, which is the negation of Oedipus, because Oedipus is the repression of precisely what I plainly and consciously desire."

Leopoldo María also gave his summation of what he thought had happened after the death of Leopoldo: "Each one of us wanted to occupy the place of our father."

The day was a triumph for Chávarri. He had gotten striking new testimony from Leopoldo to contrast with the rest of his family. But the shoot at the Liceo was what brought the film together. Leopoldo's performance would leave Chávarri and his crew speechless.

"I THINK I'VE ENDED UP IN THE MOST ABSOLUTE FAILURE," LEOPOLDO SAID, SITTING on a bench in the sun-splashed patio of the school, next to Felicidad and Michi. Michi was quieter and more timid than ever before on camera, dwarfed by the presence of his older brother, as if he'd been displaced as narrator.

Leopoldo was responding to a reminiscence Felicidad had just shared about the priest at the Liceo who had said that he might turn out to be everything or nothing.

"The thing is," Leopoldo said, "I consider failure to be the most resplendent victory."

"I kind of think that, too," Felicidad replied with disarming directness.

She was guiding the conversation with her two sons from an outline she had showed them beforehand—or *trying* to guide it. Leopoldo kept using her fond recollections to launch the epigrammatic Molotov cocktails he was so talented at constructing, like the one that came next when he described school as "a penal institution in which they teach us how to forget childhood." No matter. Felicidad steered onward into her plan, and Leopoldo allowed the three of them to discuss memories she brought up, proof that her sons hadn't in fact forgotten their childhoods. Then she made the mistake of asking Leopoldo what he thought of that past now that it was so far away.

"I would say," he replied, "that in childhood we thrive and after that we survive."

Then Leopoldo went on the offensive.

*Leopoldo María, Felicidad, and Michi in the Liceo Italiano filming
a legendary scene*

The next few minutes would become legendary in Spanish cinema, for their sincerity in a time in which sincerity did not exist in public view, putting the lie to the sacred institution of family.

"There are two stories that can be told," Leopoldo began, avoiding the gaze of his mother. "One is the epic legend, as Lacan calls one's own exploits, and the other is *the truth*. The legend of our family that I imagine was told in this film is likely lovely, romantic, and weepy. But the truth is it's a very, well, depressing experience. Beginning with a brutal father and continuing with your cowardice."

He reminded Felicidad of how she had responded to his suicide attempts. "In order to avoid trying to understand the reasons that led me there, instead of, I don't know, asking me to explain and trying to remedy the situation that had occurred, you decided to put me in a mental asylum where I had a very hard time. This is the other face of the legend."

What Leopoldo didn't know was that the story of their family that they had been making with Chávarri wasn't lovely, romantic, or weepy. It was nearly as messy and unfiltered as Leopoldo himself. Before Chávarri's amazed eyes, he unwittingly provided the narrative climax to a year of seemingly formless opinions, anecdotes, and arguments. He was doing what Felicidad herself had done: settle old accounts, except this one was with her.

"But I also think," Felicidad said, "it's very difficult to find—"

"There are explanations for everything," Leopoldo shot back. "Evidently."

"But can one talk?"

"There are justifications for everything, including for murder." Leopoldo seemed to be reprising the verse from his recent book in relation to his mother: *All perfection is in hate and hate is all that joins me to you.*

The two began arguing about whether another mother from

Felicidad's generation would have handled Leopoldo's problems better. At which point Michi, until now very quiet, the son who adored the mother he was so similar to and who had pushed for this film to be made so that she could finally come out from behind his dead father's long shadow, did something startling. He switched sides.

Michi seconded his brother's accusation of Felicidad's bad parenting. She was cornered—but refused to surrender.

"The feeling of weakness a woman experiences when she's dealing with her sons is totally different if there's a father," Felicidad said. The past twelve years for the family, she knew, would have been different if Leopoldo hadn't died. Perhaps they would have been even worse, but maybe not. Could his rule over their family, even his explosions of rage, have been what they had needed? At all events, at least she wouldn't have been alone as a parent in the unheeding era her sons had come of age in, which her life hadn't prepared her for.

Felicidad's hands and eyelids trembled with anger.

She tried to lighten the tone and asked Leopoldo if her mishandling of her responsibilities as a mother had truly ruined his youth. Hadn't he had a few loves?

"It's very hard in an asylum." Leopoldo paused. "Well, I can tell you that I did have a few, because in the one in Reus the retards sucked me off for packs of cigarettes."

Silence.

This line would be the only one that didn't make it past the censors and Chávarri believed it was the Franco dictatorship's last expurgation from a film.

"But don't you think I've changed?" Felicidad said, after more recriminations.

"Well, look," Leopoldo said. "I think that your layer of understanding is a layer of understanding that is absolutely superficial and there is nothing beyond that."

"Are you sure about that?"

"Fine, lately you're a bit better, let it be said."

Leopoldo smiled and it seemed that he had finally exhausted his vendetta.

"The odd thing," he said, "is that what has happened now is that as a result of the fortunate death of our father, among us, in our family, a sense of humor started to emerge. I don't know, to deal with things with humor, with more happiness . . ."

"Well, at least there was more sincerity in the family," Felicidad said.

"No, there's never been sincerity."

Michi watched his mother and his brother in silence. No narrator was needed. If the Paneros were still wearing masks, they had become transparent. What they had said and done on camera over the past year took gross exhibitionism, but also courage.

"No," Felicidad admitted. "Not very much. But now, at least things are clearer."

THE DETAILS OF FRANCO'S HEALTH, HOWEVER, WEREN'T.

In early November, ABC News in the United States wrongly reported that the dictator had died, then retracted its mistake. This only heightened the anticipation. News outlets all over the world covered his impending demise in a protracted deathwatch. This prompted a recurring sketch on *Saturday Night Live* in which Chevy Chase, the news anchor of the show's "Weekend Update," satirized the momentous event which eluded the press. "This breaking news just in," Chase said one week, "Generalísimo Francisco Franco is still dead." Another week he said, "Generalísimo Francisco Franco is still valiantly holding on in his fight to remain dead."

In Spain, of course, such a joke held little comedic value. Franco's death would be a tragedy for some and a cause for celebration for others, but all Spaniards could agree that his end would usher in an unpredictable power struggle, most likely accompanied by social strife. During Spain's long history, when leaders fought for control, their subjects often died. Yet for the soldierly Franco, dying itself wasn't an easy task, as if it were the one order he couldn't obey. "How hard it is to die," he was heard mumbling in bed.

After Franco's intestinal hemorrhaging worsened, blood soaked his sheets and even the carpet of his room. He survived an emergency surgery, only to have his kidneys fail and uremia set in, requiring more surgery. From November 5 onward, he was kept alive by life support machines. His retinue at El Pardo, which sought to hold on to power in spite of Prince Juan Carlos's imminent ascension to the throne, hoped that Franco would live until the end of the month. If he did, then the dictator might regain consciousness for a meeting in which he could influence the soon-to-be king's choice of cabinet president.

As Franco lay dying, Jaime Chávarri locked himself away in the editing room of Querejeta's production office. With the editor José Salcedo—who would go on to work with Pedro Almodóvar—Chávarri tried to find a coherent way of organizing the nearly seven hours of footage he had amassed. He worked by intuition, unsure exactly what he was doing. He watched the reels again and again, throwing out whole days of shooting. He had seen the American documentary *Grey Gardens* that year at Cannes and let its influence filter into his sewing together of fragments. To separate himself from his material, Chávarri imagined the Paneros as fictional characters whom he didn't know personally. He needed to undermine their agency in the making of the documentary and finally assert himself as the guiding hand. "I try to rescue them

as human beings instead of storytellers and let myself become the teller of their story." If a seepage was taking place between what was happening in Spain at that moment—the father of a nation dying with heirs angling to replace him—and what was happening in the editing room—the creation of a film about a family with a dead father whose place the sons had fought to occupy—Chávarri wasn't aware of it. He just wanted to finish.

On the morning of November 20, Carlos Arias Navarro, the president of the government, appeared on television to address the Spanish people. In a quavering voice he delivered the momentous news: "Franco has died."

That night, while the country quietly took this in, some families uncorking bottles of champagne in private while others mourned, Juan Luis met Elías Querejeta out for dinner. He drank so much that Querejeta had to pick him up off the floor.

For two days Franco's body lay in the Oriente Palace with a mile-long line of mourners waiting to pay their respects. Nearly half a million Spaniards entered to look upon the prostrate, uniformed body of the man who had shaped national life for nearly forty years. Across the country people wore black armbands as symbols of mourning. Meanwhile, Spanish exiles scattered from distant Chile to adjacent France celebrated. On November 23, Franco was laid to rest in a tomb at the Valley of the Fallen.

SOON AFTER, CHÁVARRI AND QUEREJETA HELD A PRIVATE SCREENING OF THE FINISHED film for the Paneros. It was ninety-one minutes. The family still had final say over what would happen to it.

After watching the film, the Paneros discussed it. Felicidad disapproved of a lie Michi had told about alcoholism running in her side of the family and she didn't like the woman she saw up on the screen who played Felicidad Blanc. "Dissatisfaction," she

wrote, "the sense of still not having found myself." She also worried about the ways people would attack her sons for what they had said. But her sons, especially Leopoldo, convinced her that the film was done and deserved to be shown. They had told their story—or one version of it—and now it was time to let it speak for itself.

Unbeknownst to the Panero family, the release of *The Disenchantment* would dramatically reshape their legacy at the same time that Spain itself underwent dramatic changes. The country's transformation would become inseparable from their own.

TAXI

The Premiere, September 1976

*He died
riddled by the kisses of his sons,
absolved by the sweetest blue eyes
and with a heart more at peace than on other days,
the poet Leopoldo Panero,
who was born in the city of Astorga
and grew up under the silence of an evergreen.
Who loved greatly.
drank greatly and now,
eyes blindfolded,
awaits the resurrection of the flesh
here, beneath this stone.*

The house lights came up. The film had ended with the epitaph Leopoldo Panero wrote for himself near the end of his life, followed by the haunting image that had opened the documentary: the statue of him mummified in the plastic tarp, like an ancient pharaoh preserved for the afterlife. Riddled by

gestures quite other than kisses, and far from absolved, the poet Leopoldo Panero had once again been resurrected.

It was September 17, 1976. *The Disenchantment* had just premiered.

Luis Rosales stood up from his seat. It was a Friday night and the Palace e Infants theater, in the basement of the elegant Palace Hotel, was packed with the flora and fauna of the city's cultural in crowd—*all of Madrid*, as people later described the audience that night. Other friends of Leopoldo's had abandoned the long, narrow theater in outrage during the film, but Rosales had stayed. People watched the agitated older man. What they had all just witnessed had been like a ritual sacrifice, both cruel and exhilarating. Somehow Luis Rosales had lasted until the end.

"Taxi," he said, as if hoping one would appear right there in the theater.

On one side of him sat his wife, the person whom he was speaking to. On the other side sat his Judas—Felicidad Blanc.

"Taxi," he said again.

Rosales had just watched his best friend get disemboweled on camera *by his own wife and children*. And he had unwittingly been party to it by appearing in the film. How had this happened?

He and his wife hustled out of the row and into the aisle.

According to a friend sitting near Felicidad at the premiere, she had stared up at the movie screen like a Greek statue during the scenes in which she complained about Rosales, motionless and enthralled, like there was nothing for her to feel the least bit uncomfortable about. Now she turned and watched Rosales go.

"But Luis," she called after him, "why are you leaving?"

The audience began filtering down the aisles and out of the theater. Whether they had loved or hated the film, everyone knew that they had just seen something remarkable. It had left the charged mood of a generational event. It wasn't just Jaime

Chávarri's documentary that was an indisputable work of art. It was the Paneros themselves.

OUT IN THE LOBBY OF THE PALACE, *ALL OF MADRID* DRANK AND SMOKED AND argued. Some people thought *The Disenchantment* was a masterpiece. Others thought it was a scandal.

The Paneros took in the first shock waves of what they had done. What had begun as an experiment with Chávarri, then grew into a turbulent collaboration, was now a thing out in the world. It was *of* them but didn't belong *to* them. They could no longer control it any more than Felicidad could control her three grown-up sons, who had at least agreed to show their faces at the premiere. For many people there that night it would be the first and last time they saw Michi, Juan Luis, Leopoldo, and their mother together in one place.

For Felicidad, the night was a cathartic release, the culmination of her vanity and the discharge of her bitterness. Listening to the reactions of the audience, she no longer felt any compunction about the film or how she came off. Her yearning to be more than just the wife of the poet Leopoldo Panero had finally been satisfied. Thanks to the splendid performance she had given, she would never again feel erased by him. This was the story she had been meant to write. "To feel that at last I had broken with what had tied me to a society that no longer interested me," she wrote. "To be me, myself."

Michi drank in the attention as if life itself were a great, cold gin and tonic. He had managed to escape the literary rivalries of his family yet still indirectly authored an indisputably literary work—with little of the creative toil. His friends who had come to the premiere loved his performance. If he had ever truly been happy as an epilogue to the story of his brothers—which appeared an insincere claim—Michi seemed much happier as

part of the main plot line of the family. He was no longer just a witness, and for this brief moment all the Paneros were on the same speeding train. As his now ex-girlfriend Inés Ortega aptly put it, "Michi was enchanted" at *The Disenchantment*'s premiere.

Leopoldo had left the theater a few minutes into the film to go outside and smoke. He had seen it once and had no interest in seeing it again. As he returned to the theater and walked across the lobby with his odd hunch and meandering gait, it was clear that what he'd said on camera had stirred people. He liked playing the star, but the novelty of a film about his family opening that night paled in comparison with a grander novelty in his life. He had recently fallen in love with a young Spanish woman named Mercedes Blanco who was studying in Paris, and she reciprocated his feelings, if not quite their intensity. She thought he was handsome and was attracted to his brilliance, even when it frayed into delirious rambling. Leopoldo had become devouringly obsessed with her, and she inspired him to write his first adult love poem. (Naturally, it involved death, a cadaver, and destruction.) They had just gotten back from a trip to Morocco and would see each other again soon. He left the Palace after a little while and went off to hit bars.

Juan Luis had also skipped the premiere. He'd given his ticket to a friend and hadn't entered the theater until now. He didn't identify with the character he had played and it was too bizarre of an experience watching himself; or rather, he didn't *fully* identify with the character. He knew that in life he donned a mask of similar snobbish smugness. But he could tell that the spectators had paid little attention to the things he actually cared about that had made it into the film. The public was more interested in his eccentric persona. He knew that he and his mother and his brothers would pay a price for airing a lifetime of dirty laundry. He didn't really care. Yet as he stood in the lobby taking in the scene, he didn't anticipate the immediate fallout either.

Juan Luis spotted Luis Rosales crossing the lobby with his wife and went to greet them. He called hello and held out his hand. Rosales steered past Juan Luis without making eye contact, leaving the Palace to find what he most needed at that moment—a taxi home.

Later, while Michi and Leopoldo were out elsewhere in the insomniac Madrid night, Juan Luis and Felicidad retreated to a quiet café and speculated about what was to come next.

The conversion of the Panero family into a cultural phenomenon had begun.

AUCTION OF MEMORIES

The Disenchantment *and the Transition to Democracy, 1976–1978*

The first reviews were not kind.

"The Paneros made a scandal of a movie . . ." declared the writer Francisco Umbral, who had been friendly with Leopoldo, "which Chávarri filmed, in which they sell out their intimacy, making an auction out of privacies and memories . . . because they had nothing else to sell, to keep freeloading and drinking. . . . The whole thing is a bit disgusting.

"It is the only murder of a father that has ever been filmed and Freud would have loved to watch it."

Reviews less personal than this one were nevertheless very critical of the Panero family and their alleged enabler, Chávarri. One critic treated *The Disenchantment* as though it were a horror movie, labeling it "a hair-raising settling of scores with a dead man." Another made it sound like a scene from the outbreak of the Civil War: "A summary execution of a prisoner with no voice or vote." The merits of the film as a work of art were obscured by the taboos it violated and passions it aroused.

The Disenchantment was an assault on the bedrock of Spanish life: family. It was akin to the cinematic equivalent of Luis Cernuda's poem "La Familia," which had so outraged Leopoldo Panero in London, surely never imagining that his family would one day make Cernuda's poem seem like tame, kittenish clawing at the facade of the Family. As one scholarly assessment later put it, "Possibly without intending to, the Paneros, so exhibitionist and loquacious, so obsessed with their own lineage, turned out to be a microcosm of the whole country and a precocious symbol of the necessity, the inevitable frustration, of an urgent national psychoanalysis." They hadn't just substituted the *epic legend* of their own family, as Leopoldo María aimed to do, for *the truth*. Many viewers felt they had tried do the same for Spain as a whole, for every family, except that they believed the Paneros' version of the truth was a lie and profane betrayal.

What the Paneros had done was undoubtedly a personal betrayal of their deceased patriarch, who couldn't defend himself, though the degree of bad faith was debatable. But was it a *societal* betrayal? How you felt about traditional Spanish values seemed to determine how you felt about *The Disenchantment*.

The uproar surrounding the film was so contentious because *The Disenchantment* also had a resonance that went beyond even the institution of family. It seemed to attack the political idea of the *national* family and thus commit another symbolic patricide and deconstruct another epic legend: Franco and Francoism. And it did so at the most fragile moment in modern Spanish history, during *La Transición Española*—the transition to democracy.

IN NOVEMBER OF THE PREVIOUS YEAR, TWO DAYS AFTER FRANCO'S DEATH, THE coronation of Juan Carlos had taken place beneath the Gothic spires of the Church of San Jerónimo el Real in Madrid.

Over the course of many years of patience, discretion, and dynastic chess, the young monarch had maneuvered himself into Franco's grudging confidence. Franco had appointed the thirty-seven-year-old heir to the House of Bourbon as his successor because he believed that even if he wasn't the perfect choice, he was the best hope to guard his legacy. But in the wake of the dictator's death, it wasn't clear if Spain's new king would be an active force for change or an impediment to it. He was the official heir to Francoism, which suggested he might be an arbiter of continuity and establish an absolute monarchy. Yet he also might push for a limited form of democracy, or even flirt with outright democracy. In his coronation speech, Juan Carlos had praised Franco for his fortitude and service to the country, and promised to remain loyal to the church, and to the army which he now commanded. In the same speech, however, he also expressed a commitment to create a more just Spain, improve the system of government, and listen to all Spaniards, the majority of whom wanted greater freedom. By the mid-1970s, for instance, more than half of the population believed in the right to form trade unions and political parties; three quarters believed in freedom of the press and religion. The country had changed even though Franco never did. People didn't want a patria founded on dividing society into victors and vanquished. They wanted reform and reconciliation. Above all, they longed for *convivencia*, to live together peacefully. No one wanted another civil war.

During his first months on the throne, Juan Carlos appeared to be in thrall to the torchbearers of Franco's legacy. He allowed the president of the government, Carlos Arias Navarro, to remain in this post. But out of sight of the public in his office in the Zarzuela Palace, and out of earshot of the competing political families of the regime, the king began plotting a transition to democracy. He hoped to honor the sentiments of his coronation speech and create a more just Spain and in so doing fortify

the monarchy's place in it. He wasn't a selfless hero; he was a shrewd aligner of his interests with those of Spain's progress. He didn't want to see history repeat itself for his family. In 1931, his grandfather, King Alfonso XIII, had been washed out of Spain by the popular tide that led to the founding of the Second Republic because he had supported the dictatorship of Primo de Rivera. Juan Carlos saw that the best chance he had of coming through the current transition period was by doing what his grandfather had failed to do: coax a parliamentary democracy back into existence. But pulling democracy out of the sleeve of a crumbling authoritarian regime was a magic trick few countries could pull off.

The Francoist system might be horrible, broken, and authoritarian, but it rested on a legal doctrine. This meant that alterations to the system had to come from within, via legislation and political consensus in a very tense environment. Any other route to a future resembling democracy would be the opposite of democracy: transformation by force, which had been the norm in Spain's long and cyclical history of overthrows and wars. Somehow the system Franco had left behind had to agree to destroy itself.

The king began this process in the summer of 1976 by forcing out Arias Navarro. Juan Carlos's popularity was at an all-time high and he'd strengthened his relationships with key ministers, so he faced little resistance. In parallel, orthodox Francoist holdovers were revealing themselves to be dinosaurs unequal to the delicate tasks of reform. After cornering Arias into resigning, Juan Carlos then used his powers as Head of State to have his preferred candidate named prime minister: Adolfo Suárez.

There are few cases in history of a leader so impeccably mapping himself onto a moment and not only meeting his potential but vastly exceeding it. A lifelong creature of the regime, the forty-three-year-old Suárez turned out to be the ideal person

to dismantle it. This was especially remarkable considering the low expectations he aroused across the political spectrum, as if the key to his success in transforming Spain was that no one suspected he was the man who would do so.

Francoists considered Suárez an unsophisticated nonentity whose only assets were his sycophantic charm and titanic ambition. The leftist opposition thought he was rotten fruit left over from the dictatorship, Franco with a face-lift, and that he would pose obstacles to *ruptura*—a hard break from Francoism. Over his long career inside the byzantine apparatus of the regime, Suárez had risen steadily, finally wiggling himself into the role of chief of the National Television, then secretary general of the Falange *Movimiento*. He seemed like a stalwart traditionalist. Yet reading the political tarot cards, he had cultivated a relationship with Juan Carlos, who recognized Suárez for what he was: a liquid that fit the form of its container.

Suárez wasn't chained to ideology. He was attached only to the pursuit of power. He was a finesser of influence and a servant of anyone who might give him more of it, which made him loyal to the king and his vision of the future, rather than to his own past. With reptilian good looks and a raconteur's charisma, he had an irresistible ability to please, a tennis champion's sense of timing, and a canny adaptability. Suárez was only too happy to play the prince of democracy. He had no nostalgia about the past.

In retrospect, it would seem ironic that the anti-Francoist opposition looked darkly upon Suárez's elevation to prime minister in July 1976. He wasted no time in opening dialogues with leaders from the still-marginalized left and even spurred them to become more politically active. At the same time, however, the two-timing Suárez soothed Francoist ministers and military officers by promising that the changes on the horizon would never jeopardize the values of the Spain they had dedicated their lives

to defending. The fratricidal enmities that had unleashed the Civil War were still vivid memories, and each side needed to be seduced into engaging with the other. Although the hard-liners would come to feel bitterly betrayed by Suárez, most of all when he legalized the Spanish Communist Party in the spring, this soothing massage campaign bought him permission to make an irreversible leap toward democracy: the Law for Political Reform.

Passed the same month that *The Disenchantment* premiered, the law set up free elections for the summer of 1977 to elect a new government. At first, for different reasons, both the far right and far left opposed the law. By trying to please everyone, Suárez failed to completely please anyone. But he squeaked it through the Cortes Generales, a legislative body left over by Francoism, which would be replaced by a Congress and Senate the following year. Emerging from the political apathy that nearly four decades without democratic institutions had saddled them with, the Spanish people approved the law in a national referendum at the end of the year. The new parliament would be tasked with drafting a constitution.

Emboldened by this win, Suárez used his increased political capital to light out on a daring spree of reforms at a velocity as disorienting as it was effective. In addition to legalizing the Spanish Communist Party, he legalized the Basque flag and the Catalan language, eliminated the single-party Falange *Movimiento*, and abolished the Fundamental Laws of the dictatorship—all with the buy-in of the majority of the government, leaving his foes such as the military too discombobulated to stop him.

All of a sudden, Franco's legacy was unraveling. The political children of the dictatorship were rewriting the family story, and like Leopoldo Panero, the dead father was powerless to stop it.

It was into these rocky waters of loyalties and betrayals, heirs and contentious inheritances, of father figures shaping fates and

a political tradition that had reached *the end of the line*, that the Paneros did a wild cannonball into the Spanish psyche with *The Disenchantment*, making a splash in a milieu that seemed designed for maximum effect. The film they had made while Franco was still alive took on much greater power now that he was dead.

AFTER ITS PREMIERE, MORE AND MORE PEOPLE BEGAN TO "READ" *THE DISEN-chantment* as a metaphor. Increasingly, viewers saw the deceased patriarch of the Panero family as a stand-in for Franco.

Leopoldo Panero's career had been intimately tied to the dictatorship. Of late, he was often referred to as "the poet laureate of the regime." This was an error—Franco had no *poeta oficial*—but he had sung the song of God and Family and Country in his verses, and he'd voiced fascist sentiments. The government had rewarded him for his service with awards and prestige and paid his salary for nearly two decades. Not just in his poetry but in his life Leopoldo had embodied traditional Spanish values. Of course, he had always hoped to see his country's wounds healed and over the years worked for reconciliation between the two literary Spains. But in the brave new world of the Transition, during which a reconciliation of some sort might actually be brokered, these nuances disappeared beneath the ugly and beautiful glow of *The Disenchantment*. Thanks to the story his family had told, Leopoldo was transformed into a figure dripping with symbolism.

Yet timing wasn't only to blame. The Paneros were a product of *el Franquismo*. Their family, however unique and peculiar, did speak to widely shared experiences under the dictatorship. Their polished epic legend resembled that of millions of households, as did the unvarnished truth hiding beneath. Domineering fathers and resentfully submissive mothers, rebellious children

and uncomprehending parents, public facades and private realities, love and hate, and untold losses left by a war that bent the narrative arc of life. The intimate, specifically Spanish pain of humanity's most primal institution and prolific furnace of myths—family.

The Disenchantment began to pick up admiring reviews. Some critics claimed it was an instant classic. A moral and psychological striptease, one wrote. Others believed it was Spain's first truly significant contribution to world cinema. Jaime Chávarri was thrilled if bewildered. It looked like working with the Paneros had been the right move after all. He hadn't intended his film to be a metaphor for the Franco dictatorship, though he'd had a vague intuition that the two were related. He had always been fascinated with family as the primal incubator of power struggles. "It's the first nucleus where individual rebellion has to emerge," he said. Yet his experience of making the film had been defined by his power struggles with the Panero family itself and their rebellions. Adolfo Suárez's democratic one came later.

Elías Querejeta hadn't expected anyone outside of Spain's narrow cultural demimonde would want to see *The Disenchantment*. Now it was filling theaters across the country. In Barcelona it ran for over a year. The Paneros became celebrities. They weren't movie-star famous—they were too painfully real for that—but they were a *succès de scandale*, animals of a controversy. Their story tapped into Spain's story, and yet they were also Martians. For friends of the family, like Javier Marías, watching *The Disenchantment* was like being back in the Paneros' living room, perhaps even a little tamer. But for the rest of Spain, the family's cultured hauteur, blazing phrases, and literary obsessions were fascinatingly alien. Felicidad, Juan Luis, Leopoldo María, Michi, and absent Leopoldo's need to redeem life with stories and poems about life had culminated in a national epiphany about the past and a preface to an unknown future. They had

been both the authors and the characters of this moment, but now the story had grown bigger than just their family.

Fame meant something different for each member of the family. When Juan Luis went out to restaurants in Madrid, he felt eyes slide toward him, so he hammed up his obnoxious dandy persona, drinking heavily. He bought a pair of greyhounds and took them for grandiose walks. Felicidad likewise became a magnet of glances. Cabbies sometimes gave her rides free of charge when they recognized her. With the help of a journalist, the following year she published her memoirs, *Mirror of Shadows*, prompting a new rush of attention in the press. She had cameos in movies and also published a book of short stories and miscellany titled *When I Loved Felicidad*.

Michi became the new it boy of Madrid. The boom of *The Disenchantment* enabled him to be someone without having to overcome his distaste for hard work or grapple with his creative insecurities. In practice, of course, this enabled nothing to really change. He kept doing what he always did, just with more ease: get drunk with friends and sleep around, while dreaming of

Felicidad at the launch of her book of short stories, with the artist Juan Gomila (left), her editor, and the poet José Hierro

other film projects. He claimed that the last thing he had wanted was for the film to turn his family into a myth, yet he was its *mitómano*—a Spanish word often used to describe him, which means *mythomaniac*.

Leopoldo went to Paris to see his adored Mercedes, despite the fact she had broken up with him. Instead of trying to kill himself as he had done after Ana María Moix rejected him, he lengthened his anthology of chaos. After flooding Mercedes's apartment one day while she was out, he lived on the streets, eating from garbage bins and losing more teeth. From now on he would increasingly live as if his sole purpose in life was to inflate his mythos as a visionary disaster. He denigrated his father's poetry, saying he wished he'd been the son of Luis Cernuda, not Leopoldo Panero. He posted flyers on trees advertising an unspecified talk he promised to give with Jacques Lacan and Michel Foucault; and with a bag of garbage in hand, he managed to visit Félix Guattari, the coauthor of *Anti-Oedipus*, who cordially if perplexedly received him. Leopoldo seemed the embodiment of that book's famous line. He was a schizophrenic out on a walk.

As moviegoers continued to buy tickets for *The Disenchant-ment* and it opened in more Spanish cities, however, the Paneros experienced things other than just the perks of their transgressive glamour. Michi and Juan Luis both received death threats over the phone, and very early in the morning, many days a woman would call the Calle Ibiza apartment and say, "Dirty laundry gets washed at home," then hang up. (Jaime Chávarri, meanwhile, was nearly assaulted at a screening in Granada.) Just as she desired, Felicidad accomplished her own rupture with the past—with the social circle in which she had worn the mask of Leopoldo Panero's acquiescent wife. Not just Luis Rosales but other close friends from that era cut off relations with her. A whole swath of the Spanish literary class disowned her and her black-sheep sons.

The poet Jaime Gil de Biedma, who still liked Felicidad, wrote in his diary of her three boys, "They are a true horror."

Then there was Astorga.

After the news hit the town that Leopoldo Panero's family had made a documentary about him, buses were chartered to take townspeople to nearby León, where *The Disenchantment* was playing. What they saw left them aghast, including the Paneros' former nanny and maid, Angelines, who left the theater crying. But it was Leopoldo Panero's relatives who were most hurt. The film, they felt, was unspeakable slander. The Panero sisters— "dolts," as Michi had called them—ended their relationship with Felicidad and her sons. "It was a total rupture," said the boys' first cousin Juan José, the son of Leopoldo's sister María Luisa, who was deeply wounded but less enraged than her sisters. "My aunts Odila and Asunción turned into panthers. They wanted to sue them." The aunts bought out Felicidad's share in the family home in Astorga, as they had done a few years earlier with the crumbling estate in Castrillo de las Piedras. Michi and Juan Luis had known that *The Disenchantment* would cost them Astorga and accepted this outcome willingly, if forlornly. Juan Luis had said his goodbye to the town the summer before the film came out, knowing he wouldn't return. For Michi, letting go of Astorga was harder, even though his own declarations on camera had made it inevitable. His happiest memories were from the family's summers there when he was a child. His own destructive impulses had now estranged him from that more innocent time. Perhaps losing his childhood paradise with the onset of adulthood had been too painful. He couldn't burn away the memories of it, but he could burn down the remaining links.

MUCH LIKE THE PANEROS' PERSONAL BREAK WITH THE PAST, ADOLFO SUÁREZ'S political one won him new allies and new adversaries. His daring

success in leaving Francoism behind generated both praise and fury, and stirred unrest across the political spectrum.

On June 15, 1977, in the first democratic elections held in Spain in more than forty years, the Spanish people voted for the government that would represent them. Over eighteen million citizens, close to 80 percent of the voting population, went to the polls. They cast their votes in ballot stations across the country—in noisy, crowded cities and remote, dusty villages. The lines were long in Madrid and elsewhere, but it was worth the wait. For all but the elder generation of Spaniards it was the first time that they voted for their government. They chose from the "alphabet soup" of newly formed political parties, which identified themselves by their acronyms. The elections arguably marked the most definitive historical moment for Spain since the outbreak of the Civil War. Like a thread linking these two events across time, the contentious run-up to that momentous Wednesday in June spurred rhetoric reminiscent of the brightest and darkest days of the Republic. "The wind of freedom has opened the doors!" the socialist leader Felipe González said during a stump speech in a working-class neighborhood of Madrid. Meanwhile, in the city's bullfighting arena, high-profile supporters for the candidate of an extreme right party riled the crowd with allusions to insurrection. "We don't believe in the farce of votes and ballot boxes," the Duke of Tovar boomed. "If God sometimes denies us the glory of triumph, he will never deny us the privilege of combat!"

The blend of euphoria and unease that swirled around the election climaxed with the victory of a centrist government with Adolfo Suárez remaining at its head. The losing parties accepted the results and the military didn't intervene. Democracy in Spain had established itself—for the time being.

"It is the beginning of an era in Spain, but more pertinently, it is the end of another," wrote the Welsh historian and

Hispanist Jan Morris. "Nobody knows whether democracy will last in Spain."

WHILE *LA TRANSICIÓN* WOULD DESERVINGLY BE CELEBRATED AS A STUNNING AND exemplary political triumph for a country reinventing itself after a dictatorship, it was not without bloodshed. As politicians battled for control in the parliament, some Spaniards took their battles to the streets, leading to 591 politically motivated deaths between 1975 and 1983.

In January 1975, a paramilitary fascist group attacked a law office in Madrid with links to the Spanish Communist Party, killing five people in what became known as the Atocha Massacre. Other similar bombings occurred periodically: one at a bar called La Vaquería where Leopoldo María and his beatnik-like cohort gathered, another in 1978 at the offices of the newspaper *El Pais*. Neofascist death squads executed supposed enemies; for example, the nineteen-year-old Basque student activist Yolanda González, who was shot and left by the side of the road in Madrid. ETA carried out a ferocious kidnapping and assassination campaign. Other times the violence was more spontaneous if still deliberate, as when the Guerrillas for King Christ paramilitary group killed a student protester while aiding police at a demonstration. The coziness between anti-democracy groups and the police and military pointed up the lack of transformation taking place in these Francoist institutions, and the autumn of 1978 would see an aborted coup against the government. The plotters received lights slaps on the wrists and kept their jobs.

This wasn't what democracy was supposed to look like, and this dissatisfaction was what kept the film about the Panero family urgently relevant to Spanish life.

In politics, the Transition was more pacific, but just as

action-packed. It was a period of unlikely compromises and unexpected twists. At the same time that Adolfo Suárez improbably evolved from a lifetime Francoist into the driver of democracy, other politicians underwent similarly shocking transformations. The communist leader Santiago Carrillo, who had defended Madrid as a young man during the Civil War, became one of Suárez's most committed collaborators, pushing his revolutionary party to not be revolutionary—in order to work with the new system rather than grind against the things communists didn't like about it. All across the ideological map, politicians were swerving and about-facing and making sacrifices to ensure that democracy took hold, even if they had once stood against the king or even democracy itself. This, too, was a game of masks. Such pragmatic elasticity was key to the project of the Transition, but it also alienated supporters who saw only political principles betrayed. The communist politician Julio Anguita, for example, later referred to the Transition as "The Transaction." Indeed, some Spaniards would come to consider the Transition a cheery, opportunistic myth cynically constructed by the political class to deceive the public into ceding its agency in the creation of a truly just, participatory democracy. One of the biggest complaints about the Transition, however, was about the meaning of national memory—was it just a story or was it also legal evidence?

Perhaps the weightiest and most problematic compromise—though many would argue the most essential—that fortified Spain's embryonic democracy was the 1977 Amnesty Law. The so-called Pact of Forgetting was a political accord to let the sleeping dead left by the Civil War and the dictatorship remain where they were—in the ground and in the past. Of course, the victims couldn't actually be forgotten, and this impossibility would lead to cultural, judicial, and legislative battles in the future. But the Amnesty Law legally "forgot" their deaths. The perpetrators of

crimes both on the left and right could not be prosecuted. Reconciliation, the political class agreed, was too important. The past couldn't be reconciled, only the future. So an agreed-upon sidelining of justice emerged as the lock picker's tool for opening the door to the new era.

While many Spaniards supported this approach, others emphatically did not. As Leopoldo María opined in a manifesto he published, Adolfo Suárez had made "silence definitive."

The Paneros, a Spanish family that refused to forget or to shut up, that democratically fought until each member was heard, continued to channel the zeitgeist even after their documentary had left theaters. The film they had made spoke to an aspect of the Transition that went beyond people's feelings about Franco's legacy. They reflected the present, as did the title of their movie.

People in Spain were disappointed. Disillusioned. They were *disenchanted*.

Yes, Spain had miraculously transformed and this was cause for celebration. Yet there was plenty to be unhappy about. Compromise came with displeasure, progress with setbacks, a new system with old problems. Democracy meant no one got exactly what they wanted. This was a new experience and *The Disenchantment* provided the defining word to articulate these feelings. In bars and cafés, on TV and the radio, in newspaper editorials and panel discussions, people talked about *el desencanto*—disenchantment with the Transition, disenchantment with democracy, disenchantment with life itself.

In the midst of Spain's infant democracy and its discontents, the parliamentary government still managed to take the historic step of passing a new constitution. The first article declared: "Spain is constituted by a social and democratic Rule of Law, which defends as the highest values of its judicial system liberty, justice, equality, and political pluralism."

As Spain managed to precariously hold itself together, the

Paneros drifted apart. It was if as the family's ties to the destiny of their country were stronger than their ties to each other.

After *The Disenchantment*'s success, Juan Luis left Spain again. He moved to Colombia, where he found a job as an editor. He felt just fine with an ocean between him and his country, and him and his family. For Juan Luis, being his own person meant minimizing their influence on his life.

After getting beat up in a fight he provoked while visiting Mallorca, Leopoldo descended into paranoid psychosis. He developed a persecution complex, convinced that agents sent by Adolfo Suárez and the CIA were after him. He was experiencing a definitive mental break, though he continued to write with frenetic dedication. He had completed his transformation into Peter Pan, as when J. M. Barrie wrote, "The difference between him and the other boys at such a time was that they knew it was make-believe, while to him make-believe and true were exactly the same thing."

However much the success of *The Disenchantment* seemed like the best thing that had ever happened to Michi, it might actually have been the worst. "Michi was searching for direction and *The Disenchantment* placed him in that particular class of characters of legend. . . ." wrote his friend Mercedes Unzeta Gullón. "He let himself be dragged along by that wave of the glitterati, which gives you notorious results with little effort, and if you don't have a solid direction to withstand that force, its current pulls you into the nothing." With his charisma and wit he made people around him happy, but inside he felt lonelier than ever. While from the outside Michi looked like the boy wonder of the Transition, on the inside he saw himself as a loser at life.

In spite of the liberation *The Disenchantment* gave her, Felicidad still felt trapped, stuck in the city she'd been dreaming about leaving for more than half of her life. She was unable to untangle herself from the son who carried his father's name,

whose success as a poet filled her with pride, as if he were her own literary work, but who trashed the house and fought with her to the point that she was forced to sleep elsewhere, even after slipping antipsychotic meds into his gazpacho. Felicidad had always idealized lost causes, and now it seemed like her family was one.

Yet as each member of the family orbited off further into their own life, the image of the Paneros in the collective imagination cemented itself. To some they were slanderers of Spanish life and traditions. To others they were subversive truth-tellers. To everyone they were a mirror that Spain looked into, discovering its shifting face.

After Leopoldo Panero's death in 1962, Felicidad had hoped to keep her family united. While this may not have ever truly been a possibility, she had failed.

In Astorga, vandals knocked the head off the statue of Leopoldo.

One afternoon while having coffee with Michi and a few of his friends, Felicidad shared a painful realization.

"We sold everything and now we've sold our memories," she said. "There's nothing left for us to sell."

PART 4

FIN DE RAZA
1981–2014

"There's no message in the bottle. Only liquid."
—MICHI PANERO

"To live and die in the shadow of a myth."
—JUAN LUIS PANERO

"Yesterday, yesterday, we never left yesterday."
—LEOPOLDO MARÍA PANERO

"I love goodbyes."
—FELICIDAD BLANC

LA MOVIDA

23-F, the Madrid Scene, and Democracy, 1981–1987

Michi sat alone on the red linoleum floor of his girlfriend's kitchen. Earlier that night they had fought. He wore a T-shirt and underwear and in his hands he held the box where he safeguarded keepsakes from his youth: letters and photos, mostly of ex-girlfriends and lovers. He had brought little else with him here when he moved in—just clothes, some books, and a portrait that the painter Gregorio Prieto had done of him when he was a child. Michi began lifting the items out of the box and tearing them up.

It was 1987 and he was thirty-five years old.

The girlfriend Michi was living with went by the playfully sinister name of Marta Moriarty, though there was nothing sinister about her. Stylish and hardworking, she was in her late twenties and had an angelic face. She was one of the founders of Moriarty & Co., a bookstore and art gallery she had opened six years earlier with two friends. Along with one of her fellow founders, she rechristened herself after the store, which had become a free-form space for artists in Madrid, like a Spanish niece to Andy Warhol's

Factory in New York. After meeting Marta the previous summer, Michi had become smitten, and she quickly fell for him, too. "He was the don of nomenclature," she recalled. "He pulled out the perfect word for every person, every situation, and gave everything a label." Like most people, she knew Michi from *The Disenchantment*; she had thought of him as a character from the Transition, only now here he was in person, dropped from the screen into the lap of her life.

Michi was enjoying one of the most serene periods of his life, experiencing sustained sobriety for the first time since he had started drinking at El Oliver when he was a young teen. The year before, he had developed alcohol-induced pancreatitis, which caused intense abdominal pains and promised more severe maladies if he didn't stop drinking. So he quit, and in the less antagonistic state of mind that being sober graced him with, he'd had the good fortune to meet Marta. Except now she was frustrated.

Always his mother's son, memory was like an illness for Michi. In contrast to the real-time unspooling of life, you could reshape it with words, giving it needed stylistic touch-ups and structural tweaks. For these reasons the bottle of memory was harder to kick even than alcohol, and this was what his fight with Marta had been about that night. She was tiring of his obsession with the past. At times it felt like the only thing Michi talked about. "That fatal nostalgia of the Paneros," she called it. "Nostalgia not only for the most tenuous happiness, but for every misfortune, which kept him from enjoying the present without skepticism and, above all, from considering the future."

This fatal nostalgia had shimmered in *The Disenchantment*. Indeed, the Panero family's studied wallowings in memory had been the molten dramaturgical force that had transformed them into a national symbol. But nostalgia as a lifestyle lost its appeal in a relationship, especially with a woman like Marta, who had

come of age just as Spain was casting off the burdens of its painful history to construct something new. She had urged Michi to channel his compulsive remembrance of things past into a memoir, but he quickly stalled out. He was a ruthless critic of other people's writing, which made him insecure about his own talent, as if cowed by what a critic as exacting as himself might say about his work. Marta yearned for Michi to grow and build a body of work alongside his two brothers', since she didn't think he was any less gifted. In doing so he might forge a future to replace the past as his mind's primary preoccupation. Unfortunately, change like this wasn't easy, which had led to their argument.

As Michi tore up the last of his mementos in the box, Marta appeared in the doorway of the kitchen, having awakened and come looking for him. She realized at once what he was doing. He had taken literally what she had meant metaphorically to demonstrate that, for her, he would look toward the future. But his shopworn body and appearance—his embattled pancreas, his prematurely gray wave of hair—seemed to suggest the inherent difficulty in this, as if he had more years behind him than ahead.

WHILE MICHI HAD STAYED LARGELY THE SAME IN THE ELEVEN YEARS SINCE *THE Disenchantment* had turned him into an icon, Spain had transformed.

By the mid-1980s, democracy had evolved from a precarious experiment in national reinvention into a sturdy institution. This was no small feat. Indeed, Spanish democracy had nearly come undone thanks to other men with fatal nostalgias all their own.

On February 23, 1981, a mustachioed lieutenant colonel named Antonio Tejero stormed the Congress of Deputies in Madrid with some two hundred armed soldiers and held the government representatives there hostage. He felt that the Transition had been a betrayal of Franco's legacy and that the state of political

disarray in which the government found itself was proof of this. Tejero was right in thinking that things were a mess. After orchestrating Spain's democratic rebirth, Adolfo Suárez seemed to have exhausted his political genius, as though ill-equipped to succeed in the system he had brought into being. His party was falling apart, as was the Spanish economy, and he failed to provide an effective response. This crisis led Congress to slap Suárez with a vote of no confidence and force him to resign, with the king's blessing. It was on the day of the vote for the new prime minster that Tejero appeared in uniform in the congressional chamber and shot his pistol into the air on live television, initiating a crisis that millions of Spaniards feared was the start of another civil war. War, however, wasn't the aim. Tejero was the triggerman for a conspiracy aimed at giving Spain's toddling democracy a paternalistic course correction in the form of an interim military authority. But as a result of the able handling of the king, along with missteps by the plotters, the 23-F coup, as it came to be called, unraveled over the course of eighteen tense, uncertain hours. Afterward, most Spaniards felt that democracy had definitively taken root in their country. Some even saw 23-F as the true and final end of the Civil War and Spain's bloody, centuries-long battle with itself.

Now it was time to party.

WITH THE PROSPECT OF RETURNING TO FRANCOISM NOW AS DEAD AS THE DICTATOR himself, the youth were free to express themselves in ways that had been unimaginable for their parents. A brave new world of behavior wasn't just possible but already half-made. Leopoldo María's brutalized, kamikaze generation had pioneered the frontier of transgression, and now the next generation could push further into the outer reaches of sex, drugs, art, and music. This liberation led to a legendary countercultural eruption known as

La Movida Madrileña—The Madrid Scene. It would become the messiest, loudest, and most colorful countercultural period in Spanish history. Many Spaniards who lived through La Movida remember it as a time of stepping from the black-and-white hues of the dictatorship into Technicolor, like Dorothy arriving in Oz.

With the same making-up-for-lost-time zeal with which Spaniards welcomed democracy, effectively catching up with the rest of Western Europe in warp speed, young people caught up on the artistic currents they had only heard fragmented echoes of during the dictatorship. They hungrily snorted up influences from abroad, much like they snorted up the cocaine that began appearing in abundance at parties. The visceral and experimental spirit of new sounds largely from the United States and the United Kingdom—The Clash! Patti Smith! The Police! Talking Heads! The Ramones! Joy Division! David Bowie! The Sex Pistols! The Velvet Underground!—provided inspiration for young musicians whose feelings didn't find form in traditional Spanish modes. The fashion styles of these bands also offered new aesthetics. Concert venues in Madrid and other cities with their own local Movidas boiled with miniskirts and tank tops, gaudy makeup and architecturally hair-sprayed coiffures, leather jackets and metal studs. The free-for-all of La Movida was the portal through which a certain sector of Spain stepped into a new identity, with little nostalgia or piety for the past.

Conservative society heaped opprobrium on these demonic new mores. A tornado of change had admittedly swept through in a very short period of time. It was only natural that many people were scandalized by such flamboyant flouting of convention, and surely the flouters themselves would have been disappointed if the sentries of tradition didn't throw fits. In Spain, sex, drugs, and rock 'n' roll hadn't organically evolved over decades within the cultural gene pool the way they had elsewhere. Instead, they had arrived like an invasive species disrupting the ecosystem. And

critics were right in their concerns about drug use. The prolif-
eration of heroin would gradually constitute a quiet, devastating
epidemic.

Yet the dangers of the loud 1980s, both real and perceived,
weren't limited to the new sights, sounds, and temptations.
There also occurred the upsetting of the gender norms. Spanish
women, that historically inexhaustible army of housewives, the
national stand-in for the Virgin Mary, were fighting for careers,
cultural prominence, and the right to divorce (passed in 1981)
and abort (partially in 1985)—all the while throwing chastity
to the wind like the ash from their cigarettes. Men of all po-
litical persuasions chafed at expanding female agency, although
masculinity itself saw tweaks, especially in cities. La Movida
ushered in a new sentimental aesthetic in which many women
were drawn not to the macho breadwinner but to the winningest
losers. Marta Moriarty admitted as much later in life. "Almost
all of us women fell for a loser, alcoholics, heroin addicts. . . ." she
said in an oral history. "You weren't going to fall for a good boy
who was a diplomat."

Michi saw failure as his vocation and used it as a tool for
seduction. He presented himself as an *elegant* loser, though this
wasn't the only archetype of loser. Bad-boy rockers offered a dif-
ferent appeal, as did substance abusers. This stylized, dropout
sensibility piqued more than just Catholic traditionalists. Pro-
gressives, especially old-school communists, complained about
La Movida's alleged lack of political engagement. What some
people saw as a glorious convulsion of expression that kept its
distance from the corrupt battleground of politics, others saw as
dangerous apathy in a baby democracy that demanded citizen
participation. La Movida was a wildly new kind of politics, as
exhibitionistic as it was creative, as hedonistic as it was provoca-
tive. In Pedro Almodóvar's 1980 film *Pepi, Luci, Bom and Other
Girls Like Mom*, a character playing a sixteen-year-old lesbian

urinated on a masochistic housewife. She might as well as have been urinating on a shrine of sacred Spanish values.

In the blink of a few years Madrid was a completely different city. It was no longer the stodgy hub of government ministries where family men beetled to and from work in suits while homemakers shopped, cooked, and cleaned. Or it was still that but now something else, too. It was a blasting faucet of improvisation and cultural subversion, a place where foreign bands came to play for rowdy crowds and Andy Warhol came to visit in 1983, underground scenesters and high society alike receiving him like the pope. Franco would have been aghast at what Madrid had become. Picasso's *Guernica* came home to Spain in 1982 and theaters restaged long-suppressed plays by Lorca. While the conservative politics of Ronald Reagan in the US and Margaret Thatcher in the UK reshaped the world, Spain swam against the current, as was its habit. And unlike Michi's *moderno* scene in Madrid and Barcelona in the 1970s, which had an elitist air, La Movida was a swirl of backgrounds. It attracted people from working-class and upper-class neighborhoods, rich kids and street kids. You didn't have to have a last name. Everybody was invited.

Michi existed both on the margins of La Movida and at its center. He was far enough removed from the punky, glam-rock generation not to fit in, nor would he have wanted to. He wasn't one to drink liter bottles of beer in plazas while smoking joints. That would have been too proletarian, too gritty for him. He spent most of his time at the elegant bar owned by his strong-willed, hard-partying girlfriend Amparo Suárez Bárcena, El Universal.

Amid the 1950s décor, loungey midcentury furniture, and opalescent lights, Michi played the de facto promoter and host. His presence was the flypaper that captured customers. The bar became a landmark in the never-ending Movida nights, offering

a sophisticated scene away from the mohawked punks at packed, sweaty clubs. El Universal's patrons were the cream of Michi's crop: writers, artists, directors, actors, bullfighters, even politicians. This crowd was where he felt most at home. Michi was always there, remembered the poet Blanca Andreu, "leaning back strategically close to the bar and making trouble with his curls and sharp, melancholy cleverness. El Universal was *the place*."

During this time Michi cemented a fundamental part of his character: the tendency to pull people toward him, then push them away. His friends loved him—he always showed up with gifts, a first-edition book, say, or even a pet monkey—but he could be impossible. "He could ruin a dinner because if he didn't like you he crucified you," said Marcos Giralt, a young man and future novelist whose mother was in a relationship with Michi. He was known to provoke fellow diners until eliciting a punch to the face. "Michi would laugh his ass off with blood running from his mouth. It made whoever punched him look worse and it was more of a defeat for that person." By losing with class, Michi won.

This image of Michi, bloodied but smiling, wounded but defiant, said more about him than his endless conversation ever could. In seeming paradox, he was both threatening and defenseless, cruel and superb. He felt small, so he acted big, although with his lovers his vulnerability was entwined in the seduction. Countless women were all too happy to care for Michi, providing him with a roof, money, praise, sex, love, or combinations thereof. His temper could be sighed at like a charming little boy's tantrums. (Up to a point, that is: occasional punches from Amparo gave Michi bloody lips; once he went to the police station to report her, only to leave all the cops rolling with laughter at his account of being beat up by a woman.) Yet Michi's was a learned helplessness. He worked here and there, and when he did it was usually to lose himself

in the past, like a radio program he hosted in 1983 with Felicidad, interviewing poets and artists who had lived the prewar poetic revival in Madrid and returned from exile. A few years later, he made a half-hour TV documentary about the same period titled *The End of a Party*. But by the summer of 1986, when Michi met Marta, his party had ended, too.

As it happened, Michi's pancreatitis-induced retirement from La Movida coincided with its end. Heroin use among young people combined with unprotected sex produced an AIDS crisis, while the mainstream Spanish culture's embrace of the era's music lured bands out of the dives where the scene was born to go on lucrative tours. The need to make art was supplanted by the desire to make money. A fight at the popular club Rock-Ola that left one person dead caused the venue to close, further robbing La Movida of its innocence, as well as one of its clubhouses. On top of these factors, time was simply passing. The youth who had brought the counterculture into being were no longer the youth. Many people settled down to start families, letting the next generation emerge.

La Movida had allowed Michi as well as Spain to fill a new box with memories. In a swerve of history few could have imagined before Franco died and *The Disenchantment* jump-started Spain's conversation about its past, this period was defined not by what couldn't be said but by people saying whatever they wanted, like the Paneros themselves had attempted to do. But doing so, it seemed, had estranged the members of the family.

AFTER WORKING FOR THREE YEARS AS AN EDITOR IN LATIN AMERICA, JUAN LUIS returned to Spain in 1979, spiraling into a midlife crisis at age thirty-seven. Behind him he had a few books but not a lasting body of work. Ahead he saw time expiring. He wanted to shape his life around his poetry, rather than the other way

around, and he decided he would be able to do this more easily in Spain. He moved to Barcelona, where he had editorial contacts for freelance work, only to discover he liked it better in El Ampurdán, a quiet region on the nearby coast. It was home to rolling green hills and the legendary Tramontane wind that raked itself over the landscape, stretching clouds out like taffy. The town on the sea where he spent his time was about as far from La Movida as one could get. In summer it filled up with families on holiday; in winter it was empty and drizzly. It was the ideal place to write, and there he fell for a Catalan doctor named Carmen Iglesias.

A divorcée with four children, Carmen met Juan Luis through friends in 1981. She liked his intelligence, humor, and unflinching sincerity. The daughter of a film director, she was his equal in love for art and literature, which made him feel comfortable. But her home life was a novelty for him. One day early on in the relationship, the two looked at photos of her and her children together. Juan Luis got a kick out of seeing the close-knit family posing across the years, unlike his own fragmented muddle of a family. "He liked family life a lot," Carmen said, "because he never had it." He got along well with her teenage daughter Elisabet, who liked his jokes. But as much as Juan Luis appreciated the familial harmony he had lucked into, it was alien to him, and sometimes alienating.

When Juan Luis moved in with Carmen in 1984, she mainly did house calls. She had worked in gynecology at a hospital for several years but now mainly paid visits to patients like an old-fashioned country doctor. That summer she had a great deal of work, and one Sunday evening after a hot, exhausting day, she came home to find Juan Luis drunk. He was worked up and began ranting about how he didn't belong among her family.

"I don't know what I'm doing here!" he said.

Carmen was in no mood for this. "It's true," she said. "I don't

know what you're doing. Pack your suitcase and I'll take you to the train station."

She left the room and when she came back Juan Luis had obeyed. She drove him to the train station and left him there.

A few months later, Juan Luis caved in and called her. Having set her boundaries, Carmen was willing to give him a second chance. He spent Christmas with her family and, soon after, moved back in. It was clear that he would have to change his ways and curtail his drunken outbursts to make things work. "Little by little he left those habits behind," Carmen said. When Felicidad visited and met her son's new partner for the first time, she gave Carmen a copy of her memoirs with an inscription: *For Carmina who I already knew through Juan Luis. With joy to discover that everything he told me about you was true*

That same year a publisher collected Juan Luis's three previous books into one volume, titled *Games to Put off Death*. The vogue of Castellet's *Novísimos* anthology had long since passed, and the Spanish poetry world hailed Juan Luis in a manner it never had before. He was thrilled to be plucked from the literary

Carmen Iglesias, Juan Luis, and Carmen's daughter Elisabet

margins—"rediscovered," as he put it—and integrated into the contemporary canon. An emerging generation of poets found a maestro in him, seeing Juan Luis not as an afterthought to one era but the spark of another. The next year, his new book, *Before the Fall of Night*, won the City of Barcelona Prize. It was a meditation on history, the passage of time, and the looming shadow of death, with a deliciously fatal nostalgia worthy of his last name.

"To live is to watch dying," he wrote, "aging is that, / sickly-sweet, stubborn smell of death, / while you repeat, uselessly, a handful of words, / dry husks, broken glass." Juan Luis was getting older, as was his brother Leopoldo, the Panero Peter Pan.

IN THE SPRING OF 1981, LEOPOLDO WAS ADMITTED TO THE NATIONAL PSYCHIATRIC Hospital of Santa Isabel, on the outskirts of Madrid. This was the same asylum where his aunt Eloísa, Felicidad's sister, had spent much of her life. After watching her son descend into repeated cycles of benders and delusions, Felicidad had arranged his treatment there in order to put a half hour's drive between Leopoldo and the party scene in Madrid. Yet as the hospital was a day treatment facility, it failed to slow down the ongoing set piece of destruction that his life had become. At a nearby bar, he stole drinks, got wasted, and made trouble that was occasionally entertaining, earning him a begrudging, mascot-like affection from the establishment and its patrons. The line between his performance of insanity and his actual insanity continued to vex people, including his doctors. One of his psychologists diagnosed Leopoldo as psychotic, yet denied him his craziness. "Leopoldo isn't insane," the doctor wrote, "but he knows how to speculate with his insanity. . . . He's inside of reality and wields it as it suits him. He plays a perfectly lucid and rational game." Fair or not, this assessment spoke to Leopoldo's complicity in his

own decline and raised the chicken-or-the-egg question under-lying his existence: Had his self-immolating behavior led to his *locura* or had his *locura* produced his behavior?

Leopoldo maintained his literary presence in Madrid, as well as his reputation for provocation. He was invited to read at the city's illustrious Athenaeum, where he recited a poem dedicated to his mother, who sat in the audience. "I will kill you tomorrow just before dawn when you're in bed," Leopoldo intoned, "lost among dreams and it will be like sex or semen on the lips like a kiss or a hug, or a giving of thanks." Verses like these displeased Felicidad—they were a far cry from Leopoldo Panero's "Cántico"—but she understood the transgressive gamesmanship of her son's poetry. As Leopoldo María put it, "My literature isn't innocent: it is *una locura* replete with tricks: death and insanity are none other than two more poetic resources." She believed in the greatness of her son's work. Like a personal archivist, she had preserved nearly every document from his life since childhood, amassing a thick dossier ready-made for a future biographer.

The literary world was less impressed with Leopoldo. In 1979, he had guest-edited an issue of a leading poetry magazine in which he managed to insult or mystify nearly every poet of his generation. Whether it was tongue-in-cheek shtick or conceited assholery, he squandered his peers' remaining goodwill. But hanging on to friends was of little concern to him. It seemed he was the only member of his family who didn't suffer from the hereditary disorder of nostalgia, as if being so legendarily memorable to others left him with a case of amnesia. In interviews, Leopoldo rarely ever spoke about events or people from his life, and even more rarely with any coherence. For him, the past and all the relationships it contained wasn't a keepsake to store away; neither was it a story to craft or a memory to caress. It was an invitation to destroy. "Ruin is so beautiful," he wrote.

In sync with his decline in stature in the literary world, the esoteric hellscapes of Leopoldo's poetic world largely fell out of favor with readers. They didn't feel his sense of doom. They were enjoying the sunny new days of democracy.

In spite of a slew of scandals that besmirched the ruling Socialist Party, the prime minister Felipe González stayed in power as the economy grew and more Spaniards learned the folkways of mass consumerism. Leopoldo continued to live and write as if still in protest against Francoism, except the forces he had come of age under no longer existed. In a certain sense, without the dictator his life had less purpose and direction. What was a born rebel to do when his oppressor faded, when there were fewer taboos to transgress, when democracy let more voices of the national family speak and the father figure fell definitively silent? The irony was that this is what Leopoldo had wanted and even helped make happen. Instead of ending up dead in jail, now it was more likely he would end up dead in an alleyway. Meanwhile, Felicidad continued to worry about him. She had recently won a bout against breast cancer, which made her mortality real, so she decided to find long-term care for her troubled son.

After retiring with a pension in the fall of 1985 at the age of seventy-two, Felicidad went north to the small Basque city of Irún to care for her older sister Margot, who was dying of cancer. Tucked inland from the Bay of Biscayne, peaceful Irún offered Felicidad the glassy infinity of the ocean that she had long pined for from the noisy, landlocked knot of Madrid. After Margot passed away, what began as a visit turned into a permanent move. Soon she brought Leopoldo north, too, and on a dark, rainy day in the fall of 1986, she placed him into the care of the Psychiatric Asylum of the Brothers of San Juan of God, in the town of Mondragón, an hour from Irún. There, under moody gray skies, Leopoldo met with therapists, ate with the other patients, and took walks on the grounds. A world away

from La Movida, he had little contact with the outside world. Mondragón was the perfect place for Leopoldo María Panero to be forgotten and fade into obscurity.

Instead, the opposite would happen.

MICHI TRIED TO CHANGE FOR MARTA. HE THOUGHT HE HAD WHEN HE PERSUADED THE minister of culture to give him a dream job that only Michi Panero could have finessed into being: identifying buildings in Madrid where literary and historical personages had lived, then writing the texts for plaques. Except that soon after, he and Marta ended up at a dinner at which the minister was present, and Michi couldn't help himself from making a joke at the man's expense, which got a big laugh from the people gathered. So he made another joke, then another. And another. By the time the night was over the job offer had dissolved. "It was suicide," recalled Marta. "Michi threw away everything for a laugh."

She was falling out of love with him. The allure of the hip loser had worn off. "Being clever isn't enough," she told Michi. "You have to *do* something."

In the summer of 1987, rumors circulated that Michi and Marta were getting married. In reality, they were breaking up. She felt bad for having pressured him to let go of his past only to end their future together. In their final days as a couple, Michi turned back to his other lover: alcohol. After they separated, Marta fell hard for a successful businessman who was emphatically not a loser. Michi was deeply hurt, so he indulged his battle-tested talent: translating private pain into public theater. Before Marta married her new suitor that fall, Michi married the sultry, dark-haired movie starlet Paula Molina, who was twenty-six. Photos of the newlyweds splashed across the tabloids. Michi told a gossip columnist that it was an "incredible occurrence."

Seven months later, he and Paula Molina divorced.

BURDENS AND LEGACIES

Felicidad's Goodbye, 1989–1990

As the 1980s charged toward a close, Spain's economic prosperity surged onward. The Paneros, however, were left out. As if living in a parallel country in which bounty had never arrived, they continued their steady descent as a once-respectable family *venida a menos*—fallen on hard times, brought low. They were a novel of languid decline, the Spanish Buddenbrooks, self-styled elegant losers par excellence. But this posture only provided aesthetic shelter, a literary trope with which to dress up pain and longing, as they had done in *The Disenchantment*. It failed to provide shelter from the persistent demands of life, which tended to be excruciatingly unliterary. The Paneros needed money—again.

Felicidad had exaggerated slightly when she lamented that the family had nothing left to sell after wholesaling their memories on camera. While she and her sons had sold off most of the books from Leopoldo's library and most of the paintings from the Calle Ibiza apartment's walls, they had held on to nearly everything else that Leopoldo Panero had accumulated during his life and

career: drafts and notebooks of poetry, criticism, and translations; photos, contracts, newspaper clippings, and assorted biographical miscellany; and, most private of all, thousands of pages of correspondence belonging to him and others, dating all the way back to his time as an eleven-year-old at boarding school with his brother. There were letters from his time as a soldier during the war and from his courtship with Felicidad. There were also letters from two Nobel laureates—Vicente Aleixandre and Camilo José Cela—as well as from dozens of other notable personages. The archive had tremendous historical and literary value.

The only problem was no one was buying.

In the twenty-seven years since his death in 1962, Leopoldo Panero's reputation had not undergone, as he wrote in a poem about his family, "posthumous parties of affection." He had largely been forgotten except as the father figure from *The Disenchantment*. Few beyond devout Catholic readers, or poets and academics interested in the postwar period, still appreciated his poetry. To everyone else who knew of Leopoldo Panero, his life and work seemed cast in the oppressive charcoal hues of the dictatorship, so antithetical to the vibrant colors of democracy. However, it wasn't only *The Disenchantment* and the tide of change it rode to notoriety that had relegated him to the literary ossuary. To a degree, Leopoldo had buried himself with *Canto Personal*, as Luis Rosales had predicted. That irate and jangling book-length poem had earned him the moniker of "poet laureate of the regime," which had clung to him over the decades like an unpleasant odor. And unlike his peers who survived him, Leopoldo had not lived to see democracy, missing out on the opportunity to explain himself in a Spain without Franco, although what he said might have only further complicated his legacy.

During the Transition, a controversial literary trend populated the display racks of bookstores in Spain. A spate of memoirs

by once-prominent regime officials appeared in which formerly passionate *falangistas* wrote about their pasts. Their motivations for doing so were complex, but perhaps best captured by the opening line of a 1978 novel by the writer Juan Marsé, which explored this phenomenon: "There are things one should hurry to tell before anyone asks." Spaniards hadn't been able to openly ask questions for four decades, so now there was a lot to tell, especially if you hoped to spiff up your reputation. As a result, at the same time that Spain prepared to legally erase the atrocities of its past with the Pact of Forgetting, the men who had been complicit in these crimes began to publicly remember their pasts. But these suddenly garrulous storytellers didn't necessarily equate to reliable narrators. This led to autobiographies many readers considered disgracefully opportunistic, faux-confessional *lavados de cara*—a washing of the face—more orgies of self-justification than honest reckonings with the past. As one scholar later put it, at stake was the politics of memory and the memory of politics.

Perhaps Leopoldo would only have further buried himself as the narrator of a memoir, though the poetry he left behind had been eclipsed by the collective memoir his family had written with *The Disenchantment*. Artifacts of memory both frightened and attracted Spaniards, which made the acquisition of his archive more than a mere institutional purchase. Spain was only just beginning to reconstruct its recent history free of the muzzle of censorship, and literary reconciliation was as difficult as political reconciliation. The archive might be seen as a statement prioritizing a voice that had already flourished under Franco at a time when voices smothered by the dictatorship were overdue for excavation. But would this rationale lead to another form of institutional forgetting? After all, Leopoldo Panero's life, poetry, and, politics were part of Spain's history, and they meant something whether the society escaping that past liked it or not.

Felicidad for her part felt that Leopoldo had unfairly been black-listed as a fascist; she thought his politics were much messier than that. To her pleasure, after a long wait, it appeared that an offer for her husband's archive might materialize from the University of León, in Leopoldo's home province.

A friend acting as mediator, Pedro Trapiello, played Felicidad's cicerone when she came to Léon to discuss the sale. The way she carried herself on that visit, he thought, was like an "exiled czarina." In an eerie wink to history, the hotel where it was arranged for her to stay was none another than the San Marcos Convent, where Leopoldo had narrowly escaped execution. No longer a prison, it was one of the nicer lodgings in the city. "We spent three days going from hallways to waiting rooms to offices," Trapiello wrote, "from open-ended conversations to half-closed doors." At last, he and Felicidad met with a vice chancellor, who rescinded the offer to acquire the archive. Although he hadn't read any of Leopoldo Panero's work, he believed that his politics precluded him from being a good poet. For some scholars a writer's life could preemptively disqualify the work, making literary merit a function of "extrapoetic" choices rather than aesthetic ones. *Was this fair?* one might have asked. Another might have parried: *Was the dictatorship fair?* Literature didn't exist outside of historical pain, which shaped the perception of literary works.

Politics and poetry had always been inseparable in Leopoldo's life. Now they were inseparable in his legacy.

AS FELICIDAD RECKONED WITH HER HUSBAND'S DIMINISHED REPUTATION, LIKE A counterweight to his father's drift into obscurity Leopoldo María's reputation reasserted itself.

Shut away from Spanish society in Mondragón, Leopoldo was fulfilling the literary fate he had always seemed destined for—that of the romantically mad poet locked away in an insane

asylum. He was healthy there but more miserable than ever. "In the height of my lucidity, I don't even possess that rapture of insanity that allows me to commit suicide," Leopoldo wrote in a letter to Maria ("Marava") Domínguez Torán, a woman with whom he kept up a tumultuous on-again-off-again relationship. "I see myself as unreal, as if I didn't exist anymore. I don't have memories: my life is crossed-out, it seems to me like something worse than an error or a fantasy. The only things that cheer me up are apocalyptic feelings, storms, rain, lightning that doesn't light up anything. It would seem that I'm Artaud"—the French *poète maudit* who had much in common with Leopoldo—"but for whom and for what? To write now isn't to cry, but to hallucinate." Yet he was inspired. His apocalyptically crossed-out existence became his new muse.

In his small room at the asylum, Leopoldo pecked away at a white Olivetti, smoking cigarette after cigarette. He was paring back his style, reducing the febrile allusiveness, and pushing relentlessly into a dark, pulsing truth: Living in an asylum was his eternal hell, but so was life itself. "Come brother," he wrote in a new poem, "both of us are on the floor / snout to snout, rummaging through the garbage / whose heat feeds the ending of our lives / that don't know how to end, tied down / to that prison sentence imposed on us by being born / worse than forgetting and death / and that tears apart the last closed door / with a sound that makes the children run to the frontier and scream at the toads." These verses and others became his next book, *Poems from the Mondragón Asylum.*

A scream from the frontier of human experience, *Poems from the Mondragón Asylum* resurrected Leopoldo as a poet. His helplessness in the face of life and death was everyone's helplessness; his wail of pain was everyone's wail of pain. Like Dante, he had brought back a dispatch from hell, only instead of Virgil, his guide was his own *locura.*

The book won him new readers and earned him back old ones. His poetry began to claw its way into academia. Túa Blesa, a young scholar who would devote much of his career to Leopoldo María's work, described him as "the black sun in the cosmology of contemporary Spanish poetry." Such recognition was what Felicidad had long desired for the son to whom she had dedicated so much of her life. Juan Luis in Catalonia, meanwhile, felt indifferent about his younger brother and his career. He was the tortoise to Leopoldo's hare, but they both had reached finish lines of success, if such a thing existed in poetry. And anyway, so much time had passed. In 1988, Leopoldo turned forty and Juan Luis forty-six. They were vastly different people who would have had no associations if it weren't for blood. They had no contact anymore. Their inheritance wasn't to fight to become Leopoldo Panero's heir but to transcend being his sons, to be their own men and create their own legacies.

Spanish culture outside of poetry also soaked up the rays of Leopoldo's black sun. Treated as part genius and part organ grinder's monkey, he appeared frequently on television and in newspapers. He attended literary events to read his work. He was still an impossible houseguest, at times even violent, but few wondered anymore if he was truly mentally unwell or just acting. While he still sounded ferocious on paper, in person he aroused pathos. The misshapen gourd of his nose hung below a sunken, absent gaze; he was often slack-jawed, looking as feeble as fellow asylum patients whom he loathed. In conversation he spouted literary citations and non sequiturs. He ate like a messy child. Yet none of this discouraged people from visiting him in Mondragón. In fact, by the dawn of the 1990s, like Vicente Aleixandre on Velintonia Street, Leopoldo María Panero had become a destination.

The image of a visionary poet padlocked away in a gloomy

asylum was a magnet for literary thrill seekers. The zeitgeist might also have played a role. Leopoldo offered a dark contrast to the glittering daydreams of global capitalism that followed the collapse of the Soviet Union and reached their apotheosis in Spain in 1992, on the quincentennial of the discovery of the New World. That year, the country hosted the world's fair in Seville and the Summer Olympics in Barcelona. The world celebrated Spain and Spain celebrated itself. For people who saw not the "end of history" but the beginning of a neoliberal offensive, Leopoldo's poetry of ruin and self-destruction was a dark tonic and vital counternarrative. He attracted poets, editors, academics, translators, and others. Unlike fans of Jim Morrison or Sylvia Plath, Leopoldo's fans could actually meet their tragic idol. The Chilean novelist Roberto Bolaño later fictionalized this phenomenon in his opus *2666*. The estranged wife of one of the main characters visits a mad poet she is obsessed with, who lives in an asylum in Mondragón, only to lose her own sanity. Bolaño also featured Leopoldo, without a fictive mask, in another novel. In the book, a gay poet who idolizes Leopoldo refers to him admiringly as "the Great Faggot of All Sorrows." Before Bolaño, Leopoldo doubles had been already showing up in Spanish novels and would continue to do so, like a Nabokovian game of hide-and-seek played between fact and fiction.

One spring, a Madrid poetry workshop called the Leopoldo María Panero Literary Collective made the trek to Mondragón to see the man who had given the group its name. Like most visitors, the members took him out for a meal, in nearby San Sebastián. Afterward, they went for a walk on the boardwalk. It was an uncharacteristically clear, sunny day. Leopoldo rattled off jokes that made the group laugh, though he became gloomy about returning to the asylum. During the walk a member of

the collective asked Leopoldo María how he felt now about his father.

"He was a great poet," Leopoldo said.

IN 1990, AFTER THE UNIVERSITY OF LEÓN'S DEMURRAL, THE GENERATION OF '27 Cultural Centre in Málaga bought Leopoldo Panero's archive. The acquisition included not only the copious documents that he had left behind but also assorted ones that Felicidad had preserved: letters from her mother and friends, as well as scattered memorabilia from her life. Felicidad and Leopoldo had both depended on and even exploited the other to erect their intertwined legacies. Their literary marriage might not have provided either with the love or emotional fulfillment each desired, but it had produced a long and rich history of words that would forever link the two, their two stories folded into the other. Now their paper trails would rest in the same place, like two adjacent gravestones for future generations to visit. But Felicidad had little time to enjoy this triumph. She was dying of cancer.

During the previous years she had undergone multiple treatments, including chemotherapy, to no avail. In her final decline, she spoke to Juan Luis on the phone and Michi came to see her. With the sense of formal decorum she had learned as a child in a very different Spain, she bought a new nightgown and had a stylist come do her hair before he arrived. "I prefer you not to see me like this," she told Michi.

In October, the temperatures in the north dropped and the Atlantic wind blew through the streets of Irún. As the days shortened, Felicidad sat with her past. It was the novel that she never tired of rereading. In spite of all the people and events that had shaped her life, she felt that nothing, not even her two Leopoldos, had destroyed her inner world. She lived with her

"beloved ghosts," the real people and literary characters who had defined her in equal measure. She loved them the same.

On October 30, Felicidad Blanc died in San Sebastián at the age of seventy-seven.

On receiving the news, Michi took the next flight he could from Madrid. He was the first to arrive. He was devastated. His longtime feeling of being an orphan was now a fact. "The death of my mother left me alone, absolutely alone. . . ." he said later. "It's a void that no one fills, not lovers, not brothers, not friends, nobody." Soon after, Leopoldo arrived from nearby Mondragón, with Juan Luis and Carmen en route on a train from Catalonia. In the morgue, Leopoldo applied the laws of fiction to the reality of death. Inspired by a reanimation scene from Robert Louis Stevenson's novel *The Master of Ballantrae*, he tried to resuscitate Felicidad and had to be restrained. If anyone would have been equal to the task of dealing with this absurdist theater of grief, of *locura* and *literatura*, it would have been Felicidad. Instead, only the hospital staff was there with Michi, who was disgusted with his brother. Leopoldo left and went on a bender in Irún, tortured in a new way by the woman whom he had tortured and felt tortured by, whom he saw as his enemy yet knew was his guardian—and who loved him unconditionally. The following month, Leopoldo would dedicate a book of his essays to his mother with these words:

> *To Felicidad Blanc, widow*
> *of Panero, begging you to forgive me*
> *for the monster that I was.*

After Leopoldo was gone, Juan Luis and Carmen arrived. He was stoic about the loss, like the jaded, melancholy speaker of so many of his poems. "People die. Life is hard. . . ." he said later. "One must worry about people while they're living. Afterward,

everything else is rhetoric." Nevertheless, in December he wrote a poem in which he mentioned Felicidad, as well as other friends who had died that year. "They are just names, exiled shadows," he wrote, "crossings-out in the appointment book of time."

With Felicidad gone, there was little left that linked the three Panero brothers besides their past, their last name, and their place in Spain's history. How they would fare without their misfit mother, who had raised three misfit sons, was anyone's guess. They had been her burden, and now her absence was theirs, though they could rest assured that, while she may never have attained lasting *felicidad*—"happiness"—in life, she was satisfied with her legacy. As she had once written of the literary works of her three sons, "Their presence makes me think that the battle was not so sterile, and at night, the words from their books come to me, they affirm my conviction that none of them faltered. They have been themselves, with their stumbles, with their defeats. But they didn't fold beneath all that surrounded them, and in spite of everything they are free."

THE END OF A PARTY

After So Many Years *and Michi's Decline, 1995–2004*

In early 1995, a second documentary about the Paneros opened in Madrid. Not exactly a sequel to *The Disenchantment*—but also not *not* a sequel—the director wasn't Jaime Chávarri, who hadn't wanted to do it, but Ricardo Franco, the well-regarded filmmaker who knew the family. Its title was *Después de Tantos Años*, or *After So Many Years*.

The film was well received by critics, although spectators agreed that where *The Disenchantment* had been cathartic and incendiary, *After So Many Years* was raw and depressing. Felicidad's singsong recollections and twinkling memories were absent, as were the electric family arguments. *The Disenchantment* had related the collective destruction of a family; *After So Many Years* seemed to capture the individual destruction of those family members. On camera, Juan Luis was now a portly grump, Leopoldo María was a languishing mental patient, and Michi was a fatalistic alcoholic. What turned out to be the most famous moment of the film was Michi's enraged outbursts about his two brothers: "The worst thing you can be in this life is *un coñazo*"—"a pain in

the ass," though in Spanish this literally means "big cunt"—"and my two brothers are a pain in the ass that have tortured me my whole blessed life with this whole thing about literature and their literary personas! I wish they'd leave me alone! You can't get all literary when you're in a bed and they tell you that you've become paralytic." He was referring to his polyneuritis, a pathology of the nervous system that had caused him to temporarily lose the ability to walk a few years earlier. "No matter how much literature you read, you're going to be paralytic." Michi no longer spun gold out of family history to create family legends. He bemoaned the sadistic agonies of memory, saying it was the cruelest part of human existence. *After So Many Years* wasn't about the fatal nostalgia of the Paneros. It was about the end of nostalgia.

The film was a flop. As much as Ricardo Franco had hoped to recast the Paneros for a new generation, young people weren't enchanted or disenchanted by the film. They were indifferent. The Paneros had little to say to the youth of Spain, who were growing into adulthood under essentially buoyant conditions. They enjoyed a transformative increase in social spending, which provided unprecedented levels of education and job training. Women were making significant gains in the workplace and the Catholic Church no longer played such an influential role in national life. Older Spaniards likewise had little use for the Paneros, engaged as they were with the concerns of the present rather than the legacies of the past. After more than a decade of political dominance, the socialists had lost the trust of the electorate. A flotilla of corruption scandals along with other factors sank the party in the 1996 elections, allowing the conservative People's Party to take power. Under the new government, a construction and real-estate boom dawned, filling Spain with optimism. What did the dour Paneros have to offer to mainstream Spanish culture? Precious little, it appeared, and not even the frisson of transgression.

MICHI HAD PEGGED HIS HOPES ON *AFTER SO MANY YEARS* CATAPULTING HIM BACK TO stardom. He needed the money, yes, but what he really needed was a sense of meaning. As he himself put it, *The Disenchantment* had taken a banal story and transformed it into legend, yet now here he was as banal as ever. He lived in his family's longtime apartment, which was crawling with cockroaches thanks to the trash he failed to take out, and when it came down to it he simply hadn't done much with his life. He was the entertaining, venom-spitting TV critic for a newspaper, sure, but it didn't pay well enough to sustain his drinking or his wife's. In 1991, as paparazzi flashbulbs popped, he had gotten married, for a second time, to a woman named Sisita García Durán. Although there was love between them—and mutual adoration between Michi and Sisita's son, Javier Mendoza—she was as fragile and tormented as he was, and after the failure of *After So Many Years* their relationship caved in. He landed in the hospital with a dislocated shoulder after a fall and learned that he had diabetes. Upon being discharged in January 1996, he was evicted from Ibiza 35. The Panero family's fifty-four years of residence in the apartment had come to a sudden and unceremonious end.

Subsisting on money a group of friends pitched in to create a charity fund for him, Michi ended up in the Sear Clinic, a health-care facility for patients with long-term illnesses and no other means of receiving treatment. Only forty-five among much older patients, Michi felt like geriatric life had been prematurely thrust upon him. He spent his days reading and watching television, waiting for friends to visit, and working on his memoirs.

Since the 1980s, rumors about Michi's memoirs had been rumbling among the Spanish cultural elite, like tectonic vibrations promising an earthquake. Gossip had it that the book would be a historical encyclopedia of sexual life, a detailed chronicle of everyone Michi had ever slept with, along with everyone all those people had ever slept with. Instead of disrobing his family

as he had done in *The Disenchantment*, he would rip the sheets off his whole social class. By 1997, however, Michi had lost interest in any such salacious romp across the page, and not just because physically speaking sex was limited only to nostalgia for him. He was more interested in his own stories than anyone else's.

Like his mother before him, and his brother Juan Luis soon after, Michi needed help converting his life into a book from a combination of editor, ghostwriter, and amanuensis. He found this cocktail of assistance in the form of a thirty-year-old journalist and aspiring novelist named Asís Lazcano. A dedicated cyclist, Lazcano had ridden his bike by the Sear Clinic numerous times, never suspecting that one day he would spend countless summer afternoons on a bench out on the grounds, recording stories from Michi's life. Inside the clinic, where they also worked, was a literal life-versus-death struggle between illness and medicine—"a smell of urine, disinfectant, and cotton," Lazcano noted in his diary. Outside, summer thunderstorms periodically raged over Madrid. Lazcano imagined Michi trapped in exile, the twenty-six stories of the newly built, sleek-black, sentinel-like KIO Towers rising in the distance like a closed city gate.

The pity Michi aroused in Lazcano didn't mean their collaboration was easy. He wasn't spared Michi's brand-name prickliness, no matter that he was working for free.

"You're no Jean-Yves Tadié," Michi snapped one afternoon, referring to Marcel Proust's French biographer, who had published his book the year before.

"Well," Lazcano replied, "you're no Proust."

The project came to a premature end when Michi received a tempting invitation. An Italian poet and businessman named Claudio Rizzo had gotten legal permission to bring Leopoldo María from cloudy Mondragón to the sunny Canary Islands, where he lived. He and Leopoldo had collaborated on a book

and Rizzo wanted to help him. He knew of a program in the city of Gran Canaria in which mental patients lived in communal apartments. He hoped to arrange Leopoldo's transfer to one. Rizzo invited Michi to come along, too.

Michi abandoned work on his memoir and left Madrid.

IN GRAN CANARIA, LEOPOLDO DID WHAT WAS ONLY NATURAL FOR HIM—BE LEOPOLDO.
As the past had made abundantly clear, Leopoldo could turn any situation into a china shop to his bull, even the patient china shop of Rizzo's apartment, where he lived after a spot in the psychiatric living program failed to open up. Hence came an onslaught of vintage Leopoldo. He vomited all over, accused his host of trying to kill him, ran up exorbitant long-distance phone bills, and got conned in a bogus drug deal. As much as Leopoldo loathed living in mental institutions, they were the only places on earth equipped to withstand him for more than a few days. Finally Rizzo kicked him out. Soon after, he found a new home at the Insular Psychiatric Hospital of Las Palmas, where Michi visited him and took him out to eat and run errands. (Michi had little else to do.) At the hospital, Leopoldo would keep being the same *poeta maldito*, the same man and legend, just in a new place. The church for his pilgrims had simply changed its address.

AFTER SPENDING TWO AIMLESS YEARS IN THE CANARY ISLANDS, MICHI RETURNED TO Madrid, the city he always came back to no matter how much he yearned to escape. He got by on continued help from friends. His former Movida girlfriend Amparo briefly took him in. He was like a ghost robbed of the ability to haunt, trapped in the cruel irony of his own myth: Michi Panero was a product of Madrid and had contributed to the forging of its contemporary identity, yet the city no longer had any use for him. A physically

spent, emotionally broken, sad-sack litterateur was a contradiction of Spain's self-image.

The country's economy had continued to grow like a teen shooting into puberty. Democratic capitalism—a term Spanish communists considered an oxymoron—had rung the gong of upward mobility. People from all social classes were securing mortgages and filling new apartment buildings and housing developments with children and dreams. Prosperity seemed to be inexhaustible, not just in Spain but throughout the developed world, which in turn redounded back to Spain. Tourists fell from the sky in millions each year, beckoned by the country's food, culture, and beaches. Yet amid this bounty, like a family secret threatening to shatter a holiday feast, the past trembled under the surface of the new millennium—and under the actual ground.

All across Spain mass graves from the Civil War remained in the earth, untouched since the bodies that disappeared into them were covered with soil. A handful of forensic anthropologists had begun disinterring these sites for families who wished to identify lost relatives. This was a hot-button political issue, as some saw it as a betrayal of the Transition's Pact of Forgetting. Others saw that pact as the original betrayal and these excavations as its rectification. The search for Lorca's remains in the hills of Granada became—and still remains—one of the flash points for this painful national debate. Those in favor of locating his body envisioned it as a symbolic act of justice; others were vehemently opposed. (In 2007, the Socialist Party, back in power again, would pass the Historical Memory Law; among many other measures, it attempted to return rights to the victims of the Civil War's violence.) The viewpoints seemed irreconcilable, as were those of Spaniards who celebrated Franco's birthday every year with people who fought to have his name removed from every remaining street and public monument. Michi had long claimed that Spain used forgetting as a weapon, although this was

as much personal as political for him. After all, he was a victim of cultural amnesia. His attempt at a second act had failed and now he was stuck, as his stepson Javier put it, in "an eternal epilogue."

In 2002, the city of Astorga bought the former Panero home on what was now named Leopoldo Panero Street. It was in a state of collapse, its insides crumbling. The mayor, Juan José Perandones, a teacher and historian, hoped to turn it into a cultural center. The town's major cultural claim, of course, was of being the birthplace and muse of Leopoldo Panero and what is known as the Astorga School of writers, which included Juan Panero. In 1992, the city had hosted the launch of a new anthology of Leopoldo Panero's poetry, edited by the highly respected writer Andrés Trapiello, who urged readers to look past Spain's political divisions to appreciate its literary history. "What land is ours," he wrote, "where an exceptional poet like Leopoldo Panero has disappeared not only from the memory of the people, but also that of the poets themselves." Astorga's mayor hoped to use the Panero mansion, once renovated, to host more such events.

That same year, Perandones invited Michi to appear on a panel honoring Leopoldo Panero. The renovations had yet to commence, but Michi had come to the release of Trapiello's anthology a decade earlier and enjoyed it, so he accepted the invitation. In recent years he had come to feel he and the rest of his family had been unjust with his father in *The Disenchantment*. At the event, Michi talked with Javier Huerta Calvo, the foremost scholar on his father's work. When *The Disenchantment* came up, Michi told him, "We were assholes to my father."

During that visit to Astorga, Michi also reconciled with his cousins, the sons and daughters of his father's sisters. Among them was his father's niece, Odila, now almost in her eighties. She still recalled the day that soldiers had come to arrest Leopoldo in 1936.

In the fall, Michi moved to Astorga.

PEOPLE WOULD LATER DEBATE WHETHER MICHI WENT TO ASTORGA TO LIVE OR TO die. It might be fair to say that he returned to the place he had been happiest as a child to do both—live and die. While he knew he didn't have many years left, he hoped to play a role in the cultural center that would soon be opened in his ancestral home.

Using the funds his few indefatigable friends still provided, Michi moved into a small attic apartment in the center of town. In the mornings, he hobbled down to a kiosk to buy a newspaper, which he read at a café. Some members of the community were happy to have him. Sure, he had sharp edges, but his reappearance was vaguely moving, their own prodigal son returned. Others resented him. This snooty tabloid celebrity who had burned Astorga now expected the city's walls to just open for him?

Both positions were understandable and Michi was no less ambivalent about his homecoming. "He came with an idea of a city that no longer existed," said the mayor, Perandones. Michi discovered that Astorga wasn't the Arcadia of his father's poetry, if it ever even had been. He was rarely satisfied with much in life, so Astorga seamlessly failed to live up to his expectations. Among petty gripes, however, he also had legitimate ones. Local politics delayed the renovations for the cultural center. This infuriated Michi, as if robbing him of his life's purpose. Nonetheless, he was glad to be there. "Sooner or later we all return to what remains of one's origin . . ." he wrote. "I've returned to Astorga, after eternities and nostalgias, because still, despite everything, over it hovers mystery, pain, and silence."

A few years earlier Michi had survived a bout of mouth cancer. Now, empowered by his host of chronic maladies, it reasserted itself. This in turn revitalized his host of maladies. His ouroboros of illness brought on a diabetic coma, landing him in the hospital, though he was soon discharged. A young poet named Ángel García Alonso had befriended Michi on his arrival in town, and Michi played literary mentor of sorts to the young

man, even as he languished. García Alonso thought Michi was dying of loneliness. Michi sheltered himself beneath flashes of humor, however morbid. He recorded an answering machine message saying: "I am what remains of Michi Panero."

He spent his bedridden and painful final months mostly reading and watching movies. Javier Marías, Enrique Vila-Matas, and other friends sent him their new works. And he kept writing. People often referred to Michi as "the writer with no books"—sometimes affectionately, sometimes disparagingly. But at the very end of his life, the Panero dilettante who hadn't become an author like every other member of his family proved himself to be a writer down to his remotest marrow. Between recurring thoughts of Domitilla, Michi put himself on paper as if this might save him. It was the best writing of his life, lucid and melancholy, elegiac and honest.

On the otherwise normal morning of March 11, 2004, a massive explosion shook Madrid's Atocha Train Station. Bombs ripped through commuter trains, killing 192 people and injuring ten times more. The attack turned out to be the work of an al-Qaeda cell. Spain's conservative president José Aznar had supported George W. Bush's invasion of Iraq and this was fundamentalist payback. The bombing was the country's first encounter with terrorism in the post-9/11 world. On hearing the news of the attack, Michi called his old Madrid friend Rafael Zarza, whom he had recently had a spat with.

"You're alive!" Michi said when Zarza picked up. "Not me!"

Visiting Michi in Astorga at this time was an artist named Elba Martínez. She had come from the Canary Islands, where she was making a short film about Leopoldo María, to meet Michi. He invited her to stay in his spare room and they spent the next few days together; he told her stories from his life in between movies they watched. In a vase stood mimosas, Felicidad's favorite flower. For Elba the experience was surreal yet

spellbinding. In a platonic sense, she was Michi's last seduction, proof of his magnetism to the end—and also proof that it was never too late for him to push someone away. When Elba raised the idea of him going to a clinic where he might get better care, Michi blew up. Couldn't she see he was dying! The next day Michi gave her a letter he had written apologizing, clearly aware it was one of the last things he would ever write:

> *I went back to the unreal to treat you as if I were still a dancer—a dancer without music, nor grace, who only knows how to fall, fall in order to lift myself teeteringly back up, swaying, someone who wanted to repeat the zigzagging of his days of alcohol. . . .*
> *I'm sorry (what a tacky word)*
> *See you in infinity*
> *—End of the tropic of cancer—*

ON THE MORNING OF MARCH 16, A SOCIAL WORKER FOUND MICHI DEAD SITTING upright in bed, with one foot on the floor, as though trying to lift himself to standing. He rarely changed his clothes and was no longer able to attend to his hygiene, but he wore a clean collared shirt and had groomed himself. He'd had a heart attack.

Michi was fifty-two—the same age his father died.

The next day his remains passed through the gates of the Astorga Cemetery like his father and many other relatives. The city split the costs of the funeral home and the burial with his cousin Odila. A few poems were read, including one by Leopoldo Panero.

National media reported on Michi's death and a few months later the magazine *Leer* devoted an entire issue to him. It included reminiscences from friends and exes. One of the contributors was Marta Moriarty. She closed her piece by saying, "If I had to write his epitaph I would say, 'Although he tried, he never hurt anyone.'"

The magazine also printed a short essay Michi had written in his final days, titled "The Wasteland (without Eliot)." Its ending was a fitting note of farewell from Michi Panero, who was no longer standing on the platform watching the train go by:

> *Perhaps twistedly, I have been faithful to a tradition of losers, people who didn't want to cross the frontier and didn't know how to find their way back to return home on time; on time to save the last ruins of happiness. . . . There will be a day that we must all step again onto the soil that we rejected, those first lips that we touched one afternoon, standing against the wall with one's heart beating harder than ever, like the city itself.*

Michi had crossed the frontier. His heart was no longer beating.

Michi in 1990s before his final decline

THE END OF THE LINE

The Final Years of Juan Luis and Leopoldo María, 2004–2014

Leopoldo María learned of Michi's death in the courtyard of the School of Humanities at the University of Las Palmas.

During the mornings, he was free to leave his psychiatric hospital and roam the streets of the city. He often made his way to the university's café, where he chain-smoked and compulsively drank Coca-Colas. When he first began turning up, students didn't know what to make of this haggard figure with the glassy gaze who would just as easily talk about the pain of solitude as claim that Javier Bardem played basketball with human heads. A few professors took it upon themselves to explain who he was, and gradually the campus community adopted Leopoldo as a treasured guest, a mascot. Students gathered around him between classes and faculty let him hang out in their offices. The waiters at the café were protective of him, people ignored his provocative remarks (and burps), and security guards only censured Leopoldo when he urinated in public. He was like an eccentric literary emeritus who had used

his retirement to go crazy. As history professor Fernando Bru-
quetas, a frequent interlocutor, recalled, "We chatted about
the divine, the outlandish, and the human," until Leopoldo
would tire and ask, "Will you buy me a Coca-Cola?" It fell on
Bruquetas, one day in the courtyard, to inform Leopoldo of
Michi's death.

"I'm very sorry," the professor said after delivering the news.
He had rehearsed a brief speech offering condolences, but before
he could launch into it, Leopoldo lifted his hand up, as though
physically halting the conversation with his open palm.

"Don't feel sad," he said. "You're full of life and so am I!"

Bruquetas was stunned and moved by this life-affirming
reaction from Spain's foremost poet of the death drive.

In the stilted recasting of reality that constituted Leopoldo's
inner life, however, he was aggrieved by Michi's death. He would
later claim that a shadowy conspiracy had poisoned him. He
talked about having missed resuscitating him, a coded refusal
to let his brother go, while surely a prospect Michi would have
found horrifying.

LEOPOLDO WAS A REGULAR NOT JUST ON CAMPUS BUT AT CAFÉS AND BOOKSTORES
around Las Palmas, where he made many friends. His ominous
mots and vacant stare often gave way to an image which might
have been disappointing to readers who thrilled to his semen-
laden, cadaver-strewn verses: a sweet, crinkly smile befitting a
harmless, loopy uncle. For the local literary community Leo-
poldo was like a World Heritage Site, part of Spain's living,
breathing cultural patrimony. He often lay on public benches in
the city's shopping district, calling out to pedestrians, "I'm not a
bum. I'm a poet!" Sometimes people took him to the beach. He
was the island's otherworldly laureate, their *maudit*-in-residence.

During his years in Las Palmas, Leopoldo collaborated on

literary projects with numerous people, both from Gran Canaria and elsewhere. To work with Leopoldo María Panero was both an inspiring artistic experience and a privilege that conferred status. The first time his Italian translator Ianus Pravo came to visit, Leopoldo met him in the lobby of his psychiatric hospital. "Let's get out of here," Leopoldo said to his visitor. "This place is full of crazies." He also drew filmmakers that made short documentaries about him, as well as photographers who shot dramatic portraits and musicians who set his verses to music. He rarely disappointed these seekers in search of that blurry entity floating between the poetry and the myth—the man himself.

While Leopoldo justifiably received criticism for publishing too much and too monotonously in his later years—his poems could read like imitations of Leopoldo María Panero poems—his work never stopped speaking to readers. A spokesman for

Leopoldo María in his latter years

humanity's darkest thoughts, he was a frequent guest at literary festivals. In Roberto Bolaño's last interview before his death, when asked if he was ever afraid of his fans, he replied, "I've been afraid of the fans of Leopoldo María Panero, who in my opinion, by the way, is one of the three best living poets in Spain. In Pamplona, during a series of readings organized by Jesús Ferrero, Panero was the last on the program, and as the day of his reading approached, the city (or the neighborhood where our hotel was) filled up with freaks who seemed to have just escaped from a mental asylum, which incidentally is the best audience any poet can hope for. The problem is that some of them didn't look only like madmen. They looked like killers, and Ferrero and I were afraid that at some point someone would get up and say: I shot Leopoldo María Panero, and then plug four bullets into Panero's head—and then with one each for Ferrero and me for good measure."

What was surely comic poetic license on Bolaño's part underscored a powerful quality of Leopoldo's work, and literature in general: he accepted anyone. No one was excluded. Leopoldo was the godfather of the weirdos and outcasts and anyone else who didn't fit in somewhere and needed company. "I'm the paradise for all of the failures of Spain," he wrote, "their idol and only hope."

Each June, Leopoldo dutifully attended the Madrid Book Fair, where he signed his books in the booth of his longtime publishers, Antonio Huerga and Charo Fierro. The fair is a festive occasion, turning the hedged paths of the Retiro into an outdoor bookstore. Leopoldo stood out from other authors promoting their work. His line of waiting fans didn't find a groomed public persona. They met the dusk of that black sun that had often outshone the work. Approaching his sixth decade in the country that he described as crazy—unlike him, he claimed—he had become a strange and precious heirloom

passed down through time. As with all old men, only history itself could truly explain him.

WHILE LEOPOLDO TRAVELED PERIODICALLY, EVEN VENTURING ACROSS THE ATLANTIC to Latin America in 2004 and 2010, Juan Luis mostly stayed put with Carmen in their small town on the coast. A smoker like his brother Michi, he too had mouth cancer and now lived under "a permanent sense of provisionality," as he put it.

When Juan Luis wasn't watching old movies on TV, he spent his time in his tiny second-floor office with a view of a hotel and houses spread out down the hill below. The seemingly unremarkable room throbbed with secret histories and fading stories. His bookcase held old editions of works by his favorite authors, which he took down to reread, and tucked into a shelf was a book of poems by his ex-wife, published after they had split in 1977. Marina Domecq had privately printed twenty copies and sent one to Juan Luis. She wrote an inscription that wrapped around the page with the title—*Homage to Complicity*—so that it read: *For Juan Luis, because this* Homage to Complicity *goes deeper*. On the bookcase there stood a photo of his parents walking in a London park with Luis Cernuda. More history hid out of sight. Juan Luis kept photo albums with nearly a century's worth of photos, images from his mother's childhood and his own, from his father's literary career and his own. In the albums were pictures of his brothers as kids, too. Otherwise they had no presence in this castle's keep of his life, and he didn't talk about them either. One evening years earlier, *The Disenchantment* ran on television and Carmen had made him sit and watch it with her. He hadn't seen it since the 1970s. When the film ended, Juan Luis didn't say a word.

With Carmen's family, however, he continued to feel at home. At family gatherings he played the photographer and took

pictures of the family, as if still reluctant to enter their photo albums, though not always. He adored Carmen's granddaughter and once on her birthday posed for a photo with her. He shared these happy moments with the family, as well as sad ones. When one of Carmen's sons died, Juan Luis was devastated.

Like Leopoldo María, to the extent that it was possible for a Panero, Juan Luis had become a nice old man. He cleared the table each night after dinner with Carmen, then did the dishes before staying up into the night reading. In the mornings, he woke late and heaped sugar on his yogurt.

In 2008, Juan Luis turned sixty-six and Leopoldo sixty. They had lived through more than a half century of Spanish history as the country went from poverty to prosperity, from dictatorship to democracy. But they hadn't seen it all yet. As the first decade of the twenty-first century marched toward its close, the black clouds of the global financial crisis descended on Spain. And suddenly, the Panero family's magnificent fatalism became relevant again.

SPAIN'S MIRACULOUS ECONOMIC RISE IN THE YEARS PRECEDING THE FINANCIAL CRISIS turned out to be a grim parable disguised as a fairy tale. Along with the rest of the world, Spaniards woke to a hidden narrative of subprime mortgages and unchecked speculation beneath the fiction of the boom, underwritten by woefully inadequate regulation and political complicity. The lives of millions had been paid for by a check that bounced.

As the government bailed out the banks, the impact of the crisis deepened even more disastrously in Spain than in most other nations. A perilously disproportionate number of its economic eggs lay in the construction-sector basket. When its bottom fell out, shattering the great shell of prosperity, tourism and other industries could not put the economy back together again. Neither could the political class. Corruption scandals prolifer-

ated, the country's elite having treated politics as their private mint instead of public service. While this was an old story not just native to Spain, such systemic corruption looked different in the harsh glare of the crisis.

Paro—the Spanish word for unemployment—rose like an ineluctable flood over the country, and over hope itself. Surpassing the worst levels of the Great Depression in the United States, by 2012 a quarter of eligible workers in Spain were jobless, with *paro* eventually reaching a staggering peak of 29 percent. These circumstances set off a dizzying onslaught of foreclosures. (They would reach four hundred thousand by 2016.) Families cried on the streets as police removed their possessions from their homes. The lines of soup kitchens swelled. Men and women took their own lives out of desperation. It seemed there was no solution, so many Spaniards called on tradition: they took to the streets.

On May 15, 2011, a spontaneous social movement irrupted in Madrid. Its epicenter and headquarters was the Puerta del Sol plaza, the former location of the General Direction of Security. An encampment of thousands of outraged, peaceful protesters gathered there and quickly spread to dozens of other Spanish cities. The organizers had studied the Arab Spring and 15-M, as the movement came to be called, would help inspire the Occupy movement in the US and worldwide that fall. For a fleeting few days, Spaniards who identified with the demonstrators experienced a cathartic channeling of emotion, found a place to put their indignation, and saw a flash of hope. Then, police evicted the protesters from plaza after plaza across the country, in several instances with brutal violence. Afterward, the "Spanish Revolution," as some dubbed it, kept organizing and expanding its reach, on the streets and online, but its impact on Spanish politics was inherently limited. The movement held the antiestablishment position that Spain's democracy was not a true democracy and must be fixed in order to fix the

crisis. This stance—which could be seen as hopelessly idealis-
tic or bravely pragmatic—by default restricted its engagement
in the political process. Municipal and national elections that
year confirmed that there would be no changing of the guard
or systemic modifications, although the status quo would get
shaken up two years later by the appearance of new upstart
political parties on the left and right. In October, Leopoldo
reflected in an interview on the failure of Marxism, which had
served as his raison d'être in his youth, back when the prospect
of democracy in Spain was still a fantasy. "I don't even know
what revolution is," he said, speaking incisively to the moment.
"We must revise the concept of revolution."

Ruin, disaster, suicide, violence, depression, nostalgia for a
happier past—in the span of just a few short years, life in Spain
had become painfully Panero-esque. With the outbreak of the
crisis, the tropes that the family Panero wrote about and em-
bodied had become the substance of everyday life. As the great
"Spanish Miracle" that had begun with Franco opening the coun-
try's insular economy in the 1960s definitively died, the present
reached into the past from which the Paneros had sprung. After
the Civil War, corruption as an accepted norm had taken root in
Spain, a precursor to the present. The police had perfected their
tactics beating and arresting Leopoldo and his peers during the
dictatorship, and aspects of this policing culture persisted. The
constitution, the supposed trophy of the Transition, contained
an article intended to curb real-estate speculation and guarantee
the right to shelter for all, yet fewer Spaniards than ever had
adequate housing—thanks to speculation. Constitutional con-
tradictions such as this were no less striking than symbolic mo-
narchical failures. The instigator of the Transition himself, King
Juan Carlos, floundered as the figurehead of state. Members of
the royal family faced corruption investigations, and in 2012, the
king broke his hip while hunting elephants in Botswana. Instead

of feeling bad for him, Spain was angry. While average people were struggling to survive, he was off recklessly gallivanting on an exotic vacation. A national scandal ensued and he abdicated two years later. The red, yellow, and purple stripes of the flag of the Second Spanish Republic waved at protests.

Before the crisis, Spain had shed a painful past and created a future few could have imagined before Franco's death. But now the future was uncertain again. In spite of great, admirable progress, Spain was still pulled by the past that had created the Paneros.

AS THE SPANISH PEOPLE AND THEIR POLITICIANS ROCKILY NAVIGATED THE CRISIS, THE culture remained subtly aware of Juan Luis and Leopoldo María and the Panero family as a whole. Their books sold in a steady drip and pieces about their lives and work appeared periodically on blogs and in newspapers. *The Disenchantment* still ran on TV, was screened in local film series across the country, and the DVD still found buyers in stores. For the young cultural set the Paneros were a hip, black-and-white throwback to a past era. For older generations the family was a reminder of the Transition. And now with only two Paneros left, a question about the family murmured beneath the passage of time: Had the Wittelsbach prophecy Michi had set down in *The Disenchantment* come true? The three Paneros brothers obsessed with and burdened by their literary heritage had left no biological heir. Yet the completion of the prophecy remained elusive. When would they die out? When would the family fulfill its eerie destiny?

When would the Paneros become a *fin de raza*?

LEOPOLDO MARÍA APPEARED TO HAVE SIMILAR QUESTIONS ON HIS MIND, WITH HIS own delirious slant. In the final years of his life, he occasionally

mumbled about having a son, though who he was, how he knew about him, or who the mother was he never specified. In all likelihood it was a fiction, one last mythic reckoning with inheritance. While he had no contact with his brother, friends visited him, including a woman named Evelyn De Lezcano, who became his typist. She was reluctant to share her memories of Leopoldo, limiting herself to writing, "He was a person that I loved a lot. An exceptional man that gave me his friendship and affection. A man that suffered but knew how to hold on to a space for joy and to keep being a child. A great poet, humble, very humble in his greatness." This is a description of Leopoldo that few could ever have imagined reading when he was a young man, let alone when he was a not so young man. Such an evocation of who he had become late in life was vindication, in a sense, of a phrase he had coined years ago, which he often repeated to Evelyn: "Time, and not Spain, will say who I am."

Juan Luis near the end of his life

But Juan Luis was the Panero brother whom time would take first. His cancer surged into his lungs in 2013. In early September he moved into the hospital. Carmen felt his absence at home acutely. During her visits to the hospital, the two used jokes to talk about his imminent mortality. She asked him who was going to wash the dishes or bring her her dinner tray while she sat watching television.

"Who's going to open bottles of wine for you?" Juan Luis laughed.

While in the hospital, Juan Luis turned seventy-one. A few days later, he told Carmen that he felt he was dying. In a poem written long ago, he had described human existence as "that naïve invention of desires and memories, / of words and gestures, that we call life." A poet obsessed by death, he met his own the next day, on September 16.

His naïve invention was over. His words and gestures now belonged to memory.

WITH THE REST OF HIS FAMILY GONE, LEOPOLDO MARÍA WAS LIKE THE LAST SURVIVOR of a vanished civilization. De Lezcano recalled, "From time to time he made comments that revealed he missed having his family, not only Juan Luis, but Michi and his parents, although he usually said the opposite in front of people." Leopoldo lasted only slightly longer than Juan Luis and died younger than him. He had lived too hard, with too much abandon, for too long.

In early 2014, Leopoldo suffered a fall and hurt himself. Henceforth he stayed in bed. Soon after, on February 28, his first great love, Ana María Moix, the infatuation which had driven him to attempt suicide for the first time, died in Barcelona.

Leopoldo María died five days later, at age sixty-five.

Upon hearing of his death, two local poets sat vigil outside the morgue, while word spread from the Canary Islands to the

rest of Spain. The national media reported the news: the last member of the Panero family, that legendary *fin de raza*, was gone. A Niagara Falls of obituaries, remembrances, and other commentary flooded radio, newspapers, and social media. Gara Santana, a graduate of the University of Las Palmas who had known Leopoldo, said goodbye to him on her blog. "You were an unrepeatable person," she wrote, "who gave us your talent, like lions give us spectacle in exchange for their captivity."

It is impossible to know what Leopoldo María or the rest of the Panero family would have thought of the spectacle of their extinction. Likely, they would have disparaged all the hullabaloo, while nonchalantly taking credit for engineering it and perhaps secretly enjoying it. In his 1980 book *Last River Together*, Leopoldo María had written, "I who prostituted everything, I can still / prostitute my death and make of my cadaver my final poem." But neither Leopoldo María, nor his brothers Juan Luis and Michi, nor his mother Felicidad and his father Leopoldo, needed to keep crafting their legacy. It was already secure, a product of their imagination, their country's history, and the deep human need for stories. Indeed, if the long and singular saga of the Paneros hadn't been real life, it might very well have been a strange and timeless work of literature: a play, a novel, a poem.

A poetic hallucination.

EPILOGUE

In the spring of 1974, Leopoldo María received a grant from an arts foundation to write, as he put it in his application, "a text that devours itself." Naturally, this fantastical proposition never came to fruition, and not just because its feasibility was dubious to begin with. Eager to obtain the full sum of the grant, Leopoldo turned in excerpts of his self-immolating work in progress, trapped again, just like the rest of his family, between two dueling urges: the desire to create and to destroy.

The Paneros were prolific creators. During the 105 years of their existence, from Leopoldo Panero's birth in 1909 to Leopoldo María's death in 2014, they wrote several thousand pages of poetry and prose. The Paneros were also prolifically destructive. The choices they made resulted in a disintegration akin to the one that Leopoldo María imagined for his proposed text. They were devoured—by ambition and pride, insanity and addiction, anger and loneliness, pain and disappointment, memory and myth. They even managed to let their lives be eaten away by those two ostensibly most generative of forces, love and literature. Yet the collective text of their lives—the story of the Paneros—hasn't been devoured by time. It hasn't left behind blank pages. On the

contrary, over the decades, the destruction of the five members of a Spanish family that was both ordinary and extraordinary has become a powerful creative force of its own.

In Spain, the Paneros are a literary subgenre unto themselves. You could think of the family as a stone dropped into the pond of Spanish culture, producing a succession of ripples. At the epicenter are the lives they led and the works they published while alive, including the two documentaries they collaborated on. Radiating out from this splash of words and deeds are ever-growing ripples of related works that feed—or more accurately, *feast*—on the Paneros' legacy: academic studies and journalism examining and chronicling the family; fiction and poetry inspired by the Paneros (there's a well-known song by the singer Nacho Vegas titled "The Man Who Almost Met Michi Panero"); documentaries and experimental films; and memoirs about the family by people who knew them. Finally, in the last ring, which is also in a sense that same stone heaved into the pond, are "new" works by the Paneros: reissued books, such as Felicidad's memoirs (brought back into print in 2015) and her collected stories; new selections of poetry, such as Leopoldo Panero's *En Lo Oscuro* (In the Dark); letters, such as Leopoldo María's correspondence with a young writer-fan; and posthumous works, such as previously published manuscripts by Leopoldo María, and touchingly, Michi's short stories, which his stepson Javier Mendoza gathered together for a 2017 book that also includes a short memoir about his singular stepfather. "The writer with no books," as people referred to Michi, is at last an author with his own book. And then of course there is the book that you're reading, the latest but surely not the last entry in this veritable library of Panero literature. In the end, the family that famously died out as a *fin de raza* is still alive in the literary gene pool, continually spawning numerous offspring. "Turn yourself into your posthumous work," Leopoldo María wrote. He and his family did just that.

During the years since Leopoldo María's death and the extinction of the direct family bloodline, the Paneros have undergone a renaissance of sorts. By dying out they have been reborn. Along with the works I referred to above—nearly all of which were published either in the twilight years of the Panero saga or after they were all gone—the Spanish literary ecosystem has given renewed attention to the family. A new generation of writers is redigesting the legacy of the family in literary magazines and other venues at the same time that the older generation continues to reckon with them. (Jaime Chávarri, the director of *The Disenchantment*, published a 2016 piece revisiting his experience with them, titled "Assholes to the Father.") The Paneros are a constant on media platforms like Twitter, where people quote *The Disenchantment*, tweet their verses, invoke their magnificent dysfunction, share articles and memes about them, and make clever jokes about the family members. (My favorite #panero tweet might be one suggesting there should be a BuzzFeed quiz to determine which of the five Paneros you are.) In the subculture of Panero geek/scholars that I have come to be part of in Spain, there are even two labels used to jokingly describe us: *Paneristas* or *Panerólogos*—Panerists or Panerologists—making it sound as if entering the world of the family turns a person into either a member of a subversive political group or a doctor with an obscure medical specialty. Spain has definitively embraced the Paneros to the extent that before the movie producer Elías Querejeta's death in 2013, he and Jaime Chávarri were invited to Astorga for a screening of *The Disenchantment*. "They received us marvelously," Chávarri told me.

After the completion of the long-delayed renovations that Michi didn't live to see, the Panero family home began hosting cultural events in 2011. When I visited the house for the first time for a meeting of the members of the Casa Panero Association, I spent time wandering the sprawling second floor, then went up another flight of stairs and out onto the balcony of Leopoldo

Panero's *torreón*, where I gazed out over the rooftops of Astorga. While the renovations had made the house unrecognizable from the interiors I had examined in photos, I felt a strange and goose-bumpy sensation pass through me. It wasn't an identifiable emotion so much as the feeling of stepping across time into the place where history and myth meet. *This is where it all started*, I thought.

Now that the Paneros are gone, Spanish culture seems ready to begin assessing their lives and their works anew, both individually and in their totality. In doing so, people will struggle with an issue that others around the world find themselves struggling with today: separating—or not separating—artists from the works that they create. For example, does Leopoldo María's poetry hold up outside of the dark glow cast by his *maldito* legend? And perhaps more pertinently, does Leopoldo Panero's complicity with the Franco dictatorship nullify the merits of his work? For many readers in Spain a disqualifying odor of Francoism still clings to his poetry. The fact that more than one verse by this conservative Catholic Spanish poet nearly brought this left-wing American Jew to tears during the writing of this book suggests to me that answering this question will be an interesting but lengthy process. I suspect that until the country is able to truly relieve some of the pain and divisions left by the Civil War and the dictatorship, as well as address lingering problems from the Transition, politics and artistic merit will remain messily entangled. Maybe this is okay; maybe it isn't. A respectful conversation is surely more important than any final answer or resolution. Politics and literature have always been inseparable.

The general consensus around the Paneros seems to be that they were exceptionally unique and powerfully thematic—their lives, their works, and the borderland between the two. There will always be newcomers who discover the family and get set on fire the way I did simply because of their intoxicating weirdness,

poetic obsessions, and sacrilegious taste for destruction. They enact our fantasies of living life as if it were bigger than mere life—as if it were literature. In conjunction with this appreciation of the family's lasting magnetism comes the recognition that they are a part of Spanish history. The country wouldn't be quite the same without them. Which brings us to this last question: What do the Paneros *mean*?

I would argue that the family has meant certain decisive things, but also that they mean whatever we want them to mean. Like all great works of literature, the Paneros are open to interpretation. Individually, they serve as symbolic, perceptually fluid archetypes. Leopoldo Panero is a reactionary fascist, a symbol of a fractured nation, an avatar of traditional Spanish values. Felicidad Blanc is a sly feminist, a relic of old-world elegance, a vain manipulator of a legacy. Juan Luis is a stoic loner, a clownish dandy, a young man who rebelled against his father only to come to resemble him. Leopoldo María is a genius, a madman, a revolutionary, an asshole. Michi is a playboy, a caricature of a liberal, a cruel flamethrower, a lost soul. The family is also adaptable to the needs of time. History bears this out. During Spain's transition to democracy, the Paneros were a way for the country to talk about the era that had just ended and explore the legacy of their dictator. In spite of being a commercial failure, when *After So Many Years* came out in 1995, the Paneros became a way for Spain to both look at the legacy of the rebel generations of the 1960s and '70s and debate Spanish family values in the present. It is in this latter arena where the Paneros offer much enduring and universal power—as an exploration of that immemorial creator of memories and myth: family. To some people their collective story represents the inherent difficulties of blood, the primal love and hate that come with relationships we are born into rather than choose (or do

in fact choose, in the case of romantic relationships). To others they embody the disaster that befalls us when blood ties attenuate and we allow traditional family structures to wither. And, of course, I have used the Paneros as a way to talk about my fascination, which was their fascination: the literature we make out of our experiences and the experiences we make out of literature. There are hazards in being our own narrators—especially if we're better at constructing our stories than living our lives, as each Panero did in his or her own way to lesser and greater extents—and now more than ever in the digital age, in which we are perpetually self-presenting. But there are also possibilities for redemptive creation, for using the stories we tell not just to meaningfully reshape life as it is told, but as it is lived, too.

I BEGAN THIS BOOK WITH THE STORY OF FEDERICO GARCÍA LORCA'S DEATH, FOLlowed by my story of discovering the Paneros. It felt like the most natural introduction to a narrative that I felt an overwhelming personal connection to, but which I hoped would speak to other people as well. Now that I'm finally at the end, after having filled four hundred pages chronicling the lives of the family, I find it impossible not to return to my own life as a narrator, although it wasn't ever my intention to close the Paneros' story this way.

During the three years that I spent writing this book, I often joked with my wife, Elisa, that the perfect way to end an epic family saga would be with the two of us starting our own family. She would roll her eyes and we'd laugh—that would have been living the way the Paneros so often did, letting the demands of writerly artifice overpower a freer, less narrativized approach to life. We weren't ready yet to take on the big questions about having children; we'd figure it out eventually. But it turned out

we had less control than we thought. Recall that Lorca didn't choose to die on a moonless night.

In the final months of the writing of this book, a friend who was like a sister to me died unexpectedly. Annika was the daughter of my mom's best friend. We grew up living next door to each other from the time I was one and she was five months old. For as long as I was aware of my existence, I was aware of hers. She was family. She was, as Luis Rosales wrote of his best friend Juan Panero after his death, "spirit of my spirit." My memories begin with her. Annika and I stayed close into adulthood and when Elisa and I moved from Spain to California, where she lived a half day's drive away, we saw her regularly. We saw her even more after she had a daughter. The four of us spent lazy, perfect weekends together, eating, hiking, talking about our lives, and doting on the beautiful creature Annika had created. She and Elisa became close, perhaps even closer than me and Annika. In the fall of 2017, she came and visited us, filling our apartment with her laughter. And then, a week later, she was gone.

The past months have been the most trying of my life. My disenchantment has been profound. At times it has felt bottomless. A few days after Annika's death, Elisa looked at me and said, "It's like what Michi said after Leopoldo's death—'*Eramos tan felices,*' we were so happy." A before and after had cut our life in half into a time with Annika and a time without her. It was hard to imagine feeling joy again.

This terrible period of grief has come to be inseparable from the completion of this book, its themes seeming to have turned into a virus that left the pages I had written to invade my life. I wrote a eulogy that I read at Annika's funeral, desperately wanting to exert some kind of control, to redeem my loss in some way through the construction of a narrative and the crafting of language. I returned to the lost paradise of the past, pulled

in two directions by fatal nostalgia that reveled in pain and life-giving memories aching with love. Like Leopoldo Panero, the "serene marvel" of my childhood felt like it had become "a house of smoke." I thought about what family had meant for me before and what it would mean for me now. While I looked at pictures and felt sure that Annika couldn't be dead, I could also feel her drifting into myth. *What would her legacy be?* I wondered. Forces beyond anyone's control had rewritten the story not just of my life but many lives connected to Annika's. Like the Paneros, like Spain, like everyone, I was torn between the desire to create and to destroy, to remember and to forget.

Annika was a single mother. The father of her child had never been involved in her or her daughter's life. In one of the many moments the four of us shared, Annika asked me and Elisa if we would raise her daughter if anything ever happened to her. We said yes, never imagining the worst would actually happen.

As I write this epilogue, Elisa and I are in the final stages of the process to bring Annika's four-year-old daughter into our home and our future. Joy is emerging from the pain. This little girl who will become ours is wonderful beyond words, and, in a seeming paradox of emotions given all that has happened, we feel like the luckiest people in the world. To prepare our daughter for her transition, Elisa and I have made her a book that we hope will help her make sense of her life, now and in the future. It has pictures, a short text, and contains the unembellished truth, which nonetheless seems to possess poetry. It talks about my childhood with Annika, the good times we all had after I met Elisa, and how Annika asked us to create a new family if she were ever to die. Elisa and I have come to realize that the book is as much for us as it is for our future daughter. It is and will always be her story and ours—and Annika's. Annika

often said that she wanted us to raise our children together. It shouldn't have happened this way, but with her memory present, now we will.

This is the story that we will give our daughter. I dearly hope it will help her to live.

ACKNOWLEDGMENTS

First thanks goes to the guy who got this all started, Javier Carazo Rubio, for knowing I would flip for the Paneros and for being my pied-à-terre in Madrid for the last six years. Here's to many more years of *cañas* and conversation. Second thanks goes to Karolina Waclawiak, who went for my pitch of an essay (which she expertly edited) about a cult Spanish documentary, and thanks to *The Believer* and its staff, especially Andi Winette, for giving me a place to begin writing about the Paneros and the nerve to think that they might be of interest to American readers.

Four people in Spain who played instrumental roles in the creation of this book deserve special mention. J. Benito Fernández provided me with valuable introductions to people in the world of the Paneros when I was first beginning; his biography of Leopoldo María is not only a paragon of reporting, but a veritable archive preserving countless documents that have since disappeared. Túa Blesa, a brilliant scholar and kind person, also provided indispensable support at the very beginning. Javier La Beira of the Málaga Cultural Centre of the Generation of '27 gave me all of his enthusiasm from our

first contact, followed by unstinting assistance; help during a crisis; friendship—and *pescaíto frito*. Javier Huerta Calvo of the Complutense University of Madrid likewise embraced my project from our first meeting at El Ateneo de Madrid. Not only did he help me get started understanding the life of Leopoldo Panero and generously give of his expertise every time I needed it (which was often), he also drove me to and from Astorga and made sure I ate *cocido maragato*, the traditional dish of the region. Javier's work as a scholar and with the Casa Panero in Astorga have been essential to the preservation of a complex chapter of Spanish literary history.

The collections and staff of numerous libraries, cultural institutions, and archives made this book possible. I am indebted to: the National Library of Spain, the Astorga Municipal Library (with matchless librarian Esperanza Marcos de Paz), the Cultural Centre of the Generation of '27 (Teresa Muñoz Menaique's assistance was invaluable), the Spanish National Historical Archives, the Document Center of Historical Memory, the Military Archives of Guadalajara and Avila, the Los Angeles Public Library, and the Library of the University of California, Santa Barbara.

I am enormously grateful to the heirs of the Panero and Blanc estates: Carmen Iglesias, Javier Mendoza, and María Rosario Alonso Panero and her family.

This book would not exist without all the people who generously shared their memories with me and the countless other people who helped me in big and small ways. I would like to give extra thanks to the following people: Inés Ortega, Augusto Martínez Torres, Asís Lazcano, Marta Moriarty, Marcos Barnatán, Juan José Alonso Panero, Juan José Alonso Perandones, Luis Rosales Fouz, Marcos Giralt, Marisa Torrente, Luis Antonio de Villena, Evelyn de Lezcano, Federico Utrera, James Matthews, Joaquín Araújo, Miguel Barrero, Vicente Molina Foix, Javier

Parra, Fernando Bruquetas, A. Nicole Kelly, Sergio Fernández Martínez, Javier Domingo Martín, Miguel Caballero, Sebastian Stratan, Ernesto Burgos, Nuria Anadón, Peter Turnbull, Amanda Vaill, Tina Rosenberg, Pere Gimferrer, and Laura Santos Pérez. And a special-special thanks goes to *el gran* Jaime Chávarri, the genius director of *El Desencanto* who has become a good friend, and who makes the best margaritas.

For friendship and early enthusiasm: Chris and Emily Silver. For beers and conversation: Eloi Grasset and Mike Diliberti. And for their support and all they've taught me: Doug Abrams and Lara Love at Idea Architects.

My savvy and steadfast agent, Geri Thoma, picked my proposal out of the slush pile and pitched it to editors a few days later. Without her guidance and wisdom I would be . . . well, best not to think about it. Enormous thanks to her, Andrea Morrison, and everyone at Writers House. I was infinitely lucky to find the perfect editor for this book, Gabriella Doob, whose love for the Paneros is nearly as great as mine and who bore with me as the manuscript grew and grew, then shrank and shrank. It's been a joy working on this book together. Thanks to her, Daniel Halpern, Sara Wood, Renata De Oliveira, Linda Sawicki, Martin Wilson, Stephanie Vallejo, and everyone at Ecco. And to the PR spark plug Beth Parker.

My *polifacética* research assistant/transcriptionist Mar (Tati) Morales, whose remarkable ability to decode Felicidad Blanc's handwriting saved me countless hours (and mistakes). Young people like her will "lift up" Spain.

My good friends Jeremy N. Smith and Colin Asher wrote their books at the same time I wrote mine, providing me with vital advice and comfort in writerly and non-writerly matters alike.

Los Machotes de Granátula, my Córdoba friends who gave me a life in Spain that is always there waiting for me when I come

back: Javi (again), Chaque Hidalgo, Angelo la Torre, Manuel Amian del Pino, Fermín Marrodán Mangado, and José García Obrero (poet extraordinaire). My other friends in Spain whom I couldn't live without: Verónica Díez Arias, Carlos Briales, Patricia Alcalá, Leticia Antequera, and Miguel Salgado. You're all present in this book.

The best friends I could ask for—you all know what you mean to me: Lauren Hamlin, Caren Beilin, Andres Castillo, Carlos Queirós, Tagore Subramaniam, Ben Murray, Rob Root, Anton Handel and Emily Abrons (who gave me indispensable input as this book developed), Mark von Rosenstiel, Cheyna Young, JJ Nelson, and Anand Vimalassery (who gave this book a lovingly ruthless read for which I am eternally grateful).

My in-laws in Spain. I wouldn't know where to begin to thank you (or maybe I'd begin with all the food you've lavished on me). My *suegra*, María José Montilla Cardeñosa, my *suegro* José Luis Ortega Osuna, and my *cuñao*, Pablo Ortega Montilla. You've given me a home in Spain.

Thanks to my entire family. My parents, Judy and Bud Shulman, ingrained in me at a very young age the importance of travel, encouraged me to learn a second language, and always supported my (quixotic) dream of becoming a writer. I know how lucky I am.

And lastly, my wife, Elisa Ortega Montilla. Words are useless. *Te quiero con locura.*

NOTES

PROLOGUE: LORCA'S MOON

xi Before dawn on August 17, 1936: There is still debate among historians over what day Lorca was killed. In Miguel Caballero Pérez's book *Las trece últimas horas en la vida de García Lorca*, which I have drawn on to reconstruct the poet's final hours, he makes a convincing case that it was the seventeenth. I have also drawn on several other books: *Federico García Lorca: A Life* by Ian Gibson, *El hombre que detuvo a García Lorca: Ramón Ruiz Alonso y la muerte del poeta* by Gibson, *El asesinato de García Lorca* also by Gibson, and *Lorca: A Dream of Life* by Leslie Stainton. The exact location of Lorca's execution and subsequent resting place in the Granada hills remains unknown. Historians' quest to find it has led to two failed attempts to exhume his remains. The Lorca family is opposed to these exhumations.

xiii "I have never seen": Neruda, *Memoirs*, 122.

xiii "Not in Spain": García Lorca, *In Search of Duende*, 64.

xv "bloodbath": Trapiello, *Las armas y las letras: Literatura y guerra civil (1936–1939)*, 80. Trapiello cites an article from London's *News Chronicle* from July 18, 1936.

xv "the fag with the bow tie": Stainton, *Lorca: A Dream of Life*, 449.

xvi "Just as being born": Luis Bagaría, "Diálogos de una caricaturista salvaje: Federico García Lorca habla sobre la riqueza poética y vital mayor de España," *El Sol*, June 10, 1936.

xvi "question of questions": García Lorca, *In Search of Duende*, 13.

xvii *But now he sleeps*: Ibid., "Lament for Ignacio Sánchez Mejías," 85.

xviii "Flee, moon, moon, moon": García Lorca, "Romance de la luna, luna," *Poesía completa*, 367.

xxiii "His fantasy filled": Cervantes, *Don Quixote*, 21.

xxvi "We tell ourselves stories": Didion, "The White Album," *The White Album*, 11.

CHAPTER 1: A PREMATURE SKELETON

3 "phantasmagoria": Leopoldo Panero, "Marruecos impresiones de un viaje," *Obra completa: Prosa*, 501.

5 "Long Live Spain!": Álvarez Oblanca and Secundino Serrano Fernandéz, *La guerra civil en León*, 36.

7 "more blood": Jay Allen, "Slaughter of 4,000 at Badajoz, 'City of Horrors,' Is Told by Tribune Man," *Chicago Tribune*, August 30, 1936.

8 "It was because of wickedness": Odila Panero in discussion with the author, December 2016.

9 7,000 men: Gallo Roncero and López Alonso, *San Marcos: El campo de concentración desconocido*, 12.

10 "You'll see": To reconstruct Leopoldo's time in the San Marcos prison I have used Ricardo Gullón's *La juventud de Leopoldo Panero*, Felicidad Blanc's *Espejo de sombras*, the work of local Astorga historian Miguel García Bañales, Gallo Roncero and López Alonso's *San Marcos: El campo de concentración desconocido*, Victoriano Cremer's *Libro de San Marcos*, and the testimony of Leopoldo Panero's niece Odila Panero.

10 "resuscitated": Cremer, *Libro de San Marcos*, 58.

11 "institution": Gullón, *La juventud de Leopoldo Panero*, 9.

11 mention of him on the front page: Juan Ramón Jiménez, "Una Carta del Insigne Juan Ramón Jiménez," *La Voz*, March 23, 1935.

13 *In the prison of lived disillusions*: Leopoldo Panero, "Escrito en plata," *Obra completa: Poesía I*, 314.

CHAPTER 2: THE *SEÑORITO* FROM ASTORGA

15 "miraculous ruins": Leopoldo Panero, "La estancia vacía," *En lo oscuro*, 172.

17 "united by a link": Gullón, *La juventud de Leopoldo Panero*, 7–8.

19 "Divine treasure": Darío, "Cancíon de Otoño en Primavera," *Cantos de vida y esperanza*, 90.

20 "That walk of his": Luis Alonso Luengo, "El recuerdo y la poesía de Juan Panero," *Espadaña*, no. 5, 1944, 103.

22 "always happy": José Antonio Maravall, "Poesía del Alma," *Cuadernos Hispanoamericanos*, no. 187–88, 1965, 138.

22 "the Purpose that your arms": Leopoldo Panero, "Romance del nadador y el sol," *En lo oscuro*, 139.

22 "the ineffable and mysterious mist": Leopoldo Panero, "Creación, Poesía," *Nueva Revista*, no. 4, January 31, 1930, 1.

23 "made of wind": Leopoldo Panero, "Joaquina Márquez," *En lo oscuro*, p. 194.

24 "poor melancholy angel": Dubos, *The White Plague: Tuberculosis, Man, and Society*. "Poor melancholy angel" is what the writer George Sand called her tubercular lover, the composer Frédéric Chopin.

24 "Until I met you": Joaquina Márquez to Leopoldo Panero, December 22, 1930, LPA.

25 "I can't believe": Joaquina Márquez to Leopoldo Panero, December 7, 1930, LPA.

25 "I remove myself": Joaquina Márquez to Leopoldo Panero, March 5, 1931, LPA.

27 "brought us exotic aromas": Lorenzo López Sancho, "Cesar Vallejo," *ABC*, April 14, 1978.

29 "This is the year": Juan Panero to Luis Rosales, August 8, 1935, LRCA.

29 "closer to death": García Lorca, "Presentación de Pablo Neruda," Madrid, December 6, 1934. Quoted in Feinstein, *Pablo Neruda: A Passion for Life*, 107.

30 "I loved you": Leopoldo Panero, *Canto personal*, 123.

31 "To lose you": Leopoldo Panero, "Por el centro del día," *En lo oscuro*, 144.

CHAPTER 3: TO WIN AND TO CONVINCE

37 "*Venceréis, pero no convenceréis*": This account of Unamuno's defiance draws on Andrés Trapiello's *Las armas y las letras*, Hugh Thomas's *The Spanish Civil War*, and Luis Moure Mariño's *La generación del 35: Memorias de Salamanca y Burgos*. Máxima Torbado's journey to Salamanca draws on a variety of sources, including stories of Panero family members and Felicidad Blanc's *Espejo de sombras*.

CHAPTER 4: LIKE AN ALMOND TREE

39 brought him into the world twice: Juan José Alonso Panero in discussion with the author, December 2016.

41 some seven thousand in total: Graham, *The Spanish Civil War: A Very Short Introduction*, 27.

43 Membership had swelled: Thomas, *The Spanish Civil War*, 491.

44 "For God, For Spain": Provincial chief's name illegible, "Credencial" (Traditionalist Spanish Falange and J.O.N.S., Provincial Salamanca Headquarters, 1937), 1, LPA.

44 "The cause of republican Spain": Vallejo, *Selected Writings of César Vallejo*, 497–98.

45 "Never since": Weintraub, *The Last Great Cause*, 2.

45 "fashionable pansies": George Orwell quoted by Clarke, *Orwell in Context*, 94.

45 "In the history of the intellect": Neruda, *Memoirs*, 128.

46 "a gang of sap-headed dilettantes": Ezra Pound et al., "Authors Take Sides on the Spanish War," 28.

46 "Here I am": Miguel Hernández, "Sentado sobre los muertos," *Viento del pueblo*, 63.

47 "The great tragedy": Miguel Hernández, *Viento del pueblo*, 38.

48 "the first hopes": Leopoldo Panero, "Unas palabras sobre mi poesía," *En lo oscuro*, 319.

48 "He died for God": Unknown, "Juan Panero Torbado," *El pensamiento Astorgano*, August 10, 1937, 1.

48 "All at once": Leopoldo Panero, "Unas palabras sobre mi poesía," *En lo oscuro*, 319.

48 "I'm writing to you": Luis Rosales to Leopoldo Panero, August 10, 1937, LPA.

49 "It is absolutely necessary": Luis Rosales and Luis Felipe Vivanco to Leopoldo Panero, October 26, 1937, LPA.

49 "Naturally the verse": Leopoldo Panero to Máxima Torbado and Moisés Panero, July 20, 1938, LPA.

50 "like a fountain": Leopoldo Panero, "A Miguel Arredondo Elorza," *Obra completa: Poesía I*, 265.

51 "On opening your doors": Leopoldo Panero, "En la cathedral de Astorga," *En lo oscuro*, 241.

51 "Was it an authentic conversion": Luis Alonso Luengo, *La ciudad entre mi*, 247.

51 "Spaniards sacrificed": García Lorca, *In Search of Duende*, 97.

51 "behind the nullity": Leopoldo Panero, "Unas palabras sobre mi poesía," *En lo oscuro*, 322.

51 change his life: Lorenzo M. Juárez to Leopoldo Panero, February 22, 1938, LPA. The actual letter from Panero to Juárez has been lost, but in his response Juárez writes: "You tell me that you're going to change your life. . . ."

CHAPTER 5: VERSES OF A COMBATANT

53 "remember my house": Neruda, *España en el corazón*.

54 "Not only did they": Manuel Altolaguirre quoted in Feinstein, *Pablo Neruda: A Passion for Life*, 138.

54 "His truncheon": Ernesto Giménez Caballero, "Su porra, su falo incomparable." Quoted in Rodríguez Puértolas, *Historia de la literatura fascista española: I*, 364.

55 "Until we conquer": Camacho (pseudonym), "Con el corazón partido," *Los versos del Combatiente*, 22.

55 "The book was created": Luis Rosales, "Magnífico como escritor, insuperable como hombre," *ABC*, July 21, 1981.

55 "In the Alfambra Valley": Camacho (pseudonym for Leopoldo Panero for this poem), "Presente," *Los versos del Combatiente*, 23.

56 killed at least 1,200: This estimate comes from Payne, *The Spanish Civil War, the Soviet Union, and Communism*, 55. In *The Spanish Civil War*, 136, Thomas estimates between 1,500 and 2,000.

56 "acrostic sonnet": María Nuria Anadón Álvarez, email message to author, October 17, 2016. Anadón is the daughter of Leopoldo Panero's wartime girlfriend, María Esther Álvarez; she recalled her mother's memories of Panero.

57 "In a poetic movement": José Antonio Primo de Rivera quoted in Payne, *Fascism in Spain: 1923–1977*, 91–92.

57 "watches over": Leopoldo Panero, "Soneto a José Antonio," *Corona de sonetos en honor de José Antonio Primo de Rivera*, 16.

58 "There are many who": Hemingway, *For Whom the Bell Tolls*, 216.

59 "if mother / Spain": Vallejo, "XIV," *The Complete Posthumous Poetry*, 265.

60 "extraordinarily ruined": Leopoldo Panero to Máxima Torbado and Moisés Panero, March 25, 1939, LPA.

60 Close to 200,000 people [and other figures mentioned]: Preston, *The Spanish Holocaust*, xi.

61 "the *señorito* that rises": Leopoldo Panero, "El Jinete," *En lo oscuro*, 283.

CHAPTER 6: THE GIRL WHO CRIED

63 "That name was like": Blanc, *Espejo de sombras*, 24.

65 a cameo in a novel: Cela, *San Camilo, 1936*, 18.

67 "mythical figure": Blanc, *Espejo de sombras*, 48. Subsequent scenes I reconstruct from Blanc and her family's life are drawn from her memoir, *Espejo de sombras*.

68 "with that mixture": Ibid., 79.

69 "dead companions": Blanc, "Carta Primera," *Cuando Amé a Felicidad*.

69 "What fixation": Blanc, *Espejo de sombras*, 59.

CHAPTER 7: LONG LIVE SPAIN

72 "The first joining": Ibid., 83.

72 "Learned the eternal walk": Juan Luis Panero, "La muerte entre estas paredes (Última visita a Manuel Silvela, 8)," *Poesía Completa*, 106.

74 "The prettiest girl": Formica, *Escucho el silencio,* 100.

75 "I fall in": Blanc, *Espejo de sombras*, 110.

76 "The terror": Ibid., 105.

76 "Sunday's elections": King Alfonso XIII of Spain quoted in Thomas, *The Spanish Civil War*, 19.

77 "romantic kinship": Blanc, *Espejo de sombras*, 107.

79 "In that climate": *El desencanto*, directed by Jaime Chávarri (1976: Madrid, Spain: Video Mercury Films, S.A.), DVD.

81 "The city has": Cansinos Assens, *Novela de un literato*, vol. 3, 455.

82 eight thousand rifles: *The Spanish Civil War*, 139.

82 *We're saying goodbye*: Blanc, *Espejo de sombras*, 121.

CHAPTER 8: A FEW DAYS

87 "Every neighbor": Gullón, unpublished memoir, RGP.

CHAPTER 9: ¡NO PASARÁN!

97 "A part of the Spanish": Foxá, *Madrid, de corte a checa*, 281.

CHAPTER 10: WE WON'T BE THE SAME

100 "the same carnavalesque": Morla Lynch, *España sufre*, 797.

101 Felicidad's membership card: Felicidad Blanc, "Agrupación Femenina de Izquierda Repúblicana," (1936), DCHM.

101 *Now we must retrace*: Blanc, *Espejo de sombras*, 148.

102 "our youth": Blanc, "Carta Segunda," *Cuando amé a Felicidad.*

CHAPTER 11: LIGHT ENTERS THE HEART

106 *I hate him*: Blanc, *Espejo de sombras*, 154. To reconstruct Leopoldo Panero and Felicidad Blanc's courtship I have relied on her memoir, *El Desencanto*, and letters from LPA.

107 "The war left a deep mark": Gullón, *La juventud de Leopoldo Panero*, 92.

109 270,000 people: Preston, *The Spanish Holocaust*, 509.

110 *I'm in love*: Blanc, *Espejo de sombras*, 160.

111 "Maybe it was": Ibid., 155.

112 "other me": Ibid., 168.

112 "the man of the secret": Pedro Laín Entralgo, "El hombre de secreto," *Ínsula*, no. 193, 1962, 1.

113 "the national community": State Agency Official Bulletin of State, *Ley de Principios del Movimiento Nacional*, 1958.

113 *Your beauty is true*: Leopoldo Panero, "Cántico," *En lo oscuro*, 149–51.

CHAPTER 12: IF WE KNOW HOW TO DESERVE OUR HAPPINESS

117 "No one questioned": Gullón, *La juventud de Leopoldo Panero*, 102.

118 "Spain cannot": Preston, *Franco*, 383.

119 "I didn't know": Leopoldo Panero to Felicidad Blanc, July 18, 1940, LPA.

119 "The hours have become": Felicidad Blanc to Leopoldo Panero, July 23, 1940, LPA .

120 "To hear the whistle": Leopoldo Panero to Felicidad Blanc, July 30, 1940, LPA.

CHAPTER 13: TRIUMPH OF LOVE

122 "millionaires of crumbs": Leopoldo Panero, *Canto personal*, 83.

123 "I'm coming to Madrid": Leopoldo Panero to Felicidad Blanc, October 9, 1940, LPA.

124 "true, upright, and clean": Ridruejo, "El Poeta Rescatado," *Escorial: Revista de Cultura y Letras*, no. 1, 1940, 95.

124 "all of those": Blanc, *Espejo de sombras*, 169.

125 *If we just kept walking*: Ibid., 176.

126 "Triumph of love": Gerardo Diego, "A Felicidad Leopoldo (version provisional de urgencia)." Quoted in Blanc, *Espejo de sombras*, 178.

CHAPTER 14: THE SURVIVOR

131 "I'm a count": Agustín de Foxá quoted in Trapiello, *Las armas y las letras*, 75.

131 "the poetry of the survivors": Leopoldo Panero, "Unas palabras sobre mi poesía," *En lo oscuro*, 319.

131 "*when* the fascists win": Lowry, *Under the Volcano*, 106.

132 "God, Spain, and": G. Arias Salgado, "Nombramiento Provisional," (Vice-secretary of Education, F.E.T., and J.O.N.S., Madrid, 1944), 1, LPA.

132 "It was easier": Hemingway, *For Whom the Bell Tolls*, 383.

CHAPTER 15: WORD OF MY SILENT DEPTH

133 "the sad, dustry Madrid": Leopoldo Panero, "Los intelectuales y el verano," *Obra completa: Prosa*, 516.

133 "The desire to die": Blanc, *Espejo de sombras*, 195.

135 "drowsy frenzy": Leopoldo Panero, "Hijo mío," *En lo oscuro*, 237.

CHAPTER 16: HOUSE AND TRADITION

137 "Madrid is a city": Alonso, "Insomnio," *Hijos de la ira*, 85.

138 "Oh yes, I know her": Alonso, "Mujer con alcuza," *Hijos de la ira*, 115–21.

139 *You'll always be in those poems*: Blanc, *Espejo de sombras*, 190.

139 "the biography of my soul": Leopoldo Panero, "Unas palabras sobre mi poesía," *En lo oscuro*, 315–26.

139 "all of you": Leopoldo Panero, "La estancia vacía," *En lo oscuro*, 159–90.

141 "the masterpiece": Diego, "Poesía española contemporánea," *Obras completas*, 1091–99.

142 ten thousand Spanish Republicans: Graham, *The Spanish Civil War: A Very Short Introduction*, 126.

CHAPTER 17: BATTERSEA PARK

145 "a half-razed home": Juan Luis Panero, *Sin rumbo cierto*, 18.

149 "that polite scarecrow": Juan Luis Panero, "Galería de fantasmas," *Poesía completa*, 259.

149 "a conglomerate of horrors": Luis Cernuda quoted by Martínez Nadal, *Españoles en la Gran Bretaña,*159.

150 "like two who since long ago": Blanc, *Espejo de sombras*, 212. To reconstruct Felicidad's relationship with Luis Cernuda in London I have relied on her memoirs, short essayistic pieces from her book *Cuando amé a Felicidad*, and memories of people who knew her.

151 "didn't have her feet": Gregorio Prieto quoted by Fernández, *El contorno del abismo*, 40.

151 "The cognac loosened": Martínez Nadal, *Españoles en la Gran Bretaña*, 177–81. I have used Martínez Nadal and Felicidad Blanc's accounts to reconstruct this incident.

151 "At the head of the table": Luis Cernuda, "Familia" *Agni*, http://www .bu.edu/agni/poetry/print/2014/79-cernuda-family.html.

153 "It wasn't one day": Blanc, *Espejo de sombras*, 215.

153 "never about our love": Ibid.

154 "It is likely": Juan Luis Panero, *Sin rumbo cierto*, 24.

154 "We didn't even": Blanc, *Espejo de sombras*, 216.

CHAPTER 18: THE WRITER AND THE WOMAN, THE POET AND THE MAN

156 "the stuffy atmosphere": Blanc, "El domingo," *Cuando amé a Felicidad*.

158 "The exact good sense": Leopoldo Panero, "La vocación," *En lo oscuro*, 255–56.

158 "your intimacy with blood": Leopoldo Panero, "España hasta los huesos," *Escrito a cada instante*, 101–3.

158 "After reading your book": Luis Cernuda to Leopoldo Panero, September 27, 1949, LPA.

158 "the equality": Leopoldo Panero, "La vocación," *Escrito a cada instante*, 171.
160 "By way of pain": Leopoldo Panero, *Canto personal*, 20.

CHAPTER 19: EXTRAPOETIC CHOICES

162 "Those poems": Blanc, *Espejo de sombras*, 221.
163 *From the outset*: Leopoldo Panero to Alejandro Carrión, July 7, 1950, LPA.
164 "He tells me": Blanc, *Espejo de sombras*, 232.
166 "for the good of the Patria": Antoni Tàpies, *Memoria personal*, 244.
168 "authentic": Unknown, "Ayer, fiesta de la hispanidad, el jefe del Estado inauguró la primera exposición," *ABC*, October 12, 1951, 15.
170 "self-promotional set piece": Gibson, *The Shameful Life of Salvador Dalí*, 520.

CHAPTER 20: FRIENDS AND ENEMIES

174 "the people": Neruda, *Memoirs*, 149.
174 "Can poetry serve": Ibid., 139.
175 "I moved from house to house": Ibid., 173.
176 "gorgeously virgin": Leopoldo Panero, *Canto personal*, 44.
177 "May those who killed": Neruda, "A Miguel Hernández asesinado en los presidios de España," *Canto general*.
177 "almost forgave": Carlos Fernández Cuenca, "En su casa de Astorga y en un bar de Madrid, escribió Panero el 'Canto personal,'" *Correo Literario*, December 15, 1953, 14.
177 "blow by blow": Leopoldo Panero, "La estancia vacía," *En lo oscuro*, 190.
178 "Your insults" [and subsequent verses]: Leopoldo Panero, *Canto personal*.
180 "If political prejudice": Brenan, "A Literary Letter from Spain," *The New York Times*, October 11, 1953.
180 "The intention of Panero's book": Unknown, "Neruda frente al *Canto personal*," *Ercilla* 12–13.
180 "I was a fairly pure": Pilar Narvión, "Entrevista a Leopoldo Panero," *El Español*, June 19, 1953.
180 "My heart beats": Leopoldo Panero, "Carta con Europa en los ojos," *En lo oscuro*, 260.

CHAPTER 21: GOOD BREAD AND BAD WINE

181 "intensely happy": Leopoldo Panero, "Introducción a la ignorancia," *En lo oscuro*, 251–53.
182 "the impression of being": Álvaro Delgado, "Apuntes tras los pasos de Panero," *Astorga Redacción*, October 20, 2013, http://astorgaredaccion.com/not/2814/apuntes-tras-los-pasos-de-panero.

183 "So I said": Leopoldo María Panero quoted Blanc, *Espejo de sombras*, 248–49.

183 "I wonder if": José María Souvirón, unpublished diaries, July 10, 1956, JMSA.

184 "Poetry for the poor": Gabriel Celaya, "Poesía es una arma cargada de future," *Cantos iberos*.

186 "It is necessary": José María Souvirón, unpublished diaries, March 15, 1958, JMSA.

CHAPTER 22: THE KILLER OF NIGHTINGALES

187 "Genoa, Milan": Blanc, *Espejo de sombras*, 261.

188 "dark tomb": Juan Luis Panero, *Sin rumbo cierto*, 29.

189 "At twenty years old": Aquilino Duque in discussion with the author, April 2016.

189 "I wished time": Blanc, *Espejo de sombras*, 262.

189 "forgetful unforgettable love": Leopoldo Panero, "El viejo estío," *Escrito a cada instante*, 21.

190 "The road full of blood": Michi Panero, *El final de una fiesta* (unpublished memoir), in the author's possession, 5.

191 "Felicidad:" he wrote: Leopoldo Panero, "Como ninguna cosa," *En lo oscuro*, 269.

192 "You talk of nothing": Rafael Ormaechea in discussion with the author, August 2017.

193 "I became a conscious": Juan Luis Panero, *Sin rumbo cierto*, 50.

193 "Miguel Hernández dead": Neruda, "Meditación sobre Sierra Maestra," *Canción de gesta*, 103.

194 "system of intolerance": Open letter from Spanish writers, "El problema de la censura," *Boletín Informativo. Centro de Documentación y de Estudios*, December 1960, no. 4, 15–17.

194 "It turns out that now": Leopoldo Panero, "Por lo visto," *En lo oscuro*, 296.

195 "to sound out the truth": Leopoldo Panero, "Unas palabras sobre mi poesía," *En lo oscuro*, 326.

195 "Only poetry makes": Leopoldo Panero, *Canto personal*, 31.

195 "We started to inuit": *El desencanto*, directed by Jaime Chávarri (1976: Madrid, Spain: Video Mercury Films, S.A.), DVD.

197 "It's night now": Blanc, *Espejo de sombras*, 262.

198 *Because what matters*: Leopoldo Panero, "Como en los perros," *En lo oscuro*, 312.

CHAPTER 23: THERE I WANT TO SLEEP

202 "I was born in Astorga": Leopoldo Panero, *Canto personal*, 70.

203 "The most beautiful": Antonio Gamoneda, "Visión objetiva y emocionada de Leopoldo Panero," *El peso de lo alegre*, 50.

CHAPTER 24: EVERYTHING OR NOTHING
205 "I begin to belong": Blanc, *Espejo de sombras*, 275.
206 "personal cataclysm": *El desencanto*, directed by Jaime Chávarri (1976: Madrid, Spain: Video Mercury Films, S.A.), DVD.
206 "broken gestures": Juan Luis Panero, "Al llegar el cuarto aniversario," *Poesía completa*, 60.
207 "Being the eldest": Michi Panero, *El final de una fiesta* (unpublished memoir), in the author's possession, 39.
207 "I was free": Juan Luis Panero, *Sin rumbo cierto*, 53.
208 "my repeated navigation": Juan Luis Panero, "Used words," *Poesía completa*, 128.
212 "They could be compared": Martín Gaite, *Usos amorosos de la postguerra espanola*, 18.
213 "Even at the hour": Juan Luis Panero, *Sin rumbo cierto*, 55.
214 "Leopoldo and I": Michi Panero, *El final de una fiesta* (unpublished memoir), in the author's possession, 6.

CHAPTER 25: DISCOVERIES
216 "sentimental history": Blanc, *Espejo de sombras*, 280.
217 "a discovery named": Ibid.
217 "I think of so many women": Blanc, *Espejo de sombras*, 263.
218 "the Big Out": Fitzgerald, "The Crack-Up," *The Crack-Up*, 81.
218 "the only freedom": Juan Luis Panero, *Sin rumbo cierto*, 58.
218 "insultingly precocious": Joaquín Araújo in discussion with the author, January 2016.

CHAPTER 26: THE ENCHANTING DISASTER
224 "days became simply": Durrell, *Justine*, 18.
225 "The truth is": Juan Luis Panero, *Sin rumbo cierto*, 34.
225 "thousand dust-tormented streets": Durrell, *Justine*, 31.
228 "The damn place": Ava Gardner, *Ava: My Story*, 271.
228 "crazy": Blanc, *Espejo de sombras*, 288.

CHAPTER 27: RIVALRY AND REFERENDUM
234 "change within": Tusell, *Spain: From Dictatorship to Democracy*, 211.
237 "the search for information": Jesús Rodríguez Barrio, email message to author, August 5, 2016.
239 "I was tired": Juan Luis Panero, *Sin rumbo cierto*, 78.

241 "He gave himself": Joaquín Araújo, "No te suicidaste," *El Mundo*, March 7, 2014, http://www.elmundo.es/cultura/2014/03/07/53198965e2704e2 a248b456b.html.

242 "Not words": Pavese, *This Business of Living*, 350.

242 "Leopoldo begins to accuse": Blanc, *Espejo de sombras*, 287.

244 "As if in an encoded language": Pere Gimferrer quoted in Fernández, *El contorno del abismo*, 90.

244 "He was being called on": Pere Gimferrer in discussion with the author, June 2015.

CHAPTER 28: THE GREAT COMPLICATION

247 "cadaver that still holds": Leopoldo María Panero, "Primer amor," *Poesía completa (1970–2000)*, 28.

247 "My playmate becomes": *El desencanto*, directed by Jaime Chávarri (1976: Madrid, Spain: Video Mercury Films, S.A.), DVD.

248 "This is what no poet": Pere Gimferrer to Leopoldo María Panero quoted in Fernández, *El contorno del abismo*, 94.

248 "I value you": Ana María Moix to Leopoldo María Panero quoted in Fernández, *El contorno del abismo*, 97.

248 "Peter Pan is nothing": Leopoldo María Panero, "Unas palabras para Peter Pan," *Poesía completa (1970–2000)*, 62.

250 "Leopoldo, as you know": *El desencanto*, directed by Jaime Chávarri (1976: Madrid, Spain: Video Mercury Films, S.A.), DVD.

CHAPTER 29: *LA LOCURA*

253 "cultural effervescence": Beatriz de Moura, email message to author, September 2017.

253 "Our art": Ana María Moix to Leopoldo María Panero quoted in Fernández, *El contorno del abismo*, 100.

254 "I realize that the old language": Blanc, *Espejo de sombras*, 285.

255 "non-demencial psychotic": Fernández, *El contorno del abismo*, 112.

256 "Insanity exists": Javier Rodríguez Marcos, "Seré un monstruo pero no estoy loco," *El Pais*, October 30, 2001, https://elpais.com /diario/2001/10/27/babelia/1004139550_850215.html.

258 "If I hadn't left traces": Leopoldo María Panero to Felicidad Blanc quoted in Fernández, *El contorno del abismo*, 124–41. The other quoted letters between Leopoldo María and Felicidad from this period come from the same source.

260 "In prison the odious dichotomy": *El desencanto*, directed by Jaime Chávarri (1976: Madrid, Spain: Video Mercury Films, S.A.), DVD.

CHAPTER 30: THE MUTE WITNESS

263 "I've always felt": Michi Panero, *El final de una fiesta* (unpublished memoir), in the author's possession, 1.

263 "epilogue": Michi Panero, "Michi," *El Desencanto* (screenplay published with essays), 131.

264 "They have a vice": Michi Panero, "También Dios mandaba en Normandía," *Funerales vikingos*, 63.

264 "Since I myself": Ibid., "La tumba de Adolfo Hitler," 23.

265 "For the first time": Michi Panero, *El final de una fiesta* (unpublished memoir), in the author's possession, 11.

265 "My only occupation": Michi Panero, "Michi," *El desencanto* (screenplay), 131.

266 "You have to dedicate yourself to something": Michi Panero, *El final de una fiesta* (unpublished memoir), in the author's possession, 22.

267 "Michi had a childlike side": Javier Marías in discussion with the author, January 2016.

267 "Friends with last names": Michi Panero, "Confieso que he bebido," *Funerales vikingos*, 89.

268 "One of my greatest errors": Michi Panero, *El final de una fiesta* (unpublished memoir), in the author's possession, 24.

270 "Young people": J. M. Castellet, "Prólogo," *Nueve novísimos poetas españoles*, 28.

270 "Her eyes are dead volcanoes": Ibid., Leopoldo María Panero, "No sentiste Crisalída aún el peso del aire," *Nueve novísimos poetas españoles*, 240.

270 "an insinuated promise": Pere Gimferrer quoted in Fernández, *El contorno del abismo*, 149.

272 "I'm starting to realize": Leopoldo María Panero to Felicidad Blanc quoted by Fernández, *El contorno del abismo*, 164.

272 "unclassifiable": Enrique González Duro, email message to author, September 24, 2016.

272 "the real putrefaction": Eduardo Subirats quoted in Fernández, *El contorno del abismo*, 173.

273 "Leopoldo's generation": Michi Panero, *El final de una fiesta* (unpublished memoir), in the author's possession, 32.

274 "The demonstration of frivolity": Jaime Chávarri in discussion with the author, December 2016.

274 "It looked like the zoo": Michi Panero, *El final de una fiesta* (unpublished memoir), in the author's possession, 37.

275 "fiction that history": Michi Panero, "Michi," *El desencanto* (screenplay), 132.

CHAPTER 31: FOUR CHARACTERS IN SEARCH OF AN AUTEUR

281 "It was as if": Peter Turnbull in discussion with the author, Feburary 2017.

282 "Felicidad has a rare desire": Jaime Chávarri, "Jaime Chávarri," *El desencanto* (screenplay), 138.

283 "ghosts in the snow": Juan Luis Panero, "Fantasmas en la nieve," *Poesía completa*, 200.

284 "The aureole of love": Author's name illegible, "Nulidad Domecq-Panero" (Tribunal de la Rota, Nunciatura Apostólica de Madrid, 1977), JLPP, 6.

CHAPTER 32: GAME OF MASKS

287 "This guy doesn't have": Jaime Chávarri in discussion with the author, October 2012.

289 "Without him": Ibid., January 2016.

291 "The Paneros move": Jaime Chávarri, "Jaime Chávarri," *El desencanto* (screenplay), 139.

291 "the revolution with the weapons": Leopoldo María Panero quoted by Fernández, *El contorno del abismo*, 144.

291 "I saw how": Leopoldo María Panero, "Vanitus Vanitatum," *Poesía completa (1970–2000)*, 134.

291 "burned music": Leopoldo María Panero, "Primer amor," *Poesía completa (1970–2000)*, 28.

292 "A schizophrenic": Gilles Deleuze and Félix Guattari, *Anti-Oedipus: Capitalism and Schizophrenia*, 2.

294 "had engendered a society": Tusell, *Spain: From Dictatorship to Democracy*, 197.

299 "a game of masks": Jaime Chávarri in discussion with the author, October 2012.

301 "They wanted to make": Juan Luis Panero, *Sin rumbo cierto*, 148.

301 "the mansion of gloom": Edgar Allan Poe, "The Fall of the House of Usher."

304 "Chávarri suffers": Michi Panero, "Confieso que he bebido," *Funerales vikingos*, 89.

305 "It didn't matter": Jaime Chávarri quoted by Alvares and Romero, *Jaime Chávarri: Vivir rodando*, 67.

308 Chávarri and his crew speechless: The tavern was actually the last day

of shooting, but for narrative cohesion I have put it first and El Liceo second.

313 "How hard it is to die": Francisco Franco quoted by Preston, *Franco*, 778.

313 seven hours of footage: Although in 1976 Jaime Chávarri stated that he had seven hours of footage almost without duplicate takes (he used two cameras for parts of the shoot), today he claims that lost footage of the Paneros is a myth and that he put nearly everything usable into the film.

314 "I try to rescue them": Jaime Chávarri, "Jaime Chávarri," *El desencanto* (screenplay), 144.

315 "Dissatsifaction": Blanc, *Espejo de sombras*, 309.

CHAPTER 33: TAXI

318 *The Disenchantment* had just premiered: To reconstruct the film's opening I have relied on interviews as well as Luis Antonio de Villena's *Lúcidos bordes del abismo*.

319 "To feel that at last": Blanc, *Espejo de sombras*, 309.

320 "Michi was enchanted": Inés Ortega in discussion with the author, December 2016.

CHAPTER 34: AUCTION OF MEMORIES

323 "The Paneros made a scandal": Umbral, *Palabras de la tribu*, 249.

323 "A hair-raising settling" . . . "a summary execution": Antonio Colón discusses these reviews in his article, "El Desencanto," *ABC*, February 1977, 40.

324 "Possibly without intending": Mainer and Juliá, *El Aprendizaje de la Libertad 1973–1986: La Cultura de la Transición*, 104.

325 more than half: Tusell, *Spain: From Dictatorship to Democracy*, 271.

330 "It's the first nucleus": Jaime Chávarri quoted by Alvares and Romero, *Jaime Chávarri: Vivir rodando*, 73.

333 "They are a true horror": Gil de Biedma, *Diarios: 1956–1985*, 586.

333 "It was a total rupture": Juan José Alonso Panero in discussion with the author, December 2016.

334 "The wind of freedom": Felipe González quoted by unknown, "De veinte días de campaña, nos han sobrado diecinueve," *El país*, June 14, 1977, https://elpais.com/diario/1977/06/14/espana/235087229_850215 .html.

334 "We don't believe": Alfonso Figueroa quoted by unknown, "Quince mil personas asistieron al mitin de Fuerza Nueva en la plaza de Ventas," *El país*, June 14, 1977, https://elpais.com/diario/1977/06/14 /espana/235087229_850215.html.

335 "It is the beginning": Morris, *Spain*, 144.

335 591 politically motivated deaths: Sánchez Soler, *La transición sangrienta: Una historia violenta del proceso democrático en España (1975–1983)*.

336 "The Transaction": Julio Anguita in discussion with the author, August 2017.

337 "silence definitive": Leopoldo María Panero, "Es-pa-ña. Manifiesto anti español," *Ajoblanco*, 56.

337 "Spain is constituted by": Agencia Estatal Boletín Oficial del Estado, *Constitución Española*, Madrid, 1978.

338 "The difference between him": *Peter Pan*, J. M. Barrie.

338 "Michi was searching": Mercedes Unzeta Gullón, "Hablemos de Michi (2), *Astorga Redacción*, Feburary 23, 2017, http://astorgaredaccion.com/not/14413/hablemos-de-michi-2-/.

CHAPTER 35: LA MOVIDA

344 "He was the don": Marta Moriarty in discussion with the author, January 2016.

348 "Almost all of us women": Marta Moriarty quoted by José Luis Gallero, *Solo se vive un Vez*, 140–41.

350 "leaning back": Blanca Andreu, email message to author, January 25, 2017.

350 "He could ruin": Marcos Giralt in discussion with the author, January 2016.

352 "He liked family life": Carmen Igelsias in discussion with the author, December 2016.

354 "rediscovered": Juan Luis Panero, *Sin rumbo cierto*, 172.

354 "To live is to watch dying": Juan Luis Panero, "Y de pronto anochece," *Poesía completa*, 228.

354 "Leopoldo isn't insane": Baldomero Montoya quoted by Fernádnez, *El contorno del abismo*, 269.

355 "I will kill you tomorrow": Leopoldo María Panero, "Proyecto de un beso," *Poesía completa (1970–2000)*, 300.

355 "My literature isn't innocent": Leopoldo María Panero quoted by Fernádnez, *El contorno del abismo*, 383.

355 "Ruin is so beautiful": Leopoldo María Panero, "La canción del croupier del Mississippi," *Poesía completa (1970–2000)*, 221.

357 "incredible occurrence": Michi Panero quoted by Rosaura Díez Fuertes, "Madrid está de boda," *ABC*, July 10, 1987, 46.

CHAPTER 36: BURDENS AND LEGACIES

360 "posthumous parties:" Leopoldo Panero, "La vocación," *En lo oscuro*, 256.

361 "There are things": Marsé, *La muchacha de las bragas de oro*, 9.

361 the politics of memory: Jean-François Macé, "Los conflictos de memoria en la España post-franquista (1976–2010): entre politicas de la memoria y memorias de la politica," Bulletin hispanique, 749–74.

362 "exiled czarina:" Pedro Trapiello, "Panero, después de muerto," *El peso de lo alegre*, 128–30.

363 "In the height of": Leopoldo María Panero to Maria Domínguez Torán quoted by Fernádnez, *El contorno del abismo*, 298.

363 "Come brother": Leopoldo María Panero, "El loco al que llaman el rey," *Poesía completa (1970–2000)*, 357–58.

364 "the black sun": Túa Blesa, "La destruction fut ma Béatrice," in Leopoldo María Panero's *Poesía completa (1970–2000)*, 7.

365 "the Great Faggot": Bolaño, *Woes of the True Policeman*, 3.

367 "The death of my mother": *Después de tantos años*, directed by Ricardo Franco (Madrid, Spain: Aiete-Ariane Films, S.A.), 1994.

367 *for the monster that I was*: Leopoldo María Panero, *Aviso a los civilizados*, 7.

368 "People die": Ibid.

368 "They are just names": Juan Luis Panero, "20 de diciembre de 1990, *Poesía completa*, 325.

368 "Their presence": Blanc, *Espejo de sombras*, 310.

CHAPTER 37: THE END OF A PARTY

370 "The worst thing you can be": *Después de tantos años*, directed by Ricardo Franco (Madrid, Spain: Aiete-Ariane Films, S.A.), 1994.

372 "a smell of urine": Asís Lazcano, unpublished diary, copy in the author's possession.

375 "an eternal epilogue": Javier Mendoza, El Desconcierto, 51.

375 "What land is ours": Andrés Trapiello, "Una reconstrucción" in Leopoldo Panero's *Por donde van las águilas*, 9.

376 "He came with an idea": Juan José Perandones in discussion with the author, December 2016.

376 "Sooner or later": Michi Panero, "No se puede estar en todo," *Funerales vikingos*, 78.

376 "I've returned to Astorga": Michi Panero, "Bofetada," *Funerales vikingos*, 80.

378 *I went back*: Michi Panero, "*Carta a una desconocida*," *Funerales vikingos*, 84–86.

378 "If I had to write": Marta Moriarty, "Un niño listo y malcriado" *Leer*, no. 154, July–August 2004, 56.

379 *Perhaps twistedly*: Michi Panero, "Tierra baldía (y sin Eliot)," *Funerales vikingos*, 83.

CHAPTER 38: THE END OF THE LINE

382 "We chatted about": Fernando Bruquetas, email message to author, October 16, 2017.

384 "I've been afraid": Roberto Bolaño quoted by Mónica Maristain, *Roberto Bolaño: The Last Interview & Other Conversations*, 112.

384 "I'm the paradise": Leopoldo María Panero to Diego Medrano, *Los héroes inútiles*, 19.

385 "A permanent sense": Juan Luis Panero, *Sin rumbo cierto*, 207.

388 "I don't even know": "Encuentros con Leopoldo Maria Panero 3/3, Palacio de Viana, Córdoba" Vimeo video, 3:32. Posted by "Eureka Diskos," March 10, 2014, https://vimeo.com/88688025.

391 "that naïve invention": Juan Luis Panero, "La muerte y su museo," *Poesía completa*, 126.

392 "You were an unrepeatable": Gara Santana, "Espero no echarte mucho de menos," *Gara Santana*, March 6, 2014, http://garasantana.blogspot.com/2014/03/espero-no-echarte-mucho-de-menos.html.

392 "I who prostituted": Leopoldo María Panero, "Dedicatoria," *Poesía completa (1970–2000)*, 226.

EPILOGUE

393 "a text that devours itself": Fernández, *El contorno del abismo*, 178.

394 "Turn yourself": Leopoldo María Panero, "París," *Poesía completa (1970–2000)*, 201.

395 "They received us": Jaime Chávarri in discussion with the author, January 2016.

SELECTED BIBLIOGRAPHY

Unless otherwise noted, all translations from Spanish to English are my own.

ARCHIVES AND ABBREVIATIONS

DCHM: Document Center of Historical Memory, Ministry of Education, Culture and Sport, Salamanca, Spain.

JLPP: Juan Luis Panero Papers, Astorga Municipal Library, Astorga, Spain.

JMSA: José María Souvirón Archive, Library of the Generation of '27 Cultural Centre, Málaga, Spain.

LPA: Leopoldo Panero Archive, Library of the Generation of '27 Cultural Centre, Málaga, Spain.

LRCA: Luis Rosales Camacho Archive, National Historical Archive, Madrid, Spain.

RGP: Ricardo Gullón Papers, Astorga Municipal Library, Astorga, Spain.

SELECTED BOOKS BY THE PANERO FAMILY

Blanc, Felicidad. 1979. *Cuando amé a Felicidad.* Madrid, Ediciones Juan Gris.

————. 2015. *Espejo de sombras.* Barcelona: Cabaret Voltaire.

Panero, Juan Luis. 1999. *Enigmas y despedidas.* Barcelona: Tusquets.

————. 2006. *Leyendas y lecturas.* Barcelona: Tusquets.

————. 1997. *Poesía completa (1968–1996).* Barcelona: Tusquets.

————. 2000. *Sin rumbo cierto.* Barcelona: Tusquets.

————. 1953. *Canto personal: Carta perdida a Pablo Neruda.* Madrid: Ediciones Cultura Hispánica.

————. 2000. *El lugar del hijo.* Barcelona: Tusquets.

Panero, Leopoldo. 2011. *En lo oscuro.* Madrid: Cátedra.

————. 1949. *Escrito a cada instante.* Madrid: Escelicer.

————. 2007. *Obra completa: Poesía I.* Edited by Javier Huerta Calvo and with the collaboration of Javier Cuesta Guadaño and Juan José Alonso Perandones. Vol. 1. 3 vols. Astorga: Ayuntamiento de Astorga.

————. 2007. *Obra completa: Poesía II.* Edited by Javier Huerta Calvo and with the collaboration of Javier Cuesta Guadaño and Juan José Alonso Perandones. Vol. 2. 3 vols. Astorga: Ayuntamiento de Astorga.

————. 2007. *Obra completa: Prosa.* Edited by Javier Huerta Calvo with Javier Cuesta Guadaño and Juan José Alonso Perandones. Vol. 3. 3 vols. Astorga: Ayuntamiento de Astorga.

Panero, Leopoldo María. 1990. *Aviso a los civilizados.* Madrid: Libertarias.

————. 2010. *Poesía completa (1970–2000).* Túa Blesa, ed. Madrid: Visor Libros.

————. 2014. *Poesía completa (2000–2010).* Túa Blesa, ed. Madrid: Visor Libros.

————. 2014. *Rosa enferma.* Madrid: Huerga & Fierro.

Panero, Leopoldo María and Diego Medrano. 2005. *Los héroes inútiles.* Castellón: Ellago Ediciones.

Panero, Michi. 2017. *Funerales vikingos: Cuentos, artículos y textos dispersos*. Madrid: Bartleby Editores.

Panero Torbado, Juan. 1986. *Obra poética*. Astorga: Centro de Estudios Astorganos Marcelo Macías.

UNPUBLISHED MATERIALS (A PARTIAL LIST)

Blanc, Felicidad. Unpublished correspondence.

Gullón, Ricardo. Unpublished memoir.

Lazcano, Asís. Unpublished diary.

Lazcano, Asís (as ghostwriter) and Michi Panero. *El final de una fiesta* (Michi Panero's unpublished memoir).

Panero, Juan. Unpublished correspondence.

Panero, Leopoldo. Unpublished correspondence.

Parra, Javier. *Tocando fondo* (unpublished memoir).

Rosales, Luis. Unpublished correspondence.

Souvirón, José María. Unpublished diary.

OFFICIAL DOCUMENTS (A VERY PARTIAL LIST)

Felicidad Blanc's Izquierda Repúblicana membership card.

Juan Luis Panero and Marina Domecq's annulment.

Leopoldo Panero's contract as a censor.

Leopoldo Panero's Falange credential.

INTERVIEWS AND EMAIL CORRESPONDENCE

Albero, Miguel, 2016

Alonso Panero, Juan José, 2016

Alonso Panero, Rosario, 2015

Anadón Álvarez, María Nuria, 2017

Andreu, Blanca, 2017 and 2018

Anguita, Julio, 2017

Araújo, Joaquín, 2016 and 2017

Arrieta, Adolfo, 2017

Azúa, Félix de, 2017

Barnatán, Marcos, 2016 and 2017

Barrantes, Rafael, 2017

Barrero, Miguel, 2012

Blanco, Mercedes, 2017

Blesa, Túa, 2012

Bruquetas, Fernando, 2017

Campos Méndez, Israel, 2017

Casani, Borja, 2016

Cavalletti, Domitilla, 2017

Chávarri, Jaime, 2012, 2016, and 2017

Duque, Alquilino, 2016

Fernández, J. Benito, 2012 and 2015

Gamoneda, Antonio, 2016

García, Mariano, 2015

García Alonso, Ángel, 2017

García Lorca, Laura, 2016

García Panero, Odila, 2016

García Sánchez ("Visor"), Jesús, 2016

Gimferrer, Pere, 2015 and 2017

Giralt, Marcos, 2016

González, Eva, 2017

González Duro, Enrique, 2016

Goula Iglesias, Elisabet, 2016

Huerga, Antonio, 2015

Huerta Calvo, Javier, 2015, 2016, and 2017

Iglesias, Carmen, 2015 and 2016

Lazcano, Asís, 2015, 2016, and 2017

Lezcano Mujica Betancor, Evelyn, 2015 and 2017

Marías, Javier, 2016

Márquez Quevedo, Javier Octavio, 2017

Martínez, Elba, 2017

Martínez Oria, Andrés, 2016

Martínez Torres, Augusto, 2016 and 2017

Masoliver, Juan Antonio, 2012

Mendoza, Javier, 2016 and 2017

Molina Foix, Vicente, 2016

Moura, Beatriz de, 2017

Moriarty, Marta, 2016 and 2017

Ormaechea, Rafael, 2017

Ortega Klein, Inés, 2016 and 2017

Parra, Javier, 2015

Perandones, Juan José, 2016 and 2017

Pereda, Rosa, 2016

Porta, A. G., 2015

Pravo, Ianus, 2017

Puértolas, Soledad, 2015

Recio, Juan Luis, 2017

Rizzo, Claudio, 2017

Rodríguez Barrio, Jesús, 2017

Rosales Fouz, Luis, 2016

Sánchez Dragó, Fernando, 2017

Torrente, Marisa, 2016, 2017

Trapiello, Pedro, 2017

Turnbull, Peter, 2017

Utrera, Federico, 2015

Vaquero, Marisa, 2015

Vila-Matas, Enrique, 2015 and 2017

Villena, Luis Antonio de, 2016

PRIMARY SOURCES IN ENGLISH

Allen, Jay. 1936. "Slaughter of 4,000 at Badajoz, 'City of Horrors.'" *Chicago Tribune*, August 30: 2.

Brenan, Gerald. 1953. "A Literary Letter From Spain." *New York Times*, October 11.

Cunard, Nancy et al. 1937. "Authors Take Sides on the Spanish Civil War." *Left Review,* June.

Gardner, Ava. 1990. *Ava: My Story.* London: Bantam Press.

Hughes, Langston. 1986. *I Wonder as I Wander.* New York: Octagon Books.

Maristain, Mónica et al. 2009. *Roberto Bolaño: The Last Interview & Other Conversations.* Translated by Sybil Perez. New York: Melville House.

Neruda, Pablo. 2001. *Memoirs.* Translated by Hardie St. Martin. New York: Farrar, Straus and Giroux.

Pavese, Cesare. 1980. *This Business of Living: Diaries 1935–1950.* Translated by A. E. Murch. London: Quartet Books.

SECONDARY SOURCES IN ENGLISH

Brenan, Gerald. 2010. *The Face of Spain.* London: Serif.

Cercas, Javier. 2011. *The Anatomy of a Moment: Thirty-Five Minutes in History and Imagination.* Translated by Anne McLean. New York: Bloomsbury.

Clarke, Ben. 2007. *Orwell in Context: Communities, Myths, Values.* London: Palgrave Macmillan UK.

Deleuze, Gilles and Félix Guattari. 1983. *Anti-Oedipus: Capitalism and Schizophrenia.* Translated by Robert Hurley, Mark Seem, and Helen R. Lane. Preface by Michel Foucault. Minneapolis: University of Minnesota Press.

Didion, Joan. 1979. *The White Album.* New York: Simon & Schuster.

Dubos, René and Jean Dubos. 1987. *The White Plague: Tuberculosis, Man, and Society.* New Jersey: Rutgers University Press.

Eisner, Mark. 2018. *Neruda: The Poet's Calling.* New York: Ecco.

Feinstein, Adam. 2004. *Pablo Neruda: A Passion for Life.* New York: Bloomsbury.

Gibson, Ian. 1989. *Federico García Lorca: A Life.* New York: Pantheon Books.

———. 1998. *The Shameful Life of Salvador Dalí.* New York: W. W. Norton.

González-Ruibal, Alfredo and Carmen Ortiz. 2015. "The Prison of Carabanchel (Madrid, Spain): A Life Story (Chapter 5)." In *War and Cultural Heritage.* Marie Louise Stig Sørensen and Dacia Viejo-Rose (eds.), 128–55. Cambridge: Cambridge University Press.

Graham, Helen. 2005. *The Spanish Civil War: A Very Short Introduction.* Oxford: Oxford University Press.

Hochschild, Adam. 2016. *Spain in Our Hearts: Americans in the Spanish Civil War, 1936–1939.* New York: Mariner Books.

Matthews, James. 2012. *Reluctant Warriors: Republican Popular Army and Nationalist Army Conscripts in the Spanish Civil War, 1936–1939.* Oxford: Oxford University Press.

McIntosh, Christopher. 2012. *Ludwig II of Bavaria: The Swan King.* New York: I. B. Tauris.

Morris, Jan. 2008. *Spain.* London: Faber and Faber.

Payne, Stanley G. 2000. *Fascism in Spain: 1923–1977.* Madison: University of Wisconsin Press.

———. 2004. *The Spanish Civil War, the Soviet Union, and Communism.* New Haven: Yale University Press.

Preston, Paul. 1994. *Franco.* New York: Basic Books.

———. 2007. *The Spanish Civil War: Reaction, Revolution, and Revenge.* New York: W. W. Norton & Company.

———. 2012. *The Spanish Holocaust: Inquisition and Extermination in Twentieth-Century Spain.* New York: W. W. Norton & Company.

Rooney, Nicola. 2006. "A Prison for Priests in a Catholic State: The 'Carcel Concordatoria' in Zamora During the Franco Dictatorship." *Journal of Postgraduate Research,* 34–45.

Seidman, Michael. 2011. *The Victorious Counterrevolution: The Nationalist Effort in the Spanish Civil War.* Madison: University of Wisconsin Press.

Shafer, David A. 2016. *Antonin Artaud*. London: Reaktion Books.

Stainton, Leslie. 2001. *Lorca: A Dream of Life*. New York: W. W. Norton & Company.

Thomas, Hugh. 2001. *The Spanish Civil War (revised edition)*. New York: Modern Library Paperbacks.

Treglown, Jeremy. 2013. *Franco's Crypt: Spanish Culture and Memory Since 1936*. New York: Farrar, Straus and Giroux.

Tusell, Javier. 2011. *Spain: From Dictatorship to Democracy*. Translated by Rosemary Clark. Oxford: Wiley-Blackwell.

Vaill, Amanda. 2015. *Hotel Florida: Truth, Love, and Death in the Spanish Civil War*. New York: Picador.

Vallejo, César. 2015. *Selected Writings of César Vallejo*. Edited by Joseph Mulligan. Connecticut: Wesleyan University Press.

Weintraub, Stanley. 1968. *The Last Great Cause: The Intellectuals and the Spanish Civil War*. New York: Weybright and Talley.

Whittaker, Tom. 2011. *The Films of Elías Querejeta: A Producer of Landscapes*. Cardiff: University of Wales Press.

FICTION AND POETRY IN ENGLISH

Barrie, James Matthew. 2008. *Peter Pan*. New York: Sterling.

Bassani, Giorgio. 1977. *The Garden of the Finzi-Continis*. Translated by William Weaver. New York: Harcourt.

Bolaño, Roberto. 2008. *2666*. Translated by Natasha Wimmer. New York: Farrar, Straus and Giroux.

———. 2008. *The Savage Detectives*. Translated by Natasha Wimmer. New York: Farrar, Straus and Giroux.

———. 2012. *Woes of the True Policeman*. Translated by Natasha Wimmer. New York: Farrar, Straus and Giroux.

Cela, Camilo José. 2001. *The Hive*. Translated by J. M. Cohen and Arturo Barea. New York: Dalkey Archive Press.

———. 1991. *San Camilo, 1936*. Translated by John H. R. Polt. Durham: Duke University Press.

Cernuda, Luis. n.d. *"The Family."* Translated by Stephen Kessler. http://www.bu.edu/agni/poetry/print/2014/79-cernuda-family.html.

Cervantes Saavedra, Miguel de. 2005. *Don Quixote.* Translated by Edith Grossman. New York: HarperCollins.

Durrell, Lawrence. 1985. *Justine.* New York: E. P. Dutton & Co.

Fitzgerald, Scott F. 2009. *The Crack-Up.* New York: New Directions.

García Lorca, Federico. 1998. *In Search of Duende.* Translated by Christopher Maurer et al. New York: New Directions.

Hemingway, Ernest. 2004. *For Whom the Bell Tolls.* London: Arrow Books.

Lowry, Malcolm. 2007. *Under the Volcano.* New York: Harper Perennial

Marías, Javier. 2016. *Thus Bad Begins.* Translated by Margaret Jull Costa. New York: Alfred A. Knopf.

Pirandello, Luigi. 2015. *Six Characters in Search of an Author.* Translated by Edward Storer. New York: Dover Publications.

Poe, Edgar Allan. 2003. *The Fall of the House of Usher and Other Writings: Poems, Tales, Essays, and Reviews.* Translated by Clayton Eshleman and José Rubia Barcia. New York: Penguin.

Vallejo, César. 1980. *The Complete Posthumous Poetry.* Translated by Clayton Eshleman and José Rubia Barcia. Los Angeles: University of California Press.

Vila-Matas, Enrique. 2011. *Never Any End to Paris.* Translated by Anne McLean. New York: New Directions.

PRIMARY SOURCES IN SPANISH

Agencia Estatal Boletín Oficial del Estado. 1978. "Constitución Española." Agencia Estatal Boletín Oficial del Estado. December 27. https://www.boe.es/legislacion/documentos/ConstitucionCASTELLANO.pdf.

Aleixandre, Vicente. 1965. "Encuentro con Leopoldo Panero."
 Cuadernos Hispanoamericanos: 100–101.

Araújo, Joaquín. 2014. "No te suicidaste." *El Mundo*, March 7.

Areilza, Cristina de. 1979. "Felicidad Blanc, la memoria vital."
 ABC, May 13: 14–15.

Arias Salgado, G. 1944. "Nombramiento Provisional."
 Vicesecretary of Education, F.E.T. and J.O.N.S. Madrid,
 January 1.

"Ayer, fiesta de la hispanidad, el jefe del Estado inauguró
 la primera exposición hispanoamericana de arte." *ABC*,
 October 13: 15, 1951.

Bagaría, Luis. 1936. "Diálogos de una caricaturista salvaje:
 Federico García Lorca habla sobre la riqueza poética y vital
 mayor de España." *El Sol*, June 10: 5.

Biedma, Jaime Gil de. 2015. *Diarios 1956–1985*. Barcelona:
 Lumen.

Cansinos Assens, Rafael. 2005. *Novela de un literato (vol. 3)*.
 Madrid: Alianza.

Carvajal, Ernesto. 1986. "Amores sin coto." *ABC*, September 20:
 46.

Cebrian. 1933. "Felicidad Blanc (caricature)." *ABC*, January 8:
 51.

Colón, Antonio. 1977. "El desencanto." *ABC*, February 13: 40.

Crémer, Victoriano. 1980. *El libro de San Marcos*. León:
 Editorial Nebrija.

Crespo, Pedro. 1976. "'El desencanto' de Jaime Chávarri." *ABC*,
 September 28: 72.

Delgado, Álvaro. 2013. "Apuntes tras los pasos de Panero."
 Astorga Redacción, October 20.

"De veinte días de campaña, nos han sobrado diecinueve." *El
 País*, June 14, 1977.

Diego, Gerardo. 1948. "Escuela de Astorga." *ABC*, March 3: 3.

———. 1948. "Leopoldo Panero." *ABC*, April 4: 3.

Domecq, Marina. 1991. *La imaginación al perol.* Madrid: Grupo Libro 88.

"El Caudillo inauguró el nuevo edificio del Instituto de Cultura Hispánica." *La Vanguardia Española*, October 13: 4, 1951.

"'El desencanto.'" *ABC*: 48, 1976.

"El representante de España en Méjico, Señor Gallostra, asesinado por un anarquista exilado." *ABC*, February 22: 7, 1950.

"Felicidad Blanc de Pancro: incompatibilidad con Femando Gayo." *Blanco y Negro*, November 13: 33, 1976.

Fernández Cuenca, Carlos. 1953. "En su casa de Astorga y en un bar de Madrid, escribió Panero el 'Canto personal.'" *Correo Literario*, December 15: 8–14.

Formica, Mercedes. 1984. *Escucho el silencio.* Barcelona: Planeta.

Foxá, Agustín de. 2010. *Nostalgia, intimidad y aristocracia.* Madrid: Fundación Banco Santander.

Fuente Lafuente, Ismael. 1976. "Felicidad Blanc de Panero, entre la soledad y el desencanto." *El País Semanal*, October 31: 3–4.

Gallero, José Luis. 1991. *Solo se vive una vez.* Madrid: Ardor Ediciones.

Guinda, Ángel. 2015. *Leopoldo María Panero: El peligro de vivir de nuevo.* Madrid: Huerga y Fierro Editores.

Illegible. 1977. "Nulidad Domecq-Panero." Madrid: Tribunal de la Rota de la Nunciatura Apostólica en Madrid, October 28.

Illegible, Provincial Chief's Name. 1937. "Credential [of Leopoldo Panero]." Salamanca: Traditionalist Spanish Falange and J.O.N.S., July 19.

Jiménez, Juan Ramón. 1935. "Una carta del insigne Juan Ramón Jiménez." *La Voz*, March 23: 1.

"Juan Panero Torbado obituary." *Pensamiento. Astorgano.* Astorga: Pensamiento Astorgano, August 10, 1937.

"La Academia 'Musa musae.'" *ABC*, January 19: 11, 1940.

"La generación del 27 vista por Felicidad Blanc y Michi Panero." *Mediterráneo: Prensa y Radio del Movimiento*, November 9: 28, 1983.

"La gran odisea del heróico general García Caminero." *ABC*, August 2: 21, 1936.

La Nación. 1926. "Las mujeres españolas y el presidente." June 7: 2.

"La viuda de Panero: 'Leopoldo era un hombre cruel.'" *Hoja oficial del lunes*, September 20: 45, 1976.

Laín Entralgo, Pedro. 1976. *Descargo de conciencia (1930–1960).* Barcelona: Barral Editores.

———. 1962. "El hombre de secreto." *Ínsula* 1 and 10.

"Las mujeres españoles y el presidente." *La Nación*, June 7: 3, 1926.

Ley, Charles David. 1981. *La Costanilla de los diablos (Memorias literarias 1943–1952).* Madrid: José Esteban, editor.

López Sancho, Lorenzo. 1978. "César Vallejo." *ABC*, April 14: 3.

Luengo, Luis Alonso. 1996. *La ciudad entre mí: Crónicas astorganas desde mi tiempo.* León: Ayuntamiento de Astorga.

Luis, Leopoldo de. 1982. "La poesía de Leopoldo Panero." *ABC*, September 25: 1–3.

"Madrid está de boda." *ABC*, July 10: 46, 1987.

Manzano, Emilio. 1997. "Juan L. Panero, viajero sin fin." *La Vanguardia*, March 6: 12.

Maravall, José Antonio. 1965. "Poesía del alma." *Cuadernos Hispanoamericanos*: 138–149.

Martínez Nadal, Rafael. 1983. *Españoles en la Gran Bretaña. Luis Cernuda: El hombre y sus temas.* Madrid: Libros Hiperión.

Martínez Torres, Augusto. 2002. *Las películas de mi vida.* Madrid: Espasa Libros.

Maso, Ángeles. 1976. "'El desencanto.'" *La Vanguardia Española*, September 25.

———. 1977. "Los 'Fotogramas de plata' 1976." *La Vanguardia Española*, February 2: 41.

Mendoza, Javier. 2017. *El desconcierto: Memorias trucadas.* Madrid: Bartleby Editores.

Molina, César Antonio. 1987. "Los fantasmas culturales del franquismo." *Diario*, August 27: 16, 21.

Monegal, Ferrán. 1978. "Felicidad Blanc." *La Vanguardia*, January 24: 21.

Mooure Mariño, Luis. 1989. *La Generacion del 35: Memorias de Salamanca y Burgos.* A Coruña: Ediciós de Castro.

Moriarty, Marta. 2004. "Un niño listo y malcriado." *Leer*: 56.

Morla Lynch, Carlos. 2011. *España sufre: Diarios de guerra en el Madrid republicano, 1936–1939.* Sevilla: Renacimiento.

"Ncruda frente al 'Canto personal.'" *Ercilla*, December 29: 12–13, 1953

Panero, Leopoldo. 1930. "Creación, Poesía." *Nueva Revista*: 1.

Panero, Leopoldo, interview by Pilar Narvión. 1953. *Entrevista a Leopoldo Panero* (June 19).

Panero, Leopoldo María. 1977. "Es-pa-ña. Manifiesto anti español." *Ajoblanco*, 56–57.

Panero, Michi. 1993. "Bares, o el manuscrito encontrado en la botella." *El Europeo*, Winter 1993: 16.

"Para 'Excelsior,' la hospitalidad que Méjico concedió a los desterrados españoles 'No debe ser traicionada con el crímen.'" *ABC*, February 26: 17, 1950.

Querejeta, Elías. 1976. *El desencanto.* Madrid: Elías Querejeta Ediciones (film script).

"Quince mil personas asistieron al mitin de Fuerza Nueva en la plaza de Ventas." *El País*, June 11, 1977.

Reinares, María Antonia. 2011. "Leopoldo Panero antes y después de la cárcel de San Marcos." *Argutorio*.

"Reunión de la Academia 'Musa Musae.'" *La Vanguardia Española*, April 9: 7, 1940.

Ridruejo, Dionisio. 1976. *Casi unas memorias*. Barcelona: Planeta.

———. 2005. *Materiales para una biografía*. Madrid: Fundación Santander Central Hispano.

Romero, Emilio. 1986. *Testigo de la historia*. Barcelona: Planeta.

Santana, Gara. 2014. "Espero no echarte mucho de menos." *Gara Santana*. March 6. http://garasantana.blogspot.com/2014/03/espero-no-echarte-mucho-de-menos.html.

Souvirón, José María. 1962. "Leopoldo Panero." *ABC*, October 28: 49.

Tápies, Antoni. 2003. *Memoria personal: Fragmento para una autobiografía*. Barcelona: Seix Barral.

Triguero, Juan. 1965. "La generación de Fraga y su destino." *Cuadernos del Ruedo Ibérico*: 5–16.

Umbral, Francisco. 1994. *Las palabras de la tribu*. Planeta.

"Una protesta internacional contra la amenaza de muerte del gobierno de Nankin a unos pacifistas suizos." *Heraldo de Madrid*, October 1: 3, 1931.

Unzeta Gullón, Mercedes. 2017. "Hablemos de Michi (1–6)." *Astorga Redacción*, January 28. (6 parts). February 16, February 23, March 16, March 29, April 6, April 15. http://astorgaredaccion.com/not/14354/hablemos-de-michi-1-, http://astorgaredaccion.com/not/14413/hablemos-de-michi-2-, http://astorgaredaccion.com/not/14554/hablemos-de-michi-3-, http://astorgaredaccion.com/not/14763/hablemos-de-michi-4-, http://astorgaredaccion.com/not/14839/hablemos-de-michi-5-, http://astorgaredaccion.com/not/14929/no-hablemos-mas-de-michi-y-6-.

"Varios conatos de manifestaciones en Madrid." *ABC*, January 28: 36, 1967.

Villena, Luis Antonio de. 2014. *Lúcidos bordes de abismo: Memoria personal de los Panero.* Sevilla: Fundación José Manuel Lara.

"Yo soy la ficción." *Blanco y Negro*, December 14: 48, 1977.

Zarza, Rafael. 2004. "Buena vieja causa." *Leer*: 26–31.

SECONDARY SOURCES IN SPANISH

Alonso Perandones, Juan José. 2004. "Las primeras aficiones literarias de Leopoldo Panero." *Astorica* (Centro de Estudios Astorganos "Marcelo Macías") (23): 207–32.

———. 2005. "Luis Cernuda y la escuela de Astorga." Edited by José Enrique Martínez Fernández, José Manuel Trabado Cabado, Juan Matas Caballero, et al. *Nostalgia de una patria imposible: Estudios sobre la obra de Luis Cernuda.* Madrid: Ediciones Akal. 93–142.

———. 2016. "Luis Cernuda, Felicidad Blanc y Leopoldo Panero: Historia de una amistad, enfado y enamoramiento." *Argutorio: revista de la Asociación Cultural "Monte Irago"*: 66–74.

Álvarez, Rosa and Antolín Romero. 1999. *Jaime Chávarri: Vivir rodando.* Valladolid: Sociedad General de Autores y Editores.

Alvarez Oblanca, Wenceslao, and Secundino Serrano Fernandéz. 2009. *La Guerra Civil en León.* León: Edilesa.

Burgos, Ernesto. 2012. "Amar en tiempos de guerra." *La Nueva España*, December 29.

Caballero Pérez, Miguel. 2011. *Las trece últimas horas en la vida de García Lorca.* Madrid: La esfera de los libros.

Cabañas Bravo, Miguel. 1991. *La primera bienal hispanoamericana de arte: arte, política y polémica en un certamen internacional de los años cincuenta.* Madrid: Universidad Complutense de Madrid.

————. 2012. "Panero en las Bienales de Arte Hispanoamericano." Edited by Javier Huerta Calvo and Javier Cuesta Guadaño. *Astorica: Revista de Estudios Astorganos* (Centro de Estudios Astorganos "Marcelo Macías") (31): 183–208.

Cabañas González, José. 2010. *La Bañeza 1936: La vorágine de julio. Golpe y represión en la comarca bañezana.* León: El Lobo Sapiens.

Castellet, Josep Maria. 1977. *La cultura bajo el franquismo.* Barcelona: Debolsillo.

Delgado Idarreta, José Miguel. 2004. "Prensa y propaganda bajo el franquismo." *Centros y periferias*: 219–31.

Díaz de Alta Heikkilä, Carmen. 2012. "Aventuras y desventuras de Panero en la misión por América." Edited by Javier Huerta Calvo and Javier Cuesta Guadaño. *Astorica: Revista de Estudios Astorganos* (Centro de Estudios Astorganos "Marcelo Macías") (31): 99–130.

Diego, Gerardo. 2000. "Poesía española contemporánea." In *Obras completas*, by Gerardo Diego, 1091–99. Madrid: Santillana.

Fernández, J. Benito. 2006. *El contorno del abismo: Vida y leyenda de Leopoldo María Panero.* Barcelona: Tusquets.

Fuente, Inmaculada de la. 2006. *La roja y la falangista: Dos perfiles de la España del 36.* Barcelona: Planeta.

Gallo Rancero, Silvia, and Tania López Alonso. 2013. *San Marcos: El campo de concentración desconocido.* León: Lobo Sapiens.

García Bañales, Miguel. 2014. "Eugenio Curiel, director del Instituto de Astorga (1933–1936), una cabeza brillante que apagó la intolerancia (I)." *Astorga Redacción*.

Gibson, Ian. 2005. *El asesinato de García Lorca.* Madrid: Plaza & Janes.

————. 2007. *El hombre que detuvo a García Lorca: Ramón Ruiz Alonso y la muerte del poeta.* Madrid: Aguilar.

Gullón, Ricardo. 1985. *La juventud de Leopoldo Panero.* León: Breviarios de la Calle del Pez.

Gómez Oliver, Miguel. 2008. "El Movimiento Estudiantil español durante el Franquismo (1965–1975)." *Revista Crítica de Ciências Sociais* 93–110.

Huerta Calvo, Javier. 1996. *De poética y política: Nueva lectura del "Canto personal" de Leopoldo Panero.* León: Instituto Leonés de Cultura Diputación Provincial de León.

————. 2015. *Gerardo Diego y la Escuela de Astorga.* Astorga: Centro de Estudios Astorganos "Marcelo Macías" & Fundación Gerardo Diego.

————. 2012. "Últimas investigaciones sobre Leopoldo Panero." Edited by Javier Huerta Calvo and Javier Cuesta Guadaño. *Astorica: Revista de Estudios Astorganos* (Centro de Estudios Astorganos "Marcelo Macías") (no. 31): 17–48.

Huerta Calvo, Javier (ed.). 2016. *Abolido esplendor: En torno a la poesía de Juan Luis Panero.* Madrid: Antígona.

Iáñez, Eduardo. 2009. *Falangismo y Propaganda Cultural en el "Nuevo Estado": La Revista Escorial (1940–1950) (doctoral dissertation).* Granada: Universidad de Granada.

————. 2011. *No parar hasta conquistar. Propaganda y política cultural falangista: el Grupo de Escorial 1936–1986.* Gijón: Trea.

Imbert, Gerard. 1986. "El Madrid de la 'movida.'" *El País*, January 25.

Insua, Juan and Marina Palà (eds). 2013. *Archivo Bolaño.* Barcelona: Diputació de Barcelona.

Juliá, Santos. 2002. "¿Falange liberal o intelectuales fascistas?" *Claves de Razón Práctica* 4–13.

Labrador Méndez, Germán. 2017. *Culpables por la literatura: Imaginación política y contracultura en la transición española (1968–1986).* Madrid: Ediciones Akal.

Lechado, José Manuel. 2005. *La Movida: Una crónica de los 80.* Madrid: Algaba.

Lopez Anglada, Luis. 1988. "Juan y Leopoldo Panero, gloria y dolor de Astorga." *Centro de estudios astorganos "Marcelo Macías"*: 137–54.

Luengo, Luis Alonso. 1944. "El recuerdo y la poesía de Juan Panero." *Espadaña* 103–6.

Macé, Jean-François. 2012. "Los conflictos de memoria en la España post-franquista (1976–2010): entre políticas de la memoria y memorias de la política." *Bulletin hispanique*: 749–74.

Mainer, José Carlos and Santos Juliá. 2000. *El Aprendizaje de la Libertad 1973–1986: La cultura de la Transición.* Madrid: Alianza.

Martín Gaite, Carmen. 2011. *Usos amorosos de la postguerra española.* Barcelona: Anagrama.

Nieto Centeno, Carmen. 2011. *El desencanto: o el "deser" en canto de los Panero (doctoral dissertation).* Madrid: Universidad Complutense de Madrid.

Rivero Taravillo, Antonio. 2011. *Luis Cernuda: años de exilio (1938–1963).* Barcelona: Tusquets.

Rodero, Joaquín, Juan Moreno, and Jesús Castrillo. 2008. *Represión franquista en el Frente Norte.* Madrid: Ediciones Eneida.

Rodríguez Puértolas, Julio. 2008. *Historia de la literatura fascista española.* Madrid: Akal.

Ruiz Bautista, Edouardo. 2004. "En pos del "buen lector": censura editorial y clases populares durante el Primer Franquismo (1939–1945)." *Espacio, Tiempo y Forma*: 231–51.

Sánchez García, Manuela. 2015. "¿Descargo de conciencia o limpieza del pasado? Un estudio sobre la autobiografía de Pedro Laín Entralgo." *Creneida*: 350–73.

Sánchez Noriega, José Luis. 2012. "La (de)construcción fílmica de la familia Panero." Edited by Javier Huerta Calvo and Javier Cuesta Guadaño. *Astorica: Revista de Estudios Astorganos* (Centro de Estudios Astorganos "Marcelo Macías") (31): 209–22.

Sánchez Soler, Mariano. 2010. *La transición sangrienta: Una historia violenta del proceso democrático en España (1975–1983)*. Barcelona: Ediciones Península.

Sandín Pérez, Juan Manuel (ed.). 2012. *El peso de lo alegre: Recordando a Leopoldo Panero*. Madrid: Biblioteca Nueva.

Trapiello, Andrés. 2014. *Las armas de las letras: Literatura y guerra civil (1936–1939)*. Barcelona: Destino Libros.

Utrera, Federico. 2008. *Después de tantos desencantos: Vida y obra poéticas de los Panero*. Festival Internacional de Cine Las Palmas de Gran Canaria.

Utrera Macías, Rafael. 2009. "'Raza,' novela de Jaime de Andrade, pseudónimo de Francisco Franco." *Anales de Literatura Española*: 213–30.

———. 2012. "La academia poética 'Musa Musae.'" *Castilla. Estudios de Literatura*: 229–48.

FICTION AND POETRY IN SPANISH

Alonso, Dámaso. 2014. *Hijos de la ira*. Barcelona: Austral.

Camacho, José R. 1938. *Los versos del combatiente*. Bilbao: Arriba.

Castellet, Josep Maria. 2006. *Nueve novísimos poetas españoles*. Barcelona: Ediciones Península.

———. 1960. *Veinte años de poesía española (1939–1959)*. Barcelona: Seix Barral.

Celaya, Gabriel. 1955. *Cantos íberos*. Madrid: Turner.

Cercas, Javier. 2001. *Soldados de Salamina.* Barcelona: Círculo de Lectores.

Darío, Rubén. 2015. *Cantos de vida y esperanza.* Barcelona: Penguin Clásicos.

Foxá, Agustín de. 2001. *Madrid de corte a checa.* Barcelona: Planeta.

García Lorca, Federico. 2017. *Poesía completa.* Barcelona: Galaxia Gutenberg.

Gimferrer, Pere. 2010. *Poemas (1962–1969).* Madrid: Visor Libros.

Hernández, Miguel. 1989. *Viento del pueblo.* Madrid: Cátedra.

Marsé, Juan. 2016. *La muchacha de las bragas de oro.* Barcelona: Debolsillo.

Montero, Rosa. 2015. *Crónica del desamor.* Barcelona: Debolsillo.

Neruda, Pablo. 1970. *Canción de gesta.* Montevideo: El Siglo Ilustrado.

———. 2005. *Canto general.* Madrid: Cátedra.

———. 1938. *España en el corazón.* Santiago de Chile: Ercilla.

Panero, Colectivo Leopoldo María. 1992. *Los ojos de la escalera.* Madrid: Alejandría Editores.

Parra, Javier (ed.). 1992. *Locos.* Madrid: Ediciones Casset.

Rosales, Luis. 2010. *La casa encendida.* Madrid: Visor Libros.

Vila-Matas, Enrique. 2007. *Lejos de Veraacruz.* Barcelona: Anagrama.

FILM AND OTHER MEDIA

Después de tantos años. Directed by Ricardo Franco, 1994.

El desencanto. Directed by Jaime Chávarri, 1976.

"Encuentros con Leopoldo Maria Panero 3/3, Palacio de Viana, Palacio de Viana, Córdoba." Vimeo video, 3:32. Posted by "Eureka Diskos," March 10, 2014. https://vimeo.com/88688025.

La estancia vacía. Directed by Miguel Barrero and Iván Fernández, 2007.

Los abanicos de la muerte. Directed by Luis Miguel Alonso Guadalupe, 2009.

"Merienda de negros – Leopoldo Maria Panero," YouTube video, 12:00. Posted by "elba martinez," August 19, 2011 . (5 parts). https://www.youtube.com/watch?v=0nw4bLi -hpw&t=10s.

"'Negro sobre blanco' – Leopoldo María Panero, Sanchez Dragó." YouTube video, 59:31. Posted by "culturapractica," March 11, 2016. https://www.youtube.com/ watch?v=TaVu2LcaG4A&t=3s.

Panero, Michi. 2002. "Conferencia de Michi Panero en Astorga." YouTube video, 26:06. Posted by "Pedro Alonso González," March 6, 2014. https://www.youtube.com /watch?v=ot4SlqG6FAQ.

"Un Dia con Panero + Leopoldo Maria panero + Carlos Ann + Bunbury Documental." YouTube video, 20:53. Posted by "Eryka Bunbury," June 29, 2016. https://www.youtube.com /watch?v=HPvSVgH0rmM.

PERMISSIONS

Quotations from the estates of Felicidad Blanc, Leopoldo María Panero, and Leopoldo Panero with the permission of their heirs, represented by Rosario Alonso Panero.

Quotations from the work of Juan Luis Panero with the permission of Carmen Iglesias.

Quotations from *El final de una fiesta* with the permission of Asís Lazcano.

Excerpt from "The Family" by Luis Cernuda, translated by Stephen Kessler (from *Forbidden Pleasures: New Selected Poems* by Luis Cernuda, Black Widow Press, 2015), first published in *AGNI* magazine, copyright 2015 by Stephen Kessler, reprinted with his permission.

Quotations of unpublished letters by Luis Rosales with the permission of Luis Rosales Fouz.

PHOTO CREDITS

Diligent efforts have been made to locate all copyright holders of the photos that appear in this book. To remedy any omissions, please notify us for corrections in future editions.

All stills from El Desencanto, Jaime Chávarri, Video Mercury Films

Juan and Leopoldo Panero, unknown, courtesy of the Leopoldo Panero Archive, Library of the Generation of '27 Cultural Centre Library (LPA)

Panero family in their first home, unknown, courtesy of Astorga Muncipal Library (AML)

Panero courtyard, unknown, courtesy of AML

Joaquina Márquez, unknown, LPA

Gathering in honor of Vicente Aleixandre, unknown, courtesy of AML

Leopoldo Panero during Spanish Civil War, unknown, courtesy of LPA

Felicidad Bergnes de las Casas and José Blanc Fortacín, unknown, courtesy of AML

Felicidad Blanc as a child, unknown, courtesy of AML

Manuel Silvela 8, unknown, courtesy of AML

Felicidad as a young woman, unknown, courtesy of Javier Mendoza

Felicidad Blanc and Leopoldo Panero wedding, unknown, courtesy of LPA

Felicidad Blanc and Leopoldo Panero with baby Juan Luis, unknown, courtesy of AML

Felicidad Blanc and Leopoldo and Juan Luis Panero in Brighton, unknown, courtesy of LPA

Leopoldo Panero, Felicidad Blanc, and Luis Cernuda, unknown, courtesy of AML

Leopoldo Panero and Francisco Franco, unknown, courtesy of LPA

Felicdad Blanc and Leopoldo Panero with Dalí painting, unknown, courtesy of LPA

Panero family in Madrid street, unknown, courtesy of AML

Leopoldo María, Juan Luis, and Michi Panero as children, unknown, courtesy of Juan José Alonso Panero

Leopoldo Panero, unknown, courtesy of LPA

Juan Luis Panero on camel, unknown, courtesy of AML

Felicidad Blanc and Juan Luis Panero on ship's deck, unknown, courtesy of AML

Leopoldo María Panero, Cesar Malèt

Michi Panero, unknown, courtesy of Inés Ortega Klein

Jaime Chávarri, Carlos Saura, courtesy of Jaime Chávarri and Carlos Saura

Juan Gomila, Felicidad Blanc, Lalo Azcona, and José Hierro, Luis Pérez Minguez, courtesy of Juan Gomila and © 2018 Artists Rights Society (ARS), New York / VEGAP, Madrid

Carmen Iglesias, Juan Luis Panero, and Elisabet Goula Iglesias, unknown, courtesy of AML

Michi Panero, Antonio Martínez; **Leopoldo María Panero,** Sara del Castillo, courtesy of Sara del Castillo

Juan Luis Panero, Manuel M. Mateo

INDEX

Page numbers in *italics* refer to photo captions.